RE:THINK RE:DESIGN RE:CONSTRUCT

RE:THINK RE:DESIGN RE:CONSTRUCT

RE: THINK DESIGN CONSTRUCT

How top designers create bold new work
by RE:INTERPRETING original designs

MARK WASSERMAN

www.howdesign.com
HOW Design Books
Cincinnati, Ohio

Rethink Redesign Reconstruct. Copyright © 2004 by
Mark Wasserman. Manufactured in China. All rights
reserved. No part of this book may be reproduced in
any form or by any electronic or mechanical means
including information storage and retrieval systems
without permission in writing from the publisher,
except by a reviewer who may quote brief passages
in a review. Published by HOW Design Books, an
imprint of F&W Publications, Inc., 4700 East Galbraith
Road, Cincinnati, Ohio 45236. (800) 289-0963. First edi-
tion.

Other fine HOW Design Books are available from
your local bookstore or direct from the publisher
(see www.howdesign.com).

08 07 06 05 04 5 4 3 2 1

Library of Congress
Cataloging-in-Publication Data

Wasserman, Mark
 Rethink, redesign, reconstruct / by Mark Wasser-
man.--1st ed.
 p. cm.
 ISBN 1-58180-459-8 (hc : alk.paper)
 1. Commercial art--History--21st century. 2. Com-
munication in design. 3. Designers--Interviews. I.
Title.

NC998.4.W37 2004
741.6--dc22
 2003056731

Edited by Amy Schell
Cover and interior design by Lisa Buchanan
Production coordinated by Sara Dumford

MARK WASSERMAN:

You may remember him from the hit TV show *Diff'rent Strokes*, where he played the part of the wisecrackin' Arnold Jackson. However, author Mark Wasserman now spends his days at Plinko, the San Francisco graphic design shop he founded in 1997 with his wife and partner in design, Irene Ng. For the last seven years, Plinko has worked on all sorts of traditional and new media projects, from interactive Flash projects to CD packaging to dynamic web sites (and everything in between). Their work has been featured in various art shows, magazines, television programs and books; and they continue to work with a diverse group of clients, including American Express, Quannum Projects, Future Games, McSweeney's Publishing, Hyatt and DJ Z-Trip. This might be a good time to have a look at their site, www.plinko.com. Seriously—go look at it right now. There's nothing more to see here. Still here? Well at least turn the page, you're starting to make me nervous.

ACKNOWLEDGMENTS:

This book would not have been possible without the contributions of many people. First, an enormous thanks to all the amazing artists and designers who graciously gave their time and energy to make this book what it is; to everyone at HOW Design Books and F&W, especially Amy Schell and Clare Warmke; to everyone who watched this whole project come together and listened to me prattle on about it endlessly; Karen and Scott at ilo, Waterman at Macroscopic, Henry H. Owings at Chunklet, Mike at reConfigured, and Trisha Donnelly.

As long as we've got all this space, let's include these people who—really, let's be honest for a moment—had nothing to do with the book. I'll grudgingly admit that they helped in their own special ways, most without even knowing it: the Wasserman family; my "screen dad" Conrad Bain; all the design web portals (k10k, Design is Kinky, Newstoday); the Roberts brothers with the big brains; Quannum Projects; Mark Herlihy; Windy Chien; the good folks at 826 Valencia; the Ng family; Laura Beckwith; and Anna Klafter. Also, it seems appropriate to note the monumental influence of Dr. and Mr. Haggis-on-Whey, whose elaborate tales of globe-trotting exploits are occasionally fascinating and always lengthy.

Finally, as we bid a sweet farewell to the acknowledgment section, the biggest thanks of all go to Irene, who somehow always knows the perfect thing to say, and to our dog, Bruno, who made sure that I never worked for more than an hour at a time.

INTRODUCTION:

ON THE COVER IT SAYS RETHINK REDESIGN RECONSTRUCT…WHAT'S THAT ALL ABOUT?

Over the last few years, the concept of remixing music has become commonplace, with musicians routinely offering up alternate versions of each other's work. While the remix still references the original version of the song, it can stand on its own as an entirely new recording. The thing I've always loved about listening to remixes is hearing the exact moment where the two artists' aural visions come together. Even though the two may have never met in person, you can hear their personalities affecting each other.

Of course, like any cultural phenomenon, the term *remix* has become overused. What once started out as a musical revolution is now part of the common vernacular; remixes can even be found in the supermarket. Is a different flavor of Sprite really a remix? Well, maybe. Is a gel that gets your hair even spikier a remix? Not really. Nonetheless, despite its ubiquitous usage, the concept is still ripe with possibilities.

A few years ago, it occurred to me that artists and graphic designers could mirror the remixing process of musicians. By using the source files and the design brief as the basis for the remix, designers could take the original elements and create entirely new designs with them. Don't like DJ Shadow's album cover? No problem. Here are all the original files—do what you want with them.

Ultimately, good design is really about communication, and one of the greatest challenges of being a designer is finding the right solution for each situation. Of course, all designers want their work to look as good aesthetically as possible, but if it doesn't convey the message, then the primary goal isn't being met. And no matter how great the original design is, it's just *a* solution, never the *only* solution.

And there, the idea for *Rethink Redesign Reconstruct* was born.

OK, THAT PART MAKES SENSE, BUT I'M WONDERING WHY I HAVEN'T ALREADY SEEN ALL OF THESE DESIGNS BEFORE.

While it is fun to flip through design books and nod knowingly at each piece, I thought it might be interesting to feature work you haven't already seen. Also, most design books tend to feature the same pool of designers you've come to know—hey, look, it's that wacky clip art guy!—and feature their best designs for specific topics: Crazy Type! Brochures on a Cheap-Ass Budget! The Best Wine Labels Ever!

But not this one.

Instead of just a greatest hits collection of various designers' portfolios, this book showcases loads of never-before-seen material, created specifically for this project.

Alright… are you a believer yet? At this point, let's just agree that this book is different. There's really no need to hype it up any more, because if you're reading this, there's a good chance you've already bought it. Or,

heaven forbid, you're actually standing in a bookstore reading the introduction to a design book. Just get on with it and go look at all the pretty pictures. There'll be plenty of time for reading later.

WAS THE BOOK ASSEMBLED USING EITHER WIZARDRY (THE GOOD KIND, LIKE HARRY POTTER) OR BLACK MAGIC (THE EVIL STUFF, LIKE YANNI)?

An excellent question, but the answer is no. Actually, through hundreds and hundreds of e-mails, phone calls, and packages sent all around the world, I was somehow able to coerce some of the very best designers in the world to become involved with this book. (Many of the packages that I sent contained opiates, but that seems like just a pleasant coincidence.)

The request to each designer was simple: Submit one piece from your portfolio, and let your peers have their way with it. From Stefan Sagmeister's wildly inventive collage to Dave Eggers' stunningly complex visual labyrinth, to Joshua Davis' technological wizardry, a collection of thirty-seven already-completed design projects were chosen.

SO THEN WHAT HAPPENED?

From there, I spent months researching and viewing thousands of different online portfolios. As the book began to take shape, I invited dozens of designers to create new work based on the original designs. Soon, more and more designers began to join the project. As they referred other designers from their own communities, the talent kept coming and coming. All totaled, you'll see work by more than 160 designers representing twenty countries, spread across six continents. (Note to Antarctica: Your designers really need to step it up a bit.)

LET'S REFRAIN FROM THE ANTARCTICA BASHING, SHALL WE? STICK TO THE BOOK.

My apologies. Early on, the editors and I decided that for each of the original thirty-seven "source" projects there should be at least four redesigned versions. So, the first step was to match each of the designers with a source project to redesign. After viewing each of the thirty-seven options, each designer submitted a wish list of their top choices. After all the matchmaking had occurred, the designers were given only minimal rules to follow.

LIKE SPEED DATING?

Yes, just like speed dating. Additionally, each designer was told only a bit of information about the original piece. They were given all the source files and were free to use as much or as little of the original as they wanted. Too much text? Cut it out. Not enough? Well then, write your own damn text.

Designers were free to cut out graphics, explore wild tangents…essentially do whatever they liked. As you'll see, the designers took their own approaches to each project. Some stayed true to the original, simply rearranging a few elements to create a new result, while others tossed out all of the original design and created something entirely new. As long as there was a clear path from the original to the redesign, it was within the rules.

After the redesigns were completed, the designers of the original piece and the designers of the new versions got to comment on each other's pieces without knowing who the designer was. While you'll notice a bit of professional courtesy, you'll more often see a brutal dose of honesty. Each design is discussed in the informative and revealing question-and-answer format.

Ultimately, the project is not about making a design better; it's about different visual approaches. Sometimes the results were spectacular, and sometimes, well, they were out there. This book illustrates the fact that there can be more than one effective solution to each project and that each designer's approach is unique.

Throughout the process, I was lucky enough to have constant daily interaction with some of the best design minds around. Getting to open my e-mail each day and see these reinterpretations was a real treat. The designs were all at once brilliant, beautiful, shocking, vulgar, hilarious, disastrous and captivating. Hopefully you will find them equally as inspiring.

TABLE OF CONTENTS:

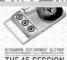

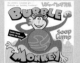

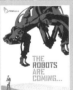

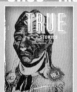

ARETHA FRANKLIN CONCERT POSTER

MW: YOUR STUDIO CREATES A HUGE VARIETY OF EVENT POSTERS. WHEN HOUSE OF BLUES CAME TO YOU WITH AN ARETHA FRANKLIN PROJECT, WHAT DID YOU USE AS YOUR INSPIRATION FOR THE PROJECT?

SC: Aretha's sheer presence, power, and femininity; "Respect"; and the work of poster designer Art Chantry.

ONLY "RESPECT"? AREN'T YOU FORGETTING "FREEWAY OF LOVE"?

Ha! It's funny, part of what I enjoy about most of my show posters is how little I know about the artists and their music initially. Until now, I never recalled that she had that hit… about a pink Cadillac, huh? So actually it had no influence…just serendipitous I guess.

WERE THERE ANY OTHER APPROACHES YOU ATTEMPTED?

This solution presented itself clearly and almost immediately, which is unusual for me. The pink was a internal debate. Pink can be too "soft" and sometimes weak in effect. Here, I feel it carries a power and strength, just as I had hoped.

WHAT WAS THE BIGGEST CHALLENGE?

I wanted to be careful to not tread on sensitive matters, so by using the paper stock itself as the skin tone, I avoided any issues and actually supplied the poster with more impact and power.

HOW WAS THE MAIN IMAGE OF ARETHA CREATED?

The client provided a range of photos, and I wanted to show her without showing her. I thought it was all about her eyes…and that hair, c'mon!

DEFINITELY. YOU GOTTA HAVE THE HAIR. WITH A PROJECT LIKE THIS, HOW MUCH FREEDOM DID YOU HAVE?

I always try to reflect my client's brand [House of Blues] in any of their posters. The process of marrying different looks and feels with the crunchy style of HOB can be tricky. The posters should convey the venue and the artist together as an event and an experience.

•••

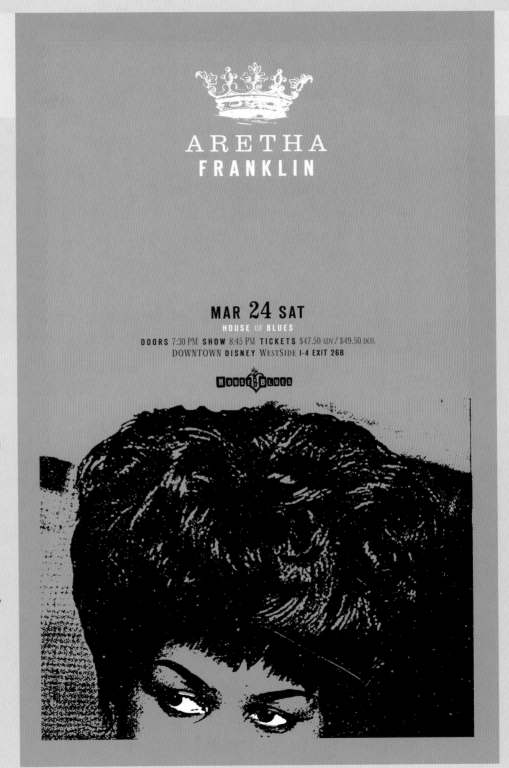

DESIGNER: Steve Carsella **STUDIO:** vibranium+co. **CITY:** Orlando, Florida **URL:** www.vibranium.com
YEAR: 2000 **SIZE:** 17" x 22" (43 x 56 cm) **SOFTWARE PROGRAMS:** Photoshop, Illustrator **TYPEFACES:** Clarendon, Tanak

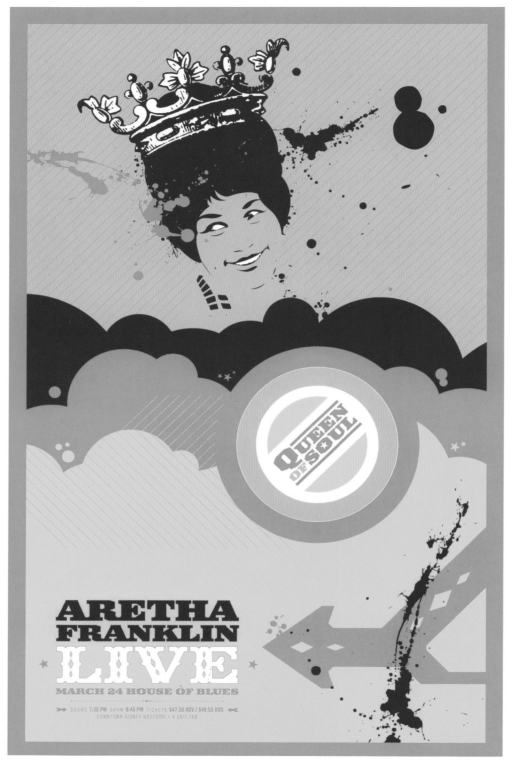

DESIGNER: Thomas Bozack **STUDIO:** Bozack Nation **CITY:** New York, New York **URL:** www.bozacknation.com **SOFTWARE**
PROGRAMS: Photoshop, Illustrator **TYPEFACE:** IronMonger

MW: SO, WHY DID YOU CHOOSE THIS PARTICULAR PIECE TO REDESIGN?

TB: Aretha Franklin reigns supreme.

HOW DID YOU FEEL ABOUT THE ORIGINAL DESIGN?

I liked it. I didn't want to choose a design that I wasn't feeling right from the start.

WHAT WAS YOUR CONCEPT FOR THE REDESIGN?

I wanted to remix the poster like I would a song: use some of the same elements, but twist it into something totally new. The original design mainly used pink and so, to "remix" it, I wanted it to use more colors, especially ones that you might not expect.

THE PIECE HAS A GREAT COMBINATION OF ULTRA-CRISP VECTOR SHAPES ALONG WITH THE PAINT SPLATTERS. HOW DID THAT COME ABOUT?

Aretha's music is very powerful and full of energy, but it also has a very smooth style along with being improvisational at times. That was the idea behind the cleaner vector shapes and the "improvisational" splatters.

YOU'RE OFFICIALLY A VISUAL REMIXER NOW. HOW WAS THE PROCESS?

Not bad at all. Projects like this are meant to be fun. When there are no restrictions on the design, it makes for a pleasurable experience.

. . .

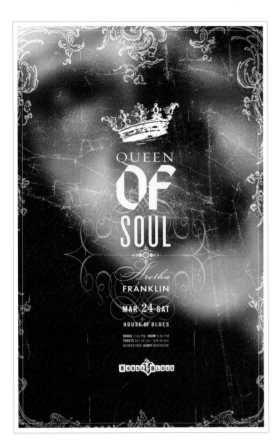

DESIGNER: Nessim Higson **STUDIO:** I Am Always Hungry **CITY:** Birmingham, Alabama **URL:** www.iamalwayshungry.com
SOFTWARE PROGRAMS: Photoshop, Illustrator, good ol' pencil and paper

MW: WHAT MADE YOU CHOOSE THIS PROJECT?

NH: To be frank, I feel like it's a great execution, and I really wanted to challenge myself. The original design was a superb solution on all levels: colors, typefaces and utilization of space. The designer created a piece that I think can be admired by a vast majority of people, and best of all, it communicates.

HIGH PRAISE INDEED. SO, WITH THAT LEVEL OF APPRECIATION FOR THE ORIGINAL, WHAT WAS YOUR CONCEPT FOR THE REDESIGN?

Primarily, it was to stay away from the original design as best as I could. Every time I looked at the source files and tried to involve them, my design just became a bastardized version of the original. I liked the cropped close-up of Aretha that was originally used, so I found a good shot of her and blurred it so that upon close viewing she became a pattern or background. It's only when standing further back that one can make out Aretha's face.

WAS IT AN EASIER OR HARDER EXPERIENCE THAN YOU THOUGHT IT WOULD BE?

Definitely harder—the original design was so well executed that many variations on its theme just looked like bad rip-offs, which, of course, we don't want.

· · ·

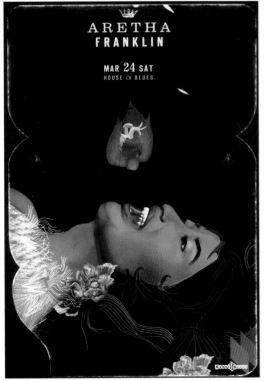

DESIGNER: Justin Wood **STUDIO:** singlecell **CITY:** Los Angeles, California **URL:** www.singlecell.to **SOFTWARE PROGRAMS:** Poser, Photoshop, Illustrator, sandpaper, tape

MW: WHAT WAS IT ABOUT THE ARETHA POSTER THAT MADE YOU CHOOSE IT?

JW: I thought that the initial design was a little sparse and just saw it calling out for something different, much like a little wet plastic flamingo that could use a warm home.

INTERESTING. WHAT WAS MISSING FOR YOU?

I thought it needed a bit more honesty. Something further down the mysterious, playful tone the original design set. Something with a bit more soul and intimacy. Something immediate, yet delicate.

HOW DID YOU EVENTUALLY APPROACH YOUR DESIGN?

It was a warm day somewhere, and I wanted to bring the viewer up close with Ms. Franklin as she lay beneath some tree or stars and belted out deliciously lush, soulful emotions. It was the proximity I would want to have when seeing her in performance.

WAS IT AN EASIER OR HARDER EXPERIENCE THAN YOU THOUGHT IT WOULD BE?

Harder. It's always a challenge to keep things simple!

· · ·

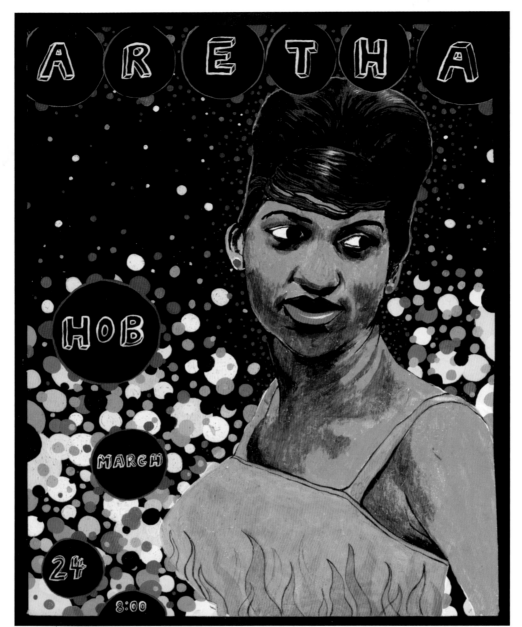

DESIGNER: Martha Rich STUDIO: Martha Rich Illustration CITY: Pasadena, California URL: www.martharich.com
SOFTWARE PROGRAM: "Just my hands!"

MW: SO, WHY DID YOU CHOOSE THIS PIECE?

MR: Franklin rocks! I have always wanted to paint her, so it was the perfect choice for me. People who are passionate and driven make excellent subjects. I wanted it to feel soulful, human, and colorful—just like Aretha.

DID YOU LIKE THE ORIGINAL POSTER, OR DID YOU WANT TO FIX IT?

I really liked the original design, especially the pink…no kidding! But, of course, I think all designs should include an illustration!

YOU DID THIS PIECE ENTIRELY BY HAND. HOW DOES YOUR APPROACH CHANGE WHEN YOU'RE AWAY FROM A COMPUTER?

I never use a computer to create an illustration or a layout. A lot of my creative process is based on mistakes and happy accidents. The rawness and imperfection of the human touch is just more interesting to me.

JUST BY LOOKING AT A DESIGNER'S WORK, CAN YOU NORMALLY TELL IF THEY HAVE TRADITIONAL ART SKILLS, SUCH AS PAINTING AND DRAWING?

I think you can tell. Maybe their work is more playful, looser, and not so based on the grid. I would think designers with traditional art skills might approach a layout like they were painting—doing quick sketches and playing with values and shapes and lines. I can see them looking at the big picture first and then honing in on the details last, working on it from far away and eventually up close.

YOU CHOSE TO PORTRAY A MUCH YOUNGER ARETHA…WHY?

I was listening to her earlier work while painting, and I seem to be attracted to the way things and people looked in the 1960s and 1970s.

WHAT WAS THE OVERALL EXPERIENCE LIKE?

It was an easy experience for me because there was no art direction. Freedom is a wonderful gift for an illustrator.

. . .

MW: SO, WHAT MADE YOU CHOOSE THE ARETHA POSTER?

KH: I like music. I like grit. The original poster seemed to appeal to my personal design aesthetic.

WHAT WAS YOUR CONCEPT FOR THIS REDESIGN?

Aretha is the "Queen of Soul." Just as this was inferred with the use of the crown in the original design, I desired to expand upon the queen theme by utilizing other famous queens, such as Freddy Mercury, Queen Latifah and Steve McQueen.

WHAT WAS THE EXPERIENCE LIKE FOR YOU?

To be properly executed, this poster would probably never be printed, due to too many copyright infringements.

HOW MUCH EASIER WOULD YOUR LIFE BE IF THINGS LIKE COPYRIGHT LAWS SUDDENLY VANISHED?

Sometimes it is essential for designers to experiment without limitations. Powerful ideas and art can be created by sampling existing information and images in an effort to create something entirely new, much like a band like Negativland approaches their music or like Warhol appropriated corporate images and celebrity images.

...

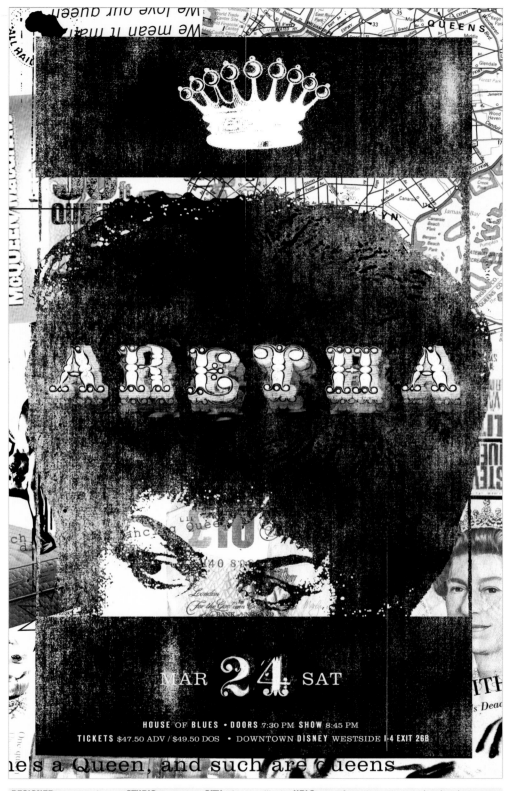

DESIGNER: Kent Henderson **STUDIO:** Fuzemine **CITY:** Chicago, Illinois **URLS:** www.fuzemine.com, www.kenthenderson.com
SOFTWARE PROGRAMS: Photoshop, copy machine

CH 2 HABITAT STORE PROMOTIONAL POSTCARD

MW: WHAT WAS THE CONCEPT FOR THIS POSTCARD?

TS: The concept was a hot summer in Bangkok: 90°, hot and humid, hand fans, ice cream, swimming pools, sweat and colorful shirts. Plus, I thought there should be a Habitat product somewhere in the design.

DID YOU TRY ANY OTHER APPROACHES WITH THIS PIECE?

We originally had the lettering customized by using spray paint and writing on the wall, to get the feeling of an urban look. Unfortunately, the client didn't like how it turned out. So we ended up using a typeface.

HOW MUCH DID THAT CHANGE AFFECT THE OVER-ALL TONE OF THE PIECE?

Not too much. The original headline was a spray-painted type, but the final design still achieves what we're trying to say. I did like the spray painted-type better though.

WHAT WAS THE BIGGEST CHALLENGE FOR THIS PIECE?

I needed to make black, white, and blue appear colorful.

YOU DO GET A LOT OF MILEAGE OUT OF THAT COLOR PALETTE. DID YOU ENJOY THE CHALLENGE OF THE STRICT COLOR CONSTRAINTS, OR DID IT FEEL LIKE YOUR HANDS WERE TIED?

After I had finished the design, I was told to use black, white, and blue based on the color of the Habitat collection. I felt a bit frustrated, but it turned out alright.

...

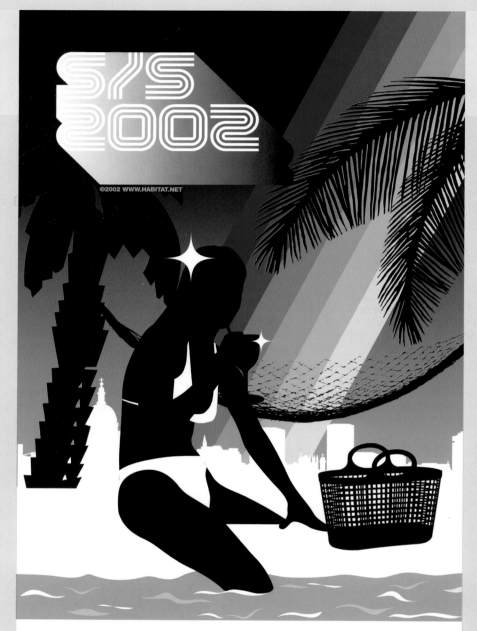

DESIGNER: Tnop W. Sillapakun STUDIO: bePOS|+|VE Design CITIES: Bangkok, Thailand and Chicago, Illinois URL: www.bepositivedesign.com YEAR: 2002 SIZE: 4½" x 7" (11 x 18 cm) SOFTWARE PROGRAMS: Illustrator, Streamline TYPEFACE: Lane (Designershock)

MW: YOU WERE PRETTY ANXIOUS TO WORK ON THIS PIECE. WHAT WAS IT THAT GRABBED YOUR ATTENTION?

BR: I wanted to do something that wasn't for the entertainment-related clients that I usually work for, and also I really enjoyed visiting Bangkok a couple of years ago, so the idea of using some sort of Thai imagery got me all excited.

WHAT DID YOU THINK ABOUT THE ORIGINAL DESIGN?

The original confused me—not so much how it was executed, but what it actually conveyed. From the project description, it was supposed to be a postcard about a "hot summer in Bangkok." I thought it looked a little too generic. It didn't feel HOT.

ALRIGHT, YOU'VE GOT SCOOTERS, GRAFFITI... WHAT'S YOUR CONCEPT FOR THIS REDESIGN?

Bangkok is pretty westernized, but it's still very Asian and has its own identity. So, taking the original design brief, I decided to glorify the urban experience and make it both Thai-centric and Western contemporary. Basically turn the focus on how Habitat could celebrate and be relevant to the actual customers in Thailand, instead of selling them their own version of occidental exoticism. Less "aspire to live like us" but more like "incorporate our style into your life." That's my unavoidable hip-hop aesthetic at work—exploiting and pulling references from the high end, instead of having the high end exploit the lower end.

I wanted it to look like it was designed by someone who lives there and who's trying to present a modern, aware, kinda cool look at the surroundings, without resorting to cliché, sterile, "good" design. So even though I used arguably predictable imagery (scooters, tower) there was careful avoidance of making it too precious, high end and fashionlike—because then it becomes too snooty.

Bangkok is an amazing, frighteningly beautiful place, but it's generally gritty, so I wanted to convey that. I chose the traffic image because it's so specific to that part of the world—three-wheeled tuktuks and scooters everywhere. It's so intrinsic to living there.

. . .

©2002 WWW.HABITAT.NET
SPRING SUMMER
HABITAT® 4TH FLOOR, SIAM DISCOVERY CENTER
RAMA1 RD., BANGKOK 10330 | T | 02.658.0400

habitat

DESIGNER: Brent Rollins **STUDIO:** Brent Rollins Design Explosion! **CITIES:** New York, New York and Brooklyn, New York
PHOTOGRAPHER: Stolen images! **SOFTWARE PROGRAMS:** FreeHand, Photoshop

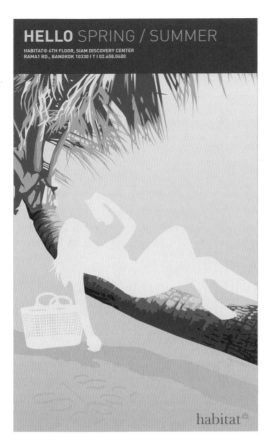

DESIGNER: Marcus Ericsson **STUDIO:** Subdisc **CITY:** Kuala Lumpur, Malaysia **URL:** www.subdisc.com **SOFTWARE PROGRAMS:** Illustrator, Flash, Photoshop **TYPEFACES:** DIN Bold, DIN Light

MW: SO, WHY DID YOU CHOOSE THIS PARTICULAR PIECE TO REDESIGN?

ME: I like Habitat.

WHAT WAS YOUR CONCEPT FOR THIS REDESIGN?

I wanted to keep the anonymous silhouette illustration style from the original design, but lighten it up a bit with a detailed background of a palm tree and brighter colors. I still tried to keep the simplicity. Notice the "S/S 2002" written in the sand?

HOW WAS THE EXPERIENCE OF REDESIGNING A PIECE? EASIER OR HARDER THAN YOU EXPECTED?

Harder. I didn't get the feel that I had in my mind at first, but in the end it turned out OK.

WHAT WAS THAT ORIGINAL FEELING YOU WERE GOING FOR—AND HOW DOES THIS FINAL REDESIGN DIFFER FROM THAT?

The initial feel I had in mind was much simpler, cleaner, and not so dull—more like the original. But at the end of the day, this final redesign turned out to be a bit more complicated and much softer than what I had in mind at first.

. . .

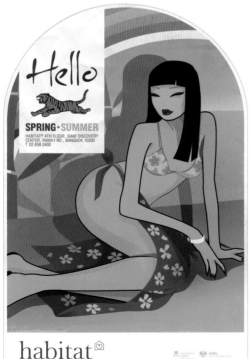

DESIGNER: Robert Lindström **ILLUSTRATOR:** Simone Legno **STUDIO:** The DesignChapel **CITY:** Skelleftea, Sweden **URLS:** www.design-chapel.com, www.tokidoki.it **SOFTWARE PROGRAMS:** FreeHand, Illustrator, Flash, Photoshop **TYPEFACES:** Inkburrow, ATTriumvirate

MW: SO WHY DID YOU CHOOSE THIS PARTICULAR PIECE TO REDESIGN?

RL: I didn't have much time for this project, so I invited Simone Legno, an excellent illustrator. He draws very beautiful and sexy girls, so we choose the Habitat piece.

DID YOU LIKE THE ORIGINAL DESIGN, OR DID YOU THINK IT NEEDED SOME HELP?

Well, I didn't like it too much. To me, the illustration was not so special.

WHAT WAS YOUR CONCEPT FOR THIS REDESIGN?

Simone and I wanted to do a new version of Habitat, both in color and in feeling. We kept the idea of a sitting girl, and he came up with this Asian girl. I took it further, which was quite hard because I wanted to keep the illustration as untouched as possible. I did a rounded top to make the card more original, and then I messed it up a little to get an old card feeling. I made it more yellow and added some scratches that I scanned from a broken CD cover.

WORKING WITH A TALENTED COLLABORATOR, HOW WAS THE REDESIGN EXPERIENCE?

The hardest part was to find a way to present Habitat in a new way and not to destroy Simone's illustration too much.

. . .

DESIGNERS: Page Burkum, Torrey Burkum **STUDIO:** Burkom **CITY:** Minneapolis, Minnesota **URL:** www.burkom.com **SOFTWARE PROGRAM:** Adobe Illustrator **TYPEFACES:** Helvetica Neue 55 Roman, ITC American Typewriter Light and Bold

MW: WHAT ATTRACTED YOU TO THIS PIECE TO REDESIGN?

P&TB: As children, we always found summer in Bangkok to be a fascinating subject. When given the opportunity to explore this theme, we knew it would be our only chance. Let's just say we took that chance.

DID YOU LIKE THE ORIGINAL DESIGN, OR DID YOU THINK IT NEEDED SOME HELP?

We don't want to start anything. No comment.

NO COMMENT? THAT'S NOT ALLOWED...C'MON, DESIGN FEUDS ARE FUN! HOW ABOUT A BRIEF STATEMENT?

To be honest with you, we didn't really like the piece all that much.

WHAT WAS YOUR CONCEPT FOR THE REDESIGN?

We were thinking that it would be really cool to have a chair floating above some sort of white tulips.

ARE WE ALL GOING TO HAVE LEVITATING EAMES CHAIRS BY 2034? WILL IT BE AVAILABLE FOR EVERYONE OR BE MORE LIKE THE SEGWAY, WHERE JUST SOME ECCENTRIC MILLIONAIRES AND LUCKY MAILMEN HAVE ONE?

Yes, everyone will have them, and levitating will only be one of their features! They will also do our taxes for us.

WAS IT AN EASIER OR HARDER EXPERIENCE THAN YOU THOUGHT IT WOULD BE?

We try not to come into any projects with a timeline or difficulty level in mind, but with that said, yes...it was extremely difficult and time consuming and took much longer than expected.

WAS THAT BECAUSE YOU WENT THROUGH SEVERAL REINCARNATIONS, OR WAS IT A PROBLEM OF THE DESIGN BEING NOT QUITE FINISHED?

The design process itself didn't take long at all. Getting started on it is what took time. We are lazy.

• • •

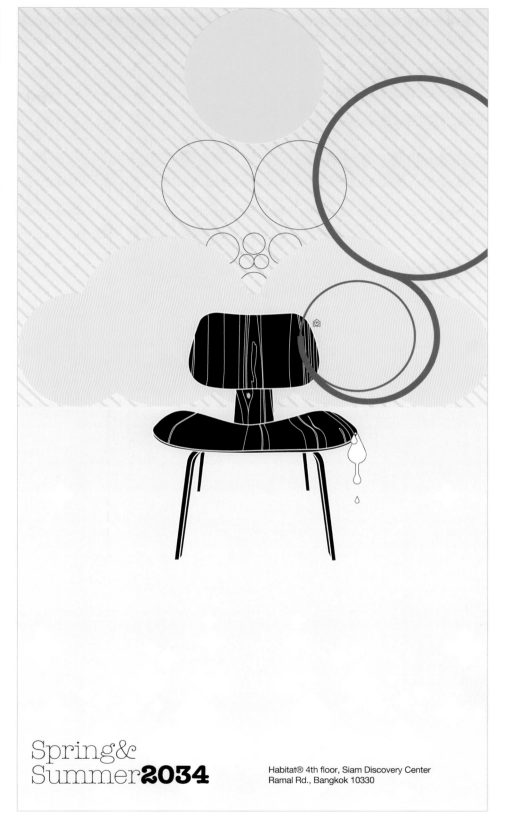

Spring& Summer**2034**

Habitat® 4th floor, Siam Discovery Center
Ramal Rd., Bangkok 10330

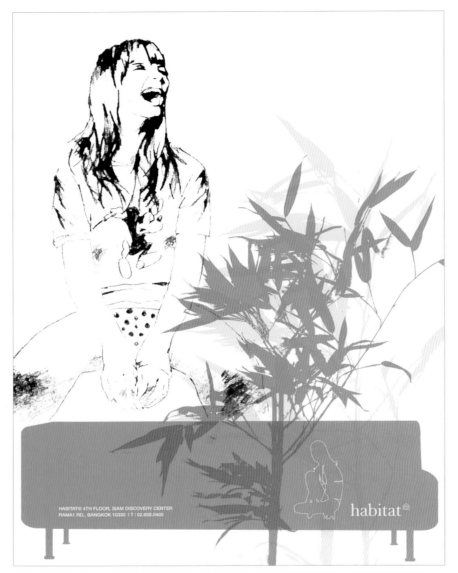

DESIGNERS: Hajdeja Ehline and Christie Rixford **STUDIO:** Super Natural Design **CITY:** San Francisco, California **URL:** www.supernaturaldesign.com **SOFTWARE PROGRAMS:** Illustrator, Photoshop **TYPEFACE:** Helvetica

MW: WHAT MADE YOU CHOOSE THIS PARTICULAR PIECE TO REDESIGN?

HE&CR: We absolutely love Habitat—their design sense is superb on all levels.

HOW'D YOU LIKE THE ORIGINAL DESIGN?

We liked it a lot. It was quite fun and playful. We just wanted to give it a different visual take but still keep the fun aspect of the original.

WHAT WAS THE CONCEPT FOR YOUR REDESIGN?

We wanted to design a whimsical, irreverent and attention-grabbing piece that would provoke someone to take notice.

WAS IT AN EASIER OR HARDER EXPERIENCE THAN YOU THOUGHT IT WOULD BE? WHY?

Challenging. We could have gone in many different directions with this concept and initially had a different plan for the design. Then we decided to keep the initial "fun" spirit of the original piece, as opposed to going a more literal route and showcasing the furniture.

INTRIGUING. I ALWAYS LOVE HEARING ABOUT DISCARDED IDEAS. CAN YOU GO INTO A BIT MORE DETAIL ABOUT THE OTHER PLAN AND WHY YOU CHOSE TO ABANDON IT?

The original plan was to create a piece that was non-illustrative in origin—something completely photographic and literal in image, and furniture related. We decided that the initial sketch ideas that we had just seemed too stiff and contrived, and what we really wanted to communicate was an idea with a looser, fresher edge that had lightness in tone and energy. There is a playfulness about Habitat's products that we felt needed to be represented in a non-literal way. Hopefully, we achieved this goal.

• • •

FEEDBACK FROM THE ORIGINAL DESIGNER: TNOP SILLAPAKUN

WHAT'S YOUR INITIAL REACTION TO EACH ONE IN ONE WORD?
Brent Rollins Design Explosion!: Different
Subdisc: Sexier
The DesignChapel: Sexiest
Burkom: Unique
Super Natural Design: Sexy

LOOKING AT THE REDESIGNS, WHICH IS YOUR FAVORITE?
All of them have their own unique points, but Super Natural's and Subdisc's probably fit the most with the look and feel of Habitat. They're very stylish. DesignChapel's has a feeling of summer heat in a sexy way. There's something about Burkom's that I like as well. It's so simple and clean. The way that the designers use graphic elements to compose the story is really cool.

WHICH ONE SURPRISES YOU?
The one by Brent Rollins Design Explosion! is really different from the others. I like how he incorporates the real images of Bangkok into the design.

OVERALL, WHAT DO YOU THINK OF ALL THE REDESIGNS?
First of all, I'd like to thank all designers that picked this design to work on. I'm really impressed with the results—they're all so refreshing.

CH 3 BUBBLE MONKEY SOAP PACKAGING

THE BUBBLE MONKEY SOAP LUMP WAS ONE OF THE MORE POPULAR PROJECTS TO WORK ON. SEEMS LIKE PEOPLE JUST LOVE MONKEYS.

MW: WHAT WAS THE MAIN INSPIRATION FOR CREATING THIS PIECE?

MS: The main inspiration was Japanese packaging.

AH, YES. THERE'S A WHOLE WORLD OF AMAZING PRODUCTS OVER THERE. DID YOU TRY ANY OTHER APPROACHES WITH THIS PIECE?

No. But we submitted other concepts influenced by Japanese character-driven packaging, and those also became product lines.

WHAT WERE THE BIGGEST CHALLENGES IN CREATING THE BUBBLE MONKEY PACKAGING?

Originally, we used a different color palette that we had to change. We also had to make sure the appeal of the project would reach a new market. Strangely—and we think this is largely due to the humor of the copywriting—teenage boys love it. That, and the not-so-subtle penis/banana on the see-through front die cut.

SEEMS LIKE YOU HAD A LOT OF FREEDOM...WERE THERE ANY GUIDELINES YOU HAD TO STICK TO?

We just needed to avoid using similar color palettes to other Blue Q products. Other than that, we were given a pretty long leash to run wild and have fun. That's what makes Mitch Nash [of Blue Q] one of the greatest clients we've ever worked with. He's very trusting. We even used Kanji script—not knowing ahead of time what it said—that we got out of a Japanese clip art book on a trip to Tokyo. It was only much later—when the product was already on the market—that we learned it said things like "Happy Hour," "Big Special Sale," "Cheap!" "Watermelon," and "Leisure Suit."

...

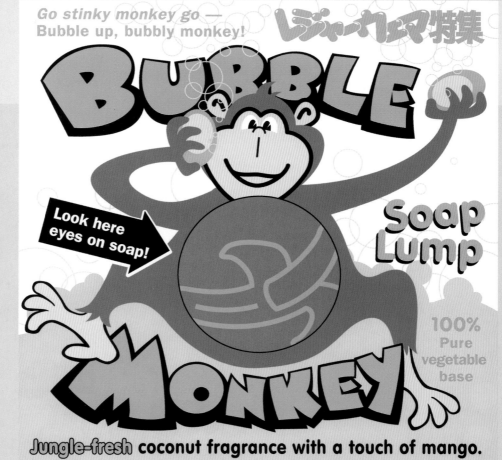

Go stinky monkey go —
Bubble up, bubbly monkey!

レジャーウェア特集

BUBBLE

Look here eyes on soap!

Soap Lump

MONKEY

100% Pure vegetable base

Jungle-fresh coconut fragrance with a touch of mango.

DESIGNER: Michael Strassburger **STUDIO:** Modern Dog Design Co. **CITY:** Seattle, Washington **URL:** www.modern-dog.com **YEAR:** 2000 **SOFTWARE PROGRAM:** Adobe Illustrator **TYPEFACES:** Franklin Gothic (ITC), VAG Rounded (Bitstream)

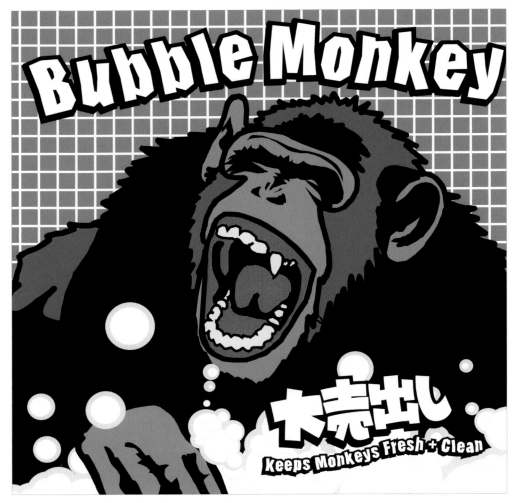

DESIGNERS: Stefan Grindley and Stephen Baker **STUDIO:** Newtasty
CITY: Birmingham, England **URL:** www.newtasty.com **SOFTWARE PROGRAMS:** Illustrator, FreeHand **TYPEFACE:** Horseradish (04)

MW: WHAT LED YOU TO CHOOSE THIS PARTICULAR PIECE TO REDESIGN?

SG&SB: Initially there were a couple of pieces we were interested in working with. We looked mainly at the pieces which instantly sparked ideas and at things which we would enjoy working on. We liked the challenge of working on something three-dimensional. Plus, everybody loves a monkey!

YEP, IT'S JUST ONE OF THOSE THINGS. EVERYONE DOES LIKE MONKEYS. HOW'D YOU FEEL ABOUT THE ORIGINAL DESIGN?

We really liked the design. It works perfectly for the product. I think our reason for choosing this piece was that this was a project that lent itself to different interpretations. When choosing the piece, we definitely chose based on whether or not we liked the idea of the project and its potential rather than the execution of the design.

THAT'S PRETTY MUCH THE WAY TO GO. WHAT WAS YOUR CONCEPT FOR THE MYSTERIOUS MONKEY SOAP?

I guess just to have fun with it, especially as there was no client to answer to and the importance of selling a specific product was no longer as important as the aesthetics of the packaging. We really liked what had been done already with the cute Japanese angle, and we loved the look of the Japanese type. We wanted to keep that but maybe develop it in a different way. We thought it would be fun to change the product from being a cosmetic soap with a monkey motif into an actual product for cleaning monkeys—just because we could. We listen to a lot of Kool Keith.

. . .

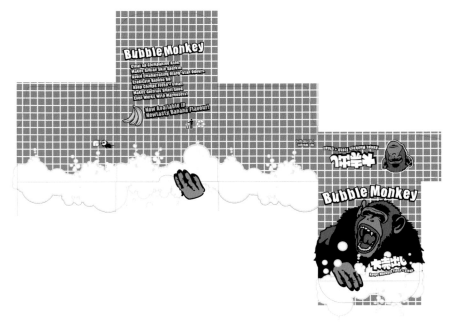

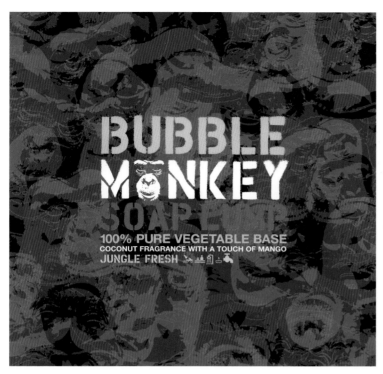

BUBBLE MONKEY
SOAP LUMP

100% PURE VEGETABLE BASE
COCONUT FRAGRANCE WITH A TOUCH OF MANGO
JUNGLE FRESH

BUBBLE MONKEY

DESIGNER: Peter Chadwick **STUDIO:** Zip Design **CITY:** London, England **URL:** www.zipdesign.co.uk

MW: SO, WHY DID YOU CHOOSE THIS PIECE TO REDESIGN?

PC: It was not an obvious choice, so that is why we went for it.

DID YOU LIKE THE ORIGINAL DESIGN, OR DID YOU WANT TO DO UNSPEAKABLE THINGS TO IT?

I think the original design is great fun, and if we had not seen that version we may well have approached our design solution in a similar way.

YOU'VE CREATED A PRETTY MENACING SOAP LUMP. WHAT WAS YOUR CONCEPT FOR THE REDESIGN?

We wanted to get a real contrast from the original version, so we took our influences from fashion and created a camouflage pattern which is made up of two chimps' faces repeated in different colors and sizes. The main type was created by cutting a stencil and spraying it, which was then combined with some original camouflage we drew up.

YOU LOOKED DEEP INTO THE HEART OF THE BUBBLE MONKEY AND SURVIVED. HOW WAS IT?

It was as enjoyable as we thought it would be.

. . .

DESIGNER: Gaëtan Albert **STUDIO:** Iridium, a design agency **CITY:** Ottawa, Ontario, Canada **URL:** www.iridium192.com **ART DIRECTOR:** Mario L'Écuyer **ARTS & CRAFTS:** Lucero Sanchez **PHOTOGRAPHER:** Yannis Souris **SOFTWARE PROGRAMS:** Quark XPress, Illustrator **TYPEFACE:** Eidetic Neo (Émigré)

MW: WHAT DID YOU THINK ABOUT THE ORIGINAL PACKAGING DESIGN?

GA: For this project, I thought it held the most potential to create something really different and take the humor to a more visual level. The idea was wacky, but the treatment was tacky. Its small size made it busy, but I thought I could expand the idea. The original package was so absurd, so naive in its fabrication—intentionally, I'm sure—that the personality of the product became very strong. There was nothing to add to this. On the other hand, when you encounter a soap product called Bubble Monkey, it's clearly evident that many other doors can be opened, leading to different territory.

WHAT WAS YOUR CONCEPT FOR THIS REDESIGN?

We wanted to transform the concept, taking a satirical approach on current trendy packaging that presents a new product treatment. The idea of contrast is always a good avenue: before and after, outside and inside, dirty and clean, monkey fur and soap. After all, what can be more curious than a personal hygiene product dressed up in orangutan pelt?

WAS IT AN EASIER OR HARDER EXPERIENCE THAN YOU THOUGHT IT WOULD BE?

First, finding the monkey fur was the challenge, since monkeys were out of season. But once the concept was nailed, the design procedures were rather straightforward. I simply applied a belly band around the furry box, using a minimal amount of visual elements. The result is a schizophrenic personality product that breathes fun and sophistication. Makes you want to get dirty again!

. . .

DESIGNERS: Steffen Sauerteig, Svend Smital, Peter Stemmler and Kai Vermehr **STUDIO:** eBoy **CITIES:** Berlin, Germany, and New York, New York **URL:** www.eboy.com **SOFTWARE PROGRAM:** Photoshop

MW: SO, WHY DID YOU CHOOSE THIS PARTICULAR PIECE TO REDESIGN?

eBoy: We loved the "X-ray-banana-in-womb monkey."

WHAT DID YOU THINK ABOUT THE ORIGINAL DESIGN TREATMENT?

It is OK as it is. We just started ours from there.

I'VE NOTICED THAT GORILLAS AND MONKEYS SEEM TO FIND THEIR WAY INTO A LOT OF eBOY WORK. WHAT IS IT ABOUT THEM THAT MAKES THEM SO INTERESTING TO DESIGN?

It's their raw animal power.

YOUR DESIGNS ARE INSTANTLY RECOGNIZABLE. DO YOU HAVE A SET LIBRARY THAT YOU TEND TO WORK FROM, OR DO YOU GENERATE NEW PATTERNS AND IMAGES EACH TIME?

We rely on a growing database, reusing and modifying parts all the time. Each new project enriches that database, and it has become the backbone of eBoy.

HOW DID YOU GO ABOUT ON YOUR GENERAL DESIGN PROCESS? IS IT STRAIGHT TO THE MACHINE, OR DO YOU DO A LOT OF HAND SKETCH-ING BEFOREHAND?

We hardly ever make sketches; we just start and then see what's happened. Sometimes we get sketches from a client—mostly if it's a larger job or if we have to produce parts for games. It's typical for eBoy that three people work at the same picture, often on the same building, monster, etc.

HOW WAS THE REDESIGN EXPERIENCE?

It was fun—pure relaxation.

• • •

MW: SO, WHY DID YOU PICK THIS PIECE TO REDESIGN?

BA: I went through all of the submitted designs, and this one felt like the odd man out. When I go to the pound to pick out a dog, I'll always go for the mutt and not the purebred.

WAS THIS ONE A CUTE MUTT OR AN UGLY ONE?

I think it was effective for what it was. It had a 1980s feel, like bubble bath packaging I used to get as a kid. I think it was effective for hitting the mark, at least nostalgically.

WHAT WAS YOUR CONCEPT FOR BUBBLE MONKEY?

I wanted to look cool in this book: I didn't really care what an eight-year-old thought of the design because I know that's not my target audience. I was trying to rope in a fat-cat art director. I know my approach would have been different had we actually been approached by the client. Am I being too honest? I think it would ultimately serve better as a club flyer than as soap packaging.

DON'T HOLD BACK NOW. HOW WAS THE OVERALL EXPERIENCE?

Too damn hard. I didn't want to spend too much time on something we weren't getting paid for, but I didn't want to look like a chump next to all of these superstars. Ultimately, I spent way too much time on it.

. . .

FEEDBACK FROM THE ORIGINAL DESIGNER:
MICHAEL STRASSBURGER

LOOKING AT THE REDESIGNS, WHAT'S YOUR INITIAL REACTION TO EACH ONE IN ONE WORD?
Newtasty: B-movie
Zip Design: Camouflage
Iridium: Hairball
eBoy: Monkey-down!
Ames Design: Thumbs-up

ALRIGHT, TIME TO PICK FAVORITES.
Honestly, the design by Iridium is the one I'd like to see produced. I think a soap that comes in a furry box is really hilarious. It's also the most different and uses a lot of restraint. The results create a sense of mystery. I really want to open that box!

DO ANY OF THEM SURPRISE YOU?
The design by eBoy made me laugh out loud. I love the illustration. This piece makes me wonder what the designers were thinking.

OVERALL, WHAT DO YOU THINK OF ALL THE REDESIGNS?
I really like the concept-driven designs: Newtasty's piece is the only one that uses Kanji, and it still would appeal to the market we were going after with our original design. I think the Japanese packaging feel is still apparent, and I love the gorilla coming out of the tub. So, on many levels, it's very successful. Zip Design's creation puts an interesting twist on the idea of jungle, monkeys and soap. But Iridium's hairball is still our favorite. The idea that the fur might belong to a monkey is a little disturbing, but very funny.

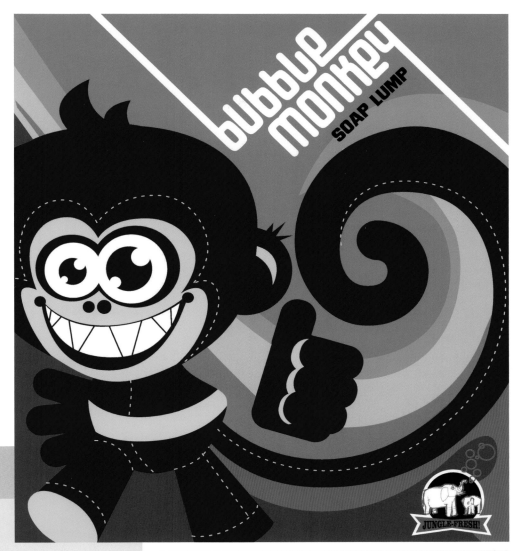

bubble monkey
SOAP LUMP

JUNGLE-FRESH!

DESIGNER: Barry Ament **STUDIO:** Ames Design **CITY:** Seattle, Washington **URLS:** www.amesbros.com, www.bigpopposters.com **SOFTWARE PROGRAM:** Illustrator

CH
4
THE PRIVATE PRESS ALBUM COVER

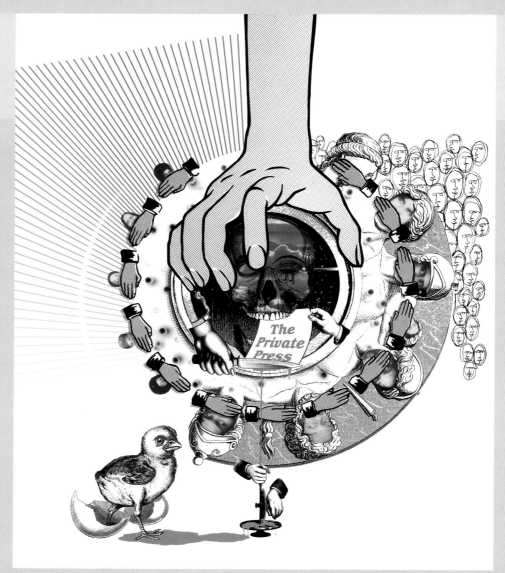

MW: SO, YOU GET TO DO THE ALBUM COVER FOR DJ SHADOW, WHO'S CERTAINLY IN THE CD COLLECTION OF MANY DESIGN STUDIOS. DID YOU FEEL ANY EXTRA PRESSURE?

KT: I knew there would be high expectations regarding the music alone, so we definitely didn't want to tarnish it with crappy packaging. Following up the quality of design established on his past releases was another added pressure. The main concern was just trying to make something unique and reflective of the music.

WHAT DO YOU THINK IT IS ABOUT SHADOW'S MUSIC THAT MAKES DESIGNERS CONNECT WITH IT SO MUCH?

Maybe it's the cut-and-paste aesthetic that designers relate to. His process of making music is similar to the way designers work in terms of gathering information and arranging it. Or maybe we just like them beats.

YOU GIVE AN ART DIRECTOR CREDIT TO DJ SHADOW. WHAT KIND OF ROLE DID HE PLAY?

It was a collaborative effort. Most of the images in the collage were chosen by him (from his personal collection), and that's what dictated the tone of the package. He's the one who kept pushing it into more unconventional directions.

IT SEEMED AS THOUGH PEOPLE HAD STRONG REACTIONS TO THE COVER ARTWORK. DID THE RECORD LABEL HAVE ANY CONCERNS?

I had the same love/hate reaction while I was working on it, which isn't necessarily a bad thing. The record label was surprisingly uninvolved and cooperative throughout the whole process. The creative control Shadow retains in the music-making carries over to the artwork as well.

FROM SEEING DJ SHADOW'S PERSONAL PRIVATE PRESS RECORDS, WHICH OF THOSE HOMEMADE COVERS REALLY AFFECTED YOUR DESIGN?

There's not one in particular, because it was more of a collective influence. There's an intimate and tactile quality that they all share, which is what we tried to duplicate. There were also some really twisted ones that made us scratch our heads in confusion and I think that definitely carried over.

. . .

DESIGNER: Keith Tamashiro **ADDITIONAL ART DIRECTION:** DJ Shadow **PHOTOGRAPHER:** B+ **STUDIO:** Soap Design Co. **URL:** www.soapdesign.com **CITY:** Los Angeles, California **YEAR:** 2002 **SOFTWARE PROGRAMS:** Photoshop, Illustrator, Quark **TYPEFACES:** ITC Bookman, ITC Lubalin Graph

MW: WHAT WAS YOUR CONCEPT FOR REDESIGNING THE PRIVATE PRESS?

CS&RB: We began with the original as a foundation, approaching the redesign much like a DJ would approach the task of remixing another artist's music. Then, we expanded upon the sleeve's existing vocabulary by incorporating additional elements that alluded to DJ Shadow's "digging" process: his culling of sounds from many various, disparate and mostly obscure sources and the resulting construction of wholly original compositions.

As this approach evolved, the resulting visuals began to feel a little too heavy and dark. While this was certainly indicative of the claustrophobia and melancholy present throughout the album, there is also much levity to be found. The incorporating of anagrams became a slightly tongue-in-cheek way (remixing the titles!) of reintroducing the humor found in the music and the original sleeve, while also addressing the sometimes willfully cryptic nature of each. Most of the anagrams were chosen based on their relevance to the record and the artist himself, but others were chosen because we thought they were funny.

WAS IT AN EASIER OR HARDER EXPERIENCE THAN YOU THOUGHT IT WOULD BE? WHY?

It was unexpectedly harder, due to both our familiarity with the record—which has been in fairly heavy rotation on the Stoltze sound system since its release—and the high esteem with which we held the original artwork.

. . .

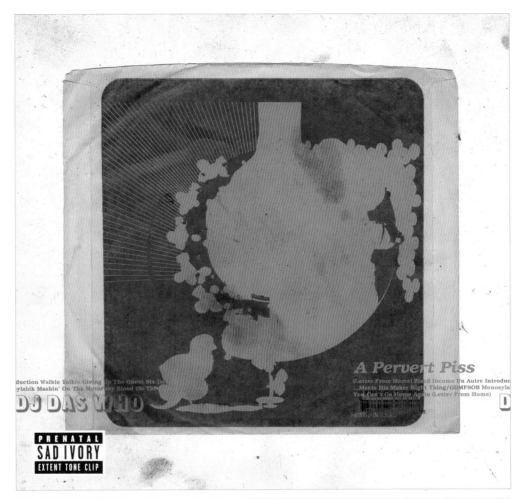

DESIGNER: Roy Burns ART DIRECTORS: Clif Stoltze and Roy Burns STUDIO: Stoltze Design CITY: Boston, Massachusetts URL: www.stoltzedesign.com SOFTWARE PROGRAMS: Photoshop, Illustrator TYPEFACES: Bookman-MT Demi (Adobe); Memphis Bold (Adobe); OPTISansSerif Shaded (Castcraft)

DESIGNER: Kin-wai Chau aka ok_static **STUDIO:** Sleepatwork **CITY:** Lautau, Hong Kong **URL:** www.sleepat-work.com **SOFTWARE PROGRAMS:** Illustrator, Photoshop

MW: WHY DID YOU CHOOSE THIS PIECE TO WORK ON?

KC: I liked both the visuals and the concept behind the design. To me, it's one of the best CD sleeve designs that was done in 2002.

SO, WITH A PIECE THAT YOU LIKED SO MUCH, WHAT WAS YOUR CONCEPT FOR THE REDESIGN?

From my perception I see brutal things like cannibalism in the original piece, and I adapted that mood into the remixed work.

DOES YOUR DESIGN SCARE YOU MORE OR LESS THAN THE ORIGINAL?

Both before and after the remix process, I was trying not to compare the remixed artwork with the original piece.

FAIR ENOUGH. WHAT WAS THE REMIX EXPERIENCE LIKE FOR YOU?

The whole redesigning process was a very enjoyable experience, especially in the early stages. I was thinking, "How can I use the elements of the original design and create a new context for it?"

• • •

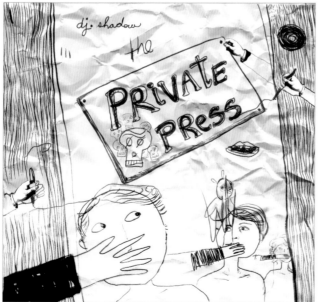

DESIGNER: Eun-Ha Paek **STUDIO:** Milky Elephant **CITY:** Brooklyn, New York **URLS:** www.milkyelephant.com, www.eun-ha.com **SOFTWARE PROGRAMS:** Painter, Photoshop

MW: WHY DID YOU CHOOSE THIS PIECE TO REDESIGN?

EP: It looked like something that would lend itself to being hand drawn, which is something I like to do and don't get to do as often as I'd like.

WHAT DID YOU THINK OF THE PRIVATE PRESS ARTWORK?

The original design works. It resembles a 'zine cover, which fits with the premise that it should look homemade. To me, the original looks a little too professional. Despite the odd imagery, collaging and clip art, it looks a little too slick.

INTERESTING. WHAT WAS THE CONCEPT FOR YOUR REDESIGN?

I pretended to be a homemade-record maker. First, I slashed the budget for clip art, and then I pretended to be a high school student making the clip art drawings from scratch. It's raw and unpolished, but I hope that allows the sincerity to come through, revealing some charm. A lot of the same imagery is used, but executed in a different fashion. Maybe the old design is what was imagined, but what came out was what I made. Nothing is quite right or perfect. Then maybe it was crumpled up in frustration. And later they picked it out of the wastebasket and decided to use it anyway when they realized they were out of paper.

I LOVE IT. YOU'VE GOT THE ONLY REDESIGN WITH ITS OWN HISTORY. WHAT WAS THE DESIGN EXPERIENCE LIKE?

It's easy to do something I'm engaged in, and I knew I could make it be exactly how I imagined it. So it was very easy. It was also easy because my idea was that it should be easy.

• • •

MW: WHAT WAS IT THAT LED YOU TO CHOOSE THE PRIVATE PRESS TO REDESIGN?

ES: I find the synesthetic-like repercussions of designing for music quite charming. I enjoy attributing colors to notes and, most particularly, providing abstract linear narratives for non-abstract tunesmithery.

I SEE, KIND OF. YOUR WORDS CONFUSE AND DELIGHT ME. SO, HOW'D YOU LIKE THE ORIGINAL ALBUM ART?

I felt the original design provided a very different visual response to the music than my own. I didn't dislike it but immediately knew I would undertake the design process rather asymmetrically in comparison. I wanted to portray the emotional life of the songs in a way that might contrast with the actual genre of the music.

YOUR DESIGN HAS A VERY HANDCRAFTED FEEL TO IT—HOW DID YOU CREATE THE MAIN IMAGE?

I painted the image in oils and then scanned it in and color corrected it using Photoshop. In turn, my oil paintings usually originate as sketches in my drawing journal. It's all a bit analog really.

WHAT WAS IT THAT LED YOU TO USE THIS VERY EARTHY COLOR PALETTE?

The objects in the image are intended to be almost fleshlike in color. There is a certain sort of detritus I hear in DJ Shadow's work—beautiful organic samplings of a myriad of creative souls.

. . .

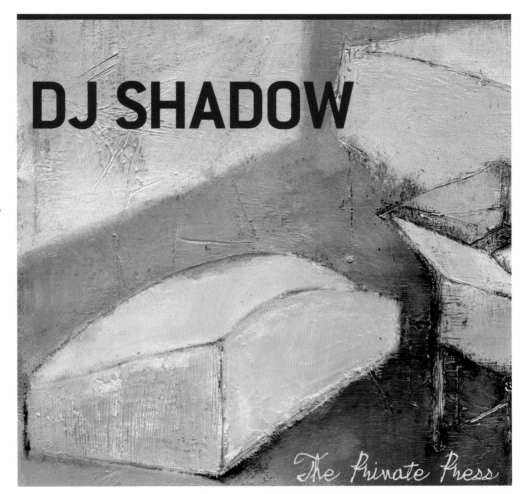

DESIGNER: Emme Stone **STUDIO:** Elephantcloud **CITY:** London, England **URL:** www.elephantcloud.com **SOFTWARE PROGRAM:** Adobe Photoshop **TYPEFACE:** Conduit (ITC)

DJ Shadow
THE PRIVATE PRESS
based on a true story

DJ Shadow
THE PRIVATE PRESS
RECORDS LEFT TOO LONG IN THE SUN
BEGIN A NEW LIFE AS ONE PIECE OF VINYL

ML

DESIGNER: Michael Leon **STUDIO:** Stacks **CITY:** Los Angeles, California **URLS:** www.commonwealthstacks.com, www.all-trueandliving.com

MW: WHAT WAS THE CONCEPT FOR YOUR REDESIGN?

ML: I don't think the original needed any help. I liked it. I had to throw it out and start over if I was gonna do anything I could live with. I imagined all the records that were sampled to make this one melted together to become one new experience. I did it in the style of a book cover, to imply a longer story than can be told with an album cover.

LIKE A LOT OF YOUR WORK, THIS ONE LOOKS SO HAPPY AND UNAPOLOGETICALLY NON-IRONIC. DO YOU TRY TO GET INTO A PARTICULAR MINDSET WHEN YOU START?

When it comes to doing a project like this, I approach it like "What does this record mean to me?" instead of "What does this record mean to DJ Shadow's audience?"

HOW DO YOU GO ABOUT YOUR DESIGN PROCESS?

I'll usually just make some tea and sit with a pen and just start writing down ideas. In this case, I put on the record, with headphones, and just wrote down visual ideas while listening to it. In the end, the thing that struck me most was an image of all the records that were used to make this one melted together into one new record. It doesn't deal with specifics of any one song, but illustrates that records have "lives" and records can sort of "live together" when they are sampled to make a new song or sound piece. After an idea like this takes shape and the less important elements fall away, the computer time is minimal. At this point, I know exactly what it's going to look like, and the last step goes very quickly.

. . .

FEEDBACK FROM THE ORIGINAL DESIGNER:
KEITH TAMASHIRO

LOOKING AT THE REDESIGNS, WHAT'S YOUR INITIAL REACTION TO EACH ONE IN ONE WORD?
Stoltze Design: Smart
Sleepatwork: Uncomfortable
Milky Elephant: Nervous
Emme Stone: Appetizing
Michael Leon: Hypnotic

IT'S DEFINITELY A DIVERSE GROUP. GOT A FAVORITE?
Sleepatwork's is probably my favorite. I like the imagery, and it has a nice duality of horror and humor. It would also translate into a really nice T-shirt.

ANY OF THEM SURPRISE YOU?
Emme Stone's, because it caused an immediate craving in me for a Neapolitan ice cream sandwich.

OVERALL, WHAT DO YOU THINK OF ALL THE REDESIGNS?
I just liked the fact that everyone took it in very different visual directions, but all of them retained the warmth of a handmade object.

CH 5 DESIGN VS. MONEY EDITORIAL ILLUSTRATION

MW: WHAT WAS THE MAIN CONCEPT FOR THIS PIECE?

TS: The main idea is about how economic matters affect design.

SO, DESIGN VERSUS MONEY…WHICH ONE NORMALLY WINS THE BATTLE?

In the best cases, it's a win-win situation. And often, it's not a battle; it's more like a dance.

DO YOU FEEL AS THOUGH MUCH OF YOUR BEST DESIGN WORK COMES OUT WHEN THERE'S LESS MONEY INVOLVED?

Sometimes yes. When little is invested then the clients feel safer with experimenting.

I'M CURIOUS ABOUT YOUR COLOR CHOICES—VERY BRIGHT RED AND YELLOW. IT REMINDS ME OF LARGE AMERICAN FAST-FOOD COMPANIES, LIKE MCDONALDS, BURGER KING, ETC. IS THIS SOMETHING YOU WERE THINKING OF, OR DID YOU CHOOSE THE COLORS FOR OTHER REASONS?

You never know what's bubbling under…

. . .

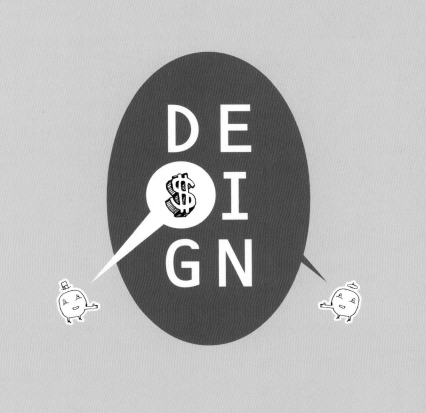

DESIGNER: Teemu Suviala **STUDIO:** Syrup Helsinki **CITY:** Helsinki, Finland **URL:** www.syruphelsinki.com **YEAR:** 2002
SIZE: 9" x 11" (23 x 28cm) **SOFTWARE PROGRAMS:** FreeHand, Photoshop **TYPEFACE:** DIN Engschrift Alternate

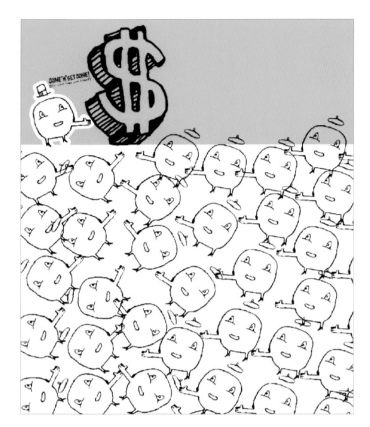

DESIGNER: Lucho Correa **STUDIO:** Lucho Correa **CITY:** Bogotá, Colombia **SOFTWARE PROGRAMS:** Photoshop, FreeHand **TYPEFACES:** Base Nine (Émigré) along with handmade type

MW: DID YOU LIKE THE ORIGINAL DESIGN, OR DID YOU THINK IT NEEDED SOME HELP?

LC: I found it was a great way to illustrate the article, although it is far different from my style. I mostly liked the illustrations of the little banker and the designer.

YOU MUST HAVE LIKED THEM, SINCE IT LOOKS LIKE THEY'VE REPLICATED IN YOUR DESIGN. WHAT WAS YOUR CONCEPT FOR THE PIECE?

My main goal was to stick to what I believe is a real redesign, which to me means keeping the elements of the original design but trying to express the concept in a different way. Doing a whole new design, for me, was not really a redesign.

WAS IT AN EASIER OR HARDER EXPERIENCE THAN YOU THOUGHT IT WOULD BE?

It was fun. I found that you can really focus on the concept because the design elements are already there. You just have to mix them to get them to say what you want.

. . .

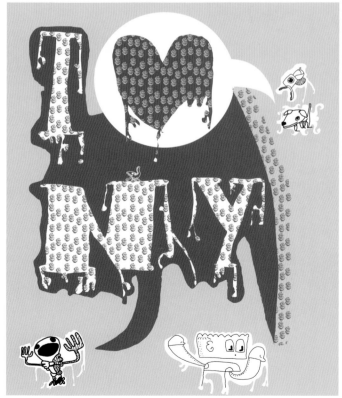

DESIGNERS: Martin Ström and Peter Ström **STUDIO:** Burnfield **CITIES:** Berlin, Germany, and Stockholm, Sweden **URL:** www.burnfield.com

MW: SO, WHY DID YOU CHOOSE THIS PARTICULAR PIECE TO REDESIGN?

M&PS: It looked like something that we liked and could make something more out of. Plus, it has a very obvious message that we could take further or make something out of.

WHAT WAS YOUR CONCEPT FOR THE REDESIGN?

To use the dollar sign as a symbol for America and the war President George W. Bush wanted, in a weird way.

MOST OF YOUR WORK HAS A VERY HAND-DRAWN FEEL TO IT. DO YOU TYPICALLY SKETCH A LOT OF THINGS FIRST, OR DO YOU GO STRAIGHT FOR THE COMPUTER?

Sometimes we sketch; sometimes not. I guess we mostly go direct for the computer with an idea and see what happens.

THE TINY CHARACTERS YOU CREATE HAVE SO MUCH PERSONALITY. EVEN THOUGH THEY LOOK SPONTANEOUS, DO YOU SPEND A LOT OF TIME MAKING THEM LOOK THAT WAY, OR CAN YOU REALLY DESIGN THEM VERY QUICKLY?

We mostly use a regular mouse, and I think that helps to make them more spontaneous, since you don't have the same control as using a pen or a Wacom tablet. We like things a bit skewed, and therefore it fits us fine. Sometimes the drawings are done in a minute; sometimes it takes days.

. . .

MW: DESIGN VERSUS MONEY. IT'S CERTAINLY A LOADED TOPIC. WHY DID YOU CHOOSE THIS PIECE TO REDESIGN?

MH: I liked the simplicity of the original and felt I wanted to make a statement, as opposed to just throwing a few blocks of color about until it looked cool. I wanted to approach the concept from a different angle.

It seems a lot of work at the moment is just "eye candy," work without a lot of thought behind it. It's just something that makes someone, somewhere, say "Hey, that looks cool." The client hands over his money, and everyone is happy! And I, like every other designer with deadlines to meet and clients to please, end up doing the same.

CAN YOU EXPLAIN YOUR CONCEPT?

Hmmm, well my hard-core left-wing past is coming out here and my general pessimism about the current state of design at the moment.

As for the redesign itself, it's based around the old USSR logo, and Soviet realist iconography. It's an ideology which is pretty much discredited nowadays, but at the beginning of the last century, it was a rallying cry of "Hey! Let's make the world a better place!" We all know how it all ended up!

In my version, I've removed all the slogans and iconography and replaced them with a dollar sign, which is rendered in an expressionistic kind of a way. With the expressionistic style, I think I'm trying to get across a message of "Hey, look at me! Look how artistic and creative I am." But at the end we all end up dancing to the silver dollar.

SO, DO THEY STILL LET YOU INTO CLIENT MEETINGS?

Yes, if I promise to behave myself!

WAS THE REDESIGN EXPERIENCE DIFFICULT FOR YOU?

Not really. The only problem was fitting it in with all the eye candy I've got to do!

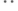

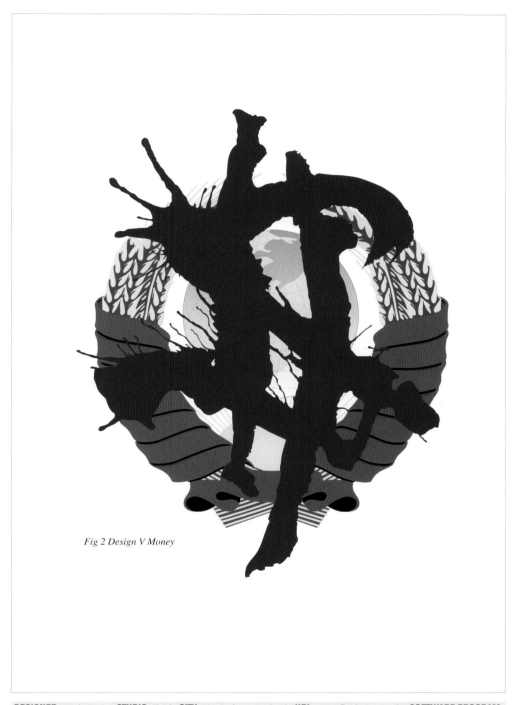

Fig 2 Design V Money

DESIGNER: Mark Harris **STUDIO:** Fluid **CITY:** Birmingham, England **URL:** www.fluidesign.co.uk **SOFTWARE PROGRAM:** Illustrator

DESIGNER: Scott Gursky **STUDIO:** Fat Truckers Union **CITY:** Brooklyn, New York **URL:** www.fattruckersunion.com **SOFT-WARE PROGRAMS:** Photoshop, Illustrator **TYPEFACES:** Many typefaces, including American Text BT, Blackoak, Fettefraktur, Hoefler Text, Ironwood, Memphis, Viva and Wood Ornaments

MW: WHAT WAS THE GUIDING CONCEPT FOR YOUR REDESIGN?

SG: Because of the simplicity of the original design, I knew that I had to conceptualize my design in the opposite direction. I needed to challenge myself to create a design that was complex and ornate, completely packed with visual information. I also wanted to include my own written content to connect the subject through the piece.

I started fooling around with different full-page compositions and found it a bit overwhelming. Then I noticed a dollar bill on my desk, and the idea to design a set of currency hit me. It offered the perfect format to include my own content and pictures in a highly ornate setting. I began experimenting with more old typefaces and images for collage, and the piece was on its way.

EVERYONE THAT'S SEEN THIS PIECE HAS BEEN DAZZLED BY IT. HOW LONG DID IT TAKE YOU TO ASSEMBLE IT FROM START TO FINISH?

I worked on the piece for about a total of twenty to thirty hours, working for several hours at night over the course of two weeks. I had to pace myself and limit each piece of money to about two to three nights each. When I am really enjoying a project, I can get pretty manic about it, so I never felt pressured or stressed about completing it.

WHAT DO YOU THINK THE CHANCES ARE OF YOUR DESIGNS BECOMING ACTUAL CURRENCY? DO PRESIDENT BUSH AND THE ILLUMINATI HAVE A GOOD SENSE OF HUMOR?

Well, I like to include a dotted "cut out here" line around some of my designs. So if someone actually cut, copied, and rained them down on Wall Street, well…who knows what would happen. And no, I doubt the current administration would find my designs funny or cute, but then again, who knows?

Designers must never forget the power they possess to communicate ideas to society. Most of the time we are hired to sell products, but I would like to encourage designers to sell more ideas, especially ones that express their political or social views. Which design is more important to society: the "Buy Our Jeans" billboard or the "No War" poster? We all understand how propaganda works, so we might as well make some.

• • •

MW: WHY DID YOU CHOOSE THIS PARTICULAR PIECE TO REDESIGN?

JJ: I chose the piece to redesign because I thought that it was a good concept, and it's something I personally deal with. Clients want you to deliver them the cow and pay only for a quart of milk. As both a designer and your own agent, you have to figure out how to find the right balance of what is and is not possible on the budget that is presented. Most likely the bottles of Crystal for the design team will have to go.

IT'S ALWAYS THE CRYSTAL THAT GETS CUT FIRST THESE DAYS. WHAT WAS YOUR CONCEPT FOR THE REDESIGN?

I liked the simplicity of the overall design but felt that it came up a little short in visual interest. The concept was to incorporate the type "de$ign" that was used in the original piece in a more visual environment and add a little humor to the piece.

OBVIOUSLY LOS ANGELES HAS A LARGE INFLUENCE ON YOUR WORK. EVEN IN THIS PIECE, I DETECT A BIT OF SO-CAL INFLUENCE. HOW LONG HAVE YOU LIVED IN L.A., AND COULD YOU IMAGINE YOURSELF ANYWHERE ELSE?

I started off in L.A. on day one. I was born here in the 1970s and have never had an address that has been out of the city. It's not that I do not like other cities, it's that I am just too big of a fan of authentic Mexican food and I only own two pairs of long pants. When New York state borders Mexico and global warming really hits its stride, get ready for NY GRAPHICA.

. . .

DESIGNER: Jon Jackson **STUDIO:** LA GRAPHICA **CITY:** Los Angeles, California **URL:** www.lagraphica.com **MODEL:** Jon Jackson **PHOTOGRAPHER:** Mike "Too Dope" Ewing **SOFTWARE PROGRAMS:** Photoshop, Illustrator **TYPEFACE:** Cooper Black

FEEDBACK FROM THE ORIGINAL DESIGNER:
TEEMU SUVIALA

LOOKING AT THE REDESIGNS, GIVE YOUR INITIAL REACTION TO EACH ONE IN ONE WORD:
Lucho Correa: Obvious
Burnfield: Fun
Fluid: Socialism
Fat Truckers Union: Rich
LA GRAPHICA: Stupidfresh

DO YOU HAVE A FAVORITE?
The piece by Fat Truckers Union because it made me say "Yes, I like this."

DO ANY OF THEM SURPRISE YOU?
All of them. They're quite brilliant works of graphic art.

CH 6 THE CLIVE BARKER PROJECT POSTER

MW: WHAT WAS THE CONCEPT FOR THE POSTER?

BA: Because this was for two different plays, I had to come up with a central image that would combine the two titles into one image. I began from that point and also followed through by printing two different color combos: monster greens and the traditional devil palette of black and red.

AH, QUITE CLEVER. DID YOU TRY ANY OTHER APPROACHES WITH THE PIECE?

I actually tightened up the sketch and hand-cut a stencil, which I used to spray paint a final image. I ended up using bits and pieces of the spray paint in the background but went back to the original five-minute sketch, nice and raw.

WHAT WAS THE BIGGEST CHALLENGE FOR YOU?

I think the original challenge of creating one poster for two separate plays was the biggest. Luckily, it also led to a great solution, which was very obvious: a hybrid monster, the bastard child of Frank and ol' Lou.

HOW WERE THE TYPEFACES CREATED?

The Clarendon in the titles was manipulated by Xerox. The "Clive Barker Project" type was hand rendered as part of the illustration.

BESIDES DOING JUST ONE POSTER, WERE THERE ANY OTHER GUIDELINES YOU HAD TO STAY WITHIN?

Keeping it cheap. We've created several posters for this production company, always on a shoestring budget. We try to keep it to two colors and also use a smaller size of paper.

. . .

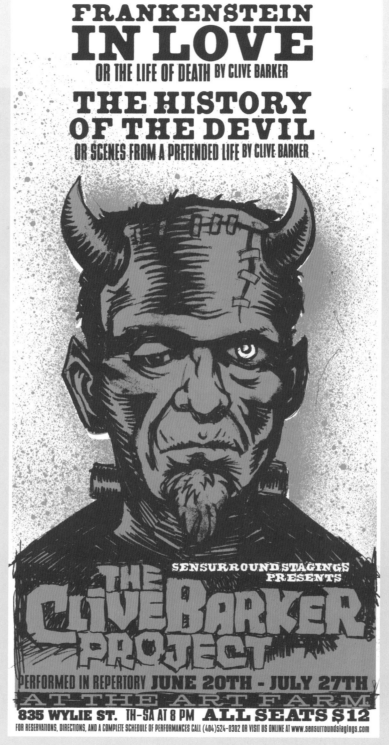

DESIGNER: Barry Ament **STUDIO:** Ames Design **CITY:** Seattle, Washington **URLS:** www.ames-bros.com, www.bigpopposters.com **YEAR:** 2002 **SIZE:** 11" x 23" (28 x 58 cm) **SOFTWARE PROGRAMS:** Illustrator, Photoshop **TYPEFACES:** Clarendon Bold, Bisteck, Biggen

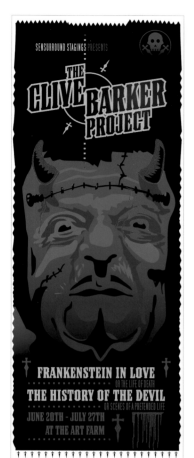

DESIGNER: Mambo (aka Flavien Demarigny) **CITY:** Paris, France **URLS:** www.mambo.vu, www.9eme.net **SOFTWARE PROGRAM:** Illustrator **TYPEFACE:** Council (Émigré)

MW: SO, WHY DID YOU CHOOSE THIS PIECE TO REDESIGN?

FD: I chose this subject because the characters, Frankenstein and the devil, both have visually and mentally strong personalities. It's a great challenge to mix them into one character.

DID YOU LIKE THE ORIGINAL DESIGNER'S VERSION OF THE BLENDED CHARACTERS?

I love the original drawing; it's a great one. It was difficult for me to start working on this idea because the original is pretty close to my style.

SINCE YOUR STYLE IS SIMILAR, HOW DID YOU CHANGE THE CONCEPT FOR THE REDESIGN?

I haven't really changed the concept; most of the motivation for redoing it was to use a different color palette to create more drama and a scarier visual. The face is a mix of the two characters (as in the original design), but the line art is more "liquid-y," like vapors, a reflection on water or a nightmare. I didn't want to abuse the "blood-on-black" cliché, so I used the blue and yellow combination to make a cold and electric atmosphere. I chose the cross icon to add a mystical sign and give more personality to the type. I love the yellow-outline-on-black effect to give an impact to the title.

WAS IT AN EASIER OR HARDER EXPERIENCE THAN YOU THOUGHT IT WOULD BE?

I can't say that the work is hard when I have fun doing it! I did six different versions before choosing one, but that's how I like doing things.

• • •

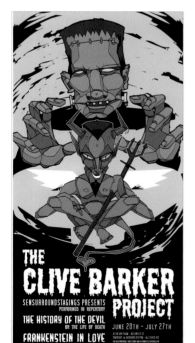

DESIGNERS: Eelco van den Berg, with Martijn van Egmond of 1127 **STUDIO:** Eelco **CITY:** Rotterdam, The Netherlands **URL:** www.eelcovandenberg.com **SOFTWARE PROGRAMS:** Photoshop, Streamline, Illustrator **TYPEFACES:** SF Movie Poster, Worthless Bum, Shlop

MW: WHY DID YOU CHOOSE THIS PARTICULAR PIECE TO REDESIGN?

EB: The subject got me excited! Making a poster for Frankenstein and the devil seemed like the perfect job for me. I'm not sure if it was the design itself or the subject matter, but drawn characters always get my interest.

WHAT WAS YOUR MAIN CONCEPT FOR THE REDESIGN?

It was to make a central image with Frankenstein and the devil that shows a combined action and to give the figures a bit of a puppet expression. For the overall design I wanted to create more balance between image and lettering.

YOUR ILLUSTRATION STYLE IS DEFINITELY A CHANGE FROM THE CURRENT TRENDS. HOW DID YOU DEVELOP YOUR STYLE?

I've been drawing since I was young, but when graffiti crossed my path I was sold! It wasn't just the colorful lettering that drew my attention but also the characters. I studied illustration at the School of Visual Arts in Rotterdam, and that made me aware of the things I could do with my work instead of leaving it behind on a wall. My teachers didn't really know what to do with my "graffiti-styled images," so during the rest of my schooling, I started working in a more realistic style. But once I graduated and left school, I slowly got back to my street-developed style, mixing it with new things I learned at school.

• • •

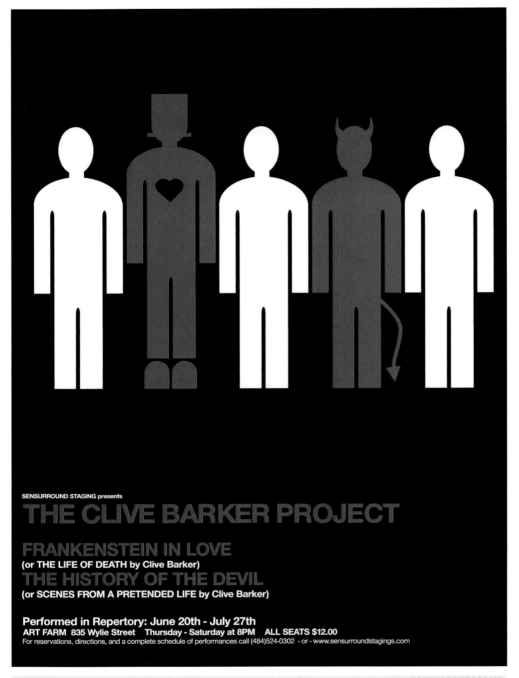

SENSURROUND STAGING presents

THE CLIVE BARKER PROJECT

FRANKENSTEIN IN LOVE
(or THE LIFE OF DEATH by Clive Barker)
THE HISTORY OF THE DEVIL
(or SCENES FROM A PRETENDED LIFE by Clive Barker)

Performed in Repertory: June 20th - July 27th
ART FARM 835 Wylie Street Thursday - Saturday at 8PM ALL SEATS $12.00
For reservations, directions, and a complete schedule of performances call (484)524-0302 - or - www.sensurroundstagings.com

DESIGNER: Stephen Fritz **STUDIO:** Olive **CITY:** New York, New York **URL:** www.olivemedia.com **SOFTWARE PROGRAM:** Illustrator **TYPEFACE:** Helvetica Neue

MW: SO, WHY DID YOU CHOOSE "THE CLIVE BARKER PROJECT" TO REDESIGN?

SF: When I first saw the design, the original designer's solution seemed like the most obvious. I couldn't immediately think of another way to handle it. Since I wasn't sure if I could come up with something comparable, I was compelled to choose it.

SO, WHAT DIRECTION DID YOU DECIDE TO GO?

I liked the original design very much. I'm always intrigued by an approach that I wouldn't have taken. Though effective, the original solution was very literal. I wanted to see if I could add more depth through a more subtle and suggestive approach.

My goal was to create an image that not only represented the two titles but also addressed the reinterpretation themes of the Clive Barker Project. I used the imagery of generic figures, similar to the iconography in public signage, to represent the average person. With subtle alteration, these figures became Frankenstein and the devil. I used red as an accent color to highlight both the altered figures and key titles to which they referred. I also wanted to convey a more sinister mood than the original, which is why I used the black-and-white palette with bright red accents. The placement of the altered Frankenstein and devil figures with the generic figures suggests some interesting questions: Are we all one slight alteration away from becoming a monster or devil? Can evil exist if not in the context of good? The piece is meant to engage the viewer by posing questions rather than providing answers.

IT'S A VERY CLEVER SOLUTION. WAS THE EXPERIENCE EASIER OR HARDER THAN YOU THOUGHT IT WOULD BE?

Definitely harder. Often when I focused on one aspect of the problem, the design lost any larger meaning. I also chose a very simple visual language for the poster, which made it harder to prevent the poster from being too analytical and having no emotional impact.

• • •

MW: SO, WHY DID YOU CHOOSE THIS PARTICULAR PIECE TO REDESIGN?

KI: I really like horror movies and thought it would be a lot of fun to interpret in a different way.

DID YOU LIKE THE ORIGINAL DESIGN, OR DID YOU THINK IT NEEDED SOME HELP?

I liked it a lot. The two-color woodcut approach was a nice way to promote a play. It was simple and eye-catching and somewhat nostalgic.

WHAT WAS YOUR CONCEPT FOR THIS REDESIGN?

I wanted to be dualistic in my interpretation and use the two main characters, the devil and Frankenstein's monster in equal positions. Placing the two figures back-to-back naturally created a visual fold down the center that resembled a Rorschach test. I decided to play upon that by adding the black splashes and placing the type on either side of the creatures.

Frankenstein's monster is based on the figure in Mary Shelley's book instead of the Boris Karloff monster, as he was depicted in the original poster. I sought to express the part animal/part human nature of the devil with ram horns to add a little bit of fierceness. Then I added some subtle elements of gore in the image: the heart held by the monster and the muscles on the devil's back.

WAS IT AN EASIER OR HARDER EXPERIENCE THAN YOU THOUGHT IT WOULD BE? WHY?

It wasn't really easier or harder—but it was a lot of fun!

. . .

FEEDBACK FROM THE ORIGINAL DESIGNER: BARRY AMENT

WHAT'S YOUR INITIAL REACTION TO EACH REDESIGN?
Mambo: Scary
Eelco: Sick
Olive: Original
Krening: Crafty

DO YOU HAVE A FAVORITE?
The one by Olive. They just took a completely different approach. All of the others seemed to use the same solution we did and just differ in the execution. This seemed like the biggest departure; a breath of fresh air.

WHICH IS THE BIGGEST SURPRISE?
Eelco's is a tight illustration. I really like seeing a hip-hop style applied to monster imagery. Obviously this guy had fun with it, because it's great subject matter.

WHAT DO YOU THINK OF ALL THE REDESIGNS?
Everything I see is top notch and super professional. It was really cool to see other people's approaches and different illustration styles. Damn, I hope our client doesn't see these.

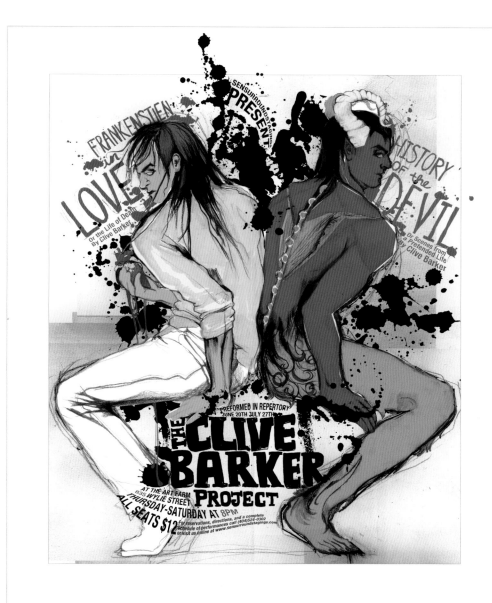

DESIGNER: Karen Ingram **STUDIO:** Krening **CITY:** Brooklyn, New York **URLS:** www.krening.com, www.kareningram.com
SOFTWARE PROGRAMS: Markers, pencils, Photoshop, Illustrator **TYPEFACES:** Helvetica Neue, hand-drawn lettering

HUSBAND & WIFE BOOK COVER

7

MW: WHAT WAS THE CONCEPT FOR THE BOOK COVER?

SG: It was a story about dysfunctional marriage, where the only thing they had left in common was in between the sheets.

THE THEME OF MARRIAGE IS OBVIOUSLY RIPE WITH POSSIBILITIES. DID YOU KNOW EARLY ON THAT YOU WANTED TO CAPTURE A SMALL MOMENT?

The interesting part about this book was that as the marriage was breaking down, so was the husband's health. He was a tour guide in Israel, and so his legs were important—he used them to make money. Towards the end of the book he is practically immobile, and the only time he is useful is when he is in between the sheets.

Sex was a very important part of the book, and I wanted to stress that point early on. Initially I had the idea of using a nut and bolt for two reasons: They are cold, and together they screw.

YOU TALKED ABOUT THEIR COMMON SEXUAL BOND, AND YET THE MOMENT YOU CHOSE TO SHOW IS DECIDEDLY UNPASSIONATE. WHAT WAS BEHIND THIS DECISION?

The marriage lacked love, conversation, and passion.

WHAT'S THE BEST ADVICE YOU'VE EVER GOTTEN ABOUT DOING A BOOK COVER?

My senior year in college was spent in Carin Goldberg's class. She's responsible for designing over four hundred books, many of which have won distinguished awards. She said that if you are not having fun, you might as well clean out your fridge. If you're having fun, the audience will have fun as well.

WHAT WAS THE BIGGEST CHALLENGE IN CREATING THIS PIECE?

As with any book cover, you have to understand the author's main intention and then translate it into a cover. You only have one shot, so you must get it right.

. . .

HUSBAND & WIFE

A NOVEL ZERUYA SHALEV

DESIGNER: Stan Grinapol **CREATIVE DIRECTOR:** Charles Rue Woods **PHOTOGRAPHER:** Joe Polillio **STUDIO:** Scribble & Tweak **CITY:** Queens, New York **URL:** www.scribbleandtweak.com **YEAR:** 2002 **SOFTWARE PROGRAMS:** Photoshop, Quark XPress **TYPEFACE:** Humanist 521

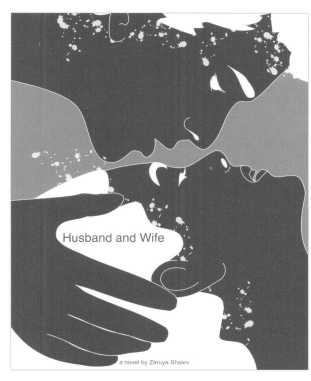

a novel by Zeruya Shalev

husband and wife

a novel

ZERUYA SHALEV

DESIGNER: Craig Metzger **STUDIO:** Engine System **CITY:** Brooklyn, New York **URL:** www.enginesystem.com **TYPE-FACE:** Helvetica for life!

MW: WHY DID YOU CHOOSE THIS PIECE TO REDESIGN?

CM: I actually wanted the "Pretty Girls Make Graves" poster (chapter 31) but I guess I wasn't hot enough! The real reason I chose this one is that I love the relationship between husband and wife, and I thought the premise of the book was kind of cool.

WHAT DID YOU THINK ABOUT THE ORIGINAL COVER?

I personally didn't like it, but I figured it worked well with the title and the story. I didn't think the cover popped—oh, sorry about using the P word—and I thought it might get lost in a bookstore. I think every project needs careful thought about where it's going to be placed and how you can make it stand out.

THAT'S SOMETHING THAT TENDS TO GET OVERLOOKED.

I sometimes buy books solely based on the cover. I figured that if I made it bold with bright colors, it would entice the reader to pick it up and see what the book is about. Really, the overall concept is finding a way to make this book jump out from the sea of other books.

HOW WAS THE OVERALL EXPERIENCE?

It was challenging, because I originally did some complex art pieces for the cover. Then I realized I needed to go simple and bold as opposed to getting all artsy.

• • •

DESIGNER: Peleg Top **STUDIO:** Top Design Studio **CITY:** Los Angeles, California **URL:** www.topdesign.com

MW: WHAT IS IT ABOUT THIS PIECE THAT WAS INTERESTING TO YOU?

PT: I've never really designed a book cover before, and since I'd already read this book, I felt it would be an interesting challenge. Plus, the original book was written in my native language, Hebrew.

SOUNDS LIKE A GOOD MATCH. DID YOU LIKE THE ORIGINAL DESIGN, OR DID YOU THINK IT NEEDED SOME HELP?

Since I read the book a few years ago I knew what the story was about. I didn't feel that the original cover image reflected the story or the tone of the writing.

CAN YOU EXPLAIN YOUR CONCEPT?

The concept was based entirely on the story: a man and a woman who are facing difficulties in their marriage due to the husband's handicap. It's a dark story, full of deep human emotions. The disconnection between the husband and wife reminded me of two puzzle pieces that simply don't fit. I felt this image was a strong representation of the mood of the book.

YOUR FIRST BOOK COVER... HOW WAS THE EXPERIENCE?

It was an easier design process than I thought, once I became inspired by the story. It was fun to design without a client to answer to. But then again, I am my own worst client.

• • •

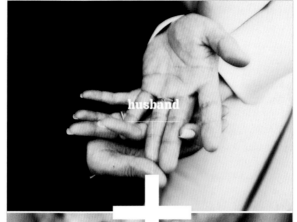

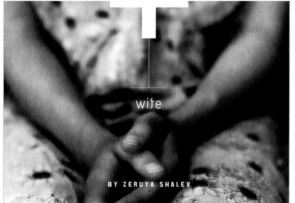

DESIGNER: Nessim Higson STUDIO: I Am Always Hungry CITY: Birmingham, Alabama URL: www.iamalwayshungry.com
SOFTWARE PROGRAMS: Photoshop, Illustrator, good ole' pencil and paper

MW: WHY DID YOU CHOOSE THIS PARTICULAR PIECE TO REDESIGN?

NH: The title drew me in immediately. Also, I haven't been given the opportunity to do many book jacket designs, so that attracted me as well. After reading the original concept behind the design, I had many gut reactions and basically went to town.

DID YOU LIKE THE ORIGINAL DESIGN, OR DID YOU THINK IT COULD USE SOME HELP?

Honestly? Clients can be restrictive, and this may have been a case where this happened. I think that the concept had so much leeway that many solutions could have been applied successfully. Choosing the right one is where differing opinions may arise.

HOW DID YOU GET STARTED ON THE REDESIGN?

I found an image of a newlywed couple holding hands. It's a very soft and intimate moment that I thought contrasts well visually with the hands of a woman that is alone. All in all, I feel like the execution solves the problem very well.

SOUNDS LIKE YOU DIDN'T HAVE ANY TROUBLE COMING UP WITH DIFFERENT CONCEPTS.

It's funny, the contrasts in my various designs were very different. I cranked on this project, and came up with as many as seven or eight executions. This subject matter allowed so much room for maneuvering that it was hard to strike out.

• • •

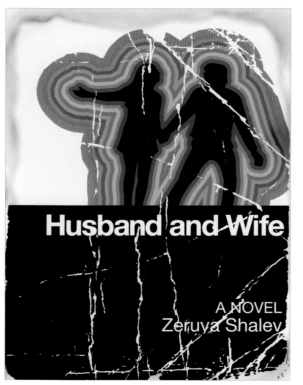

DESIGNER: Shawn Wolfe STUDIO: Shawn Wolfe Design CITY: Seattle, Washington URL: www.shawnwolfe.com SOFTWARE PROGRAMS: FreeHand, Photoshop TYPEFACE: Helvetica

MW: WHY DID YOU CHOOSE THIS PIECE TO WORK WITH?

SW: It was ambiguous, which I personally don't mind at all, but ambiguous can always use some help. Other than the straightforward presentation of a photograph, this book cover was more or less undesigned. Sometimes less design is better. Sometimes no design at all is ideal. But in this case, it certainly leaves the way wide open to try something more interesting.

WHAT WAS YOUR CONCEPT FOR THIS REDESIGN?

In this story, the wife is a social worker who works with young mothers and their children, but she's inattentive to the lives of her own family. Her active husband is a hiking guide who periodically leaves the family for long, solitary jaunts into nature. One morning he's suddenly unable to move his legs. She wrestles over whether to take him to the hospital, as she thinks back over the years of their relationship, from its vibrant beginnings through their currently sour marriage. The redesign looks like a field guide or a handbook or some brochure you'd have picked up at the free clinic in 1979. And more importantly, it looks like it's been used and abused, like a Kelley Blue Book that's been thumbed through countless times.

HOW WAS THE OVERALL EXPERIENCE?

Choosing your assignment…it's a peculiar situation to be in as a designer, isn't it? This was simply one of the pieces where there was a distinct problem to solve.

• • •

MW: WHAT LED YOU TO CHOOSE THIS PARTICULAR PIECE TO REDESIGN?

TS: I was attracted by the white space. It made me feel like drawing right there on the cover.

DID YOU LIKE THE ORIGINAL DESIGN?

I really liked the sense of the soft sheets, but the subject can be approached in other ways too. There's never one right answer in design matters.

EXACTLY. SO, WHAT WAS YOUR CONCEPT FOR THIS REDESIGN?

It was to have fun or go home!

ALWAYS A GOOD CONCEPT…IS IT EVER DIFFICULT TO FOLLOW THROUGH WITH THAT?

Yes, it's quite hard to have fun when you put pressure on yourself by saying, "Now you must have fun with this. Have fun now. Hey. Listen up now! Have fun or die!"

YOUR REDESIGN IS SO LOOSE AND FREE FLOWING. HOW DID YOU GO ABOUT YOUR GENERAL DESIGN PROCESS?

First, it's lot of thinking, and then forgetting, and then thinking again. Then, it's going through things and looking around. Then, some more thinking. If you have sketched something while doing all this…good! You can use that. But the final structure, the final layout, is often done with the machine. The idea gets its final form then.

Sometimes it works this way; sometimes it's the other way around. But this time it happened like this.

. . .

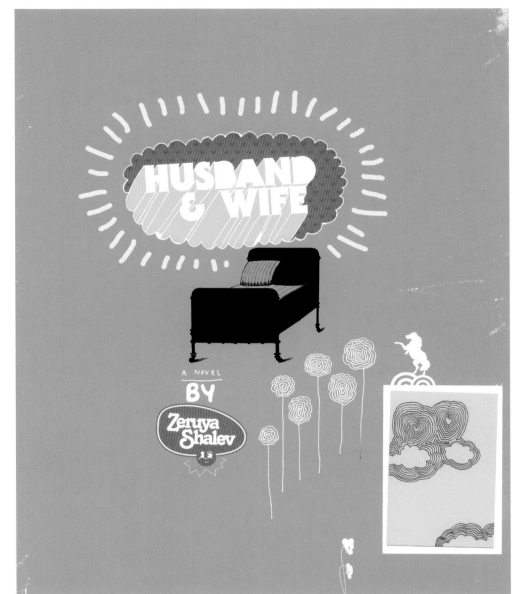

DESIGNER: Teemu Suviala **STUDIO:** Syrup Helsinki **CITY:** Helsinki, Finland **URLS:** www.syruphelsinki.com, www.syrupnyc.com
SOFTWARE PROGRAMS: FreeHand, Photoshop **TYPEFACES:** Serif Gothic, Tango

fig.1

husband + wife
a novel

○ Birth

● Ice Cream
○ Marriage
● Child Birth
● Love
○ ○
● Courtship
● Retirement
● First Crush
● College
○
● Graduation
● Grad School
● Camp
● Loss of Virginity
● Buying A House
○
● First step
● Driver's License
○
● First Raise
○ ○
○
○ ○
○
● Dog Bite
○
● Student Loan
○
● Bed-wetting
● Bills
● 2nd Mortgage
● Rejection
○
● Adultery
● Bee Sting
● Car Accident
● Divorce
● Braces
● Laid Off
○ ● Bed-wetting
● Broken Arm
○
● Cancer
○
● Loss of a Parent
○ Death

by
zeruya shalev

DESIGNER: Irene Ng **STUDIO:** Plinko **CITY:** San Francisco, California **URL:** www.plinko.com **SOFTWARE PROGRAMS:** Illustrator, Photoshop **TYPEFACES:** Helvetica Neue, Garamond

MW: WHAT DID YOU THINK ABOUT THE ORIGINAL BOOK COVER?

IN: I liked it. It's a very classic photographic solution that's been updated with a modern feel. If there was one aspect that made me want to redesign it, it's that I felt like the original design reflected more about the title rather than the turmoil that's within the story. But of course with a topic as wide open as marriage, there's a lot of possibilities.

I WAS PRETTY CURIOUS TO SEE WHAT YOU WERE GOING TO COME UP WITH FOR THE REDESIGN, SEEING AS HOW WE'RE MARRIED TO EACH OTHER.

At first, I thought of creating a scrapbook feel by using images such as marriage certificates and receipts from daily life. As I began to delve into the more mundane side of marriage, I somehow ended up with this. I was hoping that when people look closer at the redesign, it triggers some emotion or reaction. Deciding upon which life milestones would spark something in the viewer was really a challenge; it was difficult paring down to a small list of things.

SEEMS LIKE YOU HAVE A LOT OF EXPERIENCE WITH THE MUNDANE SIDE OF MARRIAGE…ARE YOU TRYING TO TELL ME SOMETHING?

Not to worry, it's nothing personal. The original design felt really intimate, so I went in a completely opposite direction. I wanted to create something that didn't spark too much emotion at first glance. The idea was to have a more clinical and cold appearance and be a bit of a mystery, where the viewer has to do some searching.

. . .

DON'T GO SOLO
AIGA POSTER

MW: WHAT WAS THE DESIGN CONCEPT FOR "DON'T GO SOLO?"

NH: It's to illustrate the necessity of joining the AIGA (American Institute of Graphic Arts) and become part of an organization, to not wander the streets alone. I also threw in a subtle hip-hop reference via the b-boy.

DID YOU TRY ANY OTHER APPROACHES WITH THIS PIECE?

Originally, I created this poster in a horizontal format and in various colors, as part of a series. It was completely haphazard that I looked at it on its side and realized it was far more successful that way.

WHAT WERE THE OTHER POSTERS IN THE SERIES LIKE?

There were three posters in the series along the same lines. I had originally designed the pieces to be as simple as possible, utilizing shape and color as major signifiers to the eye. One of the other pieces featured a man in a tree looking over to the letters AIGA with the tag line of "reach further." Another featured a man and a woman sitting down. The man read the paper, while the woman looked straight ahead to the viewer. The copy read "one word—educate."

THE VECTOR IMAGES AT THE TOP OF THE PAGE ARE QUITE UNUSUAL. HOW DO YOU GO ABOUT CREATING THEM?

Yikes! Um, I really free form them. I do most of my vector illustrations in Illustrator and generally just draw the forms off the top of my head. In this case, I sketched out a rough of where the form was going to land and went from there.

WHAT WAS THE BIGGEST CHALLENGE WITH THIS PIECE?

Having no limitations.

YEP, A BLANK SCREEN IS ALWAYS THE HARDEST PLACE TO START. ANY GUIDELINES YOU HAD TO STAY WITHIN?

Big, Big and Big. Size was of great importance, since we wanted to be in full view.

. . .

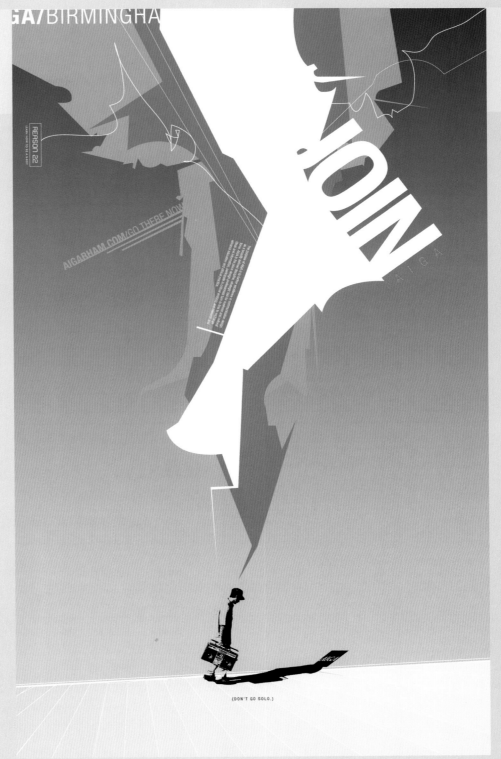

{DON'T GO SOLO.}

DESIGNER: Nessim Higson **STUDIO:** I Am Always Hungry **CITY:** Birmingham, Alabama **URL:** www.iamalwayshungry.com
YEAR: 2002 **SIZE:** 20" x 30" (51 x 76 cm) **SOFTWARE PROGRAM:** Illustrator **TYPEFACES:** Knockout (HTF), UNDA (t26), Helvetica Neue Condensed

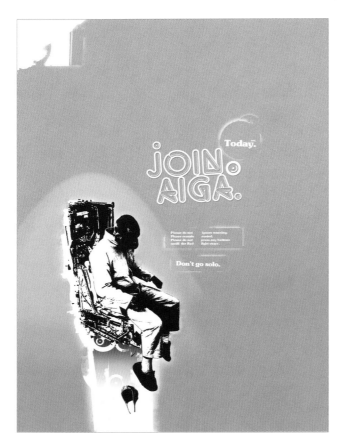

DESIGNER: Dave Correia **STUDIO:** Conduit **CITY:** Cape Town, South Africa **URL:** www.conduit.co.za **SOFTWARE PROGRAMS:** Photoshop, FreeHand **TYPEFACES:** Client, Subway

MW: WHY DID YOU CHOOSE THIS PIECE TO REDESIGN?

DC: I had an idea of an image that I thought suited the idea I had upon seeing the initial design.

WHAT MESSAGE WERE YOU TRYING TO SEND WITH YOUR REDESIGN?

It was just the fact that it's never too late to save yourself.

I THINK I SEE TWO IMAGES HERE: A MAN BLASTING OFF INTO SPACE AND A PRISONER BEING EXECUTED. CAN YOU TALK ABOUT THE MAIN IMAGE A BIT MORE AND HOW IT RELATES TO THE MESSAGE OF "DON'T GO SOLO?"

The image was an overdramatization to attract others who feel the need to escape the poor visuals and empty concepts. This is targeted to those who want to fulfill their careers and lives within a creative, design-oriented environment. The image of the man in the ejection-seat is a visual representation of that escape. The poster was designed with the intention of running through a series of images.

NICE JOB. HOW WAS THE OVERALL REDESIGN EXPERIENCE?

It was an easy enough experience. I had a predetermined idea and look that I just followed into execution. Simple concept, simple life.

• • •

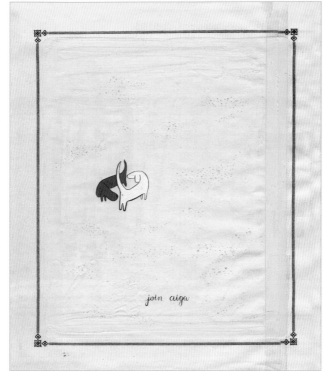

DESIGNER: Rachell Sumpter **CITY:** Los Angeles, California **URL:** www.rachellsumpter.com

MW: SO, WHY DID YOU CHOOSE THIS PARTICULAR PIECE TO REDESIGN?

RS: Because it's so different from anything I would have done.

HOW WAS IT DIFFERENT—THE STYLE OF ILLUSTRATION OR THE ACTUAL DESIGN BRIEF?

It was the way the artist communicated the idea.

HOW DID YOU APPROACH THE CONCEPT?

One of the greatest benefits of AIGA membership is the chance to meet other designers, and I chose to show that newfound interaction rather than someone who longed for it. When interpreting the world in illustrations, I like to create a sense of a reality more real than that of our memories, still leaving room for a narrative to form in the viewer's mind. I like to get people thinking, creating and projecting their own relationship with the image.

IT'S FUNNY, PEOPLE OUTSIDE THE PROFESSION OFTEN THINK THAT DESIGNERS HAVE SUCH AN EXCITING AND SOCIAL LIFESTYLE. WHAT'S BEEN YOUR EXPERIENCE?

I ride my dirt bike to the stars, skip rocks from Venus to Mars, swim with sirens in the Milky Way and carve love letters into the sides of rockets at least once a day. Sometimes my hooligan friends join in, sometimes I'm a loner, but calling it exciting would be kinda subjective, so I leave that up to you.

• • •

HOW DID YOU APPROACH THIS REDESIGN?

Hmmm, I was thinking of the feelings you would get after you joined a creative organization like AIGA. Then, words like "grow," "ignite," "participate" and "idea" popped into my mind, so the overwhelming feeling of getting one's juices flowing led to the design.

See the figure in the corner, faced with all of the lushness and growth and warmth of being a part of something bigger than herself? She sees the mess and beauty of it all.

YOUR WORK IS ALWAYS SO COMPLEX AND LAYERED. HOW DO YOU KNOW WHEN YOU'RE FINISHED? DO YOU EVER PUT TOO MANY THINGS ONTO A PAGE AND HAVE TO START STRIPPING IT DOWN?

It's a feeling, like when you know its going to rain. I usually don't strip anything out of pictures; I just keep adding adding and adding. Hmmm, is less more, or is more more?

I'M ALWAYS AMAZED BY THE VISUALS YOU COME UP WITH. WHAT'S YOUR FAVORITE SECRET SOURCE FOR FINDING IMAGERY?

I am always saving little bits and pieces of paper from everywhere: magazines, newspapers, crumpled pieces of paper I find by the copy machine, little bits of this and that, stuff on the floor, whatever.

HOW WAS THE PROJECT FOR YOU?

Once I got started, it was fun. The ideas were so close to the heart that I just had to make a mess and let them out.

AND FINALLY, I'VE GOT TO ASK: WHERE DID THE CAPITAL A IN YOUR NAME COME FROM?

My crazy love affair with capital letters.

• • •

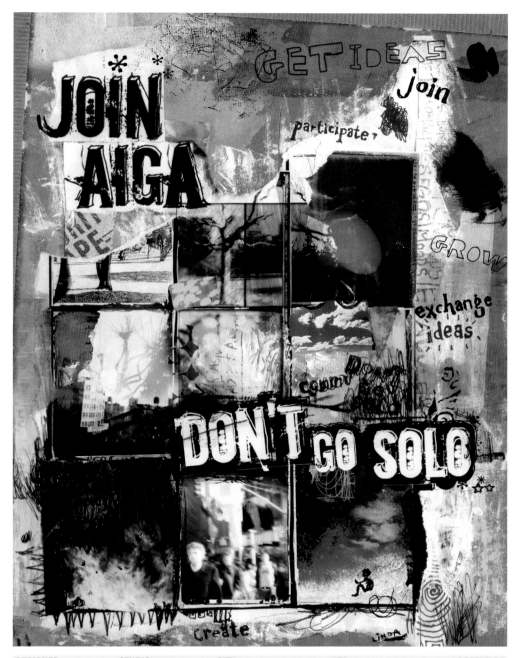

DESIGNER: lindA zacks **STUDIO:** extra-oompH **CITY:** New York, New York **URL:** www.extra-oomph.com **SOFTWARE PROGRAM:** Photoshop

DESIGNERS: Sebastian Puiggros, Chema Longobardo, Federico Joselevich, Elisa Lee **STUDIO:** area3 **CITY:** Barcelona, Spain **URL:** www.area3.net/barcelona **SOFTWARE PROGRAM:** FreeHand

MW: SO, WHY DID YOU CHOOSE "DON'T GO SOLO" TO REDESIGN?

area3: Actually, it wasn't our first choice. We included it in our selections because of its abstract shapes.

DID YOU ALWAYS PLAN TO TURN THE DESIGN INTO SOMETHING TOTALLY DIFFERENT?

Yes. By extrapolating the abstract forms from the original design, we explored the figurative forms that were suggested to us.

NOT ONLY DO YOU EXPLORE NEW FORMS, YOU GO INTO AMAZING DETAIL WITH CHARACTERS AND OBJECTS THAT ARE SO TINY THEY'RE DIFFICULT TO SEE. DO YOU OFTEN HIDE LITTLE THINGS IN YOUR DESIGNS?

The fine detail in the drawings may not be perceived by all people, but they are there for the ones who look! We love to be surprised by the discovery of hidden or obscure details in designs. In the same way, we like to offer this surprise to other people. We don't work with fine detail for superficial reasons. When used, it is integral to the concept or the portrayal of realism.

DID YOU SKETCH OUT AN ENTIRE PLAN FOR HOW THE BEACH AREA WOULD LOOK, OR DID YOU JUST GRADUALLY ADD NEW OBJECTS?

We had a lot of fun designing the space. What we saw first was a beach seen from the sky. Then gradually, as urban planners, we designed the infrastructure: signage, street lighting, facilities, waste management system, etc. Last but not least, we designed the happy beachgoers. If you look closely, they are all quite content.

• • •

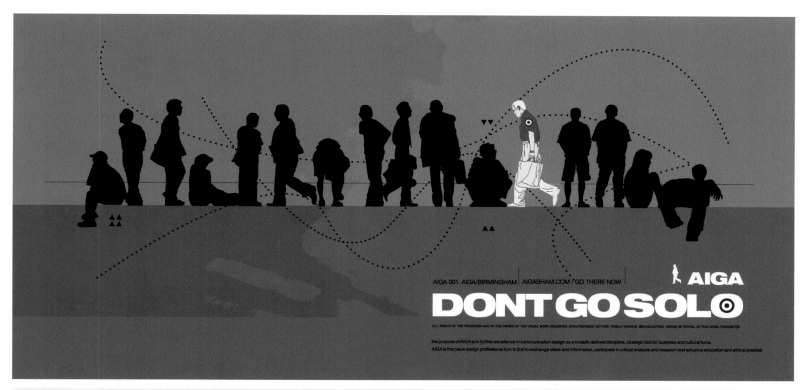

DESIGNER: Jon Black **STUDIO:** Magnetstudio **CITY:** London, England **URLS:** www.magnetstudio.net, www.gangrule.com **SOFTWARE PROGRAMS:** Photoshop, FreeHand **TYPEFACE:** Helvetica

FEEDBACK FROM THE ORIGINAL DESIGNER:
NESSIM HIGSON

WHAT'S YOUR REACTION TO EACH REDESIGN?
Conduit Studios: Explosive
Rachell Sumpter: Elegant
extra-oompH: Natural
area3: Amazing
Magnetstudio: True

THERE ARE SOME REALLY STRONG DESIGNS HERE— DO YOU HAVE A FAVORITE?
The island by area3 blew me away. The thoughtfulness and attention to detail is superior to anything I have seen recently. All of the redesigns were well executed, but this takes the cake. I need to get a copy of this for my wall.

ANY OF THEM SURPRISE YOU?
The dogs piece by Rachell Sumpter—it's brilliant! The composition, concept, and simplicity of this piece. It made me chuckle because it's very true to a degree. Networking with other creatives can be a laborious process. It takes a little time, stroking each other's egos, feeling each other out, doing a little sniffing here and there. In many respects, the process is very similar to the one that dogs do when they first meet each other. A very good analogy if I do say so myself.

MW: WHAT ATTRACTED YOU TO THIS PARTICULAR PIECE?
JB: The original design is excellent, and the subject really interested me. I didn't want to choose a piece to improve or help, but rather reinterpret. The original design was very complete; to try and redesign it would only have spoiled it.

WHAT WAS YOUR CONCEPT FOR THIS REDESIGN?
The idea was to highlight the need for interaction and communication amongst designers. It's a visualization of being alone but being surrounded at the same time, often how freelancers can feel, even when working in a busy city.

THE SILHOUETTES OF ALL THE DIFFERENT PEOPLE IN THE DESIGN ARE GREAT. WITHOUT SEEING ANY FACES, YOU'VE STILL CONVEYED SUCH CHARACTERS. HOW DID YOU GO ABOUT CREATING THOSE?
All the outlines are based on characters that architects use to visualize their work. It was important that the people had a metropolitan feel.

IT'S FUNNY, PEOPLE OUTSIDE THE PROFESSION OFTEN THINK THAT DESIGNERS HAVE SUCH AN EXCITING AND SOCIAL LIFESTYLE. WHAT'S BEEN YOUR EXPERIENCE?
Working within the independent music industry has been a very unique experience, but socially, this has nothing to do with the design community. My first job was with an underground dance label in London in 1991, and it was baptism by fire. The learning curve for me as a college-leaver was hard due to the crazy working conditions. Modern times feel quite calm in comparison, but I still believe that pressure is the best environment for music designers as it produces more natural, spontaneous results.

• • •

SPARKY
DRINK
PACKAGING

MW: DESIGNING A SOFT DRINK CAN SEEMS LIKE A PRETTY GREAT PROJECT. WHAT WAS YOUR PRIMARY INSPIRATION FOR THE SPARKY CHARACTER DESIGN?

S: Really, there is no specific inspiration, just a lot of nostalgia. The actual drop is like something you've seen in Japan, and the rest of the design is like something you drank when you were in Italy as a kid or a chocolate bar your dad brought back for you from the U.S.

WHAT ENDED UP BEING THE BIGGEST CHALLENGE IN CREATING THE DESIGN?

Trying to anticipate the effect that the round shape would have, and working with metallic colors.

WHAT WERE THE MAJOR DIFFERENCES IN DESIGNING FOR AN ACTUAL OBJECT?

It is nice to be able to hold it in your hand. The problem and the challenge is that on the curved surface, the image is distorted as it goes around the shape of the can, so you have to make all sort of compensations on the original design to make it work on the can.

WHERE DID THE NAME COME FROM?

First, we came up with the idea that liquid is a number of drops. We suggested that the can would say "more than 1,000 drops in every can" or something silly like that. Then, we thought that if all the drops were alive, they could have some kind of leader, who naturally would be the King of Drops.

THAT'S PRETTY GREAT. OF COURSE, NOW EVERY TIME I'M HAVING A SODA I'LL THINK ABOUT THAT. DID YOU EVER GET TO TASTE THE DRINK?

We never tasted the drink until the design was finished. It's a fresh lime flavor, kind of like 7up.

• • •

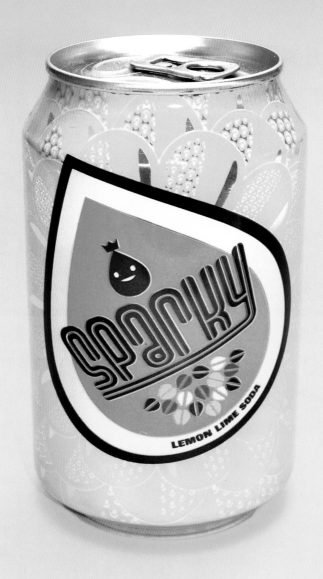

STUDIO: Sweden **CITY:** Stockholm, Sweden **URL:** www.swedengraphics.com **YEAR:** 2000 **SIZE:** soda can size **SOFTWARE PROGRAM:** Illustrator

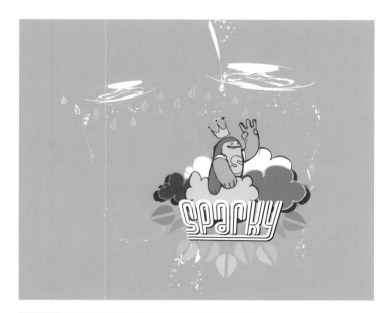

DESIGNER: Duncan Jago STUDIO: Mr. Jago CITY: London, England URL: www.mrjago.com

MW: WHAT APPEALED TO YOU ABOUT THIS DESIGN?

DJ: I really liked the name of the product. I think King Sparky would be a pretty cool fella. Plus, I liked the original design, especially the little droplet logo.

YOUR DESIGN LOOKS LIKE A WELCOMING CEREMONY. WHAT'S THE STORY BEHIND THAT?

I imagined King Sparky to be visiting us from his home planet, bringing the choicest juices with him.

NICE ONE. HOW DO YOU GO ABOUT ON YOUR GENERAL DESIGN PROCESS? IS IT STRAIGHT TO THE MACHINE, OR DO YOU DO A LOT OF HAND SKETCHING BEFOREHAND?

Most of the initial stuff is scribbled in the doodle book, and then when I see something I like, I feed it into the Mac and jumble it about until it makes me happy.

GLAD YOU BROUGHT UP YOUR DOODLE BOOK. WHAT'S THE BIGGEST DIFFER-ENCE BETWEEN WORKING ON YOUR GALLERY ARTWORK AND MAC-BASED DESIGN?

It's easier to rectify mistakes on the Mac, but it lacks the fluid motion of the brush and the satisfaction of mixing colors. I have more fun on canvas.

WAS IT AN EASIER OR HARDER EXPERIENCE THAN YOU THOUGHT IT WOULD BE?

It was harder. I couldn't believe how hard it was to keep the image juicy. Certain shapes and color combinations made some of the preliminary designs look like you were about to drink a can full of vegetable juice rather than a sparkly lemon-lime combo.

• • •

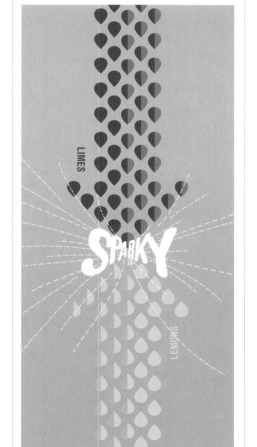

DESIGNERS: Keith Tamashiro and Gabriela Lopez STUDIO: Soap Design Co. CITY: Los Angeles, California URL: www.soapdesign.com
SOFTWARE PROGRAMS: Photoshop, Illustrator, Quark XPress TYPEFACE: Helvetica Rounded Bold Condensed

MW: I WOULDN'T HAVE GUESSED THAT THIS PROJECT WOULD APPEAL TO YOU. WHY DID YOU CHOOSE THIS PIECE TO REDESIGN?

KT: I've never had, and it's unlikely that I'll ever have, the opportunity to design a soda package.

THAT MAKES SENSE. YOUR SPARKY POSTER DESIGN USES A LOT OF ELEMENTS FROM THE ORIGINAL. WHAT DID YOU THINK ABOUT THE SPARKY CAN?

I liked the original design, which is why I kept the icons and colors intact. The only thing that bothered me was that a soft drink was created for and targeted at kids.

WHAT WAS YOUR CONCEPT FOR THE REDESIGN?

Just give me a reason to use arrows. If they can make a kid's soda, there should be one for adults too.

WAS IT AN EASIER OR HARDER EXPERIENCE THAN YOU THOUGHT IT WOULD BE?

A bit difficult, because I didn't feel there was anything wrong with the original design. Rather than go in a totally dif-ferent direction, I thought I would enjoy it more if I just played with the existing elements. Time constraints and pro-crastination were also a problem. (But those extensions you gave us helped!)

• • •

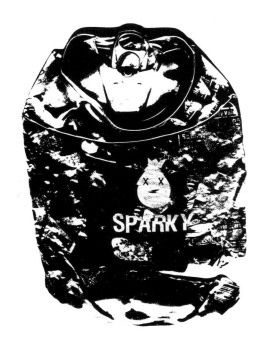

DESIGNER: Steve Carsella STUDIO: vibranium+co. CITY: Orlando, Florida URL: www.vibranium.com SOFTWARE PROGRAMS: Illustrator, Photoshop TYPEFACE: Dirtyhouse (House Industries)

MW: DID YOU LIKE THE ORIGINAL DESIGN, OR DID YOU THINK IT COULD USE HELP?

SC: I think it's great; much more enjoyable as a whole than most American designs. It was cute, fun and minimal. At some point, it also occurred to me: Soda? For kids? I thought maybe I should make some grandiose statement about kids and weight gain and sugar intake…then I just thought "nah."

THAT'S PROBABLY A GOOD IDEA. EVEN THOUGH I'M CURIOUS TO SEE SOME DESIGNS ABOUT CAVITIES AND TUBBY TODDLERS, I'M NOT SURE ANYONE ELSE IS. WHAT DID YOU TRY TO ACCOMPLISH WITH THIS REDESIGN?

I wanted to make it more minimal. Wouldn't it be great if you could buy a product with no name on it, yet you know what it is?

WAS IT AN EASIER OR HARDER EXPERIENCE THAN YOU THOUGHT IT WOULD BE?

This thing kicked my ass! That little floating drop made its way into my dreams. Man, there is a reason that I took a soda can, bashed it, Xeroxed it and added a "Sparky" with x-ed eyes. It haunted me. I found I was depending on the "normal" stuff for this one—market research, demographics, experimental marketing figures, you know that kind of crap. I initially wanted to just do something fun but ended up torturing myself until I came up with something "real." Not sure I even did, but it was fun stomping on a comped-up can!

• • •

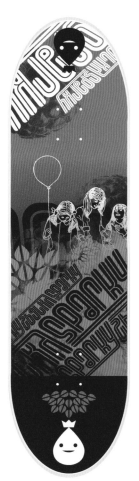

DESIGNER: Todd Baldwin STUDIO: PigeonHole Design CITY: Washington, DC URL: www.pigeonholedesign.com SOFTWARE PROGRAMS: Photoshop, FreeHand

MW: WHY DID YOU CHOOSE THIS PARTICULAR PIECE TO REDESIGN?

TB: I was drawn to the fun, lighthearted approach. The original is solid.

SOUNDS LIKE YOU LIKED THE ORIGINAL SPARKY CAN. HOW DO YOU GO ABOUT APPROACHING A DESIGN THAT YOU REALLY LIKE?

Without changing the type and illustration, I wanted to show a completely different application.

I SEEM TO REMEMBER THIS WAS A SOFT DRINK FOR KIDS…WHAT HAPPENED?

What if Sparky was a new skate company? What would the first pro-model deck look like?

PROBABLY A LOT LIKE THIS. WAS IT AN EASIER OR HARDER EXPERIENCE THAN YOU THOUGHT IT WOULD BE?

It was difficult to get started. Once I changed the vehicle from a soda can to a skateboard deck, the experience was loose and fun.

• • •

MW: WHAT DID YOU THINK OF THE ORIGINAL SPARKY CAN?

EJ: I did like some aspects of the design. It had a decidedly "Japanese pop" feel to it, almost like something from a futuristic movie where over-the-top brands smother the masses in neon advertisements atop skyscrapers. Although it had that feel, the execution of the overall presentation was lacking depth and description. The first thing that came to me was "Sparky…OK. What is Sparky going to do for me?" It needed more of a story.

I'M INTRIGUED. SO, WHAT WAS YOUR STORY?

I wanted to take this advertisement to the next level of ultra-strange pop consumerism, so I created my own 3-D version of the can. I rendered a 3-D Sparky can in Cinema and then duplicated it several times to give the sense of "saturating the market." Every great soul-less advertisement has a tag line associated with it, so I also attempted to target some ridiculously strange corner of society and decided upon singling out "small humans." That ultimately led to my very sarcastic spin on the ad: "Extensive research shows that 3 in 4 small humans prefer Sparky."

WAS IT MORE FUN OR LESS FUN THAN YOU THOUGHT IT WOULD BE? WHY?

The process seemed easy at first, until I decided that I wanted to replicate the design of the can in 3-D. But overall, it ended up becoming the most enjoyable part of the process, along with the satisfaction of making fun of the drab advertisements that cross our eyes' path day in and day out. The most difficult part was trying to avoid adding too much detail. Advertisements are typically very simplistic, and I didn't want to overdesign the piece.

•••

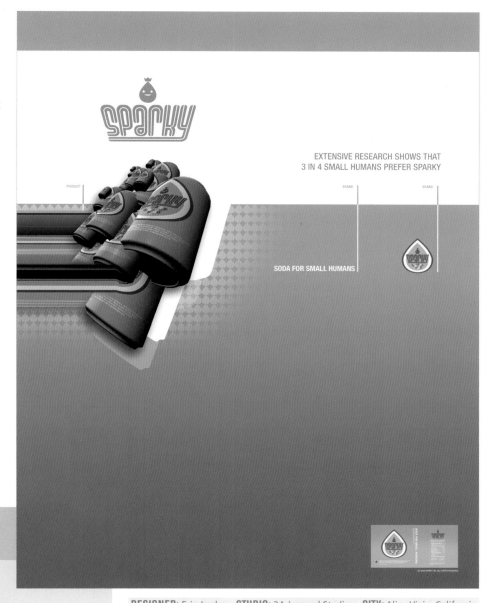

PRODUCT

EXTENSIVE RESEARCH SHOWS THAT
3 IN 4 SMALL HUMANS PREFER SPARKY

BRAND BRAND

SODA FOR SMALL HUMANS

FEEDBACK FROM THE ORIGINAL DESIGN FIRM:
SWEDEN

LOOKING AT THE REDESIGNS, WHAT'S YOUR INITIAL REACTION TO EACH ONE IN ONE WORD?
Soap Design Co.: Graphique
Mr. Jago: Friendly
vibranium+co: Subversive
PigeonHole Design: Street
2Advanced: Rendered

THERE'S A WHOLE LOT OF DIFFERENT APPROACHES HERE—DO YOU HAVE A FAVORITE?
I think Mr. Jago's. I like the shape of his character's raised hand a lot. But is he a frog now, or what? It doesn't matter; I think it looks great. Vibranium's smashed can is very nice in its graphic simplicity but feels more predictable for some reason, whereas the piece by Mr. Jago feels more from the heart.

WHICH SURPRISES YOU? WHY?
The skateboard design by PigeonHole surprised me a bit, but I guess it makes perfect sense.

OVERALL, WHAT DO YOU THINK OF ALL THE REDESIGNS?
They are pretty cool. As always in these situations, they say more about the designers' ambitions than their designing skills, but it is an awesome effort.

DESIGNER: Eric Jordan **STUDIO:** 2Advanced Studios **CITY:** Aliso Viejo, California
URL: www.2advanced.com **SOFTWARE PROGRAMS:** Photoshop, Maxon Cinema 4D
TYPEFACE: Helvetica Condensed

RELAX
ILLUSTRATION

MW: WHAT WAS THE GRAND INSPIRATION FOR THIS DESIGN?

A&FW: It was watching Shriners ride their little bikes at the Brighton Apple Festival parade after watching a little too much CNN the night before.

SO, DO YOU KNOW MUCH ABOUT THE SHRINERS? THEY'RE A PRETTY MYSTERIOUS BUNCH WITH THE TINY CARS AND ALL.

How can you not love Shriners? Not only are they visual dynamite, but they build hospitals and entertain us at parades.

I'M LEARNING ALREADY. FOR A PIECE LIKE THIS, WHAT'S THE FIRST THING YOU DO AT THE MACHINE?

For recycling purposes, we started an image collection to which we add photos and illustrations on a daily basis. This is the first folder we open when we start a project.

DID YOU ATTEMPT ANY OTHER APPROACHES WITH THIS PIECE?

Hard to say. All the elements in this picture had been floating around the office for a while. Some of them came from other projects; some of them are new. The final piece just came together one day.

A LOT HAS HAPPENED SINCE THIS PIECE WAS FIRST DESIGNED. DO YOU LOOK AT IT NOW AND SEE ANY NEW MEANINGS IN IT?

We could say that after witnessing imperialism and fervent patriotism erode free speech, the caption "Relax" seems a little more menacing. Really, though, it's just a goofy illustration disguised as an anti-war message.

"RELAX" WORKS REALLY WELL AS A ONE-WORD CAPTION. DID YOU PLAY AROUND WITH ANY OTHER TEXT, OR WAS IT ALWAYS "RELAX"?

The word came from a T-shirt we designed for OK47 called "Frankie Says," where Frankenstein was getting ready to strangle the viewer while urging him to relax. The same sentiment applied here.

. . .

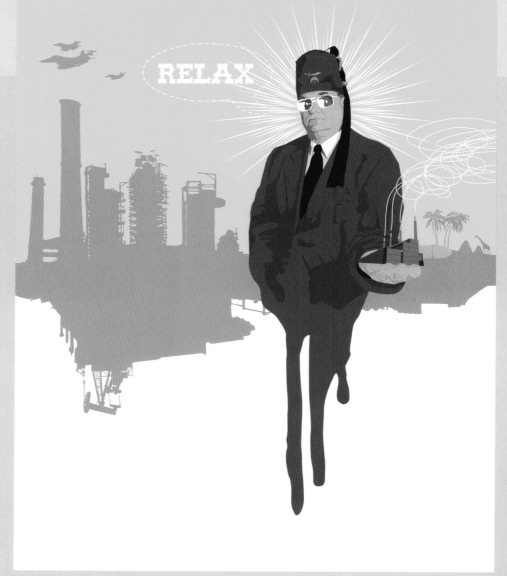

DESIGNERS: Alex and Felix Wittholz **STUDIO:** Helios Design Laboratories **CITY:** Toronto, Canada **URLS:** www.heliozilla.com, www.ok47.com, www.okflavor.com **YEAR:** 2002 **SIZE:** 12" x 18" (30 x 46 cm) **SOFTWARE PROGRAMS:** Illustrator, Photoshop, Redneck Rampage **TYPEFACE:** Western

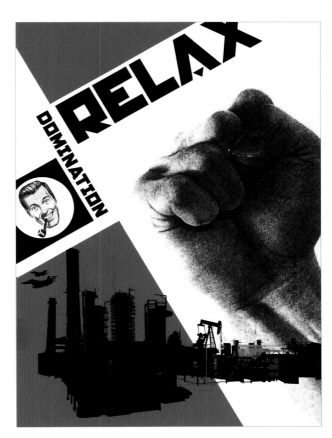

DESIGNER: Justin Wright **ART DIRECTORS:** Ed Templeton and Hamish Makgill **STUDIO:** Red Design **CITY:** Brighton, England **URL:** www.red-design.co.uk **SOFTWARE PROGRAMS:** FreeHand, Photoshop **TYPEFACE:** Constructivist (p22 Type Foundry)

MW: WHY "RELAX?"

RD: I chose this design because it seemed particularly relevant in today's political climate. I like the use of irony, with the title being at complete odds with the imagery.

DID YOU LIKE THE ORIGINAL DESIGN, OR DID YOU THINK IT NEEDED SOME HELP?

I really liked the original concept but thought a different visual approach might give it more impact.

YOUR DESIGN SHIFTS THE MESSAGE INTO AN ENTIRELY DIFFERENT ERA. CAN YOU DESCRIBE YOUR CONCEPT A BIT MORE?

I used a constructivist/revolutionary visual language to accentuate the political meaning of the piece; however, I wanted to broaden the context by replacing the obvious Middle Eastern references with a more generic global meaning.

AMONG YOUR DISTINCTLY RUSSIAN AESTHETIC HERE, YOU'VE MANAGED TO INSERT THE GOOD REVEREND BOB DOBBS. WHY'D YOU CHOOSE TO INCLUDE HIM?

As the piece is definitely ironic, I thought the counterculture superhero Mr. Bob Dobbs would like to get a look in. There's quite a strong slacker Church of the SubGenius movement here in Brighton, so we try to include a sneaky Bob whenever we can in our work.

• • •

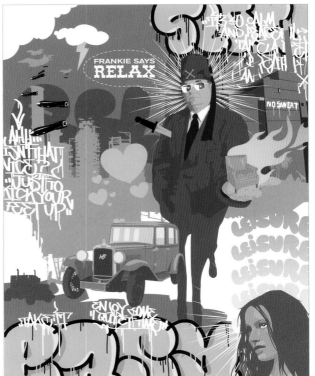

DESIGNER: Ryan Clark **STUDIO:** Asterik Studio **CITY:** Seattle, Washington **URL:** www.asterikstudio.com **SOFTWARE PROGRAM:** Adobe Illustrator

MW: WHY DID THIS PIECE STAND OUT TO YOU?

RC: For one, I was attracted to the vector aspect of it. I love working in Illustrator. I like the pseudograffiti look that it had with the drips and all. I wanted to take the graffiti thing a bit further with the redesign. I did graffiti for years, and these days I rarely get the chance to explore that direction with projects, so I jump on it whenever I get the chance.

DID YOU LIKE THE ORIGINAL, OR DID YOU JUST WANT TO COVER IT UP WITH YOUR OWN WORK?

I did like the original design. It was simple and to the point. I think originally it had a nice clean look and did its job well, but I wanted to clutter it a bit and cause a little confusion.

WHAT APPROACH DID YOU TAKE WITH THIS REDESIGN?

I basically wanted to deface it more than redesign it. That made it more fun. I wanted to just keep adding and adding until it was just jumbled with things to look at. When I see something cluttered like this, I'll stop and make sure I see every little piece that went into it.

WAS THE EXPERIENCE EASY OR HARD?

It was actually easier than I thought it might be. When I knew what I wanted to do with it, I just ran with it and didn't look back. I wanted to give it a raw feeling, like images were effortlessly thrown onto the original piece carelessly—and at the same time, I wanted there to be an element of balance and clarity to it.

• • •

4000BC Sumerian culture flourishs in the land between the Tigris and Euphrates Rivers, called the Fertile Crescent
1535 Ottomans conquer Baghdad from the Safavids
1776 American colonies gain independance from Britain
1895 Invention of combustion engine
1901 Spindletop gusher heralds the birth of the Texas oil industry, Gulf and Texaco formed
1908 Oil discovered in Persia, Anglo Persian Oil company (later BP) formed
1911 U.S. Supreme Court orders break up of Rockefeller's Standard Oil Trust, Exxon, Mobil and Socal (later Chevron) formed
1914-18 World War I, British Forces capture Baghdad in 1917
1927 Iraq grants oil rights to the Iraqi Petroleum Company, a British...
1932 Iraq achieves independence from Britain
1936 Oil discovered in Saudi Arabia by the U.S.-owned Arabian St...
1938 Mexico nationalizes foreign oil companies
1939-1945 World War II, control of oil supply from the Middle East...ultimate victory of the allies
1942 Japan invades Indonesia for access to their oil reserves
1945 Iraq becomes a founding member of the League of Arab States (Arab League)
1951 Anglo Iranian Oil Company nationalized, in response, CIA instigates a coup, entrenching the Shah in power, U.S. firms get 40% of the formerly 100% British owned company
1956 Saddam Hussein joins the Arab Baath Socialist Party
1959 Hussein attempts to assassinate the Prime Minister of Iraq, escapes Iraq
1960 OPEC founded in Baghdad
1967 Six day War, Suez Canal closed
1973 Arab oil embargo - oil prices rise from $3 to $22 per barrel
 Iraqi government takes over foreign oil companies within country
1975 George W. Bush receives a Master of Business Administration degree from Harvard, becomes Founder and CEO of Bush Exploration, an oil and gas company
1979 Shah of Iran deposed, Ayatollah Khomeini takes power
 Three Mile Island nuclear power plant accident
 Hussein becomes president of Iraq
1979-1981 Oil prices rise from $14 to $34 per barrel
1980 Hussein declares the Iraqi/Iranian border agreement (Algiers Agreement) null and void, Iran-Iraq War begins
1984 Gulf Oil acquired by Chevron after a bidding war with Arco
1985 U.S. Defense Department official estimates that it cost U.S. taxpayers about $47 billion in 1985 alone for military expenditures related to the Gulf
1986 Oil prices collapse
 Chernobyl nuclear power plant accident
1986-87 "Tanker War" between Iran and Iraq - destroying of oil tankers in Persian Gulf
1988 Iran accepts UN-sponsored ceasefire, Iran-Iraq War ends
1990 Iraqi invades Kuwait, UN embargo on Iraq
1991 Operation Desert Storm, US-led forces drive Iraq out of Kuwait, set oilfields aligh...
 Soviet Union collapses
1995 UN resolution allows partial resumption of Iraq oil exports in "oil for food" deal
1997 Key Taliban leaders meet with UNOCAL in Houstan Texas
 to discus oil and gas pipeline from Turkmenistan through Afghanistan to ports in Pakistan.
 Lukoil, the biggest oil company in Russia, signs a $20bn contract to drill the West Qurna oilfield in Iraq
1998 BP acquires Amoco for $48.2 billion, Exxon acquires Mobil for $75.4 billion, BPAmoco acquires Arco
1999 George W. Bush becomes President of the U.S.
 after 5-4 decision by Supreme Court forces Al Gore to conceed
2001 Hi-jacked planes destroy World Trade Center in NY, damage Pentagon in D.C.
 US overthrows Taliban in Afghanistan
2003 US invades Iraq

DESIGNER: Waterman **STUDIO:** Macroscopic **CITY:** San Francisco, California **URL:** www.macroscopic.com **SOFTWARE PROGRAM:** Illustrator **TYPEFACES:** Akzidenz-Grotesk/Berhold, Xavier/Solotype

MW: WHY DID YOU CHOOSE THIS PIECE TO WORK WITH?

W: The combination of politics and a Wild West font—I'm a sucker for that. And I agree with the message. Oil interests run the show in American and world politics. I like that the design questions the motives behind modern American "diplomacy."

YOU DO LOVE YOUR WESTERN FONTS. HONESTLY, DID YOU LIKE THE ORIGINAL DESIGN, OR DID YOU JUST LIKE THE MESSAGE?

I liked the original design a lot, honestly.

CAN YOU EXPLAIN YOUR CONCEPT FOR THIS REDESIGN?

I wanted to firm up the message of the piece by incorporating facts that show we've been fighting for oil since striking the first gusher.

WAS THERE ANYTHING THAT MADE THIS EXPERIENCE HARDER THAN YOU THOUGHT IT WOULD BE?

I assumed it was an editorial illustration but didn't know the origin. Once I decided to focus on the history of oil, it was simpler to complete.

• • •

DESIGNER: Von Dekker **STUDIO:** Ÿmeric **CITY:** Sydney, Australia **URLS:** www.redchopstick.com, www.umeric.com **SOFTWARE PROGRAMS:** FreeHand, Illustrator, Photoshop **TYPEFACE:** Hoefler Text (Hoefler Type Foundry)

MW: WHY DID YOU CHOOSE THIS PARTICULAR PIECE TO REDESIGN?

VD: I chose the "Relax" piece because I wanted to work on something that I had a strong opinion about. I find with art projects that I get a lot more out of them if the end piece means something to me personally, and I hope to others as well. Plus, the original design is strong, so I was attracted to it when I was choosing what to remix. I really noticed the symbols used in it, what it was saying about the world and what is going on at the moment, so I felt inspired to add my own slant to that idea.

WHAT WAS YOUR REDESIGN CONCEPT?

I chose to subvert some of the symbolic elements within the original design. I took the main element that I felt was a powerful negative symbol and tried to change the meaning so that the design showed an alternative, more human view.

WAS IT AN EASIER OR HARDER EXPERIENCE THAN YOU THOUGHT IT WOULD BE?

It was harder. First, figuring out how to work with the style and elements from the original design in a way that was mine took a while, and then clarifying the meaning of the design to a point that I was happy with took a few different variations.

• • •

DESIGNER: Robin Snasen Rengard **STUDIO:** Snasen **CITY:** Oslo, Norway **URL:** www.snasen.com **SOFTWARE PROGRAMS:** Illustrator, Photoshop, Streamline **TYPEFACE:** Dreamland

MW: SO, I DIDN'T EVEN KNOW YOU WERE WORKING ON THIS PIECE. IT JUST SHOWED UP IN MY E-MAIL ONE DAY. WHAT ATTRACTED YOU TO THIS PIECE?

RSR: I wanted to test the technique, and the elements were there for the taking. I didn't plan on remixing it, but I started fooling around with the piece and suddenly it was there.

DID YOU LIKE THE ORIGINAL DESIGN, OR DID YOU THINK IT NEEDED SOME HELP?

I liked it a lot. Faktafaen. It's a bit tricky to translate, but it roughly means "a f---ing fact." Or something like that. Sort of.

IT WOULD BE PRETTY AMAZING IF ONE DAY SOMEONE JUST SAID, "WELL, OK, THE WORLD IS IMPLODING, SO JUST GO AHEAD AND PANIC!" CAN YOU TALK ABOUT YOUR CONCEPT A BIT MORE?

Just saying the opposite of relax. It's an image of a man cutting the industry off his torso. I really like the contrast between the slick style and the violent act.

WHAT WAS THE DESIGN EXPERIENCE LIKE IN PUTTING THIS TOGETHER?

It was a lot of fun. I did it in a style I wasn't really used to, but the illustration came together surprisingly quickly and naturally.

• • •

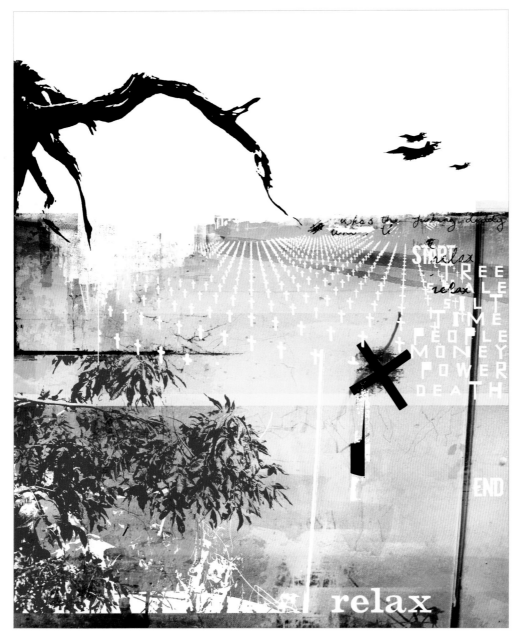

DESIGNER: Lee Basford **STUDIO:** Fluid **CITY:** Birmingham, England **URLS:** www.fluidesign.co.uk, www.meisai.ne.nu **SOFTWARE PROGRAMS:** Photoshop, Illustrator **TYPEFACE:** Tape Type (Fuse)

MW: SO, WHY DID YOU CHOOSE THIS PARTICULAR PIECE TO REDESIGN?

LB: I liked the way a serious message was used with the word "Relax." There are many heavy things in life you have no control over, so there's no alternative in many situations.

HONESTLY, DID YOU LIKE THE ORIGINAL DESIGN, OR DID YOU THINK IT NEEDED SOME HELP?

I liked the design. It's not the way I would have approached it, because my work is different and my view of the brief is different, but I think the designer did a nice job.

WHAT WAS YOUR CONCEPT FOR THIS REDESIGN?

Questioning the struggle for power and oil and how this can be viewed in the bigger picture. We all die and in many ways become the raw ingredients of the next fossil fuels, along with trees and other organic matter. I kept the fighter planes in as a nod to the original piece. There's a line in there from the film *Scum*, where Ray Winstone lets everyone know that "he's the daddy now"—a micro version of the struggle for power in an English borstal.

WAS IT AN EASIER OR HARDER EXPERIENCE THAN YOU THOUGHT IT WOULD BE? WHY?

I think is was a little harder, mainly because you can't really submit a design that's inferior to the original. There's just no point.

. . .

FEEDBACK FROM THE ORIGINAL DESIGNERS:
ALEX & FELIX WITTHOLD

WHAT ARE YOUR INITIAL REACTIONS TO THE REDESIGNS?
Red Design: Lubrication
Asterik Studio: Hemorrhoids
Macroscopic: Verbose
Ÿmeric: Yoda-Rific
Snasen: Discobloodbath
Fluid: Counseling

DO YOU HAVE A FAVORITE?
They are all interesting, but Asterik's appeals most to us. The original fused absurd collage and a sense humor into an anti-war message. This particular redesign takes those elements to new levels. The classic car makes zero sense to me, but it doesn't have to, and that's what makes it fun. Some of the others also picked up on this, but the sheer insanity and purty color usage of this one deserves props.

WHICH SURPRISES YOU? WHY?
As a redesign, the Dalai Lama by Ÿmeric seems well thought out and beautifully illustrated.

HORIZON FASHION SHOW POSTER

11

MW: HOW DID THIS PROJECT COME ABOUT?

GA: Buntin Reid, an Ottawa paper distributor, came to us with an idea to promote the Horizon line of fine papers with a paper fashion show. Interestingly, this paper fashion show would use original paper creations from local college students enrolled in fashion or graphic design courses.

SOUNDS LIKE A GREAT OPPORTUNITY. WHAT WAS YOUR DESIGN CONCEPT FOR THE POSTER?

Creatives can be difficult to motivate and wow, especially since they are frequently visited by paper reps. We knew that we had to get them excited about attending this one-of-a-kind event.

Taking inspiration from Japanimation cartoon books and paper doll cutouts, we created a double-sided poster invite using original illustrations with a male-oriented side (tabbed briefs) and a female-oriented side (tabbed bra). The title "Open Your Horizon" was created to invite the audience to open their minds when using Horizon papers.

WHAT WERE THE BIGGEST CHALLENGES IN CREATING THIS PIECE?

The major obstacle was a very short three-week deadline to design, produce and get the poster invitation out.

Also, during the design process, the client's initial reaction to our proposed concept was positive, but when showed the first mock-up, they were concerned about the look of the underwear. "Too used!" they said. A second round of illustrations made them look freshly laundered.

HOW DID THE FASHION SHOW TURN OUT?

As an event, the Premiere Paper Fashion Show was outrageous. It took place only one week before Halloween, so people were definitely in a party mood; several invited graphic designers actually cut out the bras and briefs from the poster and wore them pinned to their clothes.

• • •

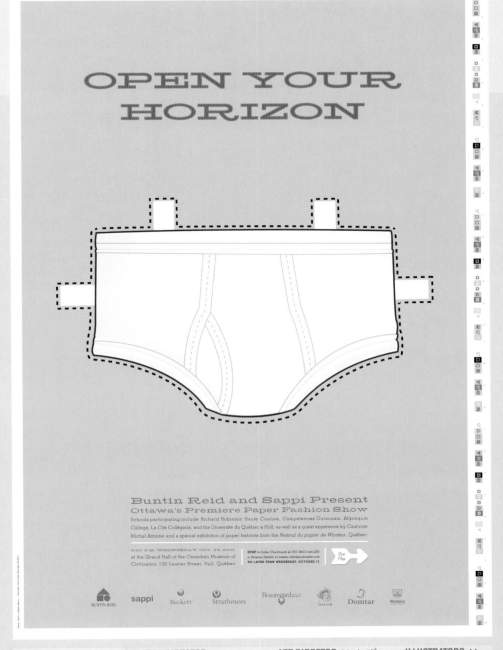

DESIGNER: Gaëtan Albert **CREATIVE DIRECTOR:** Jean-Luc Denat **ART DIRECTOR:** Mario L'Écuyer **ILLUSTRATORS:** Marc Audet and Bérangère Bouffard **STUDIO:** Iridium, a design agency **CITY:** Ottawa, Ontario, Canada **URL:** www.iridium192.com **YEAR:** 2001 **SIZE:** 22" x 32" (56 x 81 cm) **SOFTWARE PROGRAMS:** Quark XPress, Illustrator, Fractal Design Painter **TYPEFACES:** Platon (French Paper Co.), Stymie (Bitstream)

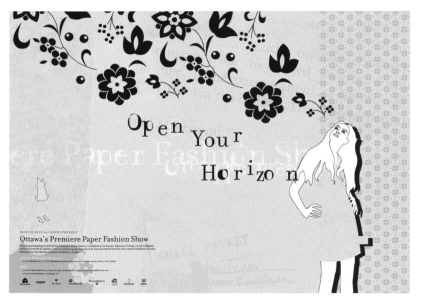

DESIGNER: Ayako Akazawa **STUDIO:** Booster Shot Café **CITY:** San Francisco, California **URL:** www.boostershotcafe.com **SOFTWARE PROGRAM:** Illustrator **TYPEFACES:** Filosofia, Meta

MW: SO, WHY DID YOU CHOOSE THIS PARTICULAR PIECE TO REDESIGN?

AA: I am into fashion and couldn't pass up this topic: a paper fashion show. Also, the original work was very different from what I would expect to see as a poster for this subject matter. The plain white men's underwear is not the first thing that I think of when I hear "fashion show."

WHAT DID YOU THINK ABOUT THE ORIGINAL DESIGN?

I liked it; it was bold and eye catching. I especially liked the idea of adding tabs to the underwear, since a paper doll is a great reference to communicate the nature of the show. I kept the idea in my redesign as well.

HOW WAS YOUR CONCEPT DIFFERENT?

To me, a fashion show is all about beauty and something imaginative; especially a show that used paper to make the outfits. I found the event very unique and unreal. I also thought that the title, "Open Your Horizon," suggested that the show is beyond ordinary and beyond your imagination.

WHAT WAS THE REDESIGN EXPERIENCE LIKE?

Creating the patterns was a bit harder than I thought it would be. Beauty and paper were two major components of my design concept, and I tried to design a poster that reminds people of those astonishingly beautiful, well-crafted hand-made papers with silk-screened delicate patterns in sophisticated colors.

. . .

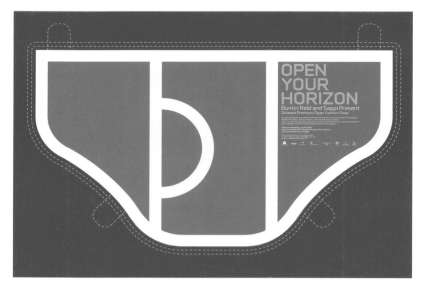

DESIGNER: Mike Lohr **STUDIO:** Semiliquid **CITY:** Los Angeles, California **URL:** www.semi-liquid.net **SOFTWARE PROGRAM:** Illustrator **TYPEFACE:** Infinity (Thirstype)

MW: WHAT APPEALED TO YOU ABOUT THIS PIECE AS A REDESIGN SUBJECT?

ML: I thought the underwear would make a bold graphic.

I'M ASSUMING YOU LIKED THE CONCEPT, SINCE YOUR DESIGN APPROACH IS SIMILAR TO THE ORIGINAL. DID YOU THINK IT WAS A CASE OF A GOOD IDEA BUT BAD DESIGN?

I liked the idea. I wasn't too keen on the execution though. I didn't think it was very fashionable.

WHAT WAS YOUR CONCEPT FOR THE DRAMATIC SHIFT IN COLORS?

I wanted to make the event appealing to attend—bright, fashionable and a little trendy.

YOU MADE SOME BIG GREEN UNDERWEAR. HOW WAS IT?

It was a pretty easy experience, since I had a few ideas right away. I just made myself a nice cup of coffee, put the headphones on and listened to The Postal Service. It was a good project to have fun with.

. . .

MW: SO, WHY DID YOU CHOOSE THIS PIECE IN PARTICULAR TO REDESIGN?

AA: I really liked the brief. When I read it, I had so many visuals going through my head, and this was before I had even seen what the artwork looked like. I thought that the idea of a fashion show with clothes made from paper would be an interesting topic to explore and would be a good base for a really beautiful, feminine design.

ONCE YOU SAW THE ORIGINAL DESIGN, WHAT DID YOU THINK?

I did like the original. However, I thought it could be developed even further.

I LOVE YOUR IDEA OF BRINGING ORIGAMI INTO THE REDESIGN, AND OBVIOUSLY THERE'S A LOT OF OTHER THINGS GOING ON HERE. WHAT WAS YOUR CONCEPT FOR THIS PIECE?

I really wanted to tie in all the themes of the brief: It was a fashion show, the clothes were made out of paper, and it was to be held in Canada. The concept was to include all of this into one illustration without being too literal about it.

I thought having a girl standing in the foreground of these beautiful mountains would represent the Canadian scenery and make it more relevant to the audience. Next, I wanted to include the paper idea, but I didn't know how to show it through her clothes. Having the origami birds was really just a subtle way of introducing the paper element into the design without looking out of place or contrived.

The only thing that was difficult was how to get all the themes in the one scene to flow naturally. I completely redesigned the whole piece, so I was almost starting from scratch, just using the previous design as a reference point.

...

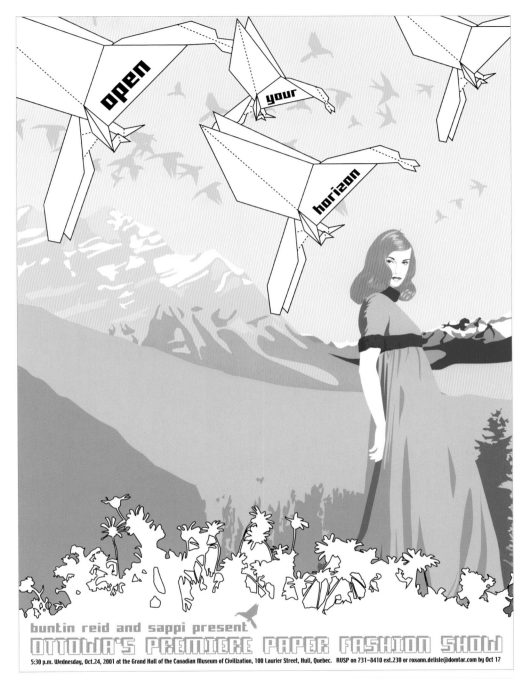

DESIGNER: Anna Augul **CITY:** Melbourne, Australia **URLS:** www.quikanddirty.com, www.australianinfront.com.au, www.neverendingremix.com **SOFTWARE PROGRAM:** Adobe Illustrator **TYPEFACE:** Supernova Fat

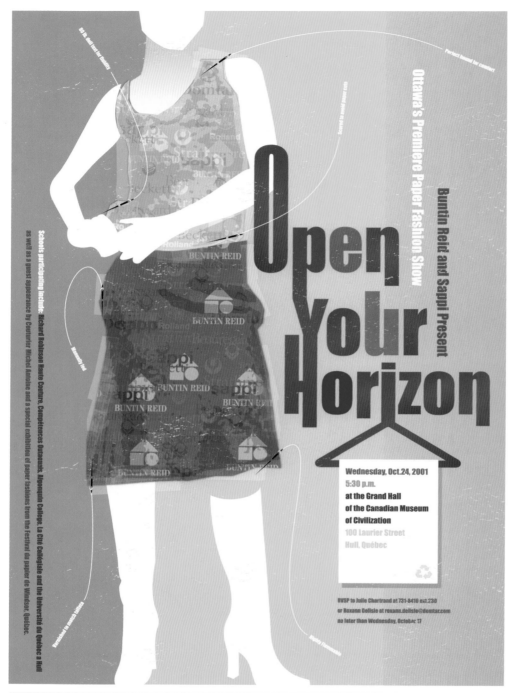

Buntin Reid and Sappi Present

Ottawa's Premiere Paper Fashion Show

Open Your Horizon

Wednesday, Oct.24, 2001
5:30 p.m.
at the Grand Hall
of the Canadian Museum
of Civilization
100 Laurier Street
Hull, Québec

RVSP to Julie Chartrand at 731-8410 ext.230
or Roxann Delisle at roxann.delisle@domtar.com
no later than Wednesday, October 17

MW: WHY DID YOU PICK THIS PARTICULAR PIECE TO REDESIGN?

ME: The idea of live models wearing clothing made of paper was intriguing.

DID YOU LIKE THE ORIGINAL DESIGN, OR DID YOU THINK IT COULD USE SOME HELP?

Yes, I liked it. I thought it was a nice, simple design that had some humorous touches to grab the audience.

WHAT WAS YOUR CONCEPT FOR THE REDESIGN?

I wanted to play upon the paper clothing more and put it on a human form to give the fashion show's twist a little more attention. I am also a choreographer and dance instructor on nights and weekends, and I design all the costumes and sets for my shows, so how bodies move is a palette that I pull from often in my professional design life. Incidentally, this has been a real asset when I collaborate with the p11 interactive team on Flash and animation projects.

WHAT DID YOU THINK ABOUT THE WHOLE EXPERI-ENCE...EASIER OR HARDER THAN YOU THOUGHT IT MIGHT BE?

I guess it was both an easier and a harder experience. Easy because it's such a different event and you can't help but wonder what the models might be thinking as they are wearing these pieces of clothing. To put that in perspective, assembling the elements together was fun. In the same respect, to not witness an event like that beforehand makes it hard to design a piece that is used to entice a target audience. But then again, being a designer is always using your imagination to see what is not there.

. . .

DESIGNER: Mike Esperanza **STUDIO:** p11creative **CITY:** Santa Ana Heights, California **URLS:** www.p11.com, www.p11funhaus.com **SOFTWARE PROGRAMS:** Photoshop, Illustrator **TYPEFACE:** Impact

MW: YOU'RE ONE OF THE MANY WHO CHOSE TO OPEN THEIR HORIZON. WHY DID YOU CHOOSE THIS PARTICULAR PIECE TO REDESIGN?

JFP: I simply thought it would be a fun piece to redo.

WHAT DID YOU LIKE ABOUT THE ORIGINAL DESIGN?

I really dug the original concept. I think that fusing paper and fashion together by using tabbed cutout outfits for paper dolls was a great idea.

SO, WHAT WAS YOUR DESIGN CONCEPT?

Since students from various fashion schools were creating original fashion designs from paper, I thought it would be interesting to put paper in a sewing context. Paper replaced fabric passing through a sewing machine, and I integrated various sewing pattern elements, such as grain direction, size and centerfold that could apply to either fabric or paper.

WAS IT ALL EASIER OR HARDER THAN YOU THOUGHT IT WOULD BE?

Maybe a bit easier than I initially thought. The whole redesign process was a blast. The fact that Dwayne, the photographer, generously accepted to work on this project made my life a lot easier, and the design came together naturally.

. . .

FEEDBACK FROM THE ORIGINAL DESIGNER:
GÄETAN ALBERT

LOOKING AT THE REDESIGNS, WHAT'S YOUR INITIAL REACTION TO EACH ONE IN ONE WORD?
Booster Shot Café: Warm+Fuzzy
Semiliquid: Can-You-Say-Complementary-Colors-Boys-And-Girls?
Anna Augul: Adobe-Illustrator-101
p11creative: Doctor-I-Keep-Seeing-Patterns-Everywhere
Kolegram: Witty

DO YOU HAVE A FAVORITE REDESIGN?
Our favorite piece is by Kolegram, because the aesthetic is fresh. The designer displays some intelligence and wit with the creative theme. This redesign is a good example of design that is concept driven: You feel that the hard work they put into it occurred before tackling the graphic design phase.

DO ANY OF THEM SURPRISE YOU?
Again, Kolegram, because of the different direction of creativity compared to the others who only showed fashion figures.

OVERALL, WHAT DO YOU THINK OF ALL THE REDESIGNS?
Sadly, most redesigned pieces were weak or trendy exercises in graphic design, whereas the theme—paper fashion show—had in itself great potential for displaying original concepts.

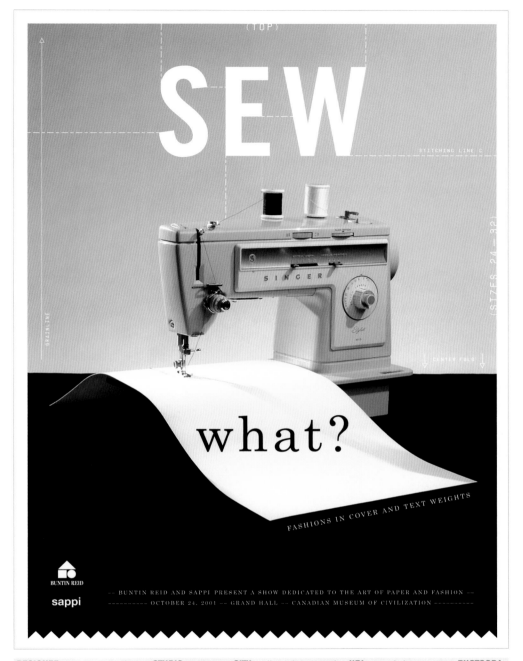

DESIGNER: Jean-Francois Plante **STUDIO:** Kolegram **CITY:** Hull, Quebec, Canada **URL:** www.kolegram.com **PHOTOGRAPHER:** Dwayne Brown **COPYWRITER:** Stephen J. Hards **SOFTWARE PROGRAMS:** Quark XPress, Photoshop **TYPEFACES:** Trade Gothic Condensed (Adobe), Century Schoolbook (Monotype), OCRK (Test Pilot Collective)

APPLE iMAC ADVERTISEMENT

Apple iMac

MW: WHAT WAS THE MAIN CONCEPT FOR THIS PIECE?

RFR: This is an advertisement for Apple resellers in Reykjavík, Iceland. It was published on the back of a catalog for a graphic design show at the Iceland Academy of the Arts. The goal was to illustrate the creative flow you could obtain by using Apple iMac computers.

SOUNDS FUN. WERE THERE ANY GUIDELINES YOU HAD TO STAY WITHIN?

The only guideline was that I had to use a photograph of an Apple iMac. Of course, the Apple resellers wanted the ad to encourage young Icelandic graphic design students to buy Apple iMacs.

NOT BAD. WHAT WERE THE BIGGEST CHALLENGES IN CREATING THIS PIECE?

The biggest challenge was to make the ad look interesting to third-year graphic design students.

HOW WAS THEIR OPINION DIFFERENT THAN A MORE TRADITIONAL AUDIENCE?

I think the difference is mainly the way design students perceive advertising. They tend to look at how the ads are designed in a critical way. I immediately thought that the piece had to be somewhat detailed and reflect some ongoing design trends.

THE SOLID BLOCKS OF COLOR AT THE TOP AND BOTTOM SEEM LIKE A DEPARTURE FROM THE INTRICATE DESIGN OF THE MAIN CONTENT. DID YOU HAVE A SPECIFIC GOAL IN MIND?

No, no specific goal. The blocks are leftovers from an earlier design of the same ad. I guess they were an attempt to frame the main content. I'd skip them if I was doing the same ad today.

• • •

DESIGNER: Ragnar Freyr Palsson **STUDIO:** Onrushdesign **CITY:** Reykjavik, Iceland **URL:** www.onrushdesign.com **YEAR:** 2002 **SIZE:** 8¼" x 12" (21 x 30 cm) **SOFTWARE PROGRAMS:** Photoshop, Illustrator **TYPEFACE:** Apple Garamond

DESIGNER: Todd Baldwin **STUDIO:** PigeonHole Design **CITY:** Washington DC **URL:** www.pigeonholedesign.com **SOFTWARE PROGRAMS:** Photoshop, FreeHand

MW: WHY DID YOU CHOOSE THE iMAC PIECE TO REDESIGN?

TB: The iMac is a clever, future-forward design. I was interested in using its parts as elements in an abstract piece.

THERE WERE DEFINITELY A LOT OF VISUAL ELEMENTS TO PLAY AROUND WITH IN THE ORIGINAL DESIGN. DID YOU LIKE IT, OR DID YOU THINK IT NEEDED A BIT OF HELP?

The original has interesting ideas, but I felt the visual hierarchy and balance were off, which made it a bit flat. I wanted to add impact with an increased sense of motion. I thought of the redesign as one frame of a motion sequence based on symmetry.

WHEN I FIRST SAW THIS PIECE, I THOUGHT YOU MAY HAVE STUMBLED ONTO SOMETHING: "THE iMAC SPECIAL LOVE EDITION." DID YOU EVER SET OUT TO DESIGN AN iMAC FOR TWO PEOPLE?

You'd have to be very much in love with your dual iMac partner. A sharing iMac, the ultimate tag-team design remix machine—communication skills required.

ALSO, I NOTICED THAT ALL THE GREEN APPLES HAVE BEEN TURNED TO RED. IS THAT A STYLISTIC OR TASTE PREFERENCE?

Stylistic mostly; red is appropriate for the "iMac 4 Lovers" theme.

SEE, I KNEW YOU HAD A GOOD REASON. HOW WAS THE ENTIRE DESIGN EXPERIENCE?

The experience was painless. The elements were always interesting to tweak.

. . .

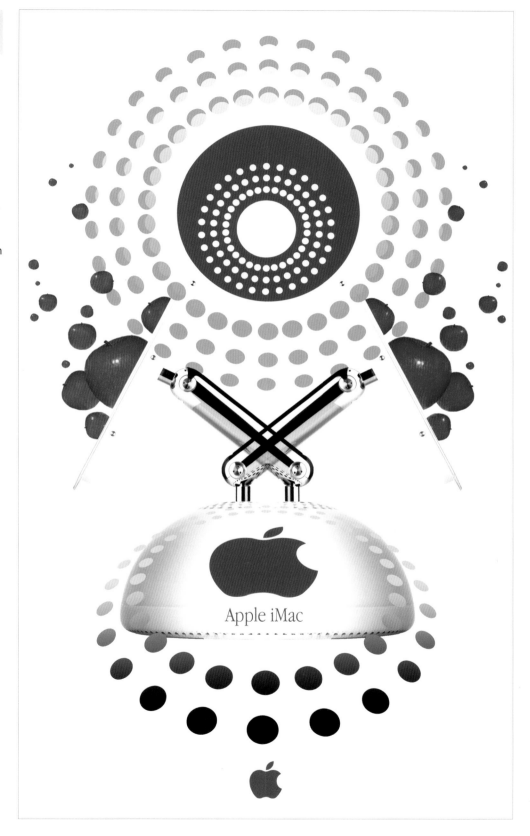

Apple iMac

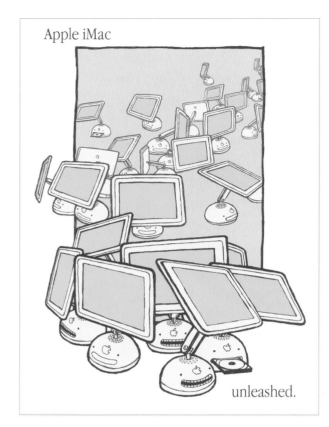

Apple iMac

unleashed.

DESIGNERS: Dan and Kozy Kitchens STUDIO: kozyndan CITY: Los Angeles, California URL: www.kozyndan.com
SOFTWARE PROGRAMS: Photoshop, Illustrator TYPEFACE: Apple Garamond, of course!

MW: SO, WHY DID YOU CHOOSE THIS PARTICULAR PIECE TO REDESIGN?

D&KK: We initially thought the concept of the iMac ad was really great but that we could take it in a much more illustrative route, with all kinds of wondrous things erupting from an iMac screen. Plus, we have three Macs, though no iMacs, unfortunately.

I'LL GO ON RECORD AS SAYING I THINK APPLE SHOULD SEND YOU ONE NOW. AND I'LL TAKE ONE TOO WHILE THEY'RE AT IT. SO, WHAT WAS YOUR CONCEPT FOR THE REDESIGN?

We thought that the original concept was really solid but that the execution was a tad derivative—too many techno, new-media clichéd design motifs for our tastes. At first we planned to do a straight-up reworking of the exact concept, but as we began to rough it out, we started coming up with different concepts and eventually focused in on the idea of "unleashing" creativity. We decided to move to something more like unleashing an army; we thought the idea of an army of stampeding cutesy iMacs was fun. It's probably not an ad that anyone would actually let us make, but since we had the opportunity, we went ahead and did it.

IT'S ALWAYS GOOD TO MAKE YOURSELF HAPPY FIRST. HOW WAS THE REDESIGN EXPERIENCE FOR YOU?

I think we were pretty lucky in that the concept was pretty straightforward and easy to convey visually. We didn't think it would be too difficult. We tried to make it harder by veering off into a new idea, but it went pretty smoothly and quickly overall.

. . .

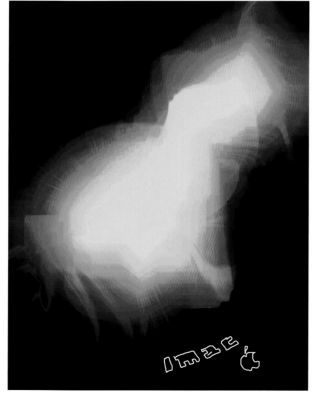

STUDIO: Honest CITY: New York, New York URL: www.stayhonest.com SOFTWARE PROGRAMS: AfterEffects, Photoshop

MW: INSTEAD OF CHOOSING A PIECE TO WORK ON, YOU ESSENTIALLY SAID, "JUST PICK ONE FOR ME." WHY WAS THAT?

H: I thought that no matter what piece I was assigned to redesign, I could bring something unique to it—a different perspective. I didn't want my motivation for picking a specific piece to get mixed into the end result.

THE ORIGINAL DESIGN REALLY HIGHLIGHTS THE REVISED DESIGN OF THE iMAC. WHAT WAS BEHIND YOUR CHOICE TO NOT SHOW THE MACHINE AT ALL?

I don't think that Apple should highlight their product designs over the benefits of using their products. That's just surface. Their products let you accomplish things that before you could only dream of. That's what I like about computers, not how skinny their screens are.

WHAT'S YOUR CONCEPT FOR THIS PIECE?

What does the spark of creativity look like? And how would that image be created using a Mac? This is what I came up with.

WHAT DO YOU THINK STEVE JOBS WOULD SAY ABOUT THIS PIECE?

He probably wouldn't like it. If I were the director of marketing for Apple, I would reject this design. Luckily, I don't have to deal with that aspect of the design process. But I do feel that Apple can do a lot of fun things with their logo. At this point, it's as recognizable as Nike, so they have the leeway to mess with it. I messed with it a little, but that's just the tip of the iceberg of what I'd like to do with it.

. . .

MW: THE ORIGINAL DESIGN SEEMS A BIT AT ODDS WITH YOUR ILLUSTRATIVE STYLE. WHAT DID YOU THINK ABOUT IT?

JS: The original design was incredible. The amount of detail and thought involved told me that the designer put in some heavy wrench time. I admire those who have an eye for detail and don't believe in white space. White space is wasted space unless it's truly meant to be that way. So, yeah, it was a treat to play with this layout.

WHAT WAS YOUR CONCEPT FOR THE REDESIGN?

The concept wasn't so much the idea to support Apple with overly abstract shapes and ideas in technology but to think along normal lines, think about the person who uses these tools to put out designs. Since Mac users are hard core about being Mac users, I wanted to work out a concept that pushed that idea along with the normality that I so enjoy. Thus, a chubby man with a large "design gut," as I call it, and a slick tattoo across his chest that signified his love for the wonderful invention of the Mac.

I THINK YOU COULD PROBABLY SELL THIS OUTSIDE THE NEXT MACWORLD. WAS THE EXPERIENCE EASIER OR HARDER THAN YOU THOUGHT IT WOULD BE?

Both. The hardest part is that I know that there are others just as (or more) talented in this book. I just didn't want to do the standard "trend" with design but rather do something that might make someone go, "Dang!" Once the creative aspect was birthed, the project was fun and exciting.

• • •

Apple iMac BRANDED.

DESIGNER: Joshua Smith STUDIO: Hydro74 CITY: Dayton, Ohio URLS: www.hydro74.com, www.axismediagroup.com
SOFTWARE PROGRAMS: Photoshop, Illustrator

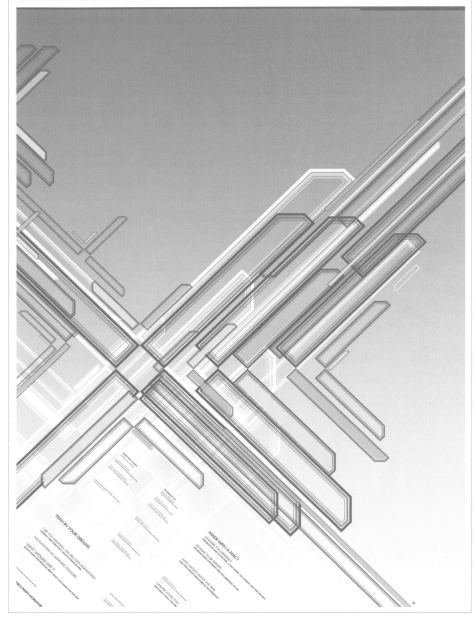

DESIGNER: Bradley Grosh **STUDIO:** gmunk **CITY:** Los Angeles, California **URL:** www.gmunk.com **SOFTWARE PROGRAMS:** Photoshop, Illustrator **TYPEFACES:** VAG Rounded

MW: THIS POSTER PROBABLY WOULDN'T SELL A LOT OF iMACS. WHAT WAS YOUR CONCEPT FOR THIS PIECE?

BG: I wanted to dis on the Mac a bit 'cuz I'm a PC user. The concept was just to make a vector structure that resembled a repurposed iMac, but not in the chrome white bulls--t. I wanted it to be more tweaked but in a more structured regime.

DO YOU LOOK AT ALL THESE MAC-USING DESIGNERS LIKE THEY'RE PART OF SOME SORT OF CULT?

Definitely not, although most Mac users that I know are designers or editors, so I guess it's a "design cult" if you will…

HAVE YOU ALWAYS USED A PC FOR EVERYTHING? WHY IS IT SO MUCH BETTER FOR YOUR WORK?

Hehehe…I used to be a Mac guy back in the day, and I switched over. I would never switch back either. PCs are simply much more powerful and have much more stability at the OS level, although OS X looks to be extremely stable.

YOU'RE LIKE THE OPPOSITE OF ALL THOSE APPLE "SWITCH" COMMERCIALS. WHAT DO YOU THINK STEVE JOBS WOULD SAY ABOUT THIS PIECE?

He'd f---ing love it. I'm sure he'd want a vintage A4 up on his wall.

YOU WERE PRETTY JAZZED ON THE PROJECT FROM THE START. DID IT TURN OUT TO BE HARDER THAN YOU THOUGHT IT MIGHT BE?

Not at all. It was quite easy and natural, actually.

. . .

FEEDBACK FROM THE ORIGINAL DESIGNER:
RAGNAR FREYR PALSSON

WHAT'S YOUR INITIAL REACTION TO THE REDESIGNS?
PigeonHole Design: Stretched
kozyndan: Funny
Honest: Abstract
Hydro74: Particular
gmunk: Controversial

DO YOU HAVE A FAVORITE?
I must say that kozyndan's and Hydro74's are equal in my mind, although they're all good in different ways. In the Hydro74 piece, I like the detailed vector drawing, and that tattoo is really something. kozyndan's is funny, yet stylish. I like their use of colors and the way the iMacs jump out of the frame, giving them personality.

DO ANY OF THEM SURPRISE YOU?
gmunk's piece surprises me because it isn't really an ad for iMac. You can see which side he's on! But it is a really well-done piece with good use of forms and creation of diagonal tension in the composition.

OVERALL, WHAT DO YOU THINK THE REDESIGNS?
They are surprisingly different but all good in some way.

CH 13 SELFRIDGES MAGAZINE FASHION SPREAD

HANDSOME AND GRETEL

Dark forces drove this season's fashion, spawning magical, fairy-tale collections. So what better time to dress up as your favourite pantomime protagonists, be they Puss in Boots or Rapunzel

Dress by Stella McCartney, £550

What could account for the dark seam of myth and wonderment that runs through so many of this winter's collections? Where did those medieval fantasy and witchy-wear looks constructed out of battle-scarred leather, tattered chiffon and antique velvet that appeared on so many runways originate? Was it simply that the visually sensitive design community's imaginations had run riot after being spellbound by *The Lord of the Rings*?

Well, yes, but not completely. Cinema often has an influence over fashion, but only if the timing is exactly right. The resonances have to penetrate far deeper than 'Oh, that was a great film!'. Fashion only hits a nerve when it connects with bigger themes, with what's going on in the outside world. The clever designing mind takes hold of political and social realities – the

issues that affect us all in daily life – and transforms them into something strong, beautiful, reassuring and relevant. We're living in troubled, anxious times when the forces of evil seem rampant in the world. So what does fashion do? It plans an escape. But in this case, not, as it may first seem, turning its back on bleakness and fear, but confronting it in a subtle and creative way, telling us about how we feel now.

Take Ann Demeulemeester. To look at her show was to witness a tribe of survivors, cave or forest-dwellers, who had come down from the hills, ruggedly swathed in skins and trophies, but walking, heads high, with a proud swagger. Or turn to Gucci, a collection that looked like a convocation of modern witchy women, channelling Stevie Nicks and a black-eyed Goth sensibility. At Martin Margiela you could catch a

glimpse of massive coats made out of several recycled furs, perfect attire for Harry Potter's giant guardian Hagrid, perhaps. Alexander McQueen literally sent on the wolves, held by chains in the hands of a violet leather-cloaked Little Red Riding Hood character. She roamed in the disturbing surroundings of the dank medieval prison that had been the last home of Marie Antoinette before her execution. Then look at Fendi, Markus Lupfer, Emma Cook, Clements Ribeiro – all collections that had something of the raw, wild-wood, natural world about them, but seen through the prism of a dark fairy tale.

Both Markus Lupfer and Emma Cook say the influence of *The Lord of the Rings* came out unconsciously in their work. 'It wasn't obvious, but I had it in my mind somewhere,' says

Lupfer. 'I never know where things come from, but I had this image of forests that came out in the colours and I felt really strongly about medieval influences.' Lupfer comes from Germany, the home of the Brothers Grimm, and if his instinct was to retreat into the magical landscapes of his remembered childhood, ('I thought about being home and walking in the woods on weekends'), it is not surprising that his show suggested primal forces at play. An impression compounded by the fact that he chose to show his collection in an atmospherically awesome Victorian-Gothic church.

'I was fed up with the hippy look and wanted to do something more magical. I've always been a fan of fairy tales,' says Emma Cook. She pinned children's book illustrations and the drawings of Aubrey Beardsley on her inspiration

board and focused on an image of Joan of Arc as her heroine. The resulting collection featured armour pieces, crushed velvet, aged silver, leather with layers of chiffon and trousers tucked into high, medieval thigh boots.

There is nothing twee or cute about winter's excursion into fairyland. If part of the tendency in many fashion collections – not just these – is to regress into a naïve childhood state in response to the terrors of the modern world, we should remember that fairy stories are far from a haven of prettiness and innocence. Many of the tales are the original horror stories, full of ogres, witches, hideous beasts and children fending for themselves in dangerous forests. When we take a closer look at the apparently pretty pictures of the fairy world in art – say those drawn by Richard Dadd or

Aubrey Beardsley – we see strange and disturbing things. *The Lord of the Rings* itself is the site of the epic battle between the ancient forces of good and evil, as are the Narnia stories. The point of all these tales, though, is that even if everything is confusing and chaotic out there, good will triumph in the end.

It's a pleasant thing to believe, and small wonder that fashion's subconscious is tagging on to that kind of hope when modern civilisation can often seem as if it's slipping into a new nightmare version of the Dark Ages. In the end though, it is just a bit of fun. It means we get to play dress-up, stride into battle with everyday life feeling like archetypal heroes and heroines, magically equipped to overcome whatever the mean streets decide to throw at us.

DESIGNERS: Paul Humphrey and Luke Davies **STUDIO:** INSECT **CITY:** London, England **URL:** www.insect.co.uk **YEAR:** 2002 **SIZE:** 17" x 10¾" (43 x 27 cm) **SOFTWARE PROGRAM:** Adobe Illustrator

MW: WHAT WAS THE CONCEPT FOR THIS PIECE?

PH: The piece was commissioned by Wink Media for the *Selfridges* magazine. It was a fashion spread illustration to show how dark forces drove this season's fashion collections along the lines of dark magical fairy-tale styles, with the main image focusing on a dress designed by Stella McCartney.

ALMOST ALL OF THE DESIGNERS THAT SAW THIS PIECE WERE DAZZLED BY IT. WHO ARE YOUR MAIN ILLUSTRATION

INFLUENCES, AND HOW DID YOU BEGIN TO REFINE YOUR STYLE?

Our main influence came from 1970s–1980s fantasy illustrators such as Boris Vallejo and Julie Bell, but we simplified the whole illustration process and reduced the highly detailed airbrush techniques to vector line art.

WHEN CREATING THIS TYPE OF FANTASY IMAGERY, WHERE DID YOU LOOK FOR INSPIRATION?

We have quite a large collection of old fantasy books and comics collected by Luke and myself

over the years. The Internet is obviously a good source for reference on this style of work, too.

DO YOU TRY TO KEEP UP WITH FASHION, OR IS IT JUST ANOTHER WORLD?

I don't think we consciously try to keep up with fashion. If anything, we try to keep away from current trends. If we are influenced by what's out there, it's not a conscious decision; we usually just go with whatever style we feel is relevant to a certain project. We never produce work solely to fit in with what's fashionable.

. . .

DESIGNER: Nago Richardis **STUDIO:** Nonconceptual **CITY:** New York, New York **URLS:** www.nonconceptual.com, www.moniker-non.com **SOFTWARE PROGRAMS:** Photoshop, Pilot pen

HOW DID YOU CREATE THIS PIECE?

I used a Pilot rolling ball pen, and Photoshop to stitch it all up.

DID YOU REALLY USE A PILOT ROLLING PEN? ARE THE MAIN ILLUSTRATIONS COMPLETELY HAND DRAWN?

Yeah, it's almost entirely hand drawn. I love those pens… I just found a new favorite though: the Pilot Bravo!

BRAVO! SO, WHY DID YOU CHOOSE THIS PARTICULAR PIECE TO REDESIGN?

Stella McCartney is funny. She has a real up-your-ass attitude. She's probably a lot of fun to drink with.

DID YOU LIKE THE ORIGINAL DESIGN?

I like the original, but I think her style is a bit edgier.

YOUR PIECE CONTAINS THE PHRASE "FASHION IS FANTASY" MANY TIMES. IS THAT WHAT YOU THINK WHEN YOU SEE HIGH-END FASHION RUNWAY SHOWS?

I think fashion is a bit ridiculous at times but definitely entertaining. I like Hussein Chalayan's stuff a lot. You can see the influence that architecture has on his work.

I LOVE THE CHILDREN'S WRITING PAPER AS A BACKGROUND. HOW GOOD WERE YOU AT KEEPING WITHIN THE LINES IN SCHOOL?

Horrible! I was always drawing or reading. I used to look at my watch and practice holding my breath. I guess I should have looked more closely at careers in free diving, because I can go for about two minutes without breathing these days.

• • •

MW: SO, WHY DID YOU CHOOSE THIS PARTICULAR PIECE TO REDESIGN?

G: We thought that the original illustration was just amazing and incredibly detailed, so it would be fun to remix it.

YOUR DESIGN HAS A VERY FREE-FORM FEELING, AS THOUGH YOU TOOK THE ORIGINAL DESIGN AND KEPT DOODLING ON TOP OF IT. HOW DID YOUR VERSION COME ABOUT?

We loved the original so much, we wanted to keep some aspects of it and just add some Graphic Havoc craziness to it. I think that you express it perfectly: we just doodled on top of it. Just having fun.

IS IT JUST ME, OR IS HANSEL POSSIBLY RELATED TO OWEN WILSON?

I have a one-word answer: *Zoolander*.

SEEMS LIKE A GOOD TIME WAS HAD BY ALL. WAS IT AN EASIER EXPERIENCE THAN YOU THOUGHT IT WOULD BE?

It was actually a lot harder than I expected it to be. The original design was executed so well, it was hard to try and come up with something better, so we just ran with it and had fun.

. . .

STUDIO: GHava **CITY:** Brooklyn, New York **URL:** www.ghava.com **SOFTWARE PROGRAMS:** Illustrator, Photoshop **TYPEFACE:** Duezhood

MW: WHAT WAS YOUR CONCEPT FOR THE REDESIGN?

PB: We have been influenced by shadow puppets and cut-paper illustrations—the style of which is locked in my memory from reading things like Grimm's Fairy Tales and Hans Christian Andersen tales as a kid. I'm not sure where the style comes from originally, but I always thought it felt Germanic, Scandinavian or Czech. I remember finding the style of illustrations in these books quite disturbing.

When I was discussing this as an idea for this book with my partner Paul West, he understood exactly, so after spending a few hours gathering research imagery in Sweden over Christmas, Paul created these illustrations. Then Claire Warner here at Form re-created them with fabric in Photoshop. Because of the somewhat pagan feel to the whole thing, we used pagan words to describe the autumn/winter collection. We've enjoyed getting into this project so much that we have decided to do a range of T-shirts with these illustration stories on them.

NOT BAD. YOU MANAGED TO CREATE A CLOTHING LINE OUT OF IT. WAS IT AN EASIER OR HARDER EXPERIENCE THAN YOU THOUGHT IT WOULD BE?

Easy…if you delete the previous solution from your mind.

. . .

DESIGNERS: Paula Benson and Paul West **STUDIO:** Form **CITY:** London, England **URLS:** www.form.uk.com, www.uniform.uk.com **SOFTWARE PROGRAM:** Photoshop **TYPEFACE:** Cloister Black

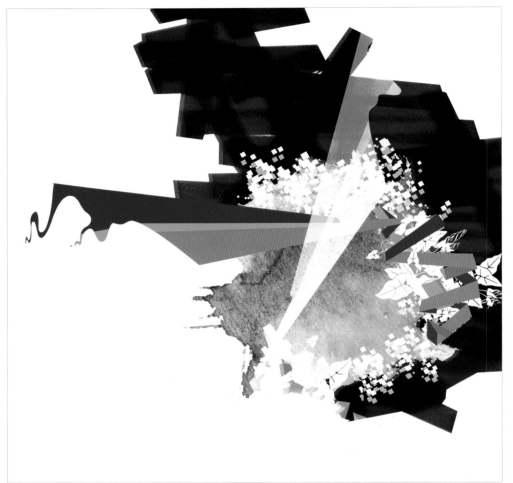

DESIGNER: Jon Santos **STUDIO:** Common Space Design **CITY:** New York, New York **URL:** www.commonspace.fm **SOFTWARE PROGRAMS:** Adobe Illustrator, Adobe Photoshop, watercolor paint

MW: I THINK THAT A LOT OF DESIGNERS PICKED THIS PIECE BECAUSE IT WAS THEIR PERSONAL FAVORITE. ULTIMATELY, DID THAT MAKE IT MORE DIFFICULT WHEN YOU BEGAN TO THINK ABOUT REDESIGNING IT?

JS: "Design" implies a problem-solving approach to working with an idea. A "remix" is a more personal way to work with someone else's language or style without really having to solve any problems. Since I used a more personal approach to working on this piece, I wasn't really thinking about how difficult it might be; I just wanted to have some fun.

SO, WHAT WAS YOUR CONCEPT FOR THIS REMIX?

There was no concept really; just to see how much information I could take away before losing the idea or essence of fantasy as a trend in fashion.

DO YOU STILL SEE A REPRESENTATION OF FASHION IN YOUR PIECE, OR HAS IT MUTATED INTO SOMETHING ELSE?

There's less fashion but more fantasy.

HOW IMPORTANT IS THE CONCEPT OF FASHION TO YOU? WHAT DO YOU THINK WHEN YOU SEE HIGH-END FASHION RUNWAY SHOWS?

Fashion is important to me on a pedestrian level. I like subtle nuances in fashion. I think of Ali G's character Bruno when I see a high-end fashion show.

IT SEEMS LIKE MANY OF THE REDESIGNS INVOLVE ADDING MORE TEXT AND IMAGERY. WHY WAS YOUR INITIAL IMPULSE TO TAKE AWAY INFORMATION?

Because information can be misleading!

...

MW: YOU REALLY JUMPED AT THE CHANCE TO WORK ON THIS PIECE. WHAT WAS IT THAT APPEALED TO YOU?

DW: Stella: Everything little thing she does is magic. Deciding to update a piece that was already perfect was challenging. Insect did a bang-up job. So I hope this reworking, a modern take on medieval vernacular symbolism, still continues the graphic dialogue—or at least lands me a job with Stella with a starting bonus of $50k.

THE ORIGINAL FILE IS SO LAYERED AND CONTAINS SO MUCH…HOW DID YOU GO ABOUT WORKING WITH IT?

With a magnifying glass and tweezers, as Illustrator's pointer tool was essentially pointless.

JUST LIKE INSECT'S ORIGINAL, THERE'S A LOT GOING ON IN YOUR PIECE. HOW DID YOU GO ABOUT CHOOSING ALL THE IMAGERY?

I got sidetracked by all the little details, the little gnomes for the trees, and decided they should all have a recurring cameo. Other details were brought up to speed, so to speak, e.g. the muscle car in place of the horse.

WAS IT AN EASIER OR HARDER EXPERIENCE THAN YOU THOUGHT IT WOULD BE?

Harder. Much, much harder.

. . .

FEEDBACK FROM THE ORIGINAL DESIGN FIRM:
INSECT

LOOKING AT THE REDESIGNS, WHAT'S YOUR INITIAL REACTION TO EACH ONE IN ONE WORD?
Nonceptual: Nice
Ghava: Lazy
Form: Cool!
Common Space: Why?
Abigail's Party: Jasper (Goodall)

GO AHEAD, PICK A FAVORITE.
Our favorite is the piece by Form. We like the use of the simple clip art style of illustration and the choice of colors. There is an effectively menacing atmosphere to the piece.

DO ANY OF THEM SURPRISE YOU?
There was nothing that surprised us particularly. If anything, I guess we thought the brief could have been pushed a little further, as it was so open. But generally we thought they were really good.

OVERALL, WHAT DO YOU THINK OF ALL THE REDESIGNS?
They were five very different takes on the original magazine spread supplied, but we feel only one of the pieces answers the brief by creating a fantasy style of illustration.

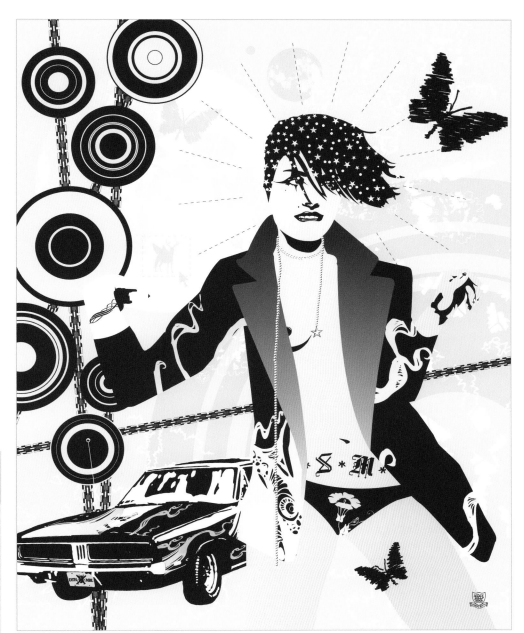

DESIGNER: David J. Weissberg **STUDIO:** Abigail's Party **CITY:** Echo Park, California **URL:** www.davidweissberg.com

CH 14

THE NEW PORNOGRAPHERS POSTER

MW: WHAT WAS THE CONCEPT FOR THE POSTER?

MB&DI: It was to illustrate the band's name, The New Pornographers, in the most tasteful, innocent way we could, as well as giving some insight to the nature of the band's sound, which is super catchy, sugary, fuzzy pop. The camera, in combination with the images of the people with bars over their eyes, hints at the idea of pornography.

WHAT'S THE SECRET FOR MAKING THE CAMERA LOOK BOTH THREATENING AND REFRESHINGLY INNOCENT?

Hmm, I guess I never saw it as threatening. I think just the size of the camera makes it somewhat imposing, but the pink dots keep everything rather innocent and somewhat naughty at the same time.

IT COULD BE INTERPRETED THAT THE CAMERA WOULD HAVE BEEN THE DEVICE OF CHOICE FOR AN OLD PORNOGRAPHER...ANY TRUTH TO THAT?

Are you asking me if I'm an old pornographer? I would guess that Super8 cameras did indeed serve some time as devices used in pornography.

WERE YOU KICKING AROUND ANY KIND OF MORE "ADULT" IDEAS?

Actually, no. Well, we worked on an option that was maybe a bit more disturbing that hinted at the world of "furries." Furries, from what I understand, are people who get pleasure from dressing up like cute little animals, hanging out together and doing who knows what.

HOW DOES KNOWING THAT THE ARTWORK WILL ULTIMATELY BE SCREEN PRINTED AFFECT YOUR DESIGN PROCESS?

Well, it definitely limits the color palette, simply because I know we're going to be printing it ourselves. It also pushes you to simplify things, knowing that an overly complicated design with a lot of trapping issues may in the end be a huge headache to print.

. . .

THE NEW PORNOGRAPHERS

with The Frames // Saturday, February 9 // The Annex

DESIGNERS: Michael Byzewski and Dan Ibarra **STUDIO:** Aesthetic Apparatus **CITY:** St. Paul, Minnesota **URL:** www.aestheticapparatus.com **YEAR:** 2002 **SIZE:** 19" x 25" (48 x 64 cm) **SOFTWARE PROGRAMS:** Illustrator, Photoshop **TYPEFACES:** Trade Gothic Extended and Bold Condensed

MW: WHAT WAS THE CONCEPT BEHIND YOUR REDESIGN?

KR: It was to create a graphic piece without overtly going for the naked women route. I wanted some kind of sexual image to be included, and I also wanted the piece to look a bit dirty in the graphic sense, since that's what most people consider pornography to be. I included stars in the design, because a lot of pornography uses this kind of graphic to hide sexual acts and body parts.

ISN'T IT FUNNY THAT NO MATTER HOW LEWD A PORNOGRAPHIC IMAGE MAY BE, PUTTING STARS ON IT SEEMS TO MAKE IT ACCEPTABLE FOR PUBLIC CONSUMPTION?

It's all about censorship. Censorship prevents, or at least hinders, communication. People can't be offended by something that doesn't communicate to them both visually and verbally. Censorship allows the viewer to complete the message, so your mind communicates what you want it to. The general public seems unable to make this leap at times, so maybe that's why censored pornography becomes acceptable.

WAS IT AN EASIER OR HARDER EXPERIENCE THAN YOU THOUGHT IT WOULD BE? WHY?

I just get on with it and do it my way, and I find my way pretty easy.

YOU MAKE IT SOUND TOO EASY…DOES DESIGN ALWAYS FLOW SO EASILY FOR YOU?

If you have the talent, I think it's a blessing. Everyone has creative blocks, but these do seem pretty rare for me. I love design, I love communication, and I'm influenced by everything—from everyday conversations to people to places to music. It's great the way that music can touch you and stir up an emotion. I aim to do this through my design work; I want people to react.

. . .

THE NEW PORNOGRAPHERS

WITH THE FRAMES/
SATURDAY FEBRUARY 9/
THE ANNEX

DESIGNER: Kerry Roper **STUDIO:** beautiful **CITY:** London, England **URL:** www.youarebeautiful.co.uk **SOFTWARE PROGRAMS:** Photoshop, Illustrator **TYPEFACES:** Gotham, Clarendon Condensed

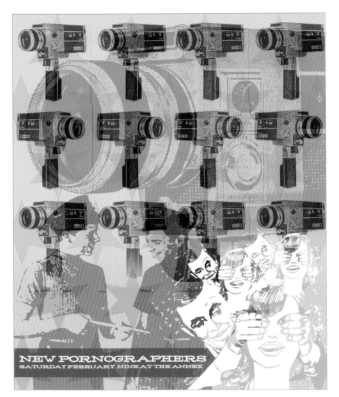

DESIGNER: Mark Wasserman STUDIO: Plinko CITY: San Francisco, California URL: www.plinko.com SOFTWARE PROGRAMS: Illustrator, Photoshop TYPEFACE: Stereo

MW: WHY DID YOU WANT TO WORK WITH THIS PARTICULAR PIECE?

MW: It's just a terrific poster. I really like everything about it, especially the Super8 image and the devious illustrations at the bottom. And of course, there's the title.

WHAT WAS THE CONCEPT FOR THE REDESIGN?

For the other redesigns that I worked on, I made an effort to create a lot of new imagery and write new text. For this one, my strategy was really as true to the idea of a music remix as possible. I took the elements that were in the original file, tweaked them, added colors and a few new graphics and ended up with something brand new.

HOW WAS THE REDESIGN EXPERIENCE THIS TIME AROUND?

In the end, it turned out to be a pretty easy experience because the source material was so great. Early on in the process, I was getting too hung up on the band's name and trying to come up with some wacky idea. Luckily, I realized that they were terrible concepts before I followed through on any of them. For a minute, I was even considering a poster showing a graduation ceremony from pornography school, as though there was going to be this whole army of new pornographers. Seriously. See? They really were terrible.

• • •

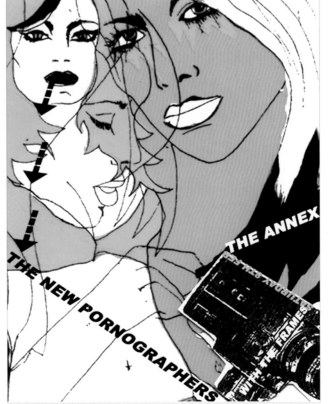

DESIGNER: Anna Magnowska STUDIO: Supergympie CITY: Leeds, England URL: www.supergympie.com SOFTWARE PROGRAM: Photoshop TYPEFACE: Arial Black

MW: DID YOU LIKE THE ORIGINAL POSTER, OR DID YOU THINK IT NEEDED A BIT OF REVISION?

AM: I liked the retro feel to the original, but knowing I was going to redesign it, I couldn't help but look at it critically. I decided that even though it might be a cliché, I wanted to "sex it up" somewhat.

BESIDES "SEXING IT UP," WHAT WAS YOUR REDESIGN CONCEPT?

I thought the Super8 on the original was fantastic, and I wanted to incorporate it in my design, so I decided that the porn star would turn director and be pictured holding the camera. I wanted a 1960s, swirly kind of fantasy feel to the image, with fairly muted colors and images of girls layered on girls with one central character in control of the scene.

WAS IT AN EASIER OR HARDER EXPERIENCE THAN YOU THOUGHT IT WOULD BE? WHY?

It was a very enjoyable experience as it gave me a chance to experiment with my own style. Usually, I collaborate with my partner Laura from Supergympie on most projects. I was quite relaxed about the way it would turn out—I had a rough idea of the concept but let it evolve naturally.

• • •

MW: SO, WHAT DID YOU THINK OF THE ORIGINAL DESIGN?

RV: Honestly, it was too timid for me. From where I sit, it looked like it was a point-of-sale ad in an Urban Outfitters.

WHAT'S THE REDESIGN CONCEPT IN YOUR PIECE?

The concept was midlife crisis meets Young Britney, somewhere in Salt Lake City.

IS SHOWING LESS ALWAYS MORE ALLURING?

It depends on what you are showing less of. In the case of this image, the masking of her eyes with a black rectangle speaks without any text. In this context, the simple graphic gesture is alluring, thanks to the code of concealed identities in early pornography.

YOU'RE WELL KNOWN AND RESPECTED FOR YOUR TYPE DESIGN. HOW MANY DIFFERENT DISPLAY FONTS DO YOU TYPICALLY TRY OUT FOR A PIECE LIKE THIS, AND HOW DO YOU GO ABOUT IT?

I first start with those fonts of our own design. If the statement is not made with those letterforms, I'll either draw a message-specific letter or look elsewhere. In this case, Chester and I had just finished the Alexey Collection, and as a result there was not much fretting over this type selection. The military (see M.A.S.H.) references surrounding a stencil font added just the right amount of "POW" to an already objectified subject matter.

ANY LAST THOUGHTS?

All is fair in love and war. Love is a battlefield.

. . .

FEEDBACK FROM THE ORIGINAL DESIGN FIRM:
AESTHETIC APPARATUS

LOOKING AT THE REDESIGNS, WHAT'S YOUR INITIAL REACTION TO EACH ONE IN ONE WORD?
beautiful: Dirty
Plinko: Errr...
Supergympie: Pink!
Thirstype.com: Wha?

DO YOU HAVE A FAVORITE?
The piece by beautiful succeeds in being provocative without showing too much. It's simple and smart.

OVERALL, WHAT DO YOU THINK OF ALL THE REDESIGNS?
Maybe it's because I really love the band, but I guess I'm not sure if all of them say much about the band. They seem to be saying more about the band's name than anything.

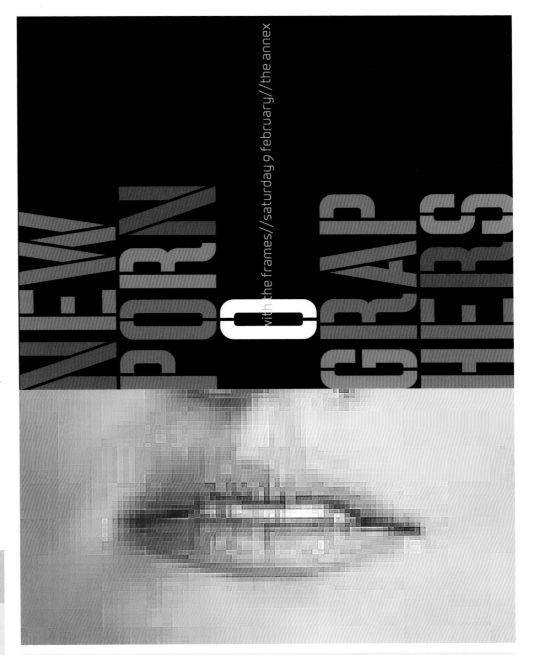

DESIGNER: Rick Valicenti **STUDIO:** Thirstype.com **CITY:** Barrington, Illinois **URLS:** www.thirstype.com, www.3st.com
SOFTWARE PROGRAMS: Photoshop, InDesign **TYPEFACES:** Alexey, Infinity (both Thirstype)

THE ROBOTS ARE COMING POSTER

MW: WHAT WAS YOUR DESIGN CONCEPT FOR THIS PIECE?

AE: At first, we only had low-quality images supplied by various artists, so we had to develop a style that would allow us to produce striking images and break away from the supplied JPEGs. Once we generated tight graphic elements, it is in their combination that a piece can have a sense of humor built in and not be taken too seriously. It also helps to have a good strapline to work with.

EXACTLY...YOU WERE PRETTY LUCKY TO BE ABLE TO WORK WITH THE BEST TAG LINE EVER. WHAT IS "THE ROBOTS ARE COMING" A REFERENCE TO?

"The Robots are Coming" refers to a range of shows visiting Nottingham as part of the NOW Festival. NOW Festival is an annual arts festival that is based in Nottingham, England. It is a platform for artists to show work, run workshops and involve the audience in performances. That year's theme was based around a range of performances involving robots and mechanoids.

THERE'VE BEEN SO MANY FAMOUS INTERPRETATIONS OF ROBOTS THROUGHOUT THE YEARS. HOW DID YOU DECIDE UPON YOUR VERSION?

We were lucky in that several of the robots and mechanoids taking part in the festival were very interesting and exciting visually. We tried to reinforce the idea that these were visiting performances, and they draw audiences as would a traveling circus, only with mechanical acts. Also, they lent themselves to a conceptual take on B-movie publicity, hinting at what was going to be unleashed on a unsuspecting audience.

. . .

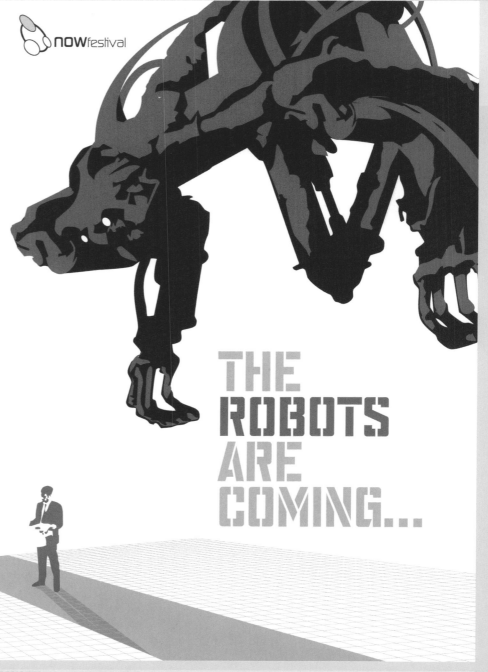

DESIGNER: Alun Edwards **STUDIO:** twelve:ten **CITY:** Nottingham, England **URL:** www.twelveten.com **YEAR:** 2001
SIZE: A3-A1 **SOFTWARE PROGRAM:** FreeHand **TYPEFACE:** Watertower

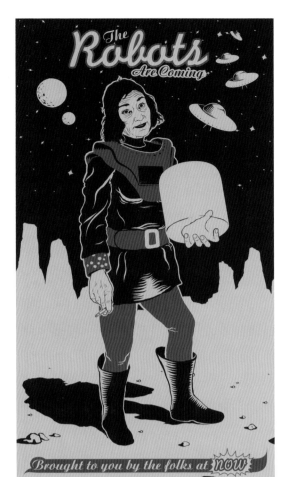

DESIGNER: Jason Hillyer **STUDIO:** Office Nerd **CITY:** Brooklyn, New York **URLS:** www.officenerd.com

MW: SO, WHY DID YOU CHOOSE THIS PARTICULAR PIECE TO REDESIGN?

JH: I liked the original, and then I got an itch to draw robots. It was also a good excuse to investigate the aesthetic of the golden age.

WHAT WAS YOUR CONCEPT FOR THIS REDESIGN?

I wanted to show a sassy astronaut having her last smoke before the impending doom of the robot brigade.

THIS WAS A NEW TYPE OF ILLUSTRATION FOR YOU. WHAT WERE YOUR INFLUENCES IN CREATING THIS PIECE?

During the hunt for robot references I ran into a book called *Blast Off* by Dark Horse Comics that pretty much loaded me with visual goodies. The tough part was making something that didn't look like anything in the book, but I must admit that the Buck Rogers illustrations were a heavy influence.

WHAT WAS THE MOST DIFFICULT PART FOR YOU?

I feel the typography on the bottom feels rushed. But the most difficult part was certainly working on a low-end iBook; no fun when the vector points start to pile up. I guess I'm a sadist that way.

• • •

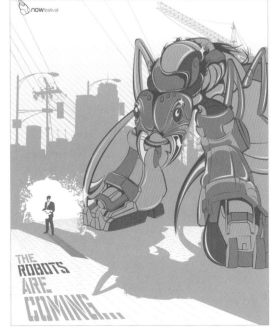

DESIGNER: Joshua Smith **STUDIO:** Hydro74 **CITY:** Dayton, Ohio **URLS:** www.hydro74.com, www.axismediagroup.com
SOFTWARE PROGRAMS: Photoshop, Illustrator

MW: DID YOU LIKE THE ORIGINAL DESIGN?

JS: Yeah, a lot. I like robots, and I thought it was incredible.

YOU'VE GOT ESSENTIALLY THE SAME LAYOUT HERE BUT WITH A MUCH MORE DETAILED ROBOT.

Basically, I kept the same concept. I wanted to do a nature-vs.-technology mechabot so that there would be a more organic feeling to the layout.

WHAT ARE YOUR FAVORITE TYPES OF ROBOTS?

The idea of robots and the mecha style has always excited me. Beginning with my first anime movie, I've always been into the aspect of Japanese culture that shows how technology can evolve to this giant form, whether it's for military use or for the use of development for manufacturing.

YOUR ROBOT DOES SEEM TO HAVE EVOLVED FROM THE INSECT WORLD. CAN YOU TALK ABOUT THE NATURE VS. TECHNOLOGY ASPECT A BIT MORE?

This past year I was trying to think of a theme for developing illustrations, and one of them that really popped out was this idea of technology vs. nature. If you look at evolution in its purest form, there has always been a battle waged upon some form in its environment.

• • •

DESIGNER: Justin Wood STUDIO: Singlecell CITY: Los Angeles, California URL: www.singlecell.to SOFTWARE PROGRAMS: Poser, Photoshop, Illustrator, tape, acrylic paint, sandpaper TYPEFACE: Dalliance (Émigré)

MW: SO, WHY DID YOU CHOOSE THIS PARTICULAR PIECE TO REDESIGN?

JW: I was participating in an art show in San Francisco titled "Robots Have Feelings Too." I chose to redesign this piece because I was already in the right mind-set for this project, plus I was able to incorporate some of my gallery designs into this redesign piece.

THEN YOU DEFINITELY HAD PLENTY OF TIME TO THINK ABOUT ROBOTS. HOW'D YOU LIKE THE ORIGINAL DESIGN?

It was good. I commend the graphic style and the composition, but grit and weirdness are my friends. I wanted to do something that was a little more mysterious and lush with a fair amount of dirt, scratches and some double take—causing content.

WHAT WAS YOUR CONCEPT FOR THIS REDESIGN?

It was to make a robot looking like and doing what you wouldn't typically imagine a robot doing. I tried to abandon preconceived notions of what people think robots to be. The name of the original project, "The Robots Are Coming," emanated some aggressive yet subversive attitude that I tried to capitalize on in an invasion-of-the-body-snatchers sort of way. What if we made robots to have our children?

WAS IT AN EASIER OR HARDER EXPERIENCE THAN YOU THOUGHT IT WOULD BE?

Harder…I wanted to treat this subject delicately and try not to be too over-the-top.

. . .

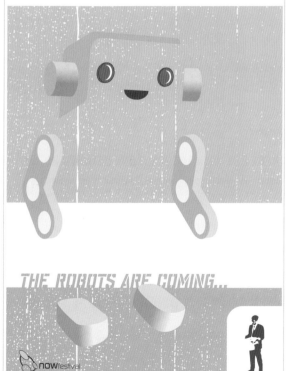

DESIGNER: Ben Benjamin STUDIO: Superbad CITY: Los Angeles, California URL: www.superbad.com SOFTWARE PROGRAM: Illustrator

MW: WHY DID YOU CHOOSE THIS PARTICULAR PIECE TO REDESIGN?

BB: I loved the original, and I thought I could do it in a different way that would tell a slightly different story that was still interesting.

SO, WHAT WAS YOUR CONCEPT FOR THIS REDESIGN?

I had a couple ideas based on the phrase "The Robots Are Coming." One was that I could have had an army of these cute robots instead of the single menacing robot. Another was that the cute robot could be warning the guy with the newspaper that "the robots are coming" and the guy would be thinking, "Aw, how cute! Yay, the robots are coming!" But in the background would be the menacing robot coming to smash him good. And finally what I did was just replace the big menacing robot with a cute robot to change the idea of the robots coming to something that's maybe not so bad.

WAS REDESIGNING THE POSTER AN EASIER OR HARDER EXPERIENCE THAN YOU THOUGHT IT WOULD BE?

Harder, because everything's always harder than I think it will be.

. . .

MW: WHY DID YOU CHOOSE THIS PIECE TO REDESIGN?

VW&MM: The robots made us do it.

WHAT DID YOU THINK ABOUT THE ORIGINAL DESIGN?

Not bad, but the "robot" in the original design was not a true visual representation, and we feel it is misleading to the public. We fear that this type of misinterpretation of what real robots are like could seriously damage the reputation of metal blockheads everywhere—not to mention the unnecessary panic it would cause among humans.

I HAD NO IDEA YOU WERE SUCH OUT-SPOKEN ROBOT SYMPATHIZERS.

We want to help the world prepare for the coming of the robots. We realize there is an existing social prejudice towards our tin-head friends. Although they can be potentially dangerous (being so much larger than us humans), we feel—with the right preparation and good intentions—humans and robots can coexist peacefully.

SOUNDS LIKE THIS WAS REALLY A LABOR OF LOVE.

It was a pleasure to work on this poster. We care deeply for robots, and we want to make sure they are understood and shown in the right light. The public can be so cruel!

. . .

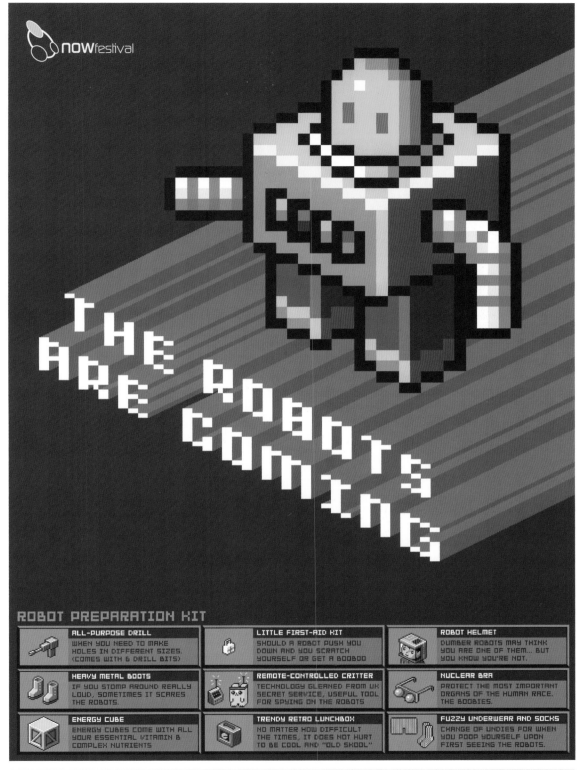

DESIGNERS: Vicki Wong and Michael Murphy **STUDIO:** Meomi Design **CITY:** Vancouver, Canada and San Francisco, California **URL:** www.meomi.com **SOFTWARE PROGRAM:** Photoshop **TYPEFACES:** 04B-03B (04 Font foundry), Isometric (self-designed)

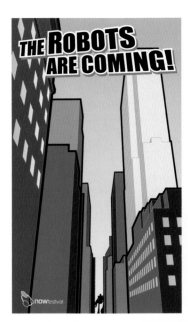 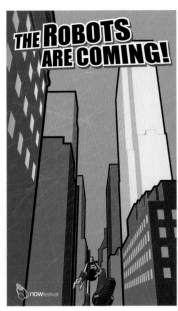 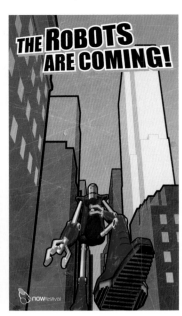 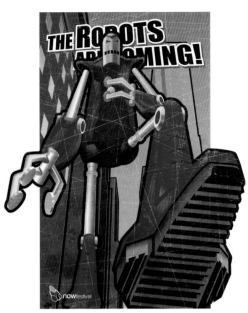

DESIGNER: Graham Stinson **STUDIO:** CrashShop **CITY:** Seattle, Washington **URL:** www.crashshop.com **SOFTWARE PROGRAMS:** FreeHand, Photoshop **TYPEFACE:** Impact

MW: THE ROBOTS WERE A POPULAR CHOICE. WHAT WAS YOUR REASON FOR WANTING TO WORK WITH THIS PIECE?

GS: We felt there was a lot of potential for different approaches—everything from the Jack Nicholson-"Heeere's Johnny"-The Shining-type approach to complete subtlety (not even including robots) to a prophet-of-doom street corner sandwich-board guy to slowly building tension and anticipation—which is the direction we ended up going.

HONESTLY, DID YOU LIKE THE ORIGINAL DESIGN?

It had a good vibe in terms of flatness vs. dimensionality and building tension, but we weren't really enamored with the colors or the impact. It had a lot of style but was lacking in character and story.

SO, WHAT WAS YOUR CONCEPT FOR THE REDESIGN?

We created four posters, meant to be placed on top of each other in sequence over a given period of time, like every three days or so. People who walk by often will see a time-lapse change in the poster, kind of a long-term animation effect. The character of the image changes, gradually becoming more imposing and more distressed as the robot breaks the barriers of the poster and the warning message of the poster becomes more emphatic.

REDESIGNS: EASY OR HARD?

Both! Coming up with the original concept was relatively easy as there were so many good directions to pursue. The execution was the hard part, and I even came close to jettisoning this idea because I wasn't terribly happy with how the illustration was coming along, but I'm glad I stuck with it.

. . .

FEEDBACK FROM THE ORIGINAL DESIGNER:
ALUN EDWARDS

WHAT'S YOUR INITIAL REACTION TO THE REDESIGNS?
Office Nerd: American
Hydro74: Type?
Justin Wood: Editorial
Superbad: Orange
Meomi Design: Dark
CrashShop: Campaign

DO YOU HAVE A FAVORITE OUT OF THE LOT?
Justin Wood's, as it takes the idea in a new direction, which I'd have hoped with such an open tag line.

DO YOU ANY OF THEM SURPRISE YOU?
What surprises me the most is that there weren't really more graphic solutions; all are still very illustrative.

OVERALL, WHAT DO YOU THINK OF THE REDESIGNS?
It is interesting to see work that appears to be non-British.

PUNK-O-RAMA
CD COVER

MW: WHAT WAS THE BIGGEST CHALLENGE IN CRE-ATING THE CD COVER?

NP: It was actually finding the perfect person to be the focal point of the cover.

HOW DID YOU FINALLY SETTLE ON THE CHARACTER?

We started off using many different characters. The inside panels of the CD contain three more characters. It was really about experimenting with different characters and seeing which one clicked. We ended up with Sara of the band The (International) Noise Conspiracy. Her pose and attitude struck me as a perfect fit for the cover of a punk rock album.

SPEAKING OF PUNK ROCK, WHAT ARE SOME OF YOUR FAVORITE PUNK ROCK ALBUM COVERS OF ALL TIME?

Wow, too many to name. First, I have to mention Art Chantry. Everything he has done always blows me away. More specifically though, standout punk records covers are: Minor Threat "Complete Discography", Fugazi "In On The Kill Taker," and Damnation AD "No More Dreams Of Happy Endings." Those album covers really inspired me to start creating design of my own.

SINCE THIS CD WAS PART OF A SERIES, DID YOU HAVE TO DO ANY EXTRA RESEARCH FOR THE PROJECT?

I was already familiar with the Punk-O-Rama series, so not much research was needed. I did know from the start that I wanted to create something very visually different from the previous ones.

EPITAPH RECORDS SEEMS TO REALLY PAY ATTEN-TION TO ITS AESTHETIC. HOW HANDS-ON WERE THEY WITH THIS PROJECT?

From concept to color, what you see are my ideas. Epitaph was very supportive of whatever I wanted to do to make it exciting.

. . .

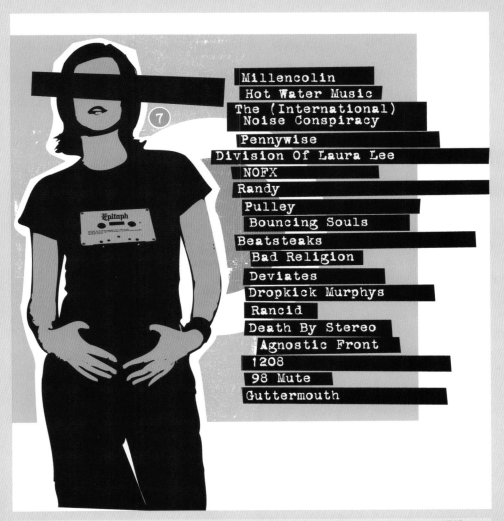

DESIGNER: Nick Pritchard **STUDIO:** metro/sea **CITY:** Los Angeles, California **URL:** www.metrosea.com **YEAR:** 2002
SIZE: 5" x 5" (13 x 13 cm) **SOFTWARE PROGRAMS:** Photoshop, Illustrator **TYPEFACE:** Vintage Typewriter

PUNK-O-RAMA

EPITAPH 2002

LABEL: EPITAPH
WEB URL_HTTP://WWW.EPITAPH.COM/ 07 256

COMP. 07

ALL RIGHTS RESERVED
2002

07 33256 72

Blanco

disc

A Template 01 B Template 02 C Template 03

YELLOW MAGENTA CYAN BLACK PMS000

D Template 04 D Greyscale

MILLENCOLIN	BAD RELIGION
HOT WATER MUSIC	DEVIATES
THE (INTERNATIONAL) -	DROPKICK MURPHYS
NOISE CONSPIRACY	RANCID
PENNYWISE	DEATH BY STEREO
DIVISION OF LAURA LEE	AGNOSTIC FRONT
NOFX	1208
RANDY	98 MUTE
PULLEY	GUTTERMOUTH
BOUNCING SOULS	
BEATSTEAKS	

0%
3%
5%
7%
45%
50%
55%
93%
95%
97%
100%

02.

NORMATONE
INDEX **07 33256 72**

120X120

LETTER-PRESS PREVIEW VERSION .01 PUNK TYPE BLACK PMS000
TEMPLATE .01

2002 Epitaph

DESIGNERS: Jackson Chang and Jan Heijnen **STUDIO:** Self **CITY:** Amsterdam, Netherlands **URL:** www.self.nl **SOFTWARE PROGRAMS:** Photoshop, Illustrator **TYPEFACE:** Helvetica Neue Bold Condensed

MW: OUT OF ALL THE PROJECTS TO CHOOSE FROM, WHAT ATTRACTED YOU TO THIS ONE?

JC&JH: We felt that the original didn't really have the proper impact.

CAN YOU EXPLAIN YOUR REDESIGN?

We didn't want to fall into the cliché of using cutout newspaper letters and dirty cut-up graphics for the Punk-O-Rama sleeve. Instead we opted to use a cliché element within the context of a graphic transfer card.

I DON'T THINK TURNING THE DESIGN INTO A GRAPHIC TRANSFER CARD IS CLICHÉ AT ALL. WHERE DID THE IDEA COME FROM?

We wanted to give the impression that punk was mainstream, add a few basic essential ingredients and voilá, it's punk. So the template idea developed into the graphic transfer card.

SO, IF PUNK ROCK HAS BECOME MAINSTREAM POP, WHAT TOOK THE PLACE OF PUNK?

I don't think you could say that a particular form of music has taken the place of punk, but you could say that acid house and house music in the late 1980s formed a new basis for the underground and rebellious mind-set. But the industry has again been successful in bringing the underground to the masses.

SINCE IT LOOKS LIKE YOU'RE STARTING A STYLE GUIDE, HOW IMPORTANT IS THE MIDDLE FINGER FOR PUNK ROCK?

We started out with a template using buttons, safety pins, zippers, etc. but decided to keep it to the essence. The middle finger is the equivalent of the devil's horn for hard rockers, the "hang loose" sign for old-school surfers, and the peace sign for Japanese teens.

• • •

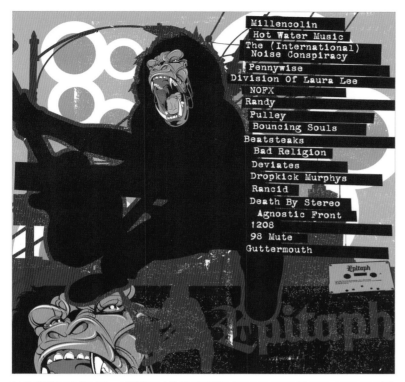

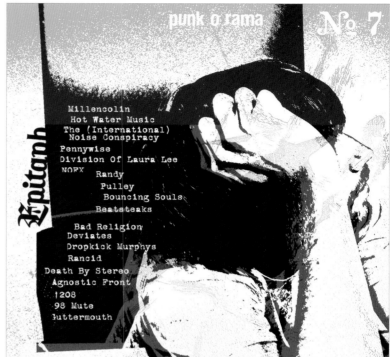

DESIGNER: Joshua Smith **STUDIO:** Hydro74 **CITY:** Dayton, Ohio **URLS:** www.hydro74.com, www.axismediagroup.com **SOFTWARE PROGRAM:** Illustrator

DESIGNER: Steve Carsella **STUDIO:** vibranium+co. **CITY:** Orlando, Florida **URL:** www.vibranium.com **SOFTWARE PROGRAMS:** Photoshop, Illustrator **TYPEFACE:** Found type

SO, WHY DID YOU WANT TO REDESIGN PUNK-O-RAMA?

I recognized it as being designed by metro/sea. Since I've always admired his use of colors, his creative thought and his, well, everything design related, I wanted to give my vision on the same project.

I TAKE IT YOU WERE A FAN OF THE ORIGINAL DESIGN. DID YOU THINK IT NEEDED ANY HELP AT ALL?

Nope, it was perfect.

I'M SURPRISED YOU CHANGED IT AS MUCH AS YOU DID. WHAT WAS YOUR CONCEPT FOR THIS REDESIGN?

Basically, it was to screw things up and make it messy. I wanted to go along the same lines as the original piece but involve a little bit more detail and excitement with it. The whole concept of punk rock to me is more of a mixture of elements and colors with a hard edge…thus, this piece.

YOU WORKED ON A FEW PIECES IN THE BOOK. HOW DID THIS ONE COMPARE?

Easy. Once the file was sent to me and I saw that it was all vector, I was a very happy man.

• • •

MW: WHY PUNK-O-RAMA?

SC: I was drawn to its punk-but-digital aesthetic. I tend towards harder and less colorful images, so I thought it'd be interesting to contrast the two.

WHAT INSPIRED THIS REDESIGN?

My new digital camera—and a friend bored at a meeting. I'm sure he was hearing music when I took this picture as opposed to paying attention to the project managers meeting. The image in the background is a Xerox of an ink stain on one of the meeting rooms desks.

IS THIS HOW PUNK ROCKERS ARE DESTINED TO AGE? BY BEING BORED IN A PROJECT MANAGER'S MEETING?

Apparently, although the kid pictured is about twenty-two, and is the most DIY punk rock kid I know. He can design interiors, make sweet architectural models, ollie big, and stitch handmade leather purses and wallets.

THAT'S PRETTY TOUGH. SO, WHAT'S THE MOST PUNK ROCK THING YOU'VE EVER DONE?

Sneaking into the Astoria Theater to see *Fast Times at Ridgemont High* when I was eleven.

YOU TURNED THIS PIECE AROUND REALLY QUICKLY. DID THAT MAKE THE EXPERIENCE EASIER OR HARDER?

I can't say it was easy or hard. It was just fun. Can we do this every year?

• • •

7 MILLENCONIN
HOT NOFX
TRACKS BY: WATER MUSIC
PULLEY PENNY WISE
THE BOUNCING SOULS
DEATH BY STEREO
BAD RELIGION

Epitaph

P-O-R 7
® Epitaph

PUNK-O-RAMA
P-O-R 7 also features newcomers Division
of Laura Lee and 1208.

DESIGNER: Santiago Tobon **STUDIO:** Atomic **CITY:** Bogotá, Colombia **URL:** www.atomicos.com **SOFTWARE PROGRAMS:** FreeHand, Photoshop **TYPEFACE:** ITC Conduit

MW: WHAT MADE YOU CHOOSE THIS PIECE TO REDESIGN?

ST: Since my college days, I have felt a fascination for punk graphics. Back then, I actually used more photocopies than scanned images, so the idea of updating the punk aesthetic attracted my attention.

WHAT DID YOU THINK OF THE ORIGINAL COVER ART?

I think the original design did need some work. I felt the title and content clashed by not having distinct graphic values, making it somehow more of a back panel and less of a cover image.

SO, THERE WAS A LOT YOU WANTED TO CHANGE. WHAT WAS YOUR CONCEPT FOR THE REDESIGN?

The original design concept of using contemporary illustration as a tool to update punk rock seemed good to me, and it brought up the question of what the piece should convey.

I took the punks-vs.-police concept as a starting point and began looking for a moment in this cat and mouse dynamic. I knew I wanted to include bold strokes, red as a base color, and a chaotic urban background. Also, the use of handmade fonts is an old staple in punk design. The place I live is full of references to violence and desolation, and, well, the police are also unpopular.

YOU HAVE THE DISTINCTION OF BEING THE LAST DESIGNER TO BECOME INVOLVED IN THE BOOK. I KNOW IT WAS CHAOTIC, BUT HOW WAS THE OVERALL EXPERIENCE?

The way I became involved in the project didn't even leave me enough time to think about if it was hard or not. There was barely enough time to decide upon a concept.

• • •

MW: WHY DID YOU CHOOSE THIS PARTICULAR PIECE TO REDESIGN?

ME: I've always enjoyed designing CD covers, so I thought this one would be fun.

THERE WERE SEVERAL DIFFERENT CD COVERS TO CHOOSE FROM...WHAT DID YOU THINK ABOUT THE ORIGINAL DESIGN?

Well, I kind of liked the style, but I thought it was a bit too busy and could use some more space.

YOUR COVER MODEL DEFINITELY SEEMS TO DEFINE PUNK FROM AN EARLIER ERA. WHAT WAS YOUR REDESIGN CONCEPT?

Less is more. I found the original to be a bit too messy for my taste, and I wanted to give it a simpler feel. So I made the "Punk-O-Rama" stand out more, gave the band list less prominence and drew a simplified illustration of a girl in very short hair. On top of that I kept the "dirt" from the original background.

WAS IT AN EASIER OR HARDER EXPERIENCE THAN YOU THOUGHT IT WOULD BE?

Easier. I don't know why, but this one was very easygoing and fun to do. I didn't even have to spend too much time working on it.

. . .

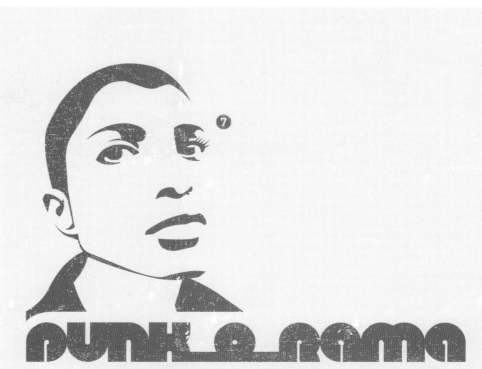

MILLENCOLIN • HOT WATER MUSIC • THE (INTERNATIONAL) NOISE CONSPIRACY PENNYWISE • DIVISION OF LAURA LEE • NOFX • RANDY • PULLEY • BOUNCING SOULS • AGNOSTIC FRONT • BAD RELIGION • RANCID • DROPKICK MURPHYS DEVIATES • DEATH BY STEREO • BEATSTEAKS • 1208 • 98 MUTE • GUTTERMOUTH

DESIGNER: Marcus Ericsson **STUDIO:** Subdisc **CITY:** Kuala Lumpur, Malaysia **URL:** www.subdisc.com **SOFTWARE PROGRAMS:** Illustrator, Flash, Photoshop **TYPEFACES:** DIN-Bold, DS Imitate

FEEDBACK FROM THE ORIGINAL DESIGNER:
NICK PRITCHARD

LOOKING AT THE REDESIGNS, WHAT'S YOUR INITIAL REACTION TO EACH ONE IN ONE WORD?
Self: Hilarious
Hydro74: Bold
vibranium+co.: Introspective
Atomic: Orange
Subdisc: Lite

WHICH ONE IS YOUR FAVORITE?
Out of all of these, vibranium's is my favorite. I like the colors a lot. One thing I would change would be to have the name "Punk-O-Rama" be the focal point and "Epitaph" secondary.

DO ANY OF THEM SURPRISE YOU?
The work by Self surprises me: a good idea and concept. Looking at it as a designer, I can really appreciate it. I think the target audience wouldn't grasp it though.

WHAT DO YOU THINK OF ALL THE REDESIGNS?
Overall I think the redesigns were good, but none really made me wish I had done something different with the original.

PLANET OF
THE DRUMS
POSTER

MW: THIS WAS DESIGNED FOR THE PLANET OF THE DRUMS 2002 TOUR: A DRUM AND BASS EVENT. WHAT KIND OF DESIGN DID THEY WANT, AND HOW WAS THAT CONVEYED TO YOU?

MC&MY: They didn't want a traditional drum and bass look; nothing dark; and maybe even a little sporty. This was for their tour, so we made an abstract globe that they were going to tour and the patterns of travel that they might take. Originally, it was a little more aggressive, but we had to change it. We started on the design before September 11th happened. We had to take out some of the elements that could look like targets or crosshairs. It changed the piece, for sure.

THE SHAPES YOU USE IN THE PIECE ARE SO DIS-TINCTLY WWFT. IT'S AN AMAZING BLEND OF ORGANIC SHAPES AND YET HIGHLY STYLIZED. DO YOU HAVE A SET LIBRARY THAT YOU TEND TO WORK FROM, OR DO YOU GENERATE NEW PATTERNS AND IMAGES EACH TIME?

We try to make custom work for each piece, but sometimes we do dip the fingers back into the jelly. Some of our work may have similar elements—or a similar look or feel—because we made them, and a lot of clients want that certain look. We try and push ourselves every job and come up with new work.

SINCE IT'S A DRUM AND BASS EVENT, DO YOU TEND TO LISTEN TO THE SAME STYLE OF MUSIC WHEN YOU'RE WORKING ON THE DESIGN, OR DO YOU WANT TO STAY FAR AWAY FROM THAT?

I don't remember what we were rocking then. We often will listen to music to get us in a mood. We love drum and bass and do listen to it when we work on drum and bass stuff for sure. Music gives us a lot of inspiration, and we use it as a tool.

. . .

DESIGNERS: Mike Cina and Mike Young **STUDIO:** WeWorkForThem **CITY:** Minneapolis, Minnesota and Baltimore, Maryland **URLS:** www.weworkforthem.com, www.youworkforthem.com, www.designgraphik.com, www.trueistrue.com **YEAR:** 2001 **SOFTWARE PROGRAMS:** Illustrator, Fontographer, Photoshop **TYPEFACE:** Bell Centennial (Adobe)

DESIGNER: Germán Olaya **STUDIO:** Typo5 **CITY:** Bogotá, Colombia **URLS:** www.typo5.com, www.surfstation.lu **SOFTWARE PROGRAMS:** Photoshop, FreeHand **TYPEFACE:** Euphoric

MW: WHY DID YOU CHOOSE THIS PIECE TO REDESIGN?

GO: I liked it, especially its geometric, clean look, as well as the various shapes and content. Seeing that, I knew there was a lot of potential to create something I would like.

THERE'S DEFINITELY A LOT OF DIFFERENT WAYS TO GO WITH THIS PIECE. WHAT WAS YOUR CONCEPT FOR THIS REDESIGN?

I wanted to use inspiration from segments of both its visual and conceptual side. I thought about the word *planet*, using the idea of an object living somewhere, whether it was a defined or undefined place. With that in mind, I started to create the environment with organic geometric, and computer-related elements.

SO YOU ESSENTIALLY STARTED BUILDING A PLANET...WAS IT A DIFFICULT EXPERIENCE TRYING TO WORK WITH A SUBJECT THAT LARGE?

I found that I was discovering the piece while I was working on it, so I had a good time. The difficult part was that I actually ended up with many discarded versions, so it was very time consuming.

• • •

DESIGNER: Joost Korngold **STUDIO:** Renascent **CITY:** Vlijmen, Netherlands **URLS:** www.renascent.nl, www.renascentfused.nl **SOFTWARE PROGRAMS:** 3ds Max, Photoshop **TYPEFACES:** Swiss 721, DS SQR553DR (DS.one)

MW: SO, WHY DID YOU CHOOSE THIS PARTICULAR PIECE TO REDESIGN?

JK: I really liked the two-dimensional version of this particular piece, and I already had it in mind how to turn it into a 3-D piece.

SINCE YOUR REDESIGN IS REALLY A PROGRESSION OF THE ORIGINAL, I'M GUESSING THAT YOU LIKED THE ORIGINAL DESIGN.

Yes, it feels like a refined and completed piece on its own, so that made it more of a challenge to redesign it into something new.

WAS IT AN EASIER OR HARDER EXPERIENCE THAN YOU THOUGHT IT WOULD BE?

It was fair, seeing that I only had a flattened TIFF file without Alpha Channels to work with. I eventually had to go about making these myself to apply it in the right way.

• • •

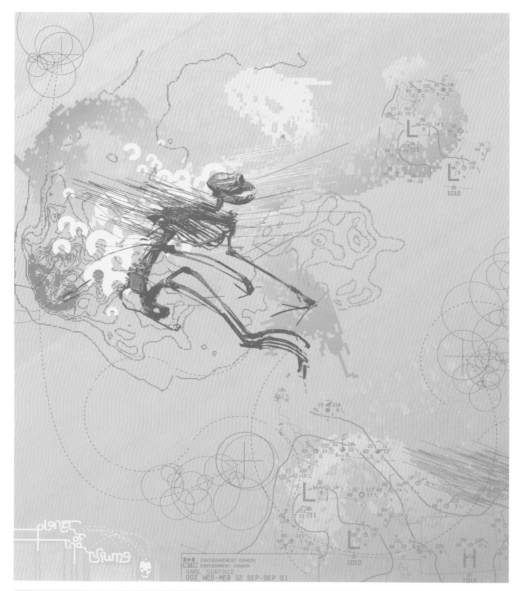

DESIGNER: Asif Mian **STUDIO:** Evaq **CITY:** New York, New York **URL:** www.evaq.com **SOFTWARE PROGRAMS:** Photoshop, Illustrator, Flash, pencil and paper

MW: SO, WHY DID YOU CHOOSE THIS PIECE?

AM: It was more about who the piece was for—Planet of the Drums—they're these drum 'n bass cats headed up by Dieselboy from Philly. So anyway, I thought it would be pretty free and open for a design direction. The original piece had that going on.

DID YOU LIKE THE ORIGINAL DESIGN?

I liked the approach it had—dense, abstract and evoking movement. I thought the concept could have been fuller or more directed—more than eye candy. But solid on its own, nonetheless.

WHAT WAS YOUR CONCEPT FOR THIS REDESIGN?

Well, with the idea of Planet of the Drums, I obviously thought of *Planet of the Apes*, and from there, a foreign planet. I wanted the piece to reference finding a buried animal, topography maps and skeletal remains. It came out as a sort of map for an archeological dig on an alien planet where they uncovered a mutated animal that looks like an ape.

THE APE IS THE FOCAL POINT, BUT THERE'S A LOT OF OTHER STUFF GOING ON. WHAT ELSE WAS DIS-COVERED ON THE ARCHEOLOGICAL DIG?

The missing link.

NICE ONE. HIDDEN AWAY AT THE BOTTOM OF THE PAGE, I NOTICED THAT WE'RE LOOKING AT THE "ANAL SURFACE." WHAT'S THAT ABOUT?

Damn, didn't even notice that. It's from a topographical map from somewhere, but it's not my anus.

. . .

DESIGNER: Michelle Thompson CITY: Cambridge, England SOFTWARE PROGRAM: Adobe Photoshop

MW: WHAT WAS YOUR CONCEPT FOR THIS REDESIGN?

MT: Movement, atmosphere, light and dark.

WITH A PIECE LIKE THIS, WHAT'S THE FIRST THING YOU TYPICALLY DO? ESSENTIALLY, HOW DID YOUR DESIGN COME ABOUT?

I researched my subject by listening to some drum and bass and basically started drawing to the music. I then went through my library of textures, colors and images, selecting pieces that I felt worked with the brief. I collect found ephemera, plus I'm also photographing all the time—skies, family and friends, old walls and anything else that catches my eye. Once I had all my elements together, I started to compose the image like a huge jigsaw puzzle.

YOUR PIECE DEFINITELY EVOKES A STRONG MOOD. CAN YOU DISCUSS THE ELEMENTS THAT YOU WORKED WITH IN A BIT MORE DETAIL?

The main part of the image is a photograph I took in New York of an old window. I had the brief in mind before I went away to New York and just kept an eye out for surfaces which could relate to the mark making I had previously done.

WAS IT AN EASIER OR HARDER EXPERIENCE THAN YOU THOUGHT IT WOULD BE? WHY?

I found it easier, because it was the type of brief I don't usually get, so I took the opportunity to do exactly what I wanted.

. . .

DESIGNER: Ebon Heath STUDIO: (((stereotype))) CITY: Planet Brooklyn SOFTWARE PROGRAMS: Quark, Photoshop

MW: DID YOU LIKE THE ORIGINAL DESIGN, OR DID YOU INSTANTLY WANT TO CHANGE IT ALL?

EH: It seemed to include the familiar aesthetic of a techno club flyer. It didn't wow me, but the design was less a factor than the theme they were attempting to address.

WHAT WAS YOUR CONCEPT FOR THIS REDESIGN?

A whole planet made of drums, what would that sound like? Look like? [I thought I'd] make type from drums, vibrating and spinning in space…use a halftone, LED clock structure to paint a picture with objects…make maps and globes with pieces from drums…and use the visual rhythm of the same elements repeated to create logic, melody and meaning, allowing the viewer to decode and discover messages in the braille of drums.

WAS IT AN EASIER OR HARDER EXPERIENCE THAN YOU THOUGHT IT WOULD BE? WHY?

It is always fun to make things without the constraint of a client's good or bad taste steering your choices. Designers are constantly sampling visually, always evolving styles—anything can be visually organized to communicate. Expression is no longer limited to the cold white walls (and faces) of the gallery snobs and rich friends. It now attacks you from every angle; media tags your imagination with songs, mantras and multiple choices of style to subscribe to. Design should be fun. Life is filled with much harder experiences to struggle through.

. . .

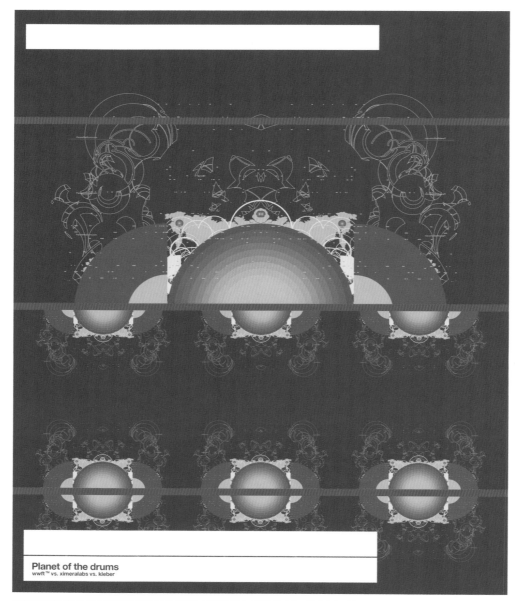

Planet of the drums
wwft™ vs. ximeralabs vs. kleber

DESIGNER: Tom Muller **STUDIO:** Kleber **CITY:** London, England **URLS:** www.kleber.net, www.ximeralabs.com **SOFTWARE PROGRAM:** Adobe Photoshop **TYPEFACE:** Helvetica Neue 75 Bold (Adobe)

MW: WHAT BROUGHT YOU TO THE PLANET OF THE DRUMS?

TM: The style and approach of the original piece lies within my own interests and approach towards design. It's as simple as that; I felt comfortable working with this piece.

WHAT DID YOU THINK OF THE ORIGINAL DESIGN?

I liked the original a lot. While it has a very specific character, it also lends itself to reinterpretation and remixing, while still keeping the visual essence in there.

YOU ALSO REALLY STUCK TO THE MAIN ELEMENTS...CAN YOU TALK ABOUT YOUR CONCEPT FOR THIS REDESIGN?

I didn't want to go in and completely change the original just because I could. Instead I wanted to add something to the existing design. I found the circular patterns very interesting and worked with those, adding rather than extracting. The main idea was to focus on those and create a Rorschach-like symmetrical pattern.

AS FAR AS DESIGN PROJECTS GO, HOW WAS IT?

All in all, it was a pretty easy experience; it didn't feel like a task doing the remix. As in most cases, coming up with the idea and concept is the hardest, but once that's figured out, it's just down to executing the idea.

• • •

FEEDBACK FROM THE ORIGINAL DESIGN FIRM
WEWORKFORTHEM

LOOKING AT THE REDESIGNS, WHAT'S YOUR INITIAL REACTION TO EACH ONE IN ONE WORD?
Typo5: Cows
Renascent: City
Evaq: Phoenix
Michelle Thompson: Reflect
(((stereotype))): Drums
Kleber: Pattern

DO YOU HAVE A FAVORITE?
I think it's the piece by Renascent. They did a great job of pulling the items out and taking it to the next level. Very well done.

DO ANY OF THEM SURPRISE YOU?
They all are surprising, but we'll go with Typo5's redesign because cows don't register in my mind at all with anything to do with drum and bass or Planet of the Drums. Maybe a cow planet? No idea, but it is a nice piece.

OVERALL, WHAT DO YOU THINK OF ALL THE REDESIGNS?
They all are very nice, and it's great to see how each person approaches the design and concept.

MW: WHAT WAS THE INSPIRATION FOR THIS PIECE?

SS: It was a sentence in my diary.

INTERESTING. WHAT INSPIRED YOU TO WRITE THAT DOWN?

Just a little list I wrote down one day about the things I think I learned in my life. This was one of them.

HOW DID YOU GO ABOUT SELECTING THE MATERIALS FOR EACH SECTION?

In all ways. Some I sketched out, some our fantastic intern Eva Hueckmann found, some Matthias Ernstberger (our designer) contributed. Even though it started out as my sentence, it was a true collaboration of the whole studio.

ONCE YOU HAD THE MATERIALS, HOW LONG DID IT GENERALLY TAKE YOU TO SET UP THE SHOOT?

We worked on and off for about three months.

WHAT DID YOU END UP DOING WITH ALL OF THE CREATIONS?

Our studio is in Manhattan, where there's no storage for anything, so we just wound up keeping the "always." The rest is in the bin. I don't mind; the final is in the magazine.

SO, IS IT STILL COMING BACK TO YOU?

Yes, good and bad, always.

. . .

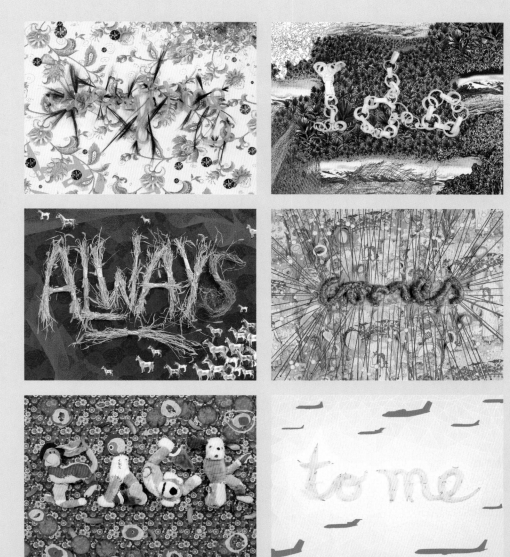

DESIGNERS: Stefan Sagmeister, Eva Hueckmann, Matthias Ernstberger, Doris Pesendorfer **STUDIO:** Sagmeister Inc. **CITY:** New York, New York **YEAR:** 2002 **SIZE:** six magazine spreads, 13¾" x 11¼" (35 x 29 cm) **SOFTWARE PROGRAMS:** Illustrator, Photoshop, FreeHand

Non preoccuparti della

vità; non dura

per sempre. (okay)

MW: WHAT WAS IT ABOUT THIS PIECE THAT LED YOU TO CHOOSE IT?

RR: I picked this piece because it seemed the toughest. I mean, why would I want to spend a bunch of time rethinking someone else's work if it wasn't going to be a challenge? The original stands out because it feels very personal. Foremost, I thought it was intimidating.

I SEE THAT YOU BROUGHT IN SOME EXTRA VISUAL SUPPORT FOR THIS ONE.

I'm lucky to be surrounded by creative friends. One day I was talking to my friend Ron Carraher, who's a retired professor and photographer, and told him all about the project.

Years ago, while in San Francisco, Ron had encountered a series of mysterious Mafia poses illustrated on a poster in a Italian restaurant's bathroom. Later, he went back and photographed the wall, always wondering what these hand signals really meant. He even ordered HBO just so he could study *The Sopranos*.

IT'S AS THOUGH YOUR DESIGN WAS FIVE YEARS IN THE MAKING...CAN YOU TALK ABOUT YOUR CONCEPT A BIT?

I was interested in creating a dialogue. The original design turns words into objects. I wanted to see if it was possible to turn an object into words. Ron and I had just finished a photo shoot with George Estrada. Ron loved working with George, who is incredibly animated, and suggested we get him back in the studio. We just let George cut loose, with very little photo art direction. George made it easy for Ron to get 180 shots in less than an hour. Some of the resulting gestures are well known; others he just made up.

The translation from Italian to English is: "Don't worry about life; it doesn't last forever."

. . .

DESIGNER: Robynne Raye **ART DIRECTORS:** Ron Carraher, Robynne Raye **STUDIO:** Modern Dog Design Co. **CITY:** Seattle, Washington **URL:** www.moderndog.com **PHOTOGRAPHER:** Ron Carraher **MODEL:** George Estrada **SOFTWARE PROGRAMS:** Photoshop, Illustrator **TYPEFACE:** Mendoza

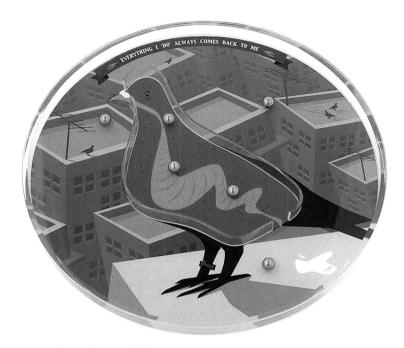

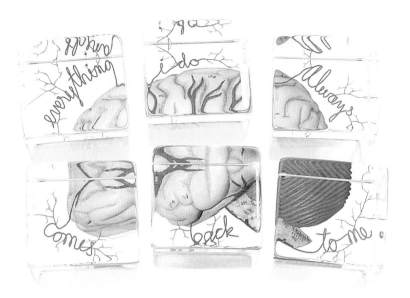

DESIGNER: Scott Andreae **STUDIO:** ilo **CITY:** San Francisco, California **URL:** www.ilodesign.com
PHOTOGRAPHER: John Caperton **SOFTWARE PROGRAMS:** Illustrator, Photoshop **TYPEFACES:**
Capitals, Apple

MW: SO, WHY DID YOU CHOOSE THIS PARTICULAR PIECE TO REDESIGN?

SA: I'm interested in two- and three-dimensional design, and this piece has both, so it
seemed like a natural fit.

WHAT DID YOU THINK ABOUT THE ORIGINAL DESIGN?

I liked it a lot. You can really tell some sweat went into making that piece, yet it
comes off so naturally. Also, it's got white bait and sausages in there to boot.

HMMM. SO, WHAT WAS YOUR CONCEPT FOR THIS REDESIGN?

We've got carrier pigeons, Homer's *Odyssey*, a play on words and a physical joke all in
the form of a cheap game!

I THINK SOME PEOPLE WOULD BE SURPRISED TO KNOW THAT YOU ACTU-ALLY BUILT A WORKING MODEL OF THE GAME AND THAT THIS IS A PHO-TOGRAPH OF IT. KNOWING THAT YOU WERE GOING TO BUILD THE GAME, DID THAT AFFECT YOUR DESIGN AT ALL?

Yep, I had to think about things like whether it would make any sense in a photograph.
The game ended up being 9" (23 cm) in diameter so that the graphics would read well
enough. That's kind of a silly size for something you'd expect to fit in your hand.

WAS IT AN EASIER OR HARDER EXPERIENCE THAN YOU THOUGHT IT MIGHT BE?

Definitely harder—the original design was pretty intimidating. I got worried that
whatever I was going to do would come off as pretentious. I suppose humor was my
only way out, like nervous laughter.

. . .

DESIGNER: Karen Lee **STUDIO:** ilo **CITY:** San Francisco, California **URL:** www.ilodesign.com
PHOTOGRAPHER: John Caperton **SOFTWARE PROGRAMS:** Illustrator, Photoshop

MW: SO, WHY DID YOU CHOOSE THIS PARTICULAR PIECE TO REDESIGN?

KL: I do a lot of experimenting with photography and mixed media…and also
because of the fish. I really like fish. And of course, the original design is beautiful. In
hindsight, it was a pretty big challenge to redesign something so well done.

WHAT WAS YOUR CONCEPT FOR THIS REDESIGN?

I thought it might be funny to literally send the redesign back to the original designer,
so I wanted to create an object. I vaguely remember waking up one morning, feeling
like my brain was scattered and seeing the rubber brain looking so perfect. I wished it
was a posable brain so that I could change it to reflect my state of mind.

EXACTLY WHAT ARE WE LOOKING AT? WAS THE BRAIN ACTUALLY CUT INTO PIECES AND PUT INTO CUBES, OR IS IT ALL A DIGITAL EFFECT?

Actually, neither. These are 1½" (4 cm) cast acrylic cubes with Polaroid transfers
applied to them. Only the lettering was created digitally.

WHAT WERE THE TECHNICAL HURDLES THAT YOU FACED IN PHYSICALLY CREATING THE PIECE?

From start to finish, the piece went from photo to computer to printout to slide to
Polaroid to emulsion transfers onto cast acrylic cubes. Combining so many different
processes was really fun, but each step usually had some effect on the image I wasn't
expecting. Plus, there were a few weeks between the first and last steps, which
meant I had to wait awhile to see the effects of any changes I made. It was just as
much a science project as a design project.

. . .

DESIGNER: Dustin Amery Hostetler **STUDIO:** UPSO **CITY:** Toledo, Ohio **URLS:** www.upso.org, www.faesthetic.com
SOFTWARE PROGRAMS: FreeHand, Photoshop **TYPEFACE:** Sunny (212f /Crosstype)

MW: SO, WHY DID YOU CHOOSE THIS PARTICULAR PIECE TO REDESIGN?

DAH: I picked it because it wasn't in a style I've ever worked in, so I knew that whatever I did would be different. Plus, I do a lot of self-portraits, and this piece works with a tag line that reflects well on that idea. I also was really inspired by the imagery the designer used.

THAT'S INTERESTING; YOU DON'T SEE TOO MANY SELF-PORTRAITS THESE DAYS. WHAT APPEALS TO YOU ABOUT THEM?

I think I enjoy drawing myself because I'm always available as a model, and the more times I draw myself the more free I am to experiment with process and form.

THE PIECE JUMPS STYLISTICALLY FROM PANEL TO PANEL. WHAT'S THE BEST PART ABOUT WORKING IN A VARIETY OF STYLES?

I really try to approach every project with a different eye. I don't want to be known for one type of thing, so it's probably best if I play around as much as possible now and figure out all I can do.

WHAT WAS YOUR CONCEPT FOR THIS REDESIGN?

It's a self-portrait dream sequence. The series was supposed to be a dream. I'm not sure why really, but it certainly isn't a nightmare. I'm plagued by nightmares in real life, so I suppose if I was able to fabricate dreams like with this series, I certainly wouldn't create more nightmares for myself.

. . .

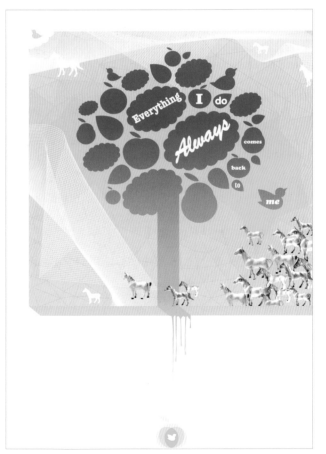

DESIGNER: Jon Jackson **STUDIO:** LA GRAPHICA **CITY:** Los Angeles, California **URL:** www.lagraphica.com **SOFT-WARE PROGRAMS:** Illustrator, Photoshop **TYPEFACES:** American Typewriter, Vag Rounded, Brush Script, Cooper Black Italic, Cooper Black, Clarendon

MW: WHY DID YOU CHOOSE THIS ONE TO REDESIGN?

JJ: I selected the design because of the challenge that it represented. The piece is so unique and different from the design styles I do, I felt it would require some brain cells on my end to come up with something that would be interesting.

I'M SENSING THAT YOU LIKED THE ORIGINAL PIECE?

I thought the original design was very smart. The use of collage gave the piece a personal feel and made the impact of the statement even greater.

WITH THAT IN MIND, WHAT WAS YOUR CONCEPT FOR THE REDESIGN?

It was to try to illustrate the meaning of the sentence. I feel this sentence can only come from nature and the earth. It is expressing that everything will return to the earth from which it came, no matter how free it seems (the bird is a great example of this freedom). In the design itself I incorporated elements from the original piece to emulate the collage that was in that design. I also included paint drips as roots of the tree to give the piece a more handmade feeling.

SOUNDS LIKE A LOT OF WORK...WAS IT AT LEAST A GOOD TIME?

I had fun in creating the artwork for this piece. The originality in the piece added to the difficulty for me. I felt that I really had to come up with a strong concept no matter how appealing the final design would be.

. . .

MW: WHY DID YOU CHOOSE THIS PARTICULAR PIECE TO REDESIGN?

CH: The solution reached by the original artist surprised me. In my opinion, the text and the imagery presented a complete contradiction. When I envision the statement "Everything I do always comes back to me," I perceive a pernicious threat. There is no happiness there. So I suppose the reason I chose this particular piece was to react to the initial shock I felt in viewing it.

WITH THAT IN MIND, DID YOU LIKE THE ORIGINAL PIECE?

The original design isn't my kind of thing, which is probably another reason why I wanted to tackle this project. It's not that the design necessarily needed help; it's that I was excited by the great difference possible in the two solutions.

WHAT WAS YOUR CONCEPT FOR THIS REDESIGN?

The seed for my redesign was provided by the perceived threat in the text. There's this feeling of overwhelming dread, as though a karmic retribution has just taken place.

I wanted to show people of different ages at their golden moment of realization—that exact millisecond when they realize that they really messed up and this is going to cost them in a personal way. Repeating the phrase on every page was intended to imply the tolling of the bell—that there is no escape from the consequences.

THAT'S QUITE A LOFTY GOAL. HOW DID THE DESIGN PROCESS WORK OUT?

I had such a visceral reaction to the original piece that the idea itself was formed within moments of seeing it. Unfortunately, I had significant difficulties because I am a very poor photographer. Most likely, I should have paid more attention in my basic photography class.

• • •

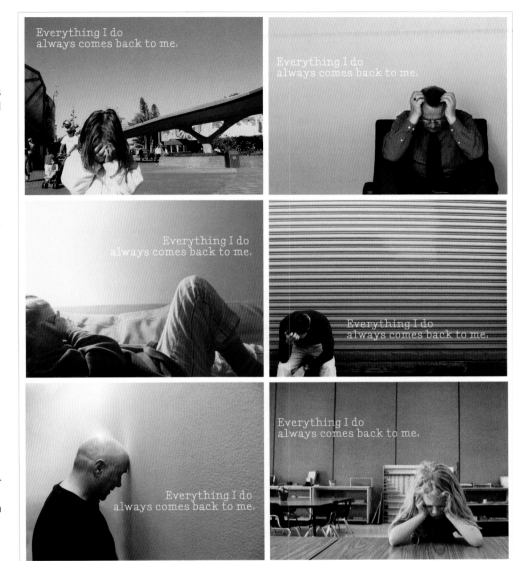

DESIGNER: Corey Holms **CITY:** Los Angeles, California **URL:** www.coreyholms.com **SOFTWARE PROGRAM:** Photoshop **TYPEFACE:** Aminta (Alias)

1972-2003

UNITS OF EVERYTHING

YEARS 1972-2003

AWARDS

IN RECOGNITION FOR YOUR CONSTANT CONTRIBUTIONS TO THE BAGGAGE THAT FOLLOWS ME AROUND MENTALLY AND PHYSICALLY

CORRESPONDENCE

Note to Everything:
Why do you find the need to follow me where ever I go? I'm just asking, I just want to know. How do you find me anyway? I thought I gave you the slip that time in Chicago. You keep bringing back shit that I thought I had dealt with along time ago...

Note to Everything:
Just to make it easier for you, Everything, here you go, this is where I live now.
JORDAN CRANE
191 N UNION ST
LAMBERTVILLE NJ 08530

EVERYTHING, 500 lbs. and growing fast
(a conceptual representation)

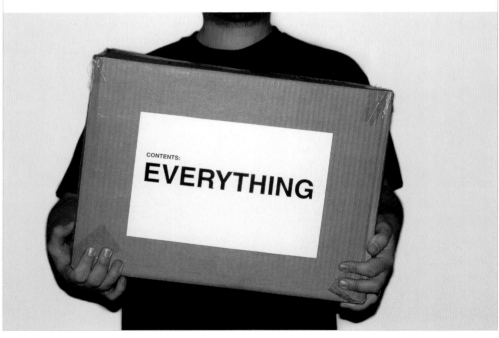

DESIGNER: Jordan Crane **CITY:** Lambertville, New Jersey **URL:** www.jordancrane.com **SOFTWARE PROGRAMS:** Illustrator, Photoshop **TYPEFACE:** Helvetica

MW: SO, WHY DID YOU CHOOSE THIS PARTICULAR PIECE TO REDESIGN?

JC: I liked the bizarre idea that everything I have ever done could come back to me. For me, it presented the most open possibilities.

HONESTLY, DID YOU LIKE THE ORIGINAL DESIGN?

Yes. I'm not much of a handcrafted sort of guy, so I'm drawn to work that, on a visual level, is unlike mine visually. I really enjoyed what it was talking about; the saying and the concept really got me thinking.

I LOVE ALL YOUR REPRESENTATIONS OF "EVERYTHING."

I wanted to deal with the idea of "everything" as some sort of physical unit. If "everything" was a unit, how would it present itself? How would it be measured? I wanted to play off that idea and deal with it in an overly obvious sort of way. I wanted to give "everything" a humorous humanish personality and create a dialogue between "everything" and me.

DID IT END UP BEING AN EASIER OR HARDER EXPERIENCE THAN YOU THOUGHT IT WOULD BE?

Harder, by far…I was dealing with "everything," and it was coming back to me.

• • •

FEEDBACK FROM THE ORIGINAL DESIGNER:
STEFAN SAGMEISTER

LOOKING AT THE ALL THE REDESIGNS, WHAT'S YOUR INITIAL REACTION TO EACH ONE IN ONE WORD?
Modern Dog: Munari
ilo (Scott): Funny
ilo (Karen): Heartbreaking
UPSO: Sweet
LA GRAPHICA: Mysterious
Corey Holms: Sad
Jordan Crane: Modern

WHICH IS YOUR FAVORITE?
I probably would give a different answer tomorrow. Today it is the bird piece by ilo, because it is beautifully conceived, extraordinarily executed and makes fun of our version.

DO ANY OF THEM SURPRISE YOU?
Corey Holms' is so very bleak.

OVERALL, WHAT DO YOU THINK OF ALL THE REDESIGNS?
It is a completely new experience for me to see a design of ours reconceived by other designers. I talked with a musician—whose songs are constantly remixed—about it and he loved the idea of a visual remix just as much as I did.

EARTHACTION CHILDREN'S RIGHTS POSTER

MW: CAN YOU TALK ABOUT THE DESIGN IDEOLOGY FOR THIS POSTER CAMPAIGN?

SS&SB: EarthAction is a global network of individuals, non-profit organizations and legislators who work together on issues like human rights, HIV/AIDS, poverty, disarmament and climate change. Our work for EarthAction takes its visual inspiration from things like tabloid newspapers, four-color process and the graphic language of warning signs.

I CAN IMAGINE THAT THERE WERE COUNTLESS POSSIBILITIES WITH THIS TOPIC. HOW DID YOU DECIDE TO APPROACH IT THIS WAY?

This campaign is part of an overall identity redesign we're working on for EarthAction. The objective of the redesign is for EarthAction to communicate in very bold and engaging ways. Since the issues that EarthAction addresses are urgent and real, we use news photography and a direct tone of voice to connect with the reader.

WHAT WERE THE BIGGEST CHALLENGES IN CREATING THIS PIECE?

Conceptually, the challenge was to bring attention to life-or-death issues that many viewers don't want to think about. Meanwhile, the children's rights materials are produced in English, French, German, Italian and Spanish, so the concepts have to be universal and the design has to be modular to accommodate the different texts.

• • •

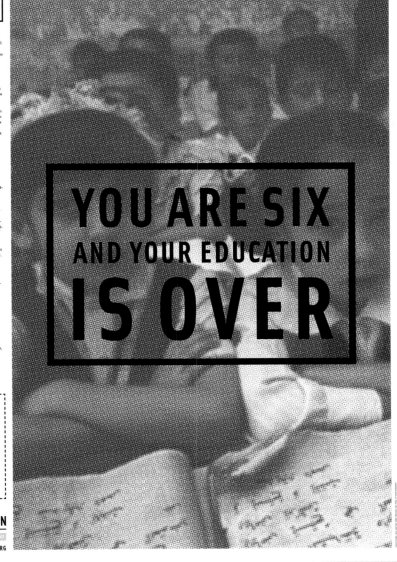

DESIGNERS: Scott Stowell and Susan Barber **STUDIO:** Open **CITY:** New York, New York **URL:** www.notclosed.com **YEAR:** 2002 **SIZE:** 17" x 22" (43 x 56 cm) **SOFTWARE PROGRAMS:** Illustrator, Photoshop, Quark **TYPEFACES:** Clarendon (Adobe), Solex (Émigré)

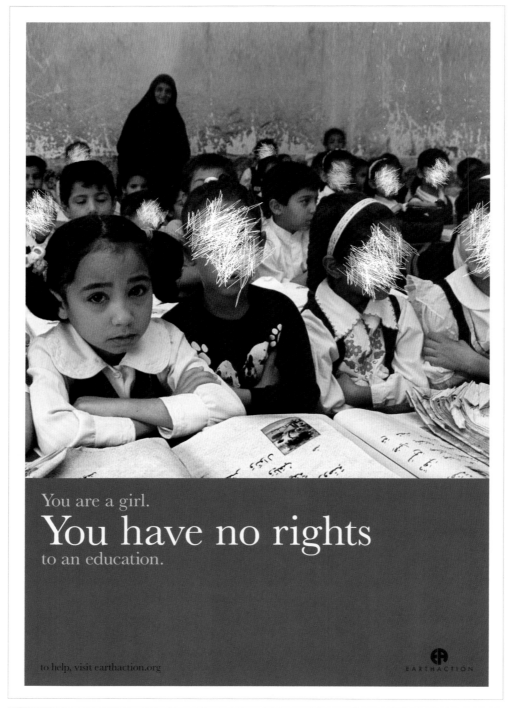

You are a girl.
You have no rights
to an education.

to help, visit earthaction.org

EARTHACTION

DESIGNERS: Josh Fehr and Tracey Lebedovich **STUDIO:** gloriousday **CITY:** San Francisco, California **URL:** www.gloriousday.com **SOFTWARE PROGRAMS:** Photoshop, Illustrator **TYPEFACE:** Baskerville

MW: WHY DID YOU CHOOSE THIS PARTICULAR PIECE TO WORK WITH?

JF&TL: It was one of a handful of designs that we felt had a compelling theme and some interesting content. We also felt that we would have taken a different approach to the design problem.

WHAT DID YOU THINK ABOUT THE ORIGINAL DESIGN?

We liked the bold typographic style in the headlines but felt the image was too important to be pushed as far into the background as it was. Once we saw the original full-color photo, we were surprised that it wasn't used as is. It's a powerful image. We also felt like there was too much copy to comfortably digest, especially since this is a poster and people will be viewing it on the go.

IT'S OBVIOUSLY A VERY LARGE CONCEPT WITH MANY DIFFERENT POSSIBLE DESIGN ANGLES. WHAT WAS YOUR CONCEPT FOR THE REDESIGN?

We focused on one message: the idea that in some nations girls are denied their right to an education simply because they are girls. That's a shocking idea.

Once we widened the crop to see the whole photograph, we realized it was so strong by itself. There was a teacher, covered with her burka, looming in the back of a classroom. In the front row sit five little girls, staring into the camera as if they are trying to tell us something.

We recropped the photo so that the girl on the left became a focal point and ending up scratching out the rest of the girl's faces. It became about that one little girl and her struggle to make her way through a system that didn't want her to be there in the first place. It told a story. That was our goal: to tell a story and have people remember it.

. . .

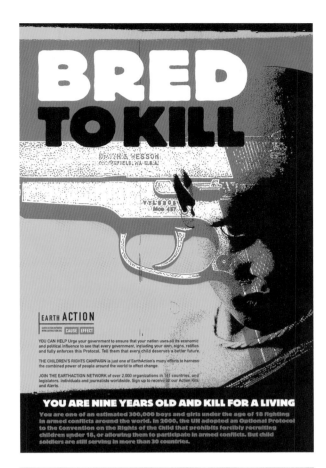

DESIGNER: Dave Kinsey STUDIO: Kinsey Visual CITY: Los Angeles, California URLS: www.kinseyvisual.com SOFTWARE PROGRAMS: Illustrator, Photoshop

MW: WHY DID YOU CHOOSE THIS PARTICULAR PIECE TO REDESIGN?

DK: I wanted the freedom to explore a new direction and visual presentation. I believe more in a critical social concern in need of a marketing message as opposed to useless products brought about by manipulating the consumer. I feel more stable utilizing my talents in a way that's not so self-demoralizing.

SINCE YOUR REDESIGN GOES IN AN ENTIRELY DIFFERENT DIRECTION THAN THE ORIGINAL, I'M CURIOUS TO KNOW WHAT YOU THOUGHT ABOUT THE ORIGINAL PIECE.

I felt the copy conveyed a strong message but that the image did not. I believe the image is the bait that catches the fish. Without this you just get a rusty hook.

SO, WHAT WAS THE CONCEPT FOR YOUR REDESIGN?

To display a more powerful image and connect the viewer to the message as quickly as possible with little or no effort. To me, this is a strict reality that should not be ignored.

WAS THE OVERALL EXPERIENCE EASIER OR HARDER THAN YOU THOUGHT IT WOULD BE?

A lot easier…I really liked what I was given to do. It fueled an inspiring building and execution process.

• • •

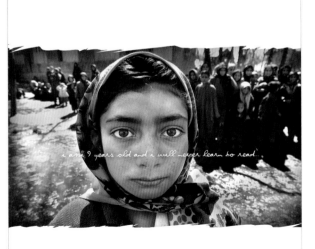

DESIGNER: Mark Arcenal PHOTOGRAPHER: Ami Vitale STUDIO: Transitlab CITY: San Francisco, California URLS: www.transitlab.com, www.arcenal.com, www.AmiVitale.com, www.fatlace.com SOFTWARE PROGRAMS: Photoshop, Illustrator TYPEFACE: Violation

MW: WHAT APPEALED TO YOU ABOUT THIS PARTICULAR PIECE?

MA: I chose this piece because it dealt with a topic that most people choose to ignore. The topic was strong, and I wanted to use an image that was just as strong.

DID YOU LIKE THE ORIGINAL DESIGN, OR DID YOU THINK IT NEEDED SOME HELP?

I thought the original design was good. It used a Photoshop effect that I haven't seen in a while. Original.

WHAT WAS YOUR CONCEPT FOR THIS REDESIGN?

It was to hook up with a great photographer, Ami Vitale, and collaborate, while letting her image do the communicating.

WAS THE REDESIGN EXPERIENCE EASIER OR HARDER THAN YOU WERE COUNTING ON?

Much harder than I thought it would be. The concept was in my head, but the photo was so strong that I needed to lessen the design around it so it wouldn't take away from the photo.

• • •

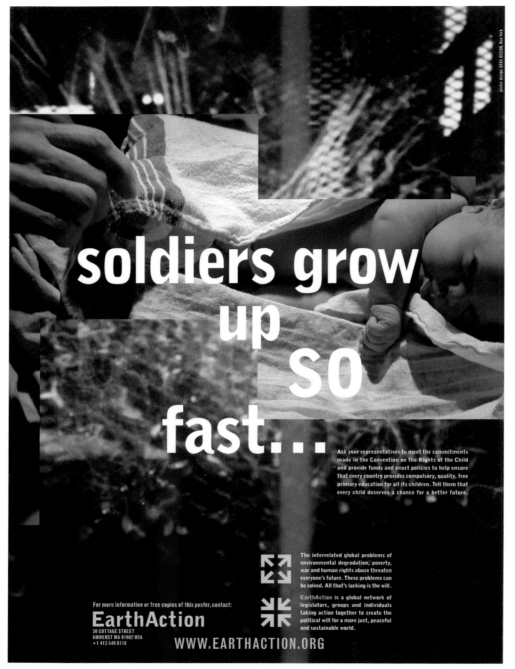

soldiers grow
up
so
fast...

Ask your representatives to meet the commitments
made in the Convention on the Rights of the Child
and provide funds and enact policies to help ensure
that every country provides compulsory, quality, free
primary education for all its children. Tell them that
every child deserves a chance for a better future.

The interrelated global problems of
environmental degradation, poverty,
war and human rights abuse threaten
everyone's future. These problems can
be solved. All that's lacking is the will.

For more information or free copies of this poster, contact:

EarthAction
30 COTTAGE STREET
AMHERST MA 01002 USA
+1 413 549 8118

EarthAction is a global network of
legislators, groups and individuals
taking action together to create the
political will for a more just, peaceful
and sustainable world.

WWW.EARTHACTION.ORG

DESIGNER: Dmitry Krasny **STUDIO:** Deka Design **CITY:** New York, New York **URL:** www.dekadesign.com **SOFTWARE PROGRAMS:** Photoshop, Quark **TYPEFACE:** Grotesque (Monotype)

MW: SO, WHY DID YOU CHOOSE THIS PARTICULAR PIECE TO REDESIGN?

DK: One often forgets to pause and reflect on important questions, and we felt that this project would give people an opportunity to have a serious discussion. We kept coming back to this problem: What can we do as designers, as individuals, that will have an impact? What can we do to inspire?

PRETTY LOFTY GOALS. WHAT DID YOU SET OUT TO CREATE?

We did not want to redesign something for the sake of making it more pretty. Our design touched on the subject presented in the original poster but solved a different aspect of the problem raised by EarthAction. The similarities are that they deal with children around the world.

Having just recently become a father changed my perspective on many things and was probably the strongest inspiration for the design of the poster. The cliché phrase "children grow up so fast" was altered to read "soldiers grow up so fast" to convey the idea of the campaign. In the main photograph, there's a hand reaching for the newborn baby—symbolizing the forceful recruitment of children and teaching them to hate from a young age. The more abstract background image evokes the feeling of the numerous armed conflicts around the world.

WHAT WAS THE EXPERIENCE LIKE?

This was definitely a challenge. This poster does not target one specific narrow demographic. It is for the general audience, and the message is ultimately successful only if people respond to it. So we had to design something that absolutely anyone could relate to, think about and act. Act!

. . .

MW: WHAT IS IT ABOUT EARTHACTION THAT WAS INTERESTING TO YOU?

S: It sounded like a good cause, and there was a lot of content which would make the redesign easier.

DID YOU LIKE THE ORIGINAL DESIGN, OR DID YOU THINK IT NEEDED A BIT OF HELP?

I think that the original piece needed some kind of focus. It was hard to understand what the poster really wanted you to do. Is it about child education, or is it a general presentation about EarthAction? At first glance it spoke of one thing, but as you kept reading the front and back it just added issues in a way I think might be overwhelming and confusing.

WHAT WAS YOUR CONCEPT FOR THIS REDESIGN?

I just wanted to focus on one issue. Maybe it's cheating, but that's what I would've suggested EarthAction do if it was our client.

WHAT MAKES IT HARDEST ABOUT NOT HAVING A CLIENT THERE? IS IT THE LACK OF FEEDBACK?

In this case it was very unclear what the purpose of the poster was. I think I would have asked them if we could concentrate on some kind of core message and try to focus on that or make a small series of posters/pamphlets on different issues.

· · ·

FEEDBACK FROM THE ORIGINAL DESIGN STUDIO:
OPEN

WHAT'S YOUR INITIAL REACTION TO EACH REDESIGN?
gloriousday: Unclear
Kinsey Visual: Manipulative
Transitlab: Cliché
Deka Design: Complicated
Sweden: Aestheticized

WHICH IS YOUR FAVORITE?
Deka Design's piece is nice and dramatic. The contrast between the innocence in the foreground and the violence in the background speaks directly to the child soldiers issue in an unexpected way. Also, the use of color is sophisticated and still leaves room for the fluorescent orange of the Earth-Action identity.

WHICH SURPRISES YOU? WHY?
The trendy look used by Sweden was kind of a shock. On the one hand, the idea of using an established contemporary style for this kind of political communication might help EarthAction appeal to a new audience. But this version of that idea seems a bit inappropriate and tends to trivialize the issues being communicated.

OVERALL, WHAT DO YOU THINK OF ALL THE REDESIGNS?
I have to say that overall most of these approaches are versions of ideas that we intentionally avoided when working on EarthAction ourselves. Transitlab's employs many of the techniques we wouldn't use, particularly the maudlin photograph and the use of a "handwritten" font. If that girl can't read, how did she write that message?

120 million children have never gone to school.

Most of these children will grow up to join the one billion people in the world who can't read or write.

EDUCATION FOR ALL

What would it take? The United Nations Childrens Fund (UNICEF) estimates it would cost an additional $9 billion a year for the next 15 years to provide quality primary education for all the world's children. This is just over 1% of last year's world military spending of $756 billion. For less than what Americans spend annually on cosmetics—or what Europeans spend on ice cream—every child on earth, age six to twelve, could go to school.

Can it be done? Of course. One way to help ensure that spending supports education is for governments to participate in the international 20:20 initiative. Proposed by UNICEF and other UN agencies, this plan calls on governments in developed countries to commit 20% of their development assistance, and those in developing countries 20% of their national government budgets, to meeting basic human needs—including primary education. Governments must turn their commitment to the Convention on the Rights of the Child into action by adopting and implementing the 20:20 approach.

THE CONVENTION ON THE RIGHTS OF THE CHILD

The Convention on the Rights of the Child (CRC) is a comprehensive international human rights treaty that spells out the basic human rights to which children everywhere are entitled. Its 54 articles guarantee a full range of rights from survival and development, to protection from exploitation and abuse and full participation in family, cultural and social life. The CRC defines children as all human beings under the age of 18.

The CRC was adopted by the UN General Assembly in 1989. Within ten years, 191 countries had ratified it, making it the most widely ratified human rights instrument in history. Today, only two countries—Somalia, which has no central government and the United States—have failed to become States Parties to the Convention.

Article 28 of the CRC commits governments to "make primary education compulsory and available free to all." Governments promised the funding to meet this goal, but most of them aren't delivering. If governments made a serious effort to give every child an education and a chance of a better life, there would be less of the hopelessness that makes the ground so fertile for extremism and terrorism.

GIRL'S EDUCATION

The value of investing in girls' education is internationally acknowledged. Educating girls brings lasting benefits to nations and to future generations: educated girls tend to marry later, have few, healthier and better nourished children; and educated mothers are far more likely to send their daughters to school than women who have not been to school.

Educated girls can better protect themselves against sexual violence, forced labor and disease such as HIV/ AIDS. Education gives girls more life choices, opportunities and self-esteem to participate in and contribute to the economic, social and decision-making forces of their countries.

YOU CAN HELP

Please write, fax or email one or more of your representatives in your national parliament or congress. Ask them to live up to the commitments governments made in the Convention on the Rights of the Child and provide funds and enact policies to ensure that every country provides free, compulsory and quality primary education for all its children. Tell them that every child deserves a chance for a better future. Specifically, ask them to do all they can to: Implement the 20:20 initiative.

In industrialized countries: Ask them to increase development assistance to the UN target of 0.7% of GNP, and devote at least 20% of that aid to provide quality basic social services, including primary education for all.

In developing countries: Ask them to devote at least 20% of your national budget to provide quality basic social services, including primary education for all.

Earth Action is a global network of legislators, groups and individuals taking action together to create the political will for a more just, peaceful and sustainable world.

The interrelated global problems of environmental degradation, poverty, war and human rights abuse threaten everyone's future. These problems can be solved. All that's lacking is the will.

Contact **Earth Action** and join the proposed Parliamentary InterGroup on Children's Rights. This is a working group made up of democratically-elected national legislators from around the world that is being created to initiate urgent action to meet the needs of the world's children — including education for all.

EARTH ACTION
WWW.EARTHACTION.COM

STUDIO: Sweden **CITY:** Stockholm, Sweden **URL:** www.swedengraphics.com **EARTHACTION LOGO:** Magnus Voll Mathiassen **SOFTWARE PROGRAM:** Illustrator **TYPEFACE:** Helvetica Neue

MW: WHAT WAS THE INSPIRATION FOR THE DESIGN?

MW: This was an event poster for a live performance where some of the top DJs in the world would be playing sets composed exclusively from vintage soul/funk 45rpm records. Also, because almost all of the DJs are obsessive collectors who constantly search for vintage records and turntables, I wanted to make sure to include a rare record player as well.

There was a lot of digging on my end. I found a very unusual spindle in a pawn shop (seventy-five-cent asking price—talked down to fifty cents). The spindle is used to allow 45rpm records to be played on standard turntables, so I traced that, and that became the basis for the pattern. Then, I found the main image of the vintage portable 45rpm-only turntable in an old issue of the Spiegel's catalog.

WERE THERE ANY OTHER APPROACHES YOU ATTEMPTED WITH THIS PIECE?

Only really a rearranging of the elements. At first I had the turntable up front and center, and even though it was a striking image, it overwhelmed the pertinent info about the show itself.

WHAT WERE THE BIGGEST CHALLENGES IN CREATING THIS PIECE?

The biggest obstacle was tracking down the imagery. Just as these DJs search every possible outlet for rare records, I found myself knee-deep in a lot of tattered magazine racks.

ANY OTHER RANDOM FACTS YOU CAN TELL US?

Well, sure. This show was actually the basis for the "Brainfreeze" sessions by DJ Shadow and Cut Chemist. That widely bootlegged CD was recorded while the two DJs were rehearsing for this show. At this point, the performance hadn't yet become associated with the 7-Eleven style graphics.

. . .

DJ SHADOW CUT CHEMIST DJ Z-TRIP
RASTA CUE-TIP & ROMANOWSKI // VISUALS BY MACROSCOPIC AND JETPACK
FOR THE FIRST TIME EVER, FUTURE PRIMITIVE SOUNDSESSION PRESENTS AN ALL-STAR GATHERING OF DJS PLAYING STRICTLY 45'S ALL NIGHT LONG

THE 45 SESSION
FRIDAY FEBRUARY 26TH | 550 BARNEVELD | 9P TO 3A

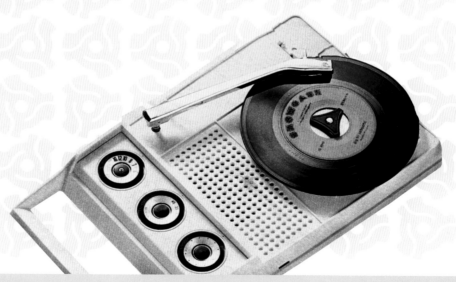

DESIGNER: Mark Wasserman **STUDIO:** Plinko **CITY:** San Francisco, California **URL:** www.plinko.com **YEAR:** 1999 **SIZE:** 18" x 24" (46 x 61 cm) **SOFTWARE PROGRAMS:** Photoshop, Illustrator **TYPEFACE:** Alternate Gothic 3

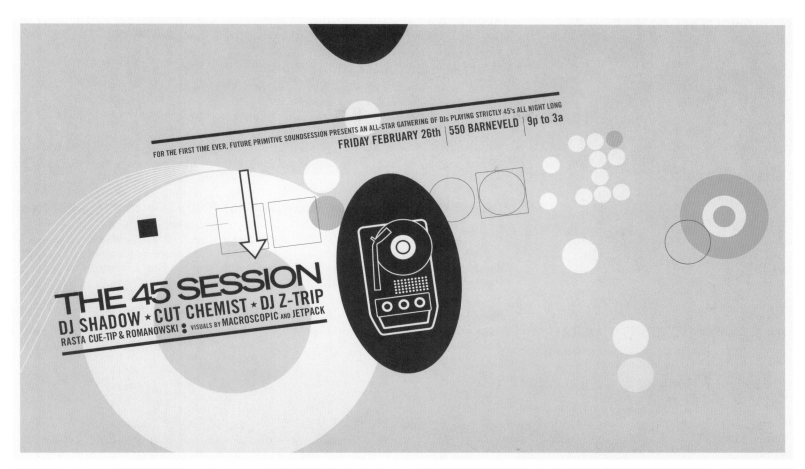

DESIGNER: Max Hancock **STUDIO:** Diphthong Interactive Design **CITY:** Singapore **URL:** www.diphthong.com **SOFTWARE PROGRAMS:** Illustrator, Photoshop **TYPEFACES:** Trade Gothic Bold Extended and Bold Condensed

MW: WHY DID YOU CHOOSE THIS PIECE TO REDESIGN?

MH: I knew my style would be best suited for the subject; I just can't help but make retro designs. Even when I'm trying to make futuristic or fashionable contemporary design, there's always something about it that ends up looking like it was done during the 1950s. Both my parents were designers, artists and collectors. Growing up, I suppose I was surrounded by material that was designed during that era, and some of it must have rubbed off on me.

IT DOES APPEAR THAT WAY. HOW'D YOU LIKE THE ORIGINAL POSTER? REMEMBER, I CAN EDIT YOUR ANSWERS...

I don't think my redesign is an improvement, per se, but I do feel it's a little more unpredictable. I wanted to create an event poster that was modern but looked like it was possibly an archival of something designed during the 1940s or 1950s. Seeing how I was designing for an event that took place at the end of the 1990s, it was a pretty unfair advan-

tage on my part. I could look back on that time when the particular artists' styles were new, with the knowledge of how to illustrate that style. I'm sure back then I'd probably have designed something similar to the original. It's a really strange feeling to redesign something that took place recently which in concept was to look like a modern version of an older era. That was a really fun challenge.

BELIEVE IT OR NOT, I ACTUALLY UNDERSTAND WHAT YOU'RE SAYING. HOW WAS THE EXPERIENCE FOR YOU?

Overall, it was a good experience, even though I didn't reach a point where I thought I was moving in a really different direction from the original. When I started it, I wanted to take more of a departure from the original concept, but that never happened, and I didn't want to force it.

. . .

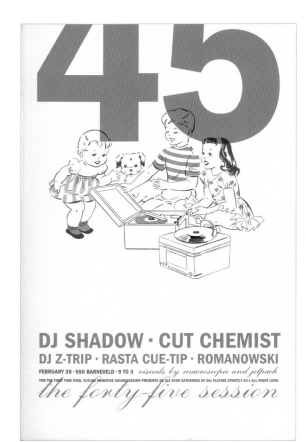

DESIGNER: TJ River **STUDIO:** Meat and Potatoes, Inc. **CITY:** Los Angeles, California **URL:** www.meatoes.com **SOFTWARE PROGRAM:** Photoshop **TYPEFACES:** AT Sackers English Script, ITC Franklin Gothic Demi Condensed

MW: SO, WHY DID YOU CHOOSE THIS PARTICULAR PIECE TO REDESIGN?

TJR: DJ Shadow and Cut Chemist are a huge inspiration to me. I thought it was interesting too, to see the original poster and realize it was probably pre- "Brainfreeze" and "Product Placement" and the start of the "strictly 45s" phenomenon from a few years back. I imagine this show was the birth of those projects.

YOU IMAGINED CORRECTLY. OK, WHAT DID YOU THINK ABOUT THE ORIGINAL DESIGN?

I liked it except for the duotone feel. I love designs that are restricted to two colors that don't feel like they've been restricted in any way.

I THINK YOU MADE THE MOST JOY-FILLED TURNTABLE POSTER EVER. WHAT WAS THE DESIGN CONCEPT FOR THIS PIECE?

I wanted to play up the impact of the number 45 as much as possible. The number holds immediate recognition with hip-hop heads and music fans alike. The illustration also led the concept. It's something that might normally be too playful for a hip-hop DJ, but it seemed to fit all these guys' personalities well. They're all about nostalgic, often silly, good times.

WAS IT AN EASIER OR HARDER EXPERIENCE THAN YOU THOUGHT IT WOULD BE? WHY?

It was a little intimidating at first, considering the high regard that I hold for these guys. Once I got started with it, though, I was having way too much fun to be daunted.

. . .

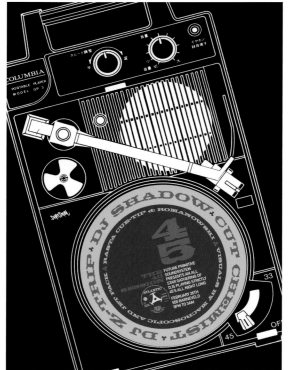

DESIGNER: Phil Bedford **STUDIO:** Phatphool **CITY:** London, England **SOFTWARE PROGRAMS:** Illustrator, Photoshop, Quark XPress **TYPEFACES:** DIN, Thunderbird

MW: SO, WHY DID YOU CHOOSE TO REDESIGN THIS PARTICULAR PIECE?

PB: The 7" (18 cm) single is such a beautiful medium. From the physical size of the disc to the removable inner of the vinyl, there's just something delicious about it.

JUST OUT OF CURIOSITY, DID YOU HAPPEN TO LIKE THE ORIGINAL DESIGN?

I thought the original design was really clean and easy on the eye, which is often very important for a poster. I tried to follow that idea and hopefully ended up with something that you'd cross the street to check out.

CONSIDER THE STREET CROSSED. WHAT WAS YOUR CONCEPT FOR THE REMIX?

Well, the starting point was the handheld 7" player which, in my opinion, is one of the funkiest pieces of design ever produced. I started with that, stuck a few old Studio One 7" records on the decks, rolled a fat one, and let it flow.

WAS IT AN EASIER OR HARDER EXPERIENCE THAN YOU THOUGHT IT WOULD BE? WHY?

I had a lot of fun with this project, as I'm a big fan of the whole artwork remix thing, although it was slightly more difficult than I first envisaged. I think this is basically because of the company I'm keeping with the other designers featured in this book. I wanted to pull something fresh outta the bag!

. . .

MW: SO, REMIND ME WHY YOU CHOSE THIS PAR-TICULAR PIECE TO REDESIGN.

HO: It wasn't chosen; it was preordained.

OH, THAT'S RIGHT. I PICKED IT FOR YOU GUYS, BECAUSE I'M SELFISH AND WANTED TO SEE WHAT YOU'D COME UP WITH. YOU'RE A HUGE FAN OF 45RPM RECORDS, RIGHT?

I'm a pretty big 45 fetishist. I think the best part of 45s is so multifaceted: two great songs, a big hole, fun artwork. Shit, there's nothing better than a 45 record. Hell, I put some out myself I love them so much!

I NOTICED THERE'S NOT A LOT OF ELEMENTS FROM THE ORIGINAL DESIGN. DID YOU LIKE THE ORIGI-NAL, OR DID YOU THINK IT NEEDED SOME HELP?

You did it, didn't you?

PERHAPS. BUT YOU CAN IGNORE THAT. SO, HONEST-LY, WHAT DID YOU THINK?

Honestly? I didn't notice.

OUCH. LET'S TALK ABOUT YOUR CONCEPT FOR THE REDESIGN. GUNS?

Yes! Chris and I were just knocking ideas around, and he had one of those "shoot the star" targets from the fair. Ever seen it? You pay your dollar and the goal is to shoot the star out to win a prize. The gun is fully automatic but just shoots pellets. Anyway, we made the entire target in FreeHand and Photoshop except for the bullet holes, which were from the actual target.

AH. COLT .45 GUNS, 45 RPM RECORDS…IT'S ALL CLEAR NOW. I'M KNOW I'M GOING TO REGRET ASK-ING THIS, BUT WAS IT AN EASIER OR HARDER EXPERIENCE THAN YOU THOUGHT IT WOULD BE?

Chris is a lot easier than I originally thought.

. . .

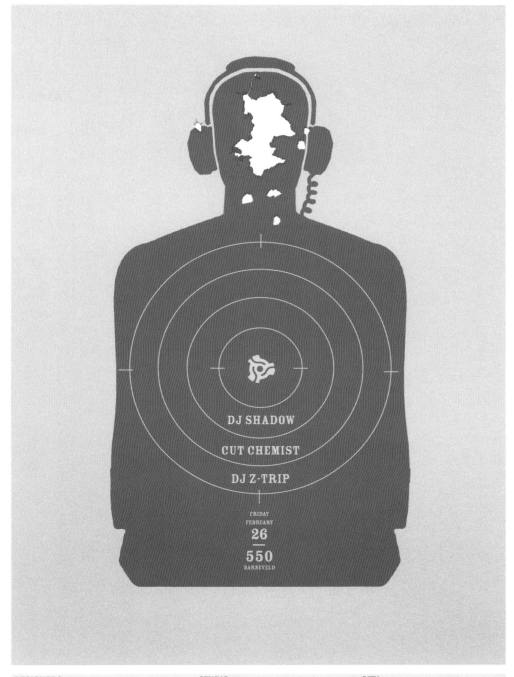

DESIGNERS: Chris Bilheimer/Henry H. Owings **STUDIO:** Three/Chunklet Graphic Control **CITY:** Athens, Georgia/Atlanta, Georgia **URL:** www.chunklet.com **SOFTWARE PROGRAMS:** Photoshop, FreeHand **TYPEFACES:** Alternate Gothic, Rosewood

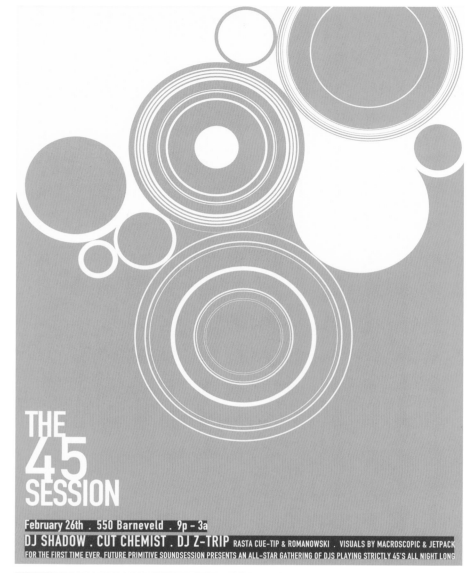

THE
45
SESSION

February 26th . 550 Barneveld . 9p - 3a

DJ SHADOW . CUT CHEMIST . DJ Z-TRIP RASTA CUE-TIP & ROMANOWSKI . VISUALS BY MACROSCOPIC & JETPACK
FOR THE FIRST TIME EVER, FUTURE PRIMITIVE SOUNDSESSION PRESENTS AN ALL-STAR GATHERING OF DJS PLAYING STRICTLY 45'S ALL NIGHT LONG

DESIGNER: Melissa Crowley **STUDIO:** Redbean **CITY:** San Francisco, California **URLS:** www.redbean.com, www.missylis.com **SOFTWARE PROGRAMS:** Illustrator, Photoshop

MW: WHAT LED YOU TO CHOOSE THIS PARTICULAR PIECE TO REDESIGN?

MC: It sounded like a cool night: all 45s, all night…DJ Shadow…nice!

ALRIGHT, HERE WE GO AGAIN, BUT ONLY BECAUSE THEY'RE MAKING ME ASK. DID YOU LIKE THE ORIGINAL DESIGN, OR WERE YOU EMBARRASSED FOR IT?

The original piece has a vintage, hand set style that I like a lot. It reminds me of a real 45 or a screen printed poster.

OH, YOU! SO, WE'VE GOT A LOT OF CIRCLES GOING ON HERE…WHAT WAS YOUR CONCEPT FOR THIS REDESIGN?

Even though I like the original, I wanted the redesign to be less linear and more stylized. The nature of the event seems free flowing and organic; I wanted to capture this and work a little more with the repetition and color.

WAS IT AN EASIER OR HARDER EXPERIENCE THAN YOU THOUGHT IT WOULD BE?

It was more difficult. With this project, the brief was visual, whereas I would usually work from something written and provided by the client. Also, while I wanted to reinterpret it in my own style, it was important to me to do the original piece justice and be inspired by it.

• • •

FEEDBACK FROM THE ORIGINAL DESIGNER:
MARK WASSERMAN

WHAT'S YOUR INITIAL REACTION TO EACH REDESIGN?
Diphthong Interactive Design: Engineered
Meat and Potatoes: See-dick-spin
Phatphool: Blueprint
Chunklet Graphic Control: Bang!
Redbean: Hypnotic

WHICH IS YOUR FAVORITE?
Well, of course I'm a big fan of them all, but if I had to pick one, I'd say the shooting target design by Three and Chunklet. As much as I'm not a gun guy, a target is still a great image to use, and the way that the information is displayed is so concise.

WHICH SURPRISES YOU? WHY?
The piece by Redbean has some great elements that I find a bit surprising. First, I love the way that the piece conveys the feeling of records spinning without showing a turntable. I'd like to see this piece go even further and not even have any information about the event.

OVERALL, WHAT DO YOU THINK OF ALL THE REDESIGNS?
I'm really impressed by all of them. If Phatphool printed up a T-shirt of his design, I'd buy it tomorrow. The vintage looks by Diphthong and Meat and Potatoes are also great, especially since they go in totally different directions. On the other hand, Diphthong goes space-age style with his design—every angle and color is absolutely perfect.

BEFORE IT'S
TOO LATE
POSTER

MW: THIS ISN'T YOUR TYPICAL ROCK POSTER. WHAT WAS THE ORIGINAL CONCEPT BEHIND THE IMAGERY?

MC: I used a hummingbird to introduce Drip Joy's new material, as they are said to be messengers who bear joy and remind us to engage in the moment. The artwork hopes to capture a sense of fresh, inspired thought and provoke curiosity.

WHAT'S SO STRIKING HERE IS THE COMBINATION OF THE BLURRED PHOTOGRAPH ALONG WITH THE SHARPNESS AND CLARITY OF THE SHAPES ON TOP OF IT. IS THAT A TECHNIQUE THAT YOU USE A LOT IN YOUR WORK?

I do like to use contrasting elements a lot, sometimes layered like this piece and other times in a more subtle way.

DID YOU TRY ANY OTHER APPROACHES WITH THIS PIECE?

The final design evolved from some initial work I had done based on the concept of illumination. These were more abstract with lots of layered, translucent curves.

WHAT WAS THE BIGGEST CHALLENGE FOR THIS PIECE?

To communicate a lightheartedness while steering clear of the fluff zone.

DID YOU EVER BUY AN ALBUM JUST BECAUSE OF THE COVER ART?

Many! Most recently, a Towa Tei CD with a cover by TDR and a Throwing Muses CD with the most beautiful foldout cover by Vaughan Oliver, Chris Bigg and Shinro Ohtake.

. . .

river
five-to-one
silence or screaming
disentertainment
from the trees
jesse

DRIPJOY

→ *Brand New* DRIP JOY ∾ BEFORE IT'S TOO LATE ON SALE NOW: WWW.DRIPJOY.COM

DESIGNER: Melissa Crowley **STUDIO:** Redbean **CITY:** San Francisco, California **URLS:** www.redbean.com, www.missylis.com **YEAR:** 2002 **SIZE:** 11" x 17" (28 x 43 cm) **SOFTWARE PROGRAMS:** Illustrator, Photoshop **TYPEFACES:** Officina Sans Bold, Shelley Andante, Rosewood

DESIGNER: Hege Aaby STUDIO: Sennep CITY: London, England URL: www.sennep.com SOFTWARE PROGRAMS: Ilustrator, Photoshop, 3D Studio Max

MW: WHY DID YOU PICK THE DRIP JOY PIECE TO REDESIGN?

HA: It wasn't easy to choose what design to reinterpret, but the name Drip Joy grabbed my attention, and I started to get ideas of how to design the poster. I also liked the idea of designing a poster for a girl garage band.

DID YOU LIKE WHAT THE ORIGINAL DESIGNER HAD DONE?

I liked the original design. I thought it was elegant and simple, and the use of typography was good. My only reservation was that the white shapes on top of the image made the design look very flat.

CAN YOU DESCRIBE YOUR REDESIGN CONCEPT?

The name of the band inspired me more than the title of the album, so I decided to visualize the name Drip Joy in a very literal way. The idea was that from the name Drip Joy, paint would leak out and run towards you, making you feel that it was about to drip on you. The three members of the band would emerge from the sticky paint in the form of rock fairies that would bring joy with their music. I wanted to contrast the cute and mysterious image of fairies with the image of rock chicks in a garage band.

. . .

DESIGNERS: Alun Edwards and Si Billam STUDIO: twelve:ten CITY: Nottingham, England URL: www.twelveten.com
SOFTWARE PROGRAM: FreeHand TYPEFACE: FF Din

MW: WHY DID YOU CHOOSE THE DRIP JOY POSTER PIECE TO REDESIGN?

AE: It was right up our alley.

SB: I was requested to apply my skills to this job.

DID YOU LIKE THE ORIGINAL DESIGN, OR DID YOU THINK IT COULD USE A BIT OF HELP?

AE: I didn't really like it that much; it seemed a bit dated.

SB: Yes, I liked it. It's a bit Carson-esque.

WHAT WAS YOUR CONCEPT FOR THE NEW DESIGN?

AE: I have always liked Japanese prints for their ability to make really powerful, intense moments become uplifting. I guess that's what I wanted to do, but something fairly digital as well.

SB: I listened to his views and then did my thing.

HOW WAS THE OVERALL EXPERIENCE?

AE: It was hard without having a client to work with, but it's often the way when doing your own work. Once we had agreed on a concept it then became fairly easy to complete.

. . .

MW: WHY DID YOU CHOOSE THIS PARTICULAR PIECE TO REDESIGN?

AM: It wasn't a complicated process. While viewing the various possibilities, one of our fellow Fork colleagues, who is American, recognized the work of the Drip Joy poster as that of a former colleague of his in the United States. We all liked the poster and thought it would be interesting and fun to do a reinterpretation of the work by a designer we were familiar with.

BUT YOU'RE NOT SUPPOSED TO KNOW WHO THE ORIGINAL DESIGNER WAS! OH WELL...TELL ME ABOUT YOUR CONCEPT FOR THIS REDESIGN.

I decided that no matter what the outcome of the poster, or how far it strayed from the original, it had to say something. The major elements of the original were the band's name, Drip Joy, the phrase "Before it's too late," and a bird surrounded by water. I took these major elements and made a series of new combinations. The resulting poster is somewhat self-explanatory, especially when you think about the multiple directions the world is often turning: politically, physically and in our own private spheres.

WAS IT AN EASIER OR HARDER EXPERIENCE THAN YOU THOUGHT IT WOULD BE?

In the beginning of this process, I found it a bit difficult to start, considering the fact that I had found nothing particularly wrong with the original. But all in all, I found this project to be rather pleasurable and refreshing. It was a time to experiment with different illustration techniques and play with different ideas of interpretation.

• • •

River Five-to-one **Silence or Screaming** Disentertainment From the Trees **Jesse**

Brand Ned
Before it's too late!
Drip Joy

DESIGNER: Anna Mentzel **STUDIO:** Fork Unstable Media **CITY:** Hamburg, Germany **URL:** www.fork.de **SOFTWARE PROGRAM:** Illustrator **TYPEFACE:** Clarendon

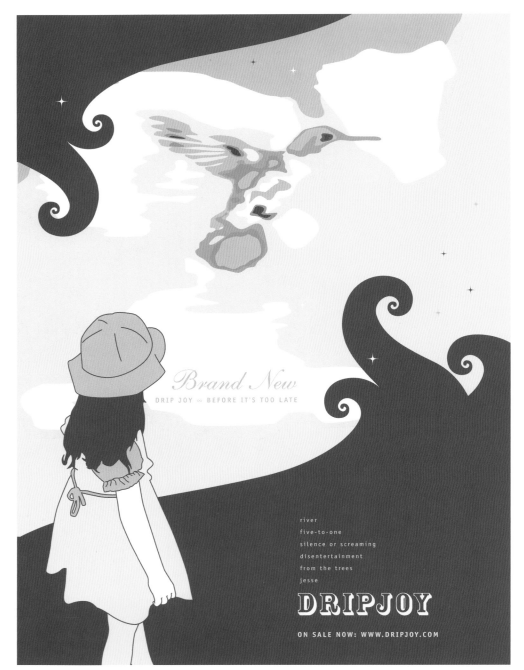

DESIGNER: Anna Augul **CITY:** Melbourne, Australia **URLS:** www.quikanddirty.com, www.australianinfront.com.au, www.neverendingremix.com **SOFTWARE PROGRAM:** Adobe Illustrator

MW: SO, WHY DID YOU CHOOSE THIS PIECE IN PARTICULAR TO REDESIGN?

AA: I really love the original poster. It's beautiful, and plus I've been quite obsessed with birds and all things girly lately, so the opportunity to use the hummingbird was very appealing.

WHAT DOES "ALL THINGS GIRLY" MEAN TO YOU?

I don't consciously try to make things girly. It just comes naturally, so if I'd moved away from it, that would be a reflection of things going on around me at the time. I wouldn't say that there are specific elements—rather a combination that stems from inspiration and application. For me that can be anything from kittens and ladybugs to high heels and 1980s glam.

YOUR REDESIGN REALLY MAKES IT FEEL LIKE WE'RE OUTSIDE A WINDOW, JUST PEEKING AT THE ORIGINAL. WHAT WAS YOUR CONCEPT?

I loved the first one so much I didn't really want to change it too much. So, I thought I'd add to it a little bit and then just play around with the colors and the positioning of the type. The little girl was added just to reiterate the notion of happiness and joy, which is one of the things people get from music.

YOUR ILLUSTRATIONS TEND TO BE SO CRISP, IT SEEMS A BIT OUT OF CHARACTER FOR YOU TO REALLY SOFTEN THE HUMMINGBIRD. ANY REASON FOR DOING THAT?

My work is constantly evolving, so I guess moving away from something I usually do is just another step in my development. I've only been at it for a couple of years, so I'm trying out new things. I have a zillion ideas rushing through my head at any one time, so it's just a matter of catching one and trying it out.

. . .

MW: SO, WHY DID YOU CHOOSE THIS PARTICULAR PIECE TO REDESIGN?

DW: I tried to choose pieces that I thought would work well conceptually and would maybe lend themselves to a play on words or something. I thought "Before It's Too Late" could offer some interesting solutions.

YEAH, UNTIL I SAW YOUR PIECE, I DIDN'T REALLY THINK ABOUT ANY OF THE APOCALYPTICAL OVERTONES TO THE TITLE. WHAT DID YOU THINK ABOUT THE ORIGINAL DESIGN?

It was cool. It's got a bit of a 4AD thing going for it. Not something I would do though, which is part of the reason I chose it. I knew I could offer a different perspective on it.

I'D SAY YOU DID. CAN YOU DESCRIBE YOUR CONCEPT?

If I did it right, you should know.

YOU'LL LET THE NUMBERS SPEAK FOR THEMSELVES, EH? YOU REALLY TOOK THE CONCEPT IN AN ENTIRELY DIFFERENT DIRECTION THAN THE ORIGINAL. HOW WAS THE OVERALL EXPERIENCE?

The idea was easy; the application took a while.

. . .

FEEDBACK FROM THE ORIGINAL DESIGNER:
MELISSA CROWLEY

LOOKING AT THE REDESIGNS, WHAT'S YOUR INITIAL REACTION TO EACH ONE IN ONE WORD?

Sennep: Esoteric
twelve:ten: Otherworldly-lovely
Fork Unstable Media: Whimsical, boundless
Anna Augul: Dreamy-vintage
sweaterWeather: Suggestive

DO YOU HAVE A YOUR FAVORITE?
I can't decide. I like them all.

WEAK! OK, DO ANY OF THEM SURPRISE YOU?
Each redesign has captured a unique aspect of Drip Joy, which is very cool, given so little source material to work with.

YOU'RE QUITE THE DIPLOMAT. ANY OVERALL THOUGHTS ABOUT ALL THE REDESIGNS?
I loooooove them!

BEFORE IT'S TOO LATE

NEW ALBUM OUT NOW : WWW.DRIPJOY.COM

DESIGNER: Dave Weik **STUDIO:** sweaterWeather **CITY:** Chicago, Illinois **URL:** www.sweaterweather.org **SOFTWARE PROGRAM:** Illustrator **TYPEFACE:** DIN Mittelschrift

CH 22

MENSA DANCE SQUAD CD COVER

MW: WHAT WAS THE INSPIRATION FOR THE MENSA DANCE SQUAD PACKAGING?

KH: A. The existence of a electronic music subgenre entitled "Intelligent Dance Music" (IDM).

B. The existence of Mensa, a society for bright people.

C. The book jacket design of Dutch designer Irma Bloom.

THE MENSA PEOPLE HAVE GOTTEN TO YOU! YOUR ANSWERS LOOK LIKE MULTIPLE-CHOICE QUESTIONS. I'LL JUST ASSUME THERE'S A "D. ALL OF THE ABOVE" CHOICE.

MUCH OF IDM COVER ART TENDS TO HAVE A RESERVED, SCHOLARLY LOOK ABOUT IT. WERE YOU CONSCIOUSLY AWARE OF MOVING AWAY FROM THAT LOOK?

The concept was to provide a gentle dose of irony, both musically and visually, to IDM's fans, who are typically stereotyped as cerebral, hypercritical music listeners.

WHAT WERE THE BIGGEST CHALLENGES IN CREATING THIS PIECE?

Taking various IQ tests during research for this project.

NOW THAT YOU'VE TAKEN THE TESTS, HOW DO YOU FEEL ABOUT MENSA?

It's an SAT test for adults. Mensa is a frivolous organization that does nothing to benefit humanity but indulge each other's intellect. An organization such as this could take a more prominent role in helping solve social and political issues.

HOW MANY TIMES HAVE PEOPLE TOLD YOU THAT THERE'S A TYPO ON THE COVER?

It's too clever for its own good. People rarely notice.

• • •

DESIGNER: Kent Henderson **STUDIO:** Fuzemine **CITY:** Chicago, Illinois **URLS:** www.fuzemine.com, www.kenthenderson.com **YEAR:** 2001 **SIZE:** 5" x 5" (13 x 13 cm) **SOFTWARE PROGRAM:** Illustrator **TYPEFACES:** Akzidenz Grotesk, ITC Century, Helvetica, Helvetica Condensed

DESIGNERS: Kjell Ekhorn and Jon Forss **STUDIO:** Non-Format **CITY:** London, England **URL:** www.non-format.com **SOFTWARE PROGRAMS:** Quark, Photoshop **TYPEFACE:** Helvetica Neue 75 Bold

MW: WHAT DID YOU THINK OF THE ORIGINAL DESIGN?

KE&JF: To use the Mensa test graphics as pure decoration seemed to us to be missing the point of the idea. Perhaps the designers wanted to convey a childlike view of the Mensa test by cutting it up and ignoring the meaning, but that didn't really seem to be the intention. We wanted to find a way to get the Mensa aspect across in a nice and direct way.

YOU WERE DEFINITELY SUCCESSFUL IN KEEPING IT DIRECT. CAN YOU DISCUSS SOME OF THE OTHER CONCEPTS OF YOUR REDESIGN?

We decided to create the booklet as a kind of Mensa test in itself, starting with the bright yellow cover sheet—we chose gray Helvetica to lend it some gravitas. We thought it would be nice to use a real stubby yellow pencil instead of the illustrated one from the original design. This could be inserted in the convenient gap on the left-hand edge of the clear jewel case.

We also thought it would be a nice idea if there was just one mind numbingly simple question written in big letters in the middle of the opened booklet. We chose "2+2=?" because of the phrase "adding two and two to get five," meaning to misunderstand a situation. As a sign-off, we wrote the solution to the equation in tiny letters upside down at the bottom—the answer, no matter what you fill in, is "Lesser."

. . .

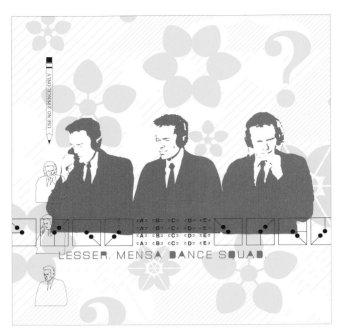

DESIGNER: Jonathan Nicol **STUDIO:** F6 Design **CITY:** Melbourne, Australia **URL:** www.f6.co.nz **SOFTWARE PROGRAMS:** Illustrator, Photoshop, Flash **TYPEFACE:** Kombat (self-designed)

MW: WHAT ATTRACTED YOU TO THIS PIECE?

JN: Initially it appealed to me because I saw a great deal of conceptual possibility in the album title and appreciated the cleverness of the original design. Having recently seen an Errol Morris documentary about the "smartest man in the world," the reference to the high-IQ Mensa society also sparked off a number of associations for me.

IS IT HARDER WHEN YOU LIKE THE ORIGINAL DESIGN?

I didn't approach my redesign from the perspective of improving on the original piece; rather I used the original as a springboard for exploring my own ideas on the same theme. I was happy to include a lot of the original visual material in my own design, and the only aspect of the original that it was really important to me to revise was to give greater prominence to the artist's name and album title on the cover.

CAN YOU ELABORATE ON YOUR CONCEPT FOR THE REDESIGN?

I amplified the more decorative aspects of the original while retaining the tongue-in-cheek references to the intellectual elite. Wearing DJ-style headphones, the three men in my cover design are a reference to the stereotypical Intelligent Dance Music listener.

HOW WAS THE OVERALL EXPERIENCE?

It flowed quite naturally; the original piece was rich with conceptual associations, which sparked my imagination when I started the redesign.

• • •

INTELLIGENCE
SHOULD BE USED
FOR THE BENEFIT
OF HUMANITY.

LESSER//
MENSA//DANCE
SQUAD//

©2003 ®bePOS|+|VEdesign
WWW.bePOSITIVEdesign.com

DESIGNER: Tnop Wangsillapakun **STUDIO:** bePOS|+|VE design **CITY:** Bangkok, Thailand **URL:** www.bepositivedesign.com **SOFTWARE PROGRAMS:** Photoshop, Illustrator **TYPEFACE:** Clarendon (Linotype)

MW: SO, WHY DID YOU CHOOSE THE MENSA DANCE SQUAD PIECE?

TW: I love doing conceptual design, so I was looking for the project that would require more thinking than just style. Plus, doing a CD project allows more freedom to express creativity, even though you only have a 5" x 5" (13 x 13 cm) canvas to work with.

HOW DID YOU FEEL ABOUT THE ORIGINAL DESIGN—DID YOU THINK IT NEEDED HELP?

Well, I like the concept of the original design but am not quite drawn by the execution. To me, the graphic elements seem to be overpowering the concept of the piece a bit. It's just a thought.

DO YOU TRY TO ACTIVELY INCORPORATE HUMOR INTO ANY OF YOUR PERSONAL OR PROFESSIONAL WORK WHEN IT'S NOT AN OBVIOUS SOLUTION?

Yes, I love design with good humor. It's more memorable, and I think design should be able to ouch people.

WHAT WAS YOUR CONCEPT FOR THIS REDESIGN?

First of all, I wanted to do something totally different from the original design, so I decided to use photography in my design. I chose Albert Einstein as an iconographic representation of the constitution of Mensa.

Then, I put all the information in the spot on the left side of Einstein's eye as though it was a part of his vision. I didn't want to make the cover too serious, so I decided to use bright colors and turned the Einstein photo into a semi-drawing.

• • •

MW: AS AN IDM FAN, I KNOW YOU PUT A LOT OF THOUGHT INTO THIS PIECE. WHAT WAS YOUR CONCEPT FOR THE REDESIGN?

MS: The original design invokes a comparison between the Intelligent Dance Music community and Mensa. It asks the viewer to explain the motivation behind the comparison. Was it an ironic jab at the IDM listener or perhaps a serious assertion that IDM is for a more intelligent caste of music listener? My personal view is that the term "IDM" serves as a means of exclusivity by creating an aura of inaccessibility around a style of music that can be enjoyed by those with SAT scores well under 1600.

I wanted to interject my cynical observations by superficially obfuscating the core type components using absurdly simplistic variations of MENSA riddles. While the artist's name and album title are deduced rather than simply read, one need apply only a smidgen of thought to decipher the core messages.

In addition, I applied a new visual treatment that would attempt to reflect the furious, unrelenting, intricate and mechanical sound of Lesser's music.

YOU WENT THROUGH A LOT OF VARIATIONS OF YOUR DESIGN THROUGHOUT THE PROCESS. LOOKING BACK, HOW WAS THE OVERALL EXPERIENCE?

It was challenging to create a new execution of the concept without constantly thinking about how the previous design had already accomplished that task. Also, it's intimidating to know that the finished piece would be contrasted and compared with the existing design, not necessarily judged solely on its own merits.

. . .

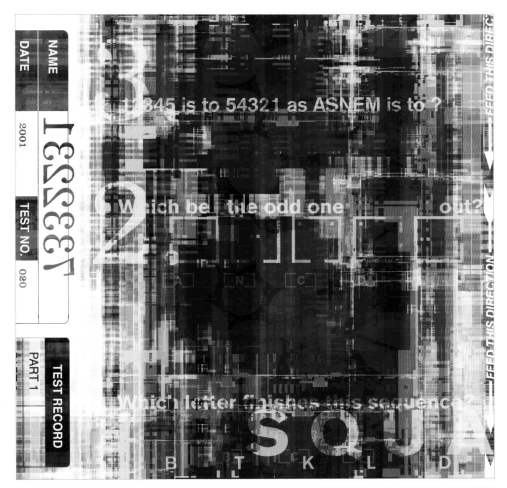

DESIGNER: Mike Stern STUDIO: reConfigured CITY: San Francisco, California URLS: www.reconfigured.com, www.proper-gander.com, www.desktopimage.com, www.Ørigin.com SOFTWARE PROGRAM: Photoshop TYPEFACES: Akzidenz Grotesk, New Century Schoolbook

FEEDBACK FROM THE ORIGINAL DESIGNER:
KENT HENDERSON

WHAT'S YOUR INITIAL REACTION TO EACH ONE IN ONE WORD?
Non-Format: Clever
F6 Design: Kraftwerk
bePOS|+|VE design: Genius
reConfigured: Algorithm

DO YOU HAVE A FAVORITE?
The Einstein one by bePOS|+|VE design—the "intelligence" idea rooted in an entirely new concept. Brilliant idea and striking design.

WHICH ONE SURPRISES YOU?
The idea by Non-Format strikes me as the most clever. It communicates the "intelligence" theme in a clear, concise and simple way.

OVERALL, WHAT DO YOU THINK OF ALL THE REDESIGNS?
Three of the four designs—by Non-Format, reConfigured, and bePOS|+|VE—are skillful interpretations of the musician's actual work and could have easily been selected as the cover.

MW: CAN YOU TALK ABOUT THE DESIGN CONCEPT FOR THIS POSTER?

LH: The theme of that year's charity event was "Rockin' 50s," so the look and feel are inspired by 1950s culture.

YOUR DESIGN REALLY NAILS THE 1950S THEME PERFECTLY. HOW DID YOU GO ABOUT MAKING SURE IT WOULD LOOK AUTHENTIC?

We began by doing research on the era. It was important for us to really take advantage of the recognizable and authentic elements of the decade in design. Once we had synthesized all of that, we were ready to infuse them with some of our own twists. The hardest aspect to the 1950s design was to make the printed pieces looked aged—as if they had been in a trunk for several decades.

Since we wanted this piece to truly look dated, we selected a very muted color palette and gave all the black elements a brown tint. Then we intentionally offset the colors with a coarse dot pattern to give it an archaic and out-of-register appearance. The brochure was then printed on a white uncoated stock; however, we created an off-white background with flecks for a gritty newsprint feel. A tremendous amount of work went into making it look old. Overall, it was quite a challenge to pull off in the design phase and on press, but the end result was well worth it.

WHAT WERE THE BIGGEST CHALLENGES IN CREATING THIS PIECE?

To create a fun, low-budget period piece in a short time-frame without being cheesy or trite.

. . .

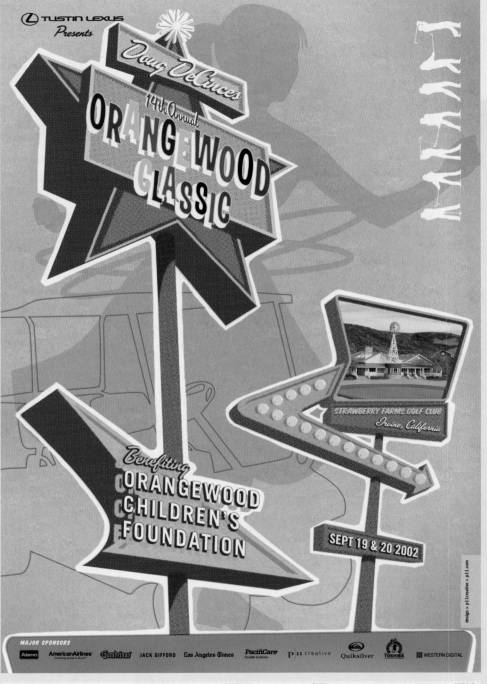

ART DIRECTOR: Lance Huante **DESIGNER:** Alex Chao **STUDIO:** p11creative **CITY:** Santa Ana Heights, California **URLS:** www.p11.com, www.p11funhaus.com **YEAR:** 2002 **SIZE:** 12" x 17½" (30 x 44 cm) **SOFTWARE PROGRAMS:** Illustrator, Photoshop **TYPEFACES:** Las Vegas (House) and Trade Gothic

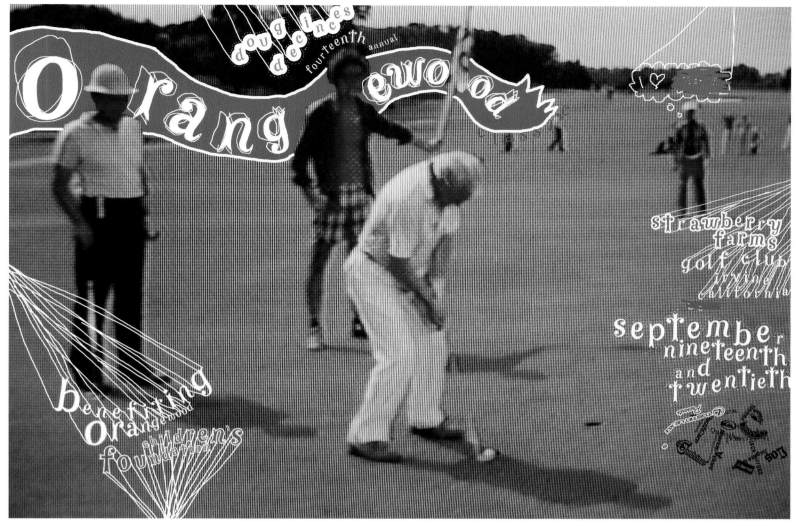

DESIGNERS: Curtis Nishimura and Conor McCann **STUDIO:** Wonder Wagon **CITY:** San Francisco, California **URL:** www.wonderwagon.com **SOFTWARE PROGRAM:** Photoshop **TYPEFACE:** New Bicycle (self-designed)

MW: I WAS HAPPY TO SEE YOU PICK THIS DESIGN TO WORK WITH…WHY DID YOU CHOOSE THIS ONE?

Nothing says "good times" more than a sporty golf poster. We also have a soft spot for instructional golf videos from the 1980s, and that could have a lot to do with it.

DID YOU LIKE THE ORIGINAL DESIGN, OR DID YOU THINK IT NEEDED SOME HELP?

Of course it needed some help! That's why we put in a little guy with a bubble over his head that said "I love…" with a scratched-out thing after it. It works on literally everything.

YOU DID SCRATCH OUT A FEW THINGS ON YOUR DESIGN. IS THE DELETE KEY JUST TOTALLY OVER-RATED?

We just love our crappy ideas and want to remind all those designers out there that you can't take yourself too serious-ly; it's OK to make an ass out of yourself sometimes. There's one jazz philosophy that says there are no wrong notes if you know how to mess up correctly.

WELL SAID. SO, WHAT WAS THE CONCEPT FOR THIS REDESIGN?

We were looking to really get messy with this piece and not be too intellectual about it. The concept boiled down to one major theme: "Get'n loose, feel'n fine."

WHAT'S THE FIRST STEP TO "GET'N LOOSE AND FEEL'N FINE"?

Don't think, just start mak'n stuff. Figure out which directions get you excited and which don't. Get into the flow, keep a focus on where it should go and let the little guy grow into a strong young man…It can happen!

. . .

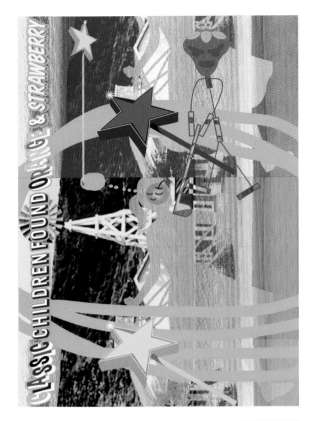

DESIGNER: Mumbleboy **STUDIO:** Milky Elephant **CITY:** New York, New York **URLS:** www.mumbleboy.com, www.milkyelephant.com **SOFTWARE PROGRAMS:** Flash, Photoshop

MW: DID YOU LIKE THE ORIGINAL DESIGN, OR DID YOU THINK IT NEEDED SOME HELP?

M: I think for its purpose it seemed perfect. I liked the colors, use of photography and the dynamic graphic elements.

SO, WHAT WAS YOUR CONCEPT FOR THIS REDESIGN?

I didn't really have a concept in the beginning. I redrew the graphic elements in Flash and tried to see if I could make a new piece using them.

YOUR INCLINATION WAS TO USE FLASH FOR A PRINT PIECE. WHY FLASH?

Well, I'm much more adept at using Flash than any other program. I also thought I could easily turn it into something using Flash, but my first trial came out as a bit boring. It seemed as though it needed a different kind of background to set the vector elements off, so I took the elements into Photoshop and worked them a little further. I also ended up putting in some originally drawn elements to sort of give it a story.

THE ORIGINAL POSTER WAS FOR A GOLF EVENT WITH A "ROCKIN' 50'S" THEME. WHAT KIND OF GOLF EVENT WOULD YOUR POSTER BE FOR?

Maybe it could be for children…to look for fruit or something.

. . .

DESIGNER: Timothy O'Donnell **STUDIO:** O'Donnell Design **CITY:** New York, New York **URL:** www.timothy-odonnell.com **SOFTWARE PROGRAMS:** Illustrator, Photoshop **TYPEFACE:** Bell Gothic Black (Adobe)

MW: SO, WHY DID YOU CHOOSE THIS PARTICULAR PIECE TO REDESIGN?

TO: I liked the challenge of tackling a subject I'm not even remotely interested in—golf—and seeing if I could do something with it.

THAT'S A PRETTY BRAVE MOVE. WHAT DID YOU THINK ABOUT THE ORIGINAL DESIGN?

There are some nice elements to the original, but I don't think the piece works as a whole. My main problem with it is that it sits in a weird place between 2-D and 3-D. I'd rather have seen the information on the sign treated as one or the other, flat or with physical depth, instead of a flat representation of a three-dimensional object.

SO, WHAT DID YOU USE AS YOUR CONCEPT FOR THE REDESIGN?

The original piece has many layers, but I found one hidden at the very back to be the most interesting. It's a little girl: not an image you'd associate with golf. The tournament benefits a children's foundation, so I thought it'd be appropriate to bring her to the front and keep the golfer in the background.

WAS IT AN EASIER OR HARDER EXPERIENCE THAN YOU THOUGHT IT WOULD BE?

It actually went much quicker than I thought it would. I went through all the original layers and just discarded the ones that didn't immediately appeal to me.

. . .

MW: DESIGNERS SEEMED TO BE HESITANT TO TAKE ON THE GOLFING PIECE. WHY DID YOU CHOOSE THIS PARTICULAR PIECE TO REDESIGN?

MH: I chose it partly because I thought the original design was so well done. I didn't want a piece that I would just try to make better; I was interested more in a reinterpretation. I thought it would be more fun to show a completely different take and mood. Unlike the original designer, I had no client to deal with, so I could pay a little less attention to what the event seemed to be calling for.

SO YOU CLEARLY LIKED THE ORIGINAL DESIGN…WAS THERE AN AREA WHERE YOU FELT IT COULD USE HELP?

I did like it, but if there was a weakness, it was that the retro-y, Charles Anderson thing seemed obvious to me, so I wanted to try something that didn't have that look.

AH. SO, WHAT WAS THE CONCEPT FOR YOUR REDESIGN?

I wasn't trying to have an overt concept. Perhaps because of how I truly feel about golf, I was inclined to make the mood of this piece a little dark. I used to play golf a lot and just became so turned off, not just for how environmentally damaging the game is or its disturbing history of social exclusivity, but mainly because the game is just too damn hard. Most images of golf courses try to capture the beauty of a long fairway; I just see all of the places my ball is going to get caught in.

. . .

FEEDBACK FROM THE ORIGINAL DESIGNER:
LANCE HUANTE

WHAT'S YOUR INITIAL REACTION TO EACH REDESIGN?
Wonder Wagon: Scary
Milky Elephant: Awful
Timothy O'Donnell: Minimal
Action Figure: Inappropriate

DO YOU HAVE A FAVORITE OUT OF THE BUNCH?
To be honest, I don't feel that any of these designs conveyed the theme of the event, nor did they effectively communicate the necessary information, which is the whole purpose of an event poster. If I had to pick a favorite, however, I would go with the design by Timothy O'Donnell. The clean silhouettes on the crisp white background with the understated type treatment has a pleasing feel. The piece by Action Figure has a unique illustration style and an interesting autumnal color palette.

DO ANY OF THEM SURPRISE YOU?
The imagery in Wonder Wagon's is funny as hell and the typography is very cool, but for an event benefiting abused children, I just don't think it's appropriate. Plus the event sponsors, who paid $15,000–$25,000 each, would not appreciate their logos crammed illegibly in the lower corner. As far as Milky Elephant's piece goes, it is so unintelligible that I don't even know where to start.

OVERALL, WHAT DO YOU THINK OF ALL THE REDESIGNS?
The designers obviously took creative liberties with these interpretations, which I suppose is OK. I just hope they approach their real-world projects a bit more appropriately.

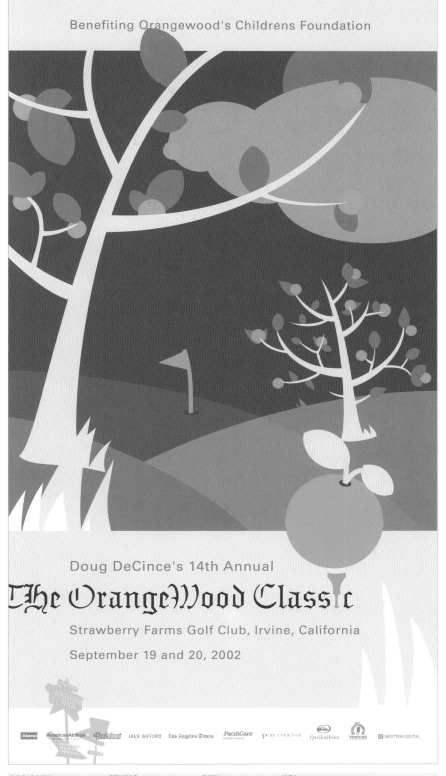

Benefiting Orangewood's Childrens Foundation

Doug DeCince's 14th Annual
The OrangeWood Classic
Strawberry Farms Golf Club, Irvine, California
September 19 and 20, 2002

DESIGNER: Matt Hovis **STUDIO:** Action Figure **CITY:** Austin, Texas **URL:** www.actionfigure.com

LITE ROCK
KILLS POSTER

MW: WHAT WAS THE INSPIRATION FOR LITE ROCK KILLS?

NS: I was in the airport in Auckland, New Zealand, and they were playing the same cheesy lite rock there that I had recently heard in the United States, Germany, England, etc. It seemed to me like an epidemic of bland cultural homogeneity was sweeping around the world, and I wanted to say something about it.

DID YOU TRY ANY OTHER APPROACHES WITH THIS PIECE?

It went through about ten iterations. At first I wanted to create a world map that tracked the spread of lite rock, but the message wasn't clear and immediate enough. Then I started researching diseases like alcoholism and depression and applied those same symptoms to lite rock listeners. The text and the brain image followed naturally from there.

WHAT WERE THE BIGGEST CHALLENGES WITH THIS PIECE?

Avoiding the police while wheat-pasting the poster around San Francisco! There weren't really any big obstacles; it was an enjoyable piece.

. . .

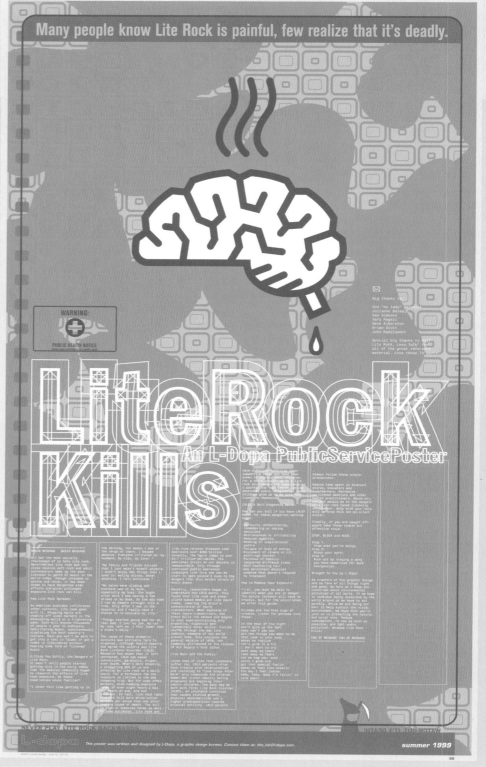

DESIGNER: Nik Schulz **STUDIO:** L-dopa **CITY:** San Francisco, California **URL:** www.l-dopa.com **YEAR:** 1999 **SIZE:** 19" x 31" (48 x 79 cm) **SOFTWARE PROGRAM:** Adobe Illustrator **TYPEFACES:** Franklin Gothic, Berthold Akzidenz Grotesk, Monotype, Eurostyle

MW: SO, WHY DID YOU CHOOSE THIS PARTICULAR PIECE TO REDESIGN?

BM&ME: It was addressing an issue that we are interested in here at FGA. We felt that the scope of the subject, "bland cultural homogenization," was far too broad and complex to be represented by a critique of "lite rock," which, after all, is nothing more than a matter of taste. Cultural homogenization goes far beyond taste and is contingent upon many things.

If the last twenty years of cultural production has taught us anything, it is that today's crap is likely tomorrow's gold. Sure, we have our own ideas of what constitutes culture; it's just hard for us to point a finger at the "bad guys." The issue's not quite so black and white.

WHAT'S GOING ON IN YOUR REDESIGN?

We thought it would be much more useful to engage the issue using a visual language drawn from the very thing it was intended to critique. Hence, the iconography of our piece is drawn primarily from suburban housing developments and exurban bedroom communities. The color palette comes from that of strip mall restaurants and airport hotel conference rooms. We also wanted to draw attention to the multiple connotations of the notion of "one," both negative and positive.

In general, our goal was to do more than preach to the faithful. We wanted to try speaking to an audience that did not necessarily share our assumptions of good and bad and to get a stronger grasp on our own role as producers.

. . .

DESIGNERS: Bill Morrison and Matt Eller **STUDIO:** Feel Good Anyway **CITY:** Portland, Oregon **URL:** www.feelgoodanyway.com **SOFTWARE PROGRAM:** Adobe Illustrator **TYPEFACE:** Akzidenz Grotesque

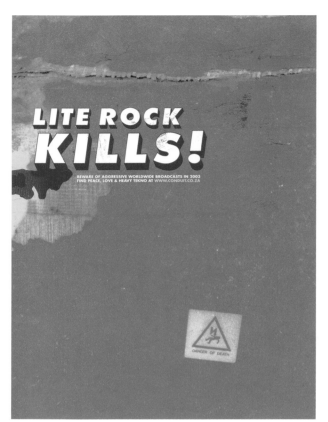

DESIGNER: Lyall Coburn **STUDIO:** Conduit **CITY:** Cape Town, South Africa **URL:** www.conduit.co.za **SOFTWARE PROGRAM:** Photoshop **TYPEFACES:** Futura Bold and Extra Bold Oblique Shadow

MW: SO, WHY DID YOU CHOOSE THIS PIECE TO REDESIGN?

LC: It's a poster that was meant to be put up around freeway overpasses. I think I chose this brief to design because I like the image of a freeway overpass shot from below.

OK. WHAT'S YOUR TAKE ON THE ORIGINAL POSTER?

I really enjoyed the concept behind the original design. The custom iconography used to portray the concept pulls it off nicely. It has too much text for a street poster, though.

CAN YOU TALK ABOUT YOUR REDESIGN CONCEPT?

Two comparative parallel themes run through the design. The nature of lite rock is compared to that of its parent country's government in the year 2003.

YOU LOST ME A BIT ON HOW THIS DESIGN COMMENTS ABOUT GOVERNMENT POLICY.

The design was my reaction to the U.S.-led war in early 2003. If lite rock kills, then it would seem to share a characteristic with the government in power at the time.

HOW WAS THE OVERALL EXPERIENCE?

I found the exercise harder than I imagined, due to the fact that the original design works really well.

• • •

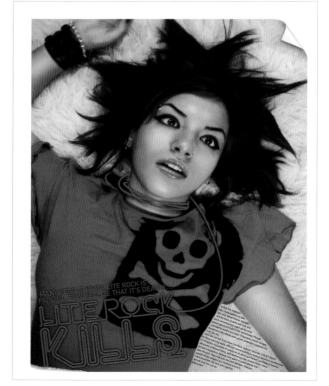

DESIGNER: Sarah Ancalmo **STUDIO:** TwoPiece **CITY:** New York, New York **URLS:** www.twopiece.net, www.freedomwig.net **SOFTWARE PROGRAMS:** Photoshop, Illustrator **TYPEFACES:** Neon, Din Mittelschrift

MW: WHY DID YOU CHOOSE THIS PARTICULAR PIECE TO REDESIGN?

SA: I really liked the concept. As someone who is not at all fond of Lite Rock, the humorous approach to this public service announcement really appealed to me.

BEYOND THE CONCEPT, DID YOU LIKE THE EXECUTION OF IT AS WELL?

I think that the design was a bit dated, considering it was originally created in 1999. I think some of the design elements were really interesting and supported the concept, but that there needed to be a more arresting image to draw people to read the hilarious copy.

SO YOU CAME UP WITH THE HIGH-VOLTAGE REDESIGN. WHAT WAS YOUR CONCEPT?

I was thinking of a hipster struck dead by the shrill spectra of lite rock. The victim's name is Juliya Chernetsky, who is the host of a hard rock show called *Uranium* on the Fuze network.

THIS COULD PROBABLY BE HER NEW PROMO PHOTO…WAS THE REDESIGN AN EASIER OR HARDER EXPERIENCE THAN YOU WERE EXPECTING?

Overall, it was a pretty en-lite-ning experience. Har, har. I don't know about anyone else, but for me getting to rethink concepts is the bread and butter of the design process. It was a good twist to be my own client.

• • •

MW: WHAT IS IT ABOUT "LITE ROCK KILLS"?

MW: The headline is just too damn funny. I think the cultural homogeneity aspect of the design is very clever, but it didn't really factor into my wanting to work with the design at all. I took this poster to mean that the smooth 'n easy sound of lite rock, native to many dental office waiting rooms, was potentially lethal. And I wouldn't argue with that.

WHAT DID YOU THINK ABOUT THE ORIGINAL DESIGN?

I like it a lot. I remember when it was first pasted up in San Francisco everywhere I would always try to grab one, but I would just end up tearing it. Wheat-pasted posters just aren't meant to be souvenirs.

HOW DID YOU APPROACH THIS REDESIGN?

I originally toyed with a bunch of different concepts. I did kind of a Shepard Fairey "OBEY" parody with Barry Manilow's face and the word "murderer" placed dramatically across it. Others were along the lines of 12-step sobriety posters with greased-up lotharios lamenting how they'd lost years of their lives while trapped in a world of lite rock. Eventually, I settled upon the funeral procession. There's nothing too deep going on here: lite rock has claimed yet another victim.

HOW WAS THE EXPERIENCE THIS TIME AROUND?

It's pretty hard to miss with this one. Sure, it's a bit elitist to talk about one genre of music being inherently better than the other, but when it's lite rock, who cares? Maybe in the alternate bizarro universe, all the lite rock fans are spreading propaganda about punk rock.

. . .

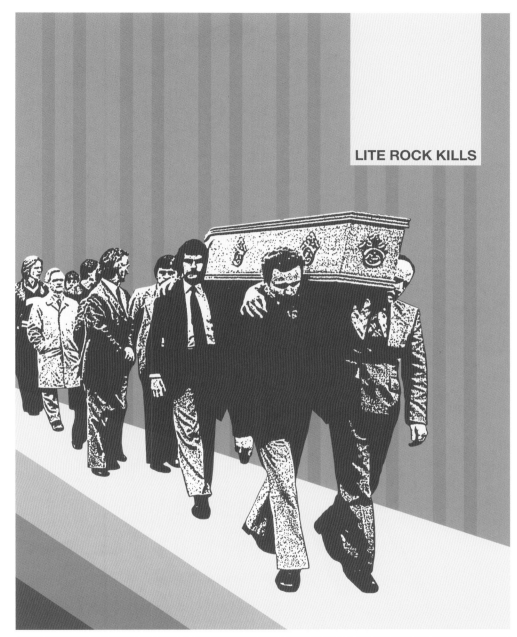

LITE ROCK KILLS

DESIGNER: Mark Wasserman **STUDIO:** Plinko **CITY:** San Francisco, California **URL:** www.plinko.com **SOFTWARE PROGRAMS:** Illustrator, Photoshop **TYPEFACE:** Helvetica

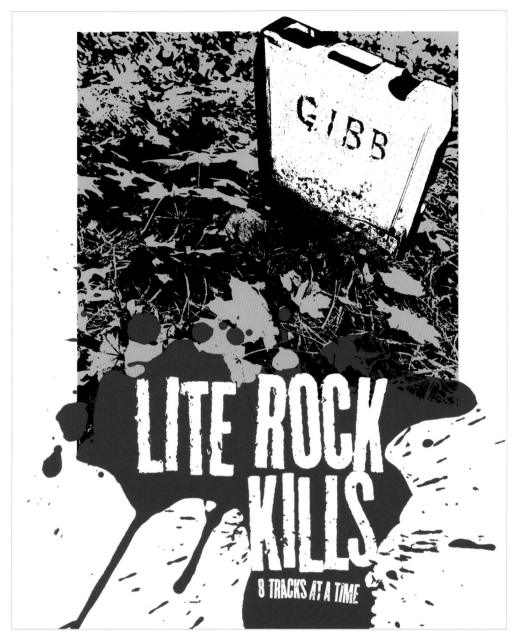

DESIGNER: Henry H. Owings **STUDIO:** Chunklet Graphic Control **CITY:** Atlanta, Georgia **URL:** www.chunklet.com **SOFTWARE PROGRAMS:** Photoshop, Illustrator, Finger Paint, Xerox machine **TYPEFACES:** Champion (HTF)

MW: SO, WHAT KIND OF IMAGE DOES LITE ROCK CONJURE UP FOR YOU?

HO: I couldn't think of anything less capable of conjuring up an image than this "genre" of rock. I think lite rock was started because guys could get laid easier than going to a Ted Nugent concert.

THE ORIGINAL DESIGN ATTACKED AN OVERALL CULTURE, BUT YOU'VE REALLY NARROWED DOWN THE MESSAGE.

I just kept thinking blood and eight-tracks. Blood just kept coming up in my mind, and I was looking at a bunch of old Art Chantry posters and thinking, "I know what he'd do: maybe use something really crude like a Xeroxed pic of Andy Gibb or one of those assholes like Leif Garrett and then put really torn-up text on top of it." It would just be something really reactionary.

HOW'D IT ALL TURN OUT IN THE END?

Honestly, this was the hardest design project I've ever worked on, even though in the end it was fun. I even showed it to my mom, and she liked it, which is a good sign considering she's clueless about a lot of music and design. In my mind, that makes her a good critic; her reactions are more genuine. I don't want it to sound like I pass everything by her; she was just visiting.

...

FEEDBACK FROM THE ORIGINAL DESIGNER: NIK SCHULZ

WHAT'S YOUR INITIAL REACTION TO EACH REDESIGN?
Feel Good Anyway: Nodalneuralnetwork
Conduit Studios: Africa!
TwoPiece: Literockkillspunkrocklives
Plinko: Wallpapernotthemagazine
Chunklet Graphic Control: Splatterfest

DO YOU HAVE A FAVORITE?
Plinko's makes it so real. It's almost like, "Lite rock killed my father!" The mock drama is excellent. It looks like the guy in the front is thinking, "I told him the Whitney Houston would kill him. Why didn't he listen?" Conduit's is strong and clear. It communicates that it's South African in a nice, subtle way. I like the humor in TwoPiece's design too. It's like this punk rock chick hears an Elton John record and instantly her heart stops. We think, "Damn! She was so young, so pretty. This needless tragedy could have been avoided!"

ANY OF THEM SURPRISE YOU?
The less direct approach by Feel Good Anyway surprised me, but then the idea of a diverse network that doesn't actually contain any choices struck me as a strong one. It makes sense as a different take on the problem of cultural homogeneity.

CH 25 18TH STREET FASHIONISTA GUIDE

MW: THAT'S A PRETTY DAMN STYLISH WALKING MAP. WHAT WAS YOUR INFLUENCE FOR THIS PIECE?

TB: The main influence was subway maps from faraway cities such as Tokyo and London.

WERE THERE ANY OTHER APPROACHES YOU ATTEMPTED WITH THIS PIECE?

I originally tried a much more traditional approach that ultimately had too much detail and too many unnecessary streets.

WHAT WERE THE BIGGEST CHALLENGES IN CREATING THIS PIECE?

Getting the info from the clients!

ISN'T IT ALWAYS THE WAY…ANY OTHER CHALLENGES?

Fitting all of 18th street and all the required information in a very limited vertical space. Another challenge was giving the feel of walking uphill to each fashion boutique and creating an interesting perspective.

SO, DID YOU EVER GO OVER TO 18TH STREET JUST TO SEE SHOPPERS WALKING AROUND HOLDING YOUR MAP?

Sort of. I did see a few littered in my hood.

• • •

DESIGNER: Todd Baldwin **STUDIO:** PigeonHole Design **CITY:** Washington, DC **URL:** www.pigeonholedesign.com **YEAR:** 2002 **SIZE:** 3½" x 10½" (9 x 27 cm) **SOFTWARE PROGRAMS:** FreeHand, Dimensions **TYPEFACE:** Chalet Sixties

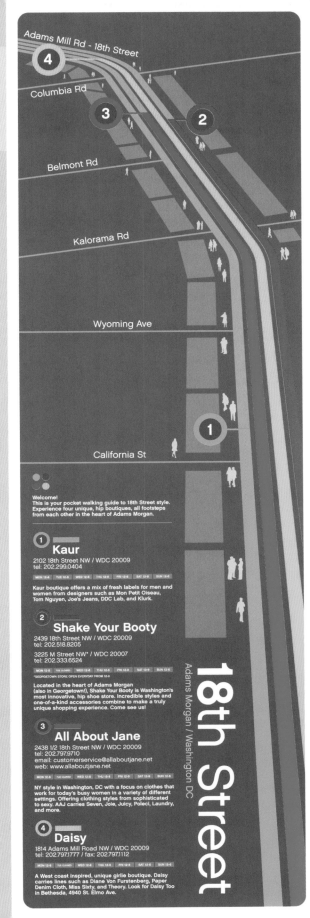

Adams Mill Rd - 18th Street
④

Columbia Rd
③ ②

Belmont Rd

Kalorama Rd

Wyoming Ave

①

California St

Welcome!
This is your pocket walking guide to 18th Street style. Experience four unique, hip boutiques, all footsteps from each other in the heart of Adams Morgan.

① Kaur
2102 18th Street NW / WDC 20009
tel: 202.299.0404

| MON 12-8 | TUE 12-8 | WED 12-8 | THU 12-8 | FRI 12-8 | SAT 12-8 | SUN 12-6 |

Kaur boutique offers a mix of fresh labels for men and women from designers such as Mon Petit Oiseau, Tom Nguyen, Joe's Jeans, DDC Lab, and Klurk.

② Shake Your Booty
2439 18th Street NW / WDC 20009
tel: 202.518.8205

3225 M Street NW* / WDC 20007
tel: 202.333.6524

| MON 12-8 | TUE CLOSED | WED 12-8 | THU 12-8 | FRI 12-8 | SAT 12-8 | SUN 12-6 |

*GEORGETOWN STORE OPEN EVERYDAY FROM 12-9

Located in the heart of Adams Morgan (also in Georgetown!), Shake Your Booty is Washington's most innovative, hip shoe store. Incredible styles and one-of-a-kind accessories combine to make a truly unique shopping experience. Come see us!

③ All About Jane
2438 1/2 18th Street NW / WDC 20009
tel: 202.797.9710
email: customerservice@allaboutjane.net
web: www.allaboutjane.net

| MON 12-8 | TUE CLOSED | WED 12-8 | THU 12-8 | FRI 12-8 | SAT 12-9 | SUN 12-6 |

NY style in Washington, DC with a focus on clothes that work for today's busy women in a variety of different settings. Offering clothing styles from sophisticated to sexy. AAJ carries Seven, Joie, Juicy, Poleci, Laundry, and more.

④ Daisy
1814 Adams Mill Road NW / WDC 20009
tel: 202.797.1777 / fax: 202.797.1112

| MON 12-8 | TUE CLOSED | WED 12-8 | THU 12-8 | FRI 12-8 | SAT 12-8 | SUN 12-6 |

A West coast inspired, unique girlie boutique. Daisy carries lines such as Diane Von Furstenberg, Paper Denim Cloth, Miss Sixty, and Theory. Look for Daisy Too in Bethesda, 4940 St. Elmo Ave.

18th Street
Adams Morgan / Washington DC

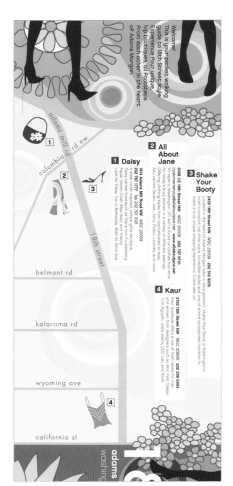

DESIGNER: Alex Chao **STUDIO:** p11creative **CITY:** Santa Ana Heights, California **URLS:** www.p11.com, www.p11funhaus.com **SOFTWARE PROGRAM:** Illustrator **TYPEFACE:** Chalet

MW: WHAT ATTRACTED YOU TO THIS PARTICULAR PIECE?

AC: I've always wanted to design maps. When I saw the thumbnail printout of the original graphic, I was excited because I thought it was a map of the subway system.

WHAT DID YOU THINK OF THE ORIGINAL DESIGN?

While the original design was very clean, understated and functional, I wanted to give it a little more flair. As one of the liveliest parts of DC, Adams Morgan has been described as the "Greenwich Village of Washington, DC." In addition, the actual names of the boutiques are so whimsical (Shake Your Booty, All About Jane, Daisy, Kaur) that I felt the map should reflect the colors and energy.

YOUR DESIGN DEFINITELY HAS FLAIR...WHAT WAS YOUR CONCEPT FOR THIS REDESIGN?

My overall concept was inspired by Italian fashion designer Emilio Pucci. He was known for rich colors, dramatic couture prints and jetset style. I also kept in mind the retail aura. Over the last decade, shopping has become more than merely buying goods. The emergence of retail "environments" has made the experience of shopping just as important as the actual merchandise itself. This map was designed to have people strut, not just walk.

THE RESULT LOOKS LIKE YOU HAD A LOT OF FUN. HOW WAS THE OVERALL EXPERIENCE?

It's never easy to redesign a project, especially when the original design already looks good. But how often do you get to design with no limitations except your own?

• • •

DESIGNER: Tsia Carson **STUDIO NAME:** Flat **CITY:** New York, New York **URLS:** www.flat.com, www.flrt.com **SOFTWARE PROGRAMS:** Illustrator, Photoshop **TYPEFACES:** Expletive Deletive (Virus Fonts), Gotham (Hoefler Type Foundry)

MW: WHY DID YOU CHOOSE THE FASHIONISTA GUIDE TO REDESIGN?

TC: We like clothes. We like cities.

WHAT WAS YOUR IMPRESSION OF THE ORIGINAL?

We liked it. We thought the piece felt really "boy," but it's for girly clothes. So we wanted to make it more "girly." Something that could fit in a small purse. Something pretty.

WHERE DID THE CLOTHING ARTWORK COME FROM?

I cut teeny tiny couture clothes out of scraps of fabric.

THEY'RE SO WELL DONE THAT I BARELY NOTICED THEM THE FIRST TIME BECAUSE I THOUGHT THEY WERE JUST PHOTOS OF NORMAL CLOTHING. SO, HOW'D YOU LIKE THE WHOLE REMIX PROCESS?

We didn't have any expectations going into the project. The hardest part is that we aren't very familiar with DC, so we did some research. We decided to make the map part of it subtle, as it isn't a very dense data set. Then I made some mini couture clothes because I really wanted to and no one could stop me.

• • •

MW: SO, DID YOU HAVE AN ELABORATE DESIGN STRATEGY FOR CHOOSING THIS PARTICULAR PIECE TO REDESIGN?

S: I replied too late, so the piece was assigned to me automatically!

OH, THAT'S RIGHT. COME ON, I BELIEVE I GAVE YOU AT LEAST A FEW DIFFERENT OPTIONS. SO, DID YOU LIKE THE ORIGINAL DESIGN, OR DID YOU THINK IT NEEDED SOME HELP?

I like the original design. I just used a different approach to redesigning the project—away from the conventional map design.

YOUR PIECE HAS SOME OF THE SUBWAY MAP FEELING OF THE ORIGINAL BUT COMBINES IT WITH ALMOST A WEB-TYPE INTERFACE. WHAT DID YOU SET OUT TO DO WITH THE REDESIGN?

I wanted to do something bright, inviting, abstract, light-hearted, geometric, fun, simple, intuitive, unconventional… and use a girl with nice hair.

HOW WAS THE REDESIGN EXPERIENCE FOR YOU…AN EASIER OR HARDER EXPERIENCE THAN YOU THOUGHT IT WOULD BE?

Sometimes it was easier, but I think, overall, design is challenging because there's always endless solutions one can explore. Regardless, it turned out to be a fun project.

. . .

DESIGNER: Sunjin **STUDIO:** Pinkroom **CITY:** Philadelphia, Pennsylvania **URL:** www.pinkroom.net **SOFTWARE PROGRAM:** Illustrator **TYPEFACES:** AmarilloUSAF, DIN Schrift, Helvetica

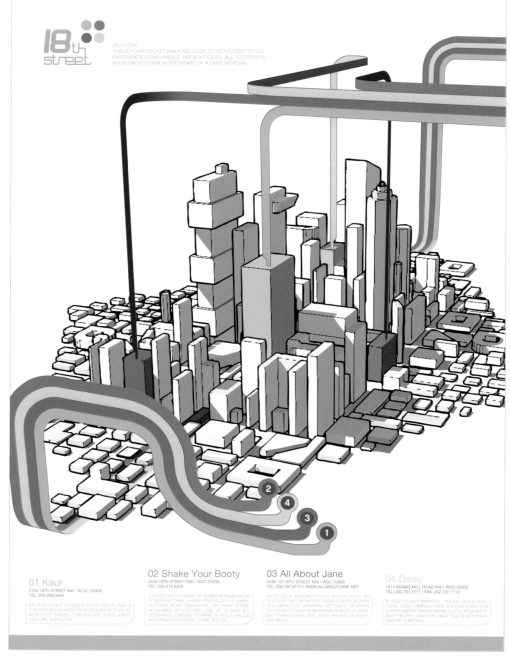

01 Kaur
2102 18TH STREET NW / W DC 20009
TEL: 202.299.0404

KAUR BOUTIQUE OFFERS A MIX OF FRESH LABELS
FOR MEN AND WOMEN FROM DESIGNERS SUCH AS
MON PETIT OISEAU, TOM NGUYEN, JOE'S JEANS,
DOC LAB, AND KLURK.

02 Shake Your Booty
2439 18TH STREET NW / WDC 20009
TEL: 202.518.8205

LOCATED IN THE HEART OF ADAMS MORGAN. ALSO
IN GEORGETOWN. SHAKE YOUR BOOTY IS WASH-
INGTON'S MOST INNOVATIVE, HIP SHOE STORE.
INCREDIBLE STYLES AND ONE OF A KIND AC-
CESSORIES COMBINE TO MAKE A TRULY UNIQUE
SHOPPING EXPERIENCE. COME SEE US!

03 All About Jane
2438 1/2 18TH STREET NW / WDC 20009
TEL: 202.797.9710 / WWW.ALLABOUTJANE.NET

MY STYLE IN WASHINGTON DC WITH A FOCUS ON
CLOTHES THAT WORK FOR TODAY'S BUSY WOMEN
IN A VARIETY OF DIFFERENT SETTINGS. OFFERING
CLOTHING STYLES FROM SOPHISTICATED TO SEXY.
JANE CARRIES BEVN, JOIE, JUICY, POLECI, LAUNDRY,
AND MORE.

04 Daisy
1814 ADAMS MILL ROAD NW / WDC 20009
TEL: 202.797.1777 / FAX: 202.797.1112

A WEST COAST INSPIRED, UNIQUE, GIRLIE, BOU-
TIQUE. DAISY CARRIES LINES SUCH AS DIANE VON
FURSTENBERG, PAPER DENIM CLOTH, MISS SIXTY,
AND THEORY. LOOK FOR DAISY TOO IN BETHESDA,
4940 ST. ELMO AVE.

DESIGNER: Oscar Vervat **STUDIO:** 1127 **CITY:** Rotterdam, The Netherlands **URL:** www.1127.com **SOFTWARE PROGRAMS:** SketchUp, Flash, Illustrator, InDesign **TYPEFACES:** Dopenakedfoul, Ro

MW: WHY DID YOU CHOOSE THIS PIECE TO REDESIGN?

OV: The original design immediately appealed to me because of its straightforward design and colors. It's quite clear what it's meant to do, and that's what I like in designs. Therefore, I didn't want to try to make a better design but to take a different approach to how city maps are normally made up. I wanted to use the buildings as a starting point, rather than the streets.

IT'S A VERY CLEVER VERSION YOU'VE CREATED. CAN YOU TALK ABOUT YOUR DESIGN CONCEPT FOR THIS PIECE?

Since buildings are often more a point of recognition than street names are, I thought of the idea to put the attention to the location of the shops in comparison to the other buildings in the city's center. I first wanted to make a road map for the future Washington DC, where the city and roads would be built up in various levels. I illustrated a white city with colored units to identify the shops on the different levels of the city. The colored lines would point out the different (air) roads to the stores.

Since I'm not really into 3-D design, I soon found out it would take me too much time to build a whole city full of different heights. So I scaled the project down to a one-level city but still with the colored lines pointing out the different locations.

...

MW: WHAT WAS THE CONCEPT FOR THE DESIGN OF THIS PIECE?

JD: The total project was four total pages, each with a different theme: "design is…," "art is…," "architecture is…," and "oxygen is…."

This is the piece for "oxygen is…" I wanted to create a very soft cloud formation using tiny colored circles to work with the symbolism of air and oxygen.

SO, YOU'RE KNOWN FOR YOUR TECHNOLOGICAL WIZARDRY. HOW DID YOU CREATE THIS PIECE?

The composition was written in Flash MX using transparent gradients. Ripping a Flash program through postscript works very well, except when rendering transparencies and gradients—which is encompassed throughout this entire work. So, I had to find a workaround, which is where the tiny circles came in. I ran the program until it generated the desired arrangement, took a screenshot, and then ran the screenshot image through a PHP program. This created a grid of the work and averaged the most dominant color, pixel by pixel, in the grid.

Then, I used this set of grid and color instructions and placed it back into Flash MX in conjunction with the drawing API to redraw the entire composition with tiny circles, which I then could rip through postscript and be ready to send off to the printer, since this rip had no transparencies or gradients. However, the final work looks like transparent gradient clouds.

ANY GUIDELINES YOU HAD TO STAY WITHIN?

Only that it look like something in my style and aesthetic, which was the easy part.

• • •

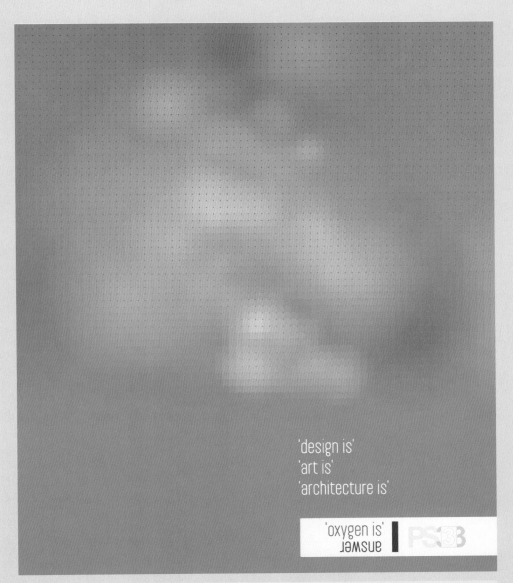

'design is'
'art is'
'architecture is'

'oxygen is'
answer | PS3B

DESIGNER: Joshua Davis **STUDIO:** Joshua Davis Studios **CITY:** Port Washington, New York **URL:** www.joshuadavis.com
YEAR: 2002 **SIZE:** 9" x 10¾" (23 x 28 cm) **SOFTWARE PROGRAMS:** Illustrator, Flash **TYPEFACE:** Pakt (youworkforthem)

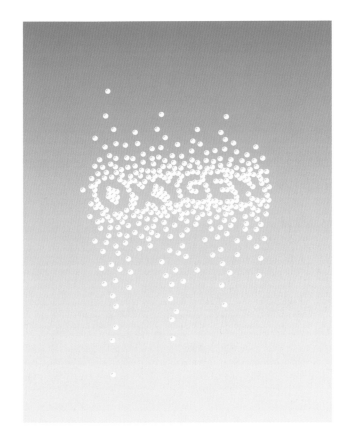

DESIGNER: Robert Hegeman **STUDIO:** Powerforward **CITY:** New York, New York **URL:** www.powerforward.com
SOFTWARE PROGRAM: Adobe Illustrator

MW: WHY DID YOU CHOOSE THIS PARTICULAR PIECE TO REDESIGN?

RH: I thought there was a lot of room to play on this one. Also, I tend to be drawn to scientific subjects, which in this case was the concept of oxygen.

HONESTLY, DID YOU LIKE THE ORIGINAL DESIGN, OR DID YOU THINK IT NEEDED HELP?

Well, the original design didn't say "oxygen" to me. I felt that a unique association with what we know to be oxygen would make a more immediate and memorable impact.

CAN YOU DISCUSS YOUR CONCEPT FOR THE "OXYGEN" REDESIGN?

I wanted the design to be extremely simple, just as you would expect when thinking about oxygen as an element. Additionally, it should be playful in its interpretation of what oxygen is. The goal was not so much to tell what the magazine is literally about but to make a creative impression which reflects the tone.

WAS CREATING YOUR REDESIGN AN EASIER OR HARDER EXPERIENCE THAN YOU THOUGHT IT WOULD BE?

The only difficult part was picking which idea was the most intuitive. This design was only one of several concepts that were developed to varying degrees. In the end, it was the simplest and most direct approach that made the most sense.

. . .

DESIGNER: Julio Peña **STUDIO:** karacter **CITY:** Bogotá, Colombia **SOFTWARE PROGRAMS:** Photoshop, Illustrator, FreeHand, Fontographer **TYPEFACES:** Prima (self-designed), Citizen (Émigré)

MW: SO, DID YOU LIKE THE ORIGINAL DESIGN?

JP: It's great…I really like the color usage, and it's obviously a true achievement in illustration. My only qualm is with the typographic solution; I just think it could have been better.

CAN YOU TALK ABOUT YOUR CONCEPT FOR THE REDESIGN?

We all move by an idea, a force. I wanted to show that this force that can be anywhere, anyhow, anytime…It pushes us to live and to continue on our way.

WAS IT AN EASIER OR HARDER EXPERIENCE THAN YOU THOUGHT IT WOULD BE?

It was a good experience. Yeah, it could be a bit easier than I initially thought. Nonetheless, I put in all my effort in order to get a good result.

WHAT WAS THE MOST DIFFICULT PART OF THE PROJECT?

The most difficult part of the project was when I was sleepy. I would go to the kitchen to make coffee, get nervous. I never know what comes first: the milk or the coffee! Sometimes, I would get depressed at the result. But to tell the truth, I had no problems redesigning the piece. It was lots of fun, and I think you just have to sink deeply into the mind-set of the original piece, and then re-create it as you think it should be done.

. . .

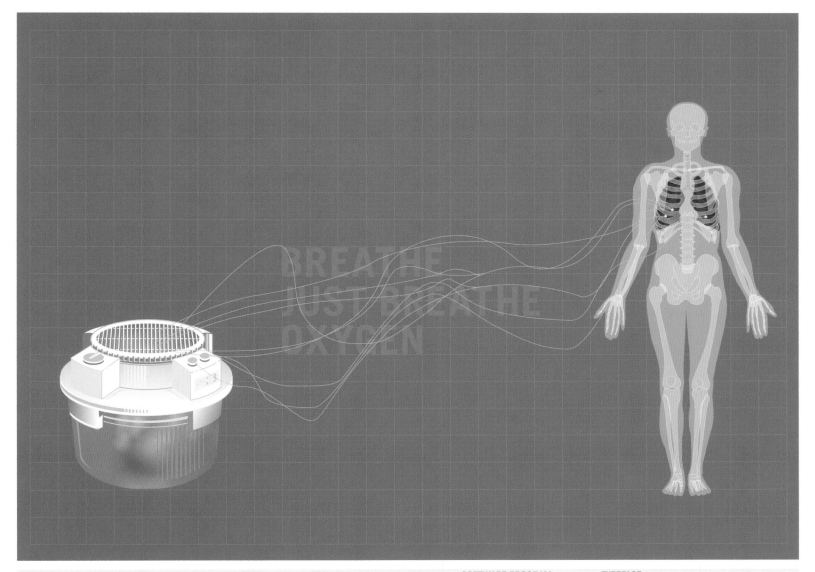

BREATHE
JUST BREATHE
OXYGEN

DESIGNER: Daniel Koh **STUDIO:** AmateurProvokateur **CITY:** Singapore **URL:** www.amateurprovokateur.com **SOFTWARE PROGRAM:** FreeHand **TYPEFACE:** Trade Gothic (Linotype AG)

MW: HONESTLY, DID YOU LIKE THE ORIGINAL DESIGN, OR DID YOU THINK IT NEEDED SOME HELP?

DK: I do favor the original. The juxtaposition and selection of colors and imagery are intriguing, so in some way it works for me.

YOUR DESIGN PRESENTS A VERY LITERAL INTERPRETATION ON THE THEME OF OXYGEN. DO YOU ENJOY WORKING IN AN ABSTRACT STYLE, OR DO YOU PREFER THINGS THAT ARE MORE DEFINED?

It depends on the subject; however, I've always liked to weave both elements together. My interpretation of oxygen is just that. The copy ("Breathe…") tends to reveal more

about the piece at first glance, then it's up to the viewer to interpret what the other elements are.

WHAT WAS YOUR CONCEPT FOR THIS REDESIGN?

I wanted to create a diagram reminiscent of a medical chart.

REALLY? WHY A MEDICAL CHART?

I'm interested in the arrows, dates, grids and statistics. Oxygen is often regarded as a scientific word, so I was looking at it from that angle when deciding how I wanted this piece to be.

• • •

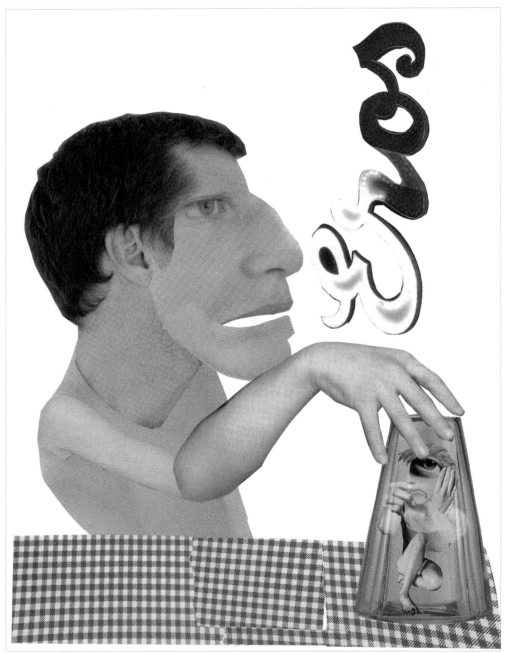

DESIGNER: Erkut Terliksiz **CITIES:** Istanbul, Turkey and London, England **URL:** www.erkutterliksiz.com **SOFTWARE PROGRAM:** Photoshop

MW: WHAT WAS YOUR CONCEPT FOR THIS REDESIGN?

ET: It was to just forget the original and do what I wanted.

HOW DID YOU CREATE THE MAIN CHARACTER? IT LOOKS LIKE A COLLAGE OF SEVERAL PHOTOGRAPHS THAT YOU'VE PASTED TOGETHER.

First, you need a main character. And I said to myself, "OK! Erkutboy! Right now! You need a main character." And then magic! Here we have the main character. Those trendy, expensive magazines saved my life.

WHO IS THE CHARACTER TRAPPED INSIDE THE GLASS?

Actually, the main character is a woman who is trapped inside the glass, which represents the Lite Rock Singers.

LITE ROCK? SOUNDS LIKE YOU MANAGED TO BLEND TWO PROJECTS TOGETHER. WITH THE LARGE TEXT "EROS," WHAT DOES THAT MEAN? IS IT SUPPOSED TO BE A LOVING ACT, OR VIOLENT BETWEEN THE TWO PEOPLE?

90% of the Lite Rock Lyrics are about love. Eros represents the wide spread of that music.

IT'S SUCH A CREEPY IMAGE BECAUSE IT LOOKS LIKE SHE'S LOSING ALL HER OXYGEN WHILE THE OTHER GUY IS JUST SITTING AT A PICNIC TABLE. IS THIS HOW YOU SEE IT, OR DO YOU SEE SOMETHING COMPLETELY DIFFERENT?

He is just trying to get rid of the cheesy female vocal. It is like turning down the volume.

DID YOU CREATE THIS ALL BY HAND AND THEN PHOTOGRAPH IT, OR WAS THIS DONE DIGITALLY?

Yes, I did it all by hand, but then I scanned it. So both.

WAS IT AN EASIER OR HARDER EXPERIENCE THAN YOU THOUGHT IT WOULD BE?

It was sooooo easy!

• • •

MW: SO, WHY DID YOU CHOOSE THIS PARTICULAR PIECE TO REDESIGN?

RP: I thought the concept and notion of oxygen was compelling. Also, I liked the original design and loved the moodiness of the colors. I felt that the colors and overall mood were very cool, and in sharp contrast to the starkness of the gray. The life that could come out of it was the only thing I felt was missing. Actually that is what ultimately drew me to this particular piece.

YOU REALLY DID A REMARKABLE JOB OF INCORPORATING THE ORIGINAL DESIGN INTO YOUR OWN WORK. WHAT WAS YOUR CONCEPT?

"Oxygen" is such a lovely word, and that was the concept in itself. I just wanted to create something that made me smile. The idea was to play off of the organic tone of oxygen and contrast it with a wee bit of whimsy.

HOW WAS THE OVERALL EXPERIENCE? EASIER OR HARDER THAN YOU EXPECTED?

I didn't find the process difficult or hard at all. Design is open for interpretation. As that was the task at hand, I approached it as if I were taking part in a conversation or simply responding to a question.

. . .

FEEDBACK FROM THE ORIGINAL DESIGNER:
JOSHUA DAVIS

WHAT'S YOUR INITIAL REACTION TO EACH REDESIGN?
Powerforward: Clever
karacter: Clean
AmateurProvokateur: Wonderful
Erkut Terliksiz: Confused
dZinenmOtion: Fantastic

DO YOU HAVE A FAVORITE?
It's a tie between the pieces by dZinenmOtion and AmateurProvokateur. I liked the piece by dZinenmOtion because it used my original concept and took it a bit further with the illustrations of birds and butterflies. Also, the work by AmateurProvokateur played on the original, and combined it with an amazing illustration of an air conditioner and human form.

ANY SURPRISES IN THE BUNCH?
The one by Erkut Terliksiz: a Cyclops in an upside-down glass who is being suffocated? At least I think that where the oxygen tie-in is. That piece just creeps me out. Well done.

OVERALL, WHAT DO YOU THINK OF ALL THE REDESIGNS?
Clean and well executed—thanks to all the remix creators for approaching either my work or this theme of oxygen.

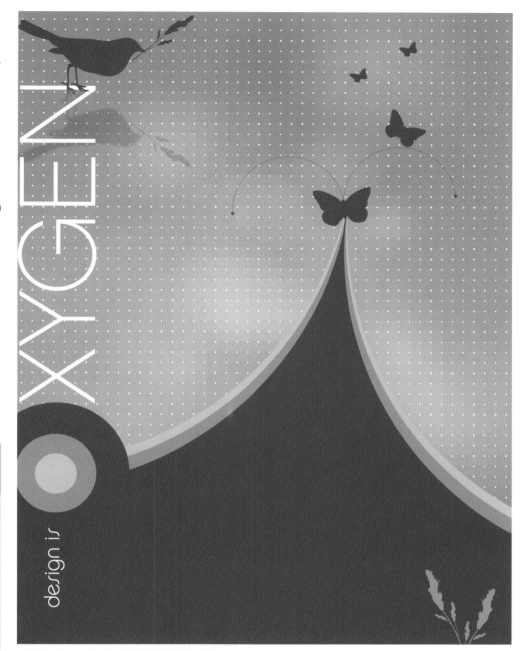

OXYGEN

design is

DESIGNER: Rose Pietrovito **STUDIO:** dZinenmOtion **CITY:** Vancouver, British Columbia, Canada **URL:** www.dzinenmotion.com
SOFTWARE PROGRAM: Photoshop **TYPEFACE:** Chalet

McSWEENEY'S ISSUE 3 COVER

MW: WHAT WAS THE CONCEPT FOR THIS COVER?

DE: Issue 3 was building on the first two issues, where the covers were getting more complex, using more words, getting more intricate and inward-spinning. At the same time, I was looking at a lot of old hermetic drawings and designs, and those two factors conspired. I wanted it to look sort of obsessive and strange, desperate even. I love art that looks like the maker was a little nutty, and this definitely has that feel, I think.

THE THING THAT REALLY DRAWS ME TO YOUR DESIGNS IS THAT MUCH OF IT SEEMS OF ANOTHER ERA. DO YOU PAY ATTENTION TO CURRENT DESIGN MOVEMENTS AT ALL, OR DO THEY NOT HOLD MUCH INTEREST FOR YOU?

I pay a lot of attention to design, but not in any really organized way. I never studied design in a formal setting, though I studied painting and art history most of my time in college. So when you say 'current design movements' I'm foggy, though if you mentioned certain designers or their work, I'd probably know who or what you were talking about. The movements I'm most interested in are those, like Fluxus or Constructivism, that marry text and design in a new way—but always in a way that facilitates communication, instead of obscuring text. So when someone finds a new way to do that, I'm interested.

DO YOU FIND THAT DESIGN PROJECTS SERVE AS A PLEASANT DISTRACTION FROM WRITING, OR IS IT MORE DIFFICULT SINCE IT'S NOT A FULL-TIME JOB?

I guess it's just a way to use a different part of my head. I miss painting but I don't have any room to paint in my house, so designing books works the muscles that painting used to. The part about design that's difficult is the production gruntwork—the fine tuning and prepress and dealing with the printers, all that. I'm not the best guy to be doing all the follow-through on some of these designs, but we don't have anyone else at McSwys who knows printing, so it's a struggle, and we mess stuff up here and there. But generally, I see the writing and designing of a given book as two parts of a whole. When I'm writing or editing a book, I'm thinking about the design of it, too, because how a book's presented has a lot to do with how you read it. I cringe when a great book has been given some goofy, distracting typeface or a terrible cover. It honestly impedes that book's chances of reaching its audience. So I try to teach writers I know some basic Quark skills, so they can be more connected to the process and presentation of their work. And I wish more designers would write, like Chip Kidd does—especially poetry—because they know what will look right on the page.

. . .

Cover of Timothy McSweeney's Quarterly Concern, Issue No. 3, Mid to Late Summer, 1999.

DESIGNER: Dave Eggers **STUDIO:** McSweeney's **CITY:** San Francisco, California **URLS:** www.mcsweeneys.net, www.826Valencia.com **YEAR:** 1999 **SIZE:** 6½" x 9¼" (17 x 23 cm) **SOFTWARE PROGRAM:** Quark **TYPEFACE:** Garamond 3

MW: WHAT DID YOU THINK ABOUT THE ORIGINAL MCSWEENEY'S COVER?

M: Although the text conveyed lots of personality, I found the final typographic result to be a little traditional. I did have empathy with the narrative text though, and the lack of any images and color was enticing.

COULD YOU EVER SEE YOURSELF USING GARAMOND?

No. Although I have worn socks with sandals on occasion.

WHAT WAS YOUR CONCEPT FOR THIS REDESIGN?

I wanted to retain the overall circular movement and diagram vibe but add some personality and style using less-traditional letter shapes.

BOTH THE ORIGINAL AND YOUR REDESIGN SEEM TO BELONG TO VERY DISTINCT TIME PERIODS. WHAT'S YOUR BIGGEST INFLUENCE IN TERMS OF DESIGN PROCESS?

I don't get out of my cell much! I try to be as spontaneous as possible and avoid outside influences. If the image isn't in my head immediately after reading a brief, then generally I'll wait until I see something that triggers a reaction. Once this happens, it's hard to think about anything else until I have the completed piece in front of me.

YOU ADDED A FACE TO YOUR REDESIGN—IS THAT SUPPOSED TO BE TIMOTHY MCSWEENEY?

That's me. I was suffering from a lack of any decent muse that day, so my mug had to suffice. The face illustrates the general confusion.

WAS IT AN EASIER OR HARDER EXPERIENCE THAN YOU THOUGHT IT WOULD BE?

Harder. Normally, I'd prefer a blank canvas, but everyone does things differently. It's always good to get a new perspective.

• • •

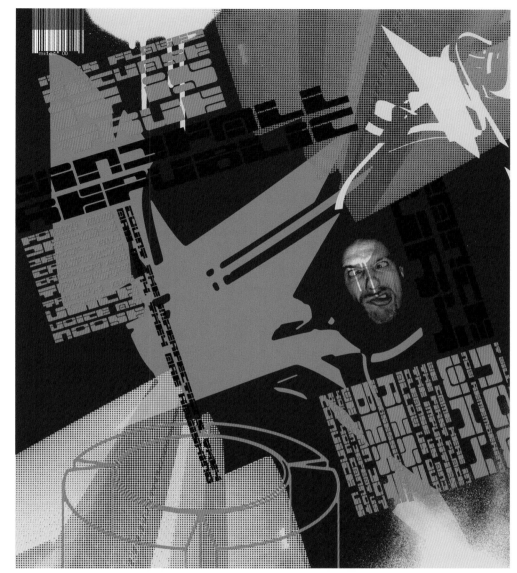

DESIGNER: Mitch **STUDIO:** Mitch **CITY:** London, England **SOFTWARE PROGRAMS:** Photoshop, Quark XPress, FreeHand
TYPEFACE: Fat Arse (self-designed)

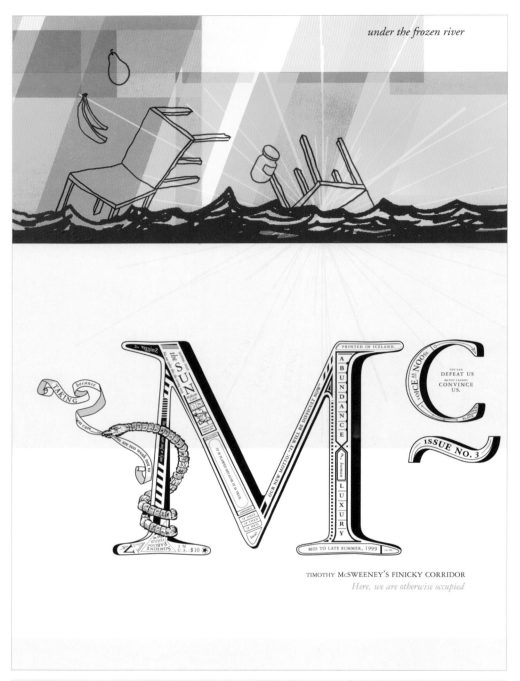

under the frozen river

TIMOTHY McSWEENEY'S FINICKY CORRIDOR
Here, we are otherwise occupied

DESIGNER: Timothy O'Donnell **STUDIO:** O'Donnell Design **CITY:** New York, New York **URL:** www.timothy-odonnell.com
SOFTWARE PROGRAMS: Illustrator, Photoshop **TYPEFACE:** Adobe Garamond

MW: WHAT DID YOU THINK OF THE ORIGINAL DESIGN?

TO: It was my favorite piece to choose from, by far. I really love the original. I wasn't aiming to improve on it but just to take it as inspiration and expand upon it.

HOW DID YOU GO ABOUT THAT?

The designer of the original referred to its "obsessive, almost desperate" quality. One aim of mine was to embrace that and try and make it feel even more desperate. I wanted to take the tension of the original and force it into a much smaller space inside the letterforms, like an illuminated manuscript.

Also, I wanted to balance this very detailed area with some space and depth and color. There are so many phrases and drawings scattered around the original. They're quite evocative, but there are too many of them to really focus on one. So I took some of the drawings from the margins, enlarged them and tried to form a narrative thread. I ended up with this strange scene of household objects falling into the sea under this golden, post-storm sky.

I THINK YOU USED THE ELEMENTS QUITE EXPERTLY. WAS IT AS DIFFICULT AN EXPERIENCE AS IT LOOKS?

I knew I was making my life harder by picking a piece I admired. There was such a wealth of material on the original that editing it down was pretty difficult. But it's nice to really work and craft something when the computer has made things so much simpler for us.

. . .

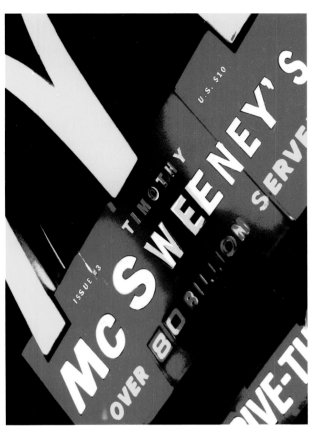

DESIGNER: Eric Kass **STUDIO:** Lodge Design Co./Funnel **CITY:** Indianapolis, Indiana **URLS:** www.lodgedesign.com, www.funnel.tv **SOFTWARE PROGRAMS:** Photoshop, Illustrator **TYPEFACES:** Big Ed, Lazyboy (The American Type Corp.)

MW: ERIC, YOU'RE A BIGGER MAN THAN ME. THIS ONE IS REALLY QUITE A CHALLENGE TO REDESIGN. WHAT WAS YOUR TAKE ON THE ORIGINAL DESIGN?

EK: I thought the original was both inspired and inspiring. It did seem like a tremendous challenge to redesign.

WHAT WAS YOUR CONCEPT FOR THIS REDESIGN?

There were so many interesting details in the original that it was difficult to select any one aspect to draw from. From the beginning, I wanted to do something completely opposite, really simple, almost void of any content, yet somehow still interesting and arresting. I finally settled on the name of the piece, "McSweeney's" for inspiration. I wanted to make it blunt, fast, loud, corporate—everything the original wasn't.

HOW WAS THE WHOLE REDESIGN EXPERIENCE?

It was as difficult as I thought it would be. The original is really a great design. With most designs, I look at them and quickly see things I would do differently to improve it, but I really thought this cover was just as it should be.

• • •

DESIGNER: Peter Stemmler **STUDIO:** QuickHoney **CITY:** Brooklyn, NY **URLS:** www.quickhoney.com **SOFTWARE PROGRAM:** Adobe Illustrator

MW: I ORIGINALLY GAVE THIS PIECE TO YOU AFTER YOU DIDN'T WANT TO CHOOSE A PIECE TO WORK WITH. DID YOU DISLIKE ALL THE OPTIONS?

PS: Most of them I didn't like, so I didn't really want anything to do with them. The ones that I did like, I don't want to change, so I just went for fate!

HOW ABOUT THIS ONE…DID YOU LIKE IT?

It needed a lot of help! I'm a really critical person, and it's hard to impress me. My only guide is my personality, taste and experience. With this design, I was thinking that someone is hiding behind all this funny type patchwork and is just waiting for a chance to show the world something cool.

HOW WAS THE OVERALL REDESIGN EXPERIENCE?

I do this every day, and I like it, so I guess it was easy for me.

EVERY DAY? DO YOU ACTUALLY REDESIGN OTHER PEOPLE'S WORK, OR JUST CREATE NEW CHARACTERS?

Hmm, close. I design people's advertisements. It's not really redesign, because I normally don't get sketches, just written or phone briefings. In a way though, I redesign the ideas that the art director has in his head, and if everything works out, it looks better.

• • •

issue no.3 mid to late summer. 1999 do not bother to find content, it does not exist in U.S. $10 elsewhere ?

TIMOTHY McSWEENEYS WINDFALL REPUBLIC. BEYOND THE YARD, BELOW THE TREES, BENEATH THE SNOW, UNDER THE FROZEN RIVER YOU CAN DEFEAT US, BUT YOU CANNOT CONVINCE US.

DESIGNER: Mike Dytri **STUDIO:** SUBFREAKIE **CITY:** Los Angeles, California **URL:** www.subfreakie.com **SOFTWARE PROGRAMS:** Illustrator/Hand/Photoshop **TYPEFACE:** Helvetica

MW: WHY DID YOU CHOOSE THIS PARTICULAR PIECE TO REDESIGN?

MD: I like cerebral things, and I am a big fan of McSweeney's. Plus, I loved the original design—it was very intense and complex. I was basically overwhelmed by the image when I first saw it and realized it would be a challenge; that's what made me want to work on it.

WAS IT AS MUCH OF A CHALLENGE AS YOU EXPECTED?

Actually, it was quite easy. Helvetica is the most versatile typeface, and the images are very basic, yet speak volumes.

THE TYPE TREATMENT IS REALLY IMPRESSIVE. WHAT WAS THE CONCEPT BEHIND STYLIZING THE TEXT LIKE THIS?

The idea was to present something that was a clear concept, like the quote that was selected, and play with the color to make it slightly out of focus. I think it makes you feel uneasy about the message.

WHERE'D YOU FIND THE COVER MODEL—IS THAT SUPPOSED TO BE MR. MCSWEENEY?

It was from an illustration that I did a few years ago that I use a lot in my graphics. It is actually Philip Glass, but he has a face that lends application to many things. The viewer could conclude it to be McSweeney, and that's a good thing.

. . .

FEEDBACK FROM THE ORIGINAL DESIGNER:
DAVE EGGERS

WHAT'S YOUR INITIAL REACTION TO EACH REDESIGN?
Mitch: Nice
Timothy O'Donnell: Love
Lodge Design: Delicious food at great prices
Quickhoney: Yikes
SUBFREAKIE: Why Philip Glass?

DO YOU HAVE A FAVORITE?
Aw, I don't think I'm gonna pick one. I really love Timothy O'Donnell's of course, because it's the closest to what I love about design—detail, intricacy, an air of madness even. All the others are great, too.

DO ANY OF THEM SURPRISE YOU?
Well, the woman working the nipple action was unexpected. But she seems like a nice person.

IS IT A STRANGE EXPERIENCE TO SEE MCSWEENEY'S PRESENTED IN SUCH A DIFFERENT STYLE?
I didn't know what to expect at all. I can't believe they're paying you to do this in the first place. It's about the strangest project I've ever heard of, and I've been involved in some odd things. I was at an abandoned pier yesterday, and two young kids were filling a bucket with water from a drinking fountain, because in the bucket they'd caught a stingray. That was strange, too.

CH 28 GREATEST BUMPS ALBUM COVER

MW: THIS WAS ONE OF THE FIRST PIECES I WANTED TO MAKE SURE TO INCLUDE IN THE BOOK. HOW DID THE ALBUM ART COME TOGETHER?

BR: When you've got the nice sounds in your car, i.e., a hooked-up stereo system with lots of bass, the music is "bumpin'." That's definitely a Oakland/Bay Area thing, and that's where these guys are from. So that was the starting point.

Coming from independent roots, Quannum is very, very conscious about their identity, and it's always an opportunity to present hip-hop in a nonclichéd way. The *Greatest Bumps* cover doesn't look like a rap cover or a even a rock cover. It's just sort of curious and stands on its own, like "What the hell kind of vehicle is that, with the eight wheels and exhausts pointing the wrong way??!!!"

DID YOU TRY ANY OTHER APPROACHES WITH THE ALBUM ARTWORK?

This was a "best of" compilation, so it was originally going to reflect that more. We never deviated from the automotive theme, but it went through a few phases that were never executed: a pile of different auto exterior parts painted with the blue flames sitting in a junky auto garage. Turntables and other audio equipment were to be placed amidst the dirty engine blocks with their old album covers hung up next to the fan belts and tools.

Logistically, that was just too difficult so we moved to the idea of making it more like a package, like something you would see hanging on a rack. I wanted it to be closer to an "object," not just a photograph stuck on the front like so many other CD/LP covers. The initial idea was a lot more mysterious and abstract, using collaged car grills and applying it like packaging for spark plugs or other automotive parts, but it was too nondescript and eventually rejected.

. . .

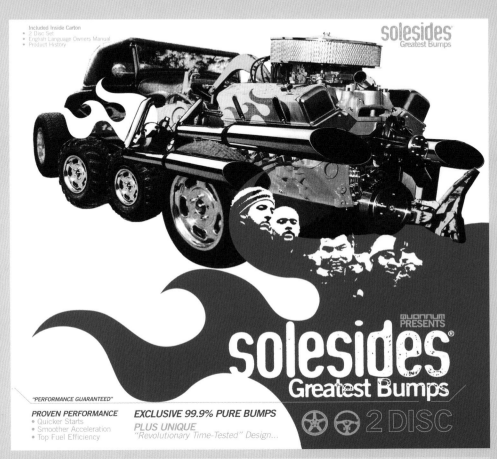

DESIGNER: Brent Rollins **STUDIO:** Brent Rollins Design Explosion! **CITY:** New York, New York **YEAR:** 2000 **SIZE:** 5" x 5½" (13 x 14 cm) **SOFTWARE PROGRAMS:** FreeHand, Photoshop, Quark **TYPEFACES:** Trade Gothic family (Adobe)

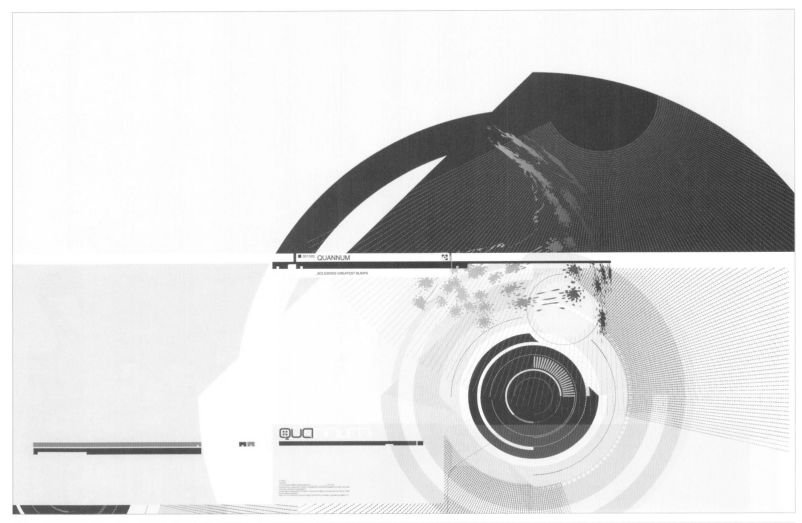

DESIGNER: Benjamin Ridgway **STUDIO:** Fluid **CITY:** Birmingham, England **URL:** www.fluidesign.co.uk **SOFTWARE PROGRAMS:** Photoshop, Illustrator **TYPEFACES:** Helvetica and a self-created logo font

MW: SO, WHY DID YOU CHOOSE THIS PIECE TO REDESIGN?

BR: I wanted to choose a piece that was, to me, very obvious and pushy in terms of getting a "cool, urban" image over to the buyer. Then, I wanted to flip the overall look and make it not so obvious, I suppose.

THAT'S FUNNY, CONSIDERING THAT THE DESIGNER OF THE COVER SET OUT TO MAKE THE COVER ART SPECIFICALLY NON-GENRE SPECIFIC.

I thought that the original piece was good and a perfect portrayal for the genre of music, but also I thought it was very obvious in terms of the style of design that is usually applied to hip-hop CDs. I thought it would be different to do something as far from the subject as possible and a bit more abstract.

YOUR APPROACH DEFINITELY TAKES IT IN A WHOLE OTHER DIRECTION. WHAT WAS YOUR MAIN CONCEPT?

I really wanted this to be a visual-based project as an answer to this brief. It was partly for my own satisfaction, but also I thought it would appeal to audiences other than just Quannum followers. It's mostly the color scheme that started the concept, and then the rotating circles were added. In a way, it represents something that has been reused and revolving, like the tracks on the album.

WAS IT A DIFFICULT EXPERIENCE WORKING WITH OTHER PEOPLE'S DESIGNS?

No, not really, because I took my own route on it. The design contains no elements of the original, as I can't seem to do that kind of design and pull it off.

• • •

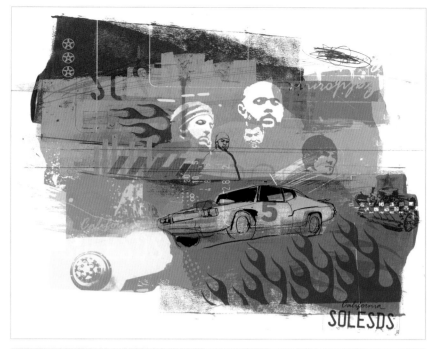

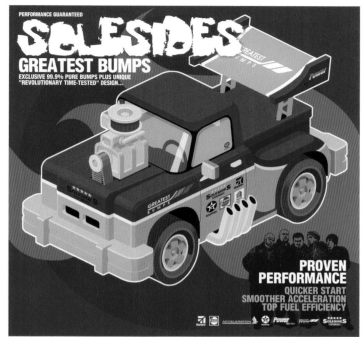

DESIGNER: Tim Marrs **CITY:** London, England **URL:** www.timmarrs.co.uk **SOFTWARE PROGRAM:** Photoshop

DESIGNER: Robert Lindström **ILLUSTRATOR:** Daniel Stolpe **STUDIO:** The DesignChapel **CITY:** Skelleftea, Sweden **URL:** www.designchapel.com **SOFTWARE PROGRAMS:** Free-Hand, Illustrator, Flash, Photoshop **TYPEFACE:** ATTriumvirate

MW: SO, WHAT ATTRACTED YOU TO THE GREATEST BUMPS PIECE TO REDESIGN?

TM: A CD cover is something I've always fancied doing; it's a great format with huge potential exposure. I had been close in the past, but with one reason or another things haven't turned out.

WHAT DID YOU THINK OF THE ORIGINAL DESIGN?

I felt the original work had its positive points, and who's to say that mine is any more successful? To me, it lacked a little power and seemed somewhat awkward, especially the hybrid lowrider auto. However, I did like the way the figures had been used, and this is something I didn't alter too much.

THE FIRST TIME I SAW YOUR DESIGN, IT LOOKED AS THOUGH YOU'D REALLY RELIED HEAVILY ON THE SOURCE FILES. AS I STUDIED IT MORE, I REALIZED THAT YOU'D ONLY GRABBED A FEW OF THE ELEMENTS AND HAD REALLY CREATED AN ALMOST ENTIRELY NEW PIECE. WHAT WAS YOUR CONCEPT FOR THE REDESIGN?

The brief for me was to create something that emphasized collective power…Solesides as diverse forces in union, or something like that! Also, to just have as much fun and freedom within the image-making. It was a time to play.

. . .

MW: SO, WHY DID YOU CHOOSE GREATEST BUMPS TO REDESIGN?

RL: I didn't have any extra time for the project, so I invited an excellent illustrator. Daniel Stolpe is excellent with drawing cool cars, so we thought *Greatest Bumps* would be cool for him.

DID YOU LIKE THE ORIGINAL DESIGN, OR WERE YOU LOOKING FORWARD TO GIVING IT A NEW LOOK?

Well, I didn't like it too much. It was OK, quite "cool," but maybe not so pretty.

WHAT WAS THE CONCEPT FOR YOUR REDESIGN?

For the redesign, we wanted to do a new style for the bands. Therefore we made a childish design for these cool bands because it would be a nice contrast. I used a dirty typeface on top of the picture to get the right feeling. Daniel made some small logotypes, which we used both on the car and beneath the text as nice graphic elements.

THE MINI LOGOS ARE GREAT; YOU'VE GIVEN IT A REAL RACING FEEL. WAS THE REDESIGN EXPERIENCE EASIER OR HARDER THAN YOU THOUGHT IT WOULD BE?

It was easier because Daniel focused on the illustration, and since it was so great, I didn't need to do too much!

. . .

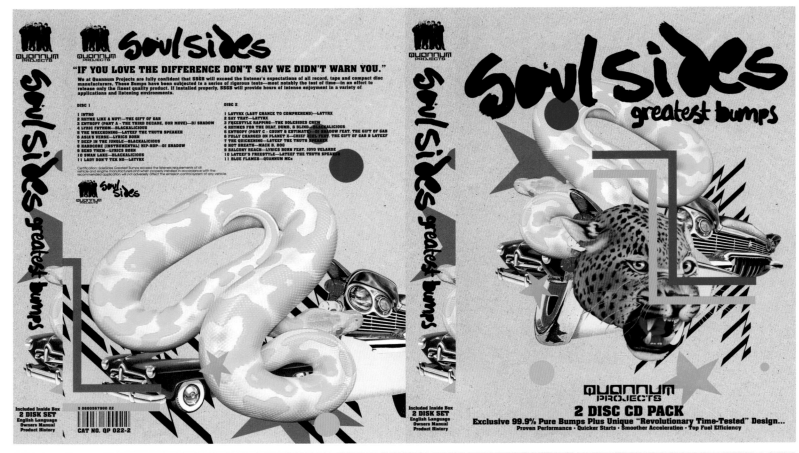

DESIGNER: Paul Humphrey and Luke Davies **STUDIO:** Insect **CITY:** London, England **URL:** www.insect.co.uk **SOFTWARE PROGRAMS:** Photoshop, Illustrator

MW: HOW DID YOU COME TO PICK THIS PIECE TO REDESIGN?

PH&LD: We chose *Greatest Bumps* to redesign because we had been listening to the album only a few weeks before this project was set, so being into the music made the process a lot easier.

AHH…MORE FANS OF QUANNUM. WERE YOU A FAN OF THE ORIGINAL DESIGN AS WELL?

The original design worked really well as a whole promotional package for the album—and has a really strong idea that is carried across to the web site.

SO, WE'VE GOT SOME SNAKES AND TIGERS AND, OF COURSE, THE MUSCLE CAR. WHAT WAS YOUR CONCEPT FOR THE REDESIGN?

We wanted to not base it on the original idea, but instead make an alternative striking image using a cut-and-paste style of illustration based on artists' work such as Blake and Jim Dine. Elements of the design would then translate across to web design and other promotional elements. Rather than the CDs being packaged in the original way, this design would be packaged in a DVD-sized cardboard box.

YOU REALLY PLANNED IT ALL OUT. WAS IT A GOOD TIME OR JUST A HEADACHE?

It was quite hard to work out what to do, as the existing piece of work works extremely well and has a strong car-based idea. This is why a more surreal route was taken.

. . .

MW: WHY DID YOU CHOOSE THIS PARTICULAR PIECE TO REDESIGN?

RSR: I'm a big Blackalicious, Latyrx, and DJ Shadow fan.

SO YOU WERE ALREADY FAMILIAR WITH THE COVER...DID YOU LIKE THE ORIGINAL DESIGN?

Yes, I have the record and have always loved the look of it. It's very tight and clean.

I COULDN'T HELP BUT NOTICE YOU'RE URINATING ON THE ORIGINAL DESIGN. WHAT'S GOING ON?

The idea is to comment on the act of remixing, which is like peeing on someone's hard work. Hopefully, you can give it a bit of color in the process.

SO YOU PEED ON IT. HOW WAS IT?

In the beginning, I didn't want to f--- up the original design too much. After a couple of rounds of sketching, I realized that this was impossible since the design suits the album so well. So, instead I flipped it around and ended up urinating all over it. I guess the hardest part was taking a picture of myself in this posture. Now I just hope that the original designer doesn't take a trip to Oslo to kick my puny behind for pissing rainbows all over their cover.

. . .

FEEDBACK FROM ORIGINAL DESIGNER:
BRENT ROLLINS

WHAT'S YOUR INITIAL REACTION TO EACH ONE?
Fluid: European
Tim Marrs: Respectful
The DesignChapel: Funny
Insect: Wild
Snasen: Perplexing

WHICH IS YOUR FAVORITE? WHY?
I think I like Insect's mostly for the imagery, cause it's just so "out there." It made me smile. It has that real reckless, "we-don't-know-what-the-hell-we're-doing-but-we're-having-fun" spirit, which is perfect for the early Solesides years.

WHICH SURPRISES YOU? WHY?
The piece by Insect, for the reasons listed above. And Snasen's, because at first I was offended by it, and then I got the joke...I think.

OVERALL, WHAT DO YOU THINK OF ALL THE REDESIGNS?
I can't think of a better word than just plain old interesting. None of them come close to what I thought I might see. I'm really curious what the other designers' objectives were and why they chose to redesign this.

GREATEST BUMPS REMIXED
Solesides

DESIGNER: Robin Snasen Rengard **STUDIO:** Snasen **CITY:** Oslo, Norway **URL:** www.snasen.com **SOFTWARE PROGRAMS:** Illustrator, Photoshop, Streamline **TYPEFACE:** Wilhelm Klingenspor Gotisch

CH 29 BLENDING BOUNDARIES ILLUSTRATION

MW: CAN YOU DESCRIBE THE CONCEPT OF THIS PIECE?

KI: Six members of the Design is Kinky crew were asked to do a few pages in *Arkitip* magazine, a print magazine made in Los Angeles. Design is Kinky is an Australian-based design portal whose audience has expanded throughout the globe. Keeping in mind our audience, as well as the origins of the crew members, it was decided that we would create visuals based on the theme "Blending Boundaries." There are many ways in which boundaries can be traversed, and I chose seasonal migration as a way of illustrating it. Using the elements of the robin, directional and monthly abbreviations and natural details, I made a piece that displays "directional suspension." The robin is in all places and seasons at once.

WERE THERE ANY OTHER APPROACHES YOU ATTEMPTED WITH THIS PIECE?

I considered constellation charts. I thought about the night sky as a patch of images that we all see in different ways as the seasons change and the earth rotates. The sky is always changing its boundaries. Constellations were also of interest to me because the Australians see a different sky from those of us in the Northern hemisphere, so I thought it would be fun to play with.

SINCE THIS WAS A GROUP PROJECT WITH OTHER MEMBERS OF THE DESIGN IS KINKY CREW, WHAT WERE SOME OF THE OTHER VISUAL INTERPRETATIONS OF "BLENDING BOUNDARIES?"

The various representations were maps, fish, people, broken shards of various things…

BIRDS HAVE BEEN SHOWING UP IN A LOT OF DESIGNS RECENTLY. WHAT IS IT ABOUT BIRDS THAT MAKES THEM APPEALING?

I just like using natural elements in my work. I thought a bird was a suitable way to illustrate my point. Birds are very symbolic animals. Drawing birds and plants are very similar in that there are hidden textures and patterns within the wings, petals and leaves. I find it fun.

…

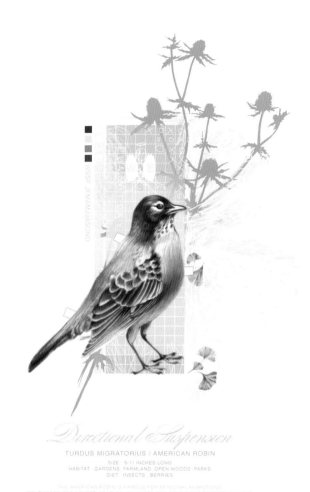

DESIGNER: Karen Ingram **STUDIO:** Krening **CITY:** Brooklyn, New York **URLS:** www.krening.com, www.kareningram.com, www.designiskinky.net **YEAR:** 2002 **SIZE:** 8½" x 10" (22 x 25 cm) **SOFTWARE PROGRAMS:** Photoshop, Illustrator **TYPEFACE:** Helvetica

DESIGNER: Deanne Cheuk STUDIO: Deanne Cheuk CITY: New York, New York URLS: www.neomu.com, www.AplentyProduct.com SOFTWARE PROGRAMS: Illustrator, Photoshop

MW: SO, WHY DID YOU CHOOSE THIS PARTICULAR PIECE TO REDESIGN?

DC: I thought it would be easy!

REALLY? TO ME, THIS ALWAYS SEEMED LIKE THE ONE OF THE MOST COMPLICATED PIECES TO REDESIGN. WHAT PART ABOUT IT MADE YOU THINK IT WOULD BE EASY?

I just thought it was easier than some others. I felt that there was more room for improvement in this particular piece, not that my design necessarily improves on the original.

WHAT WERE YOUR FEELINGS ABOUT THE ORIGINAL DESIGN?

I didn't really like or dislike the original design.

WAS THE PROJECT A NICE CHANGE OF PACE IN THAT YOU COULD FOCUS SOLELY ON AESTHETICS?

No, because everything I work on focuses a lot on aesthetics. That's why I love what I do.

WAS IT AN EASIER OR HARDER EXPERIENCE THAN YOU THOUGHT IT WOULD BE?

It was harder because my original plan was to draw the birds by hand. But then I remembered that I can't actually draw…

• • •

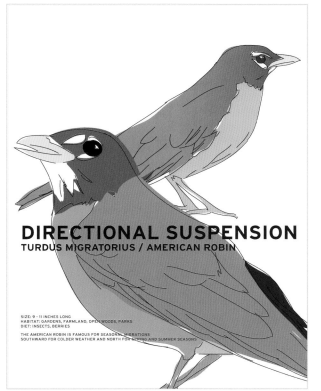

DIRECTIONAL SUSPENSION
TURDUS MIGRATORIUS / AMERICAN ROBIN

SIZE: 9 - 11 INCHES LONG
HABITAT: GARDENS, FARMLAND, OPEN WOODS, PARKS
DIET: INSECTS, BERRIES

THE AMERICAN ROBIN IS FAMOUS FOR SEASONAL MIGRATIONS
SOUTHWARD FOR COLDER WEATHER AND NORTH FOR SPRING AND SUMMER SEASONS

DESIGNER: Arthur Mount STUDIO: Arthur Mount Illustration CITY: Altadena, California URL: www.arthurmount.com SOFTWARE PROGRAM: Illustrator TYPEFACE: Interstate

MW: SO, WHY DID YOU CHOOSE THIS PARTICULAR PIECE TO REDESIGN?

AM: I like drawing birds.

REALLY, THAT'S IT? WHAT IS IT ABOUT BIRDS THAT MAKES THEM FUN TO DRAW?

They're beautiful. They have great shapes, lines and colors and have this sense of natural innocence.

IS THIS THE NEW BIRD RENAISSANCE? THEY'VE BEEN POPPING UP IN A LOT OF DESIGNS RECENTLY.

If they are, I had no idea about it. It's encouraging to hear. I think birds, and most animals in general (except for corporate mascots), are so inherently noncommercial. I'd much rather look at images of birds than next year's SUV.

HOW'D YOU LIKE THE ORIGINAL DESIGN?

I think it's great and seems appropriate for the subject.

WHAT WAS THE CONCEPT BEHIND YOUR REDESIGN?

The original design was very layered, so I wanted to simplify things: a big and bold illustration and a very straightforward type treatment. The idea was for it to be something that would catch your eye from across the room.

• • •

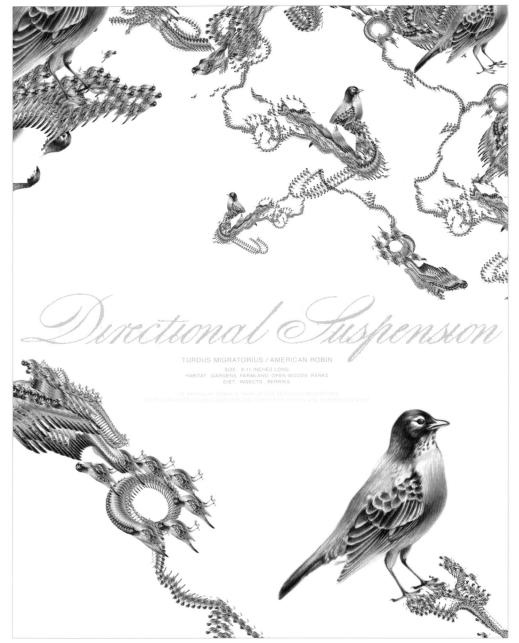

Directional Suspension

TURDUS MIGRATORIUS / AMERICAN ROBIN

SIZE: 9-11 INCHES LONG
HABITAT: GARDENS, FARMLAND, OPEN WOODS, PARKS
DIET: INSECTS, BERRIES

THE AMERICAN ROBIN IS FAMOUS FOR SEASONAL MIGRATIONS
FLYING SOUTH FOR COLDER WEATHER AND NORTH FOR SPRING AND SUMMER SEASONS

DESIGNER: Matt Rice **STUDIO:** Sennep **CITY:** London, England **URL:** www.sennep.com **SOFTWARE PROGRAMS:** Flash, Photoshop

MW: WHAT ATTRACTED TO YOU TO THIS CONCEPT?

MR: As a graphic designer who works almost entirely for the web, I wanted to take the opportunity to design something for print that used some of the skills I use everyday in my more experimental screen-based work. I had been thinking about the blurring between disciplines in all aspects of design and in particular the different processes involved in design for print and moving images. This seemed a good opportunity to explore the potential of creating something for print using nontraditional methods or techniques.

DID YOU LIKE THE ORIGINAL DESIGN, OR DID YOU THINK IT NEEDED SOME HELP?

I wasn't overly excited about the overall design. However, I did like the use of the American robin to communicate the idea of traversing physical boundaries. Plus, the title "Directional Suspension" really interested me as a starting point for the redesign. I loved the illustration of the bird and felt that something hand drawn was the perfect graphic element to put through the programmed process.

WHAT WAS YOUR CONCEPT FOR THIS REDESIGN?

My approach was to take elements from the original design and literally redesign it using action script in Flash. I wanted to create something that transformed the original design and gave it a new energy and a sense of movement. The final result is a visual analogy for the title. The bird is seen, quite literally, suspended in directional movement in Flash and applied to the design. Its pattern of movement also suggests the outlines of continents and coastlines that the bird would fly over as it migrates south.

WAS IT AN EASIER OR HARDER EXPERIENCE THAN YOU THOUGHT IT WOULD BE? WHY?

I think that my approach made the process relatively easy. I simply experimented with the elements that were at my disposal and didn't worry about creating any original material. I just wanted to take the thinking that was already in the original design, push it in a different direction and see what happened.

. . .

DESIGNERS: Felix and Alex Wittholz **STUDIO:** Helios Design Laboratories **CITY:** Toronto, Ontario, Canada **URLS:** www.heliozilla.com, www.ok47.com, www.okflavor.com **SOFTWARE PROGRAMS:** Illustrator, Photoshop, Vice City

MW: SO, WHY DID YOU CHOOSE THIS PIECE TO REDESIGN?

F&AW: We have always been suckers for white space, especially when it is used properly. The image contained tons of complex layers at various opacity levels, but the overall feel remained light and airy, like a bird. We're also fans of *Arkitip* magazine, where this image originally ran.

WHAT WAS YOUR REDESIGN CONCEPT?

We could ramble on about a deer's territorial overlap and their shrinking habitats, but basically this is a convoluted "man vs. nature" message. Combining a deer with a factory is not just pure postmodern and post-ironic genius, but also visual dyn-o-mite! Just in case, the original message is still available as a convenient tear-away coupon…highly collectible.

WAS IT AN EASIER OR HARDER EXPERIENCE THAN YOU THOUGHT IT WOULD BE?

The original message "Blending Boundaries" had been executed quite specifically. Since we wanted to keep the robin theme intact, we decided to add to it rather than reinterpret it. In that sense it was easy. Or just lazy.

• • •

DESIGNER: Ragnar Freyr Pálsson **STUDIO:** Onrushdesign **CITY:** Reykjavík, Iceland **URL:** www.onrushdesign.com **SOFTWARE PROGRAMS:** Photoshop, Illustrator **TYPEFACE:** Myriad

MW: WHAT LED YOU TO CHOOSE THIS PIECE TO REDESIGN?

RFP: Something about it struck me. It was simple and beautiful. Yet, if you zoomed into it, you saw little detailed drawings and pencil sketches. Also, there was something about the bird that caught my attention. Also, I liked it very much. It was clean and meaningful.

WHAT WAS YOUR REDESIGN STRATEGY?

With my redesign, I'm only exploring another way to communicate the message, not trying to outdesign the original. I used elements from the original design, such as the bird and the plant. I wanted to make the text more like a headline and also draw more attention to the bird. Eventually, I decided to vectorize the whole thing.

WAS IT AN EASIER OR HARDER EXPERIENCE THAN YOU THOUGHT IT WOULD BE?

My redesign took longer than I had expected. It turned out that I had so many ideas that it took ages to settle upon just one.

• • •

Substance. **75** Submicronic Colloidal Matter

Stat.ind

DESIGNERS: André Stringer and Cassidy Gearhart **STUDIO:** Stat.ind **CITIES:** New York, New York/Chicago, Illinois
URLS: www.staticopy.com, www.shilodesign.com **SOFTWARE PROGRAMS:** Photoshop, Illustrator **TYPEFACES:** HTF
Gotham, Akzidenz Grotesk Bold

MW: WHAT LED YOU TO CHOOSE THIS PIECE TO REDESIGN?

AS&CG: "Blending Boundaries" attracted us initially just because
of the wide array of possibilities it opened up for virtually any sub-
ject matter. After much discussion, we decided we would like to
examine a minute and faceless action—osmosis—and approach it
from a similar stance as the original design.

DID YOU LIKE THE ORIGINAL DESIGN, OR DID YOU THINK IT NEEDED SOME HELP?

Both of us liked the design of the original piece very much.
Because of the wide-open nature of the idea, readdressing the orig-
inal brief while staying true to the spirit of the original design
appealed to us.

WHAT'S THE CONCEPT OF YOUR REDESIGN?

We're expressing a moment of transformation that occurs unno-
ticed and unseen to the eye in a format that generally would not be
used to display the action.

WHAT WAS THE HARDEST PART OF THIS PROJECT FOR YOU?

It was just selecting the initial direction to take. We had a bunch of
ideas that we vetoed through numerous conversations. We were
drawn to the concept of water purification at a cellular level as a
vehicle for illustrating transformation.

• • •

FEEDBACK FROM THE ORIGINAL DESIGNER: KAREN INGRAM

WHAT'S YOUR INITIAL REACTION TO THE REDESIGNS?

Deanne Cheuk: Smart
Arthur Mount: Felt
Sennep: Jewel
Helios Design Laboratories: Yes
Onrushdesign: Poster
Stat.ind: Ah!

WHICH IS YOUR FAVORITE? WHY?

The piece by Helios really runs with my initial concept, and I find
that interesting. I like the fact that Deanne Cheuk's doesn't use any
words at all, and is a textural study. It's lovely. Arthur Mount's
makes nice usage of simple lines and shapes. I find Onrush's design
to be very dramatic...the robin looks so lonely and cold!

WHICH ONES SURPRISE YOU?

The work by Sennep and Stat.ind both surprise me. Stat.ind really
takes the concept in a different direction. It's less naturalistic and
more of a scientific depiction of blending boundaries. Very lovely
and educational as well. Sennep, on the other hand, takes the visu-
als in a different direction. I was really impressed with their use of
the wing texture and I loved the way they morphed the elements
into a completely different object. I suppose they've changed the
bird itself into a tool of suspension. Very clever.

TRUE STORIES FROM THE AMERICAN PAST BOOK COVER

MW: WHAT WAS THE CONCEPT FOR THE DESIGN OF THIS BOOK COVER?

EK: The book features historically accurate but sensational stories of murder, starvation, sex, etc. told with an extremely personal insight into the historical figures involved. History is as exciting and controversial as classic pulp fiction novels, and in these textbooks the editors and authors prove it.

A trip to a used bookstore and a few searches on the web provided the research needed in order to create covers with the needed punch and authenticity. The actual cracks from a well-read paperback were scanned and used to give these covers a sense of their own history.

YOU GIVE AN ILLUSTRATION CREDIT TO THE LIBRARY OF CONGRESS. HOW DID YOU DISCOVER THE MAIN IMAGE?

When I started the cover, I photocopied ten or so of the best images from inside the book and then worked with three or four until this image stood out as the most powerful. We bought the rights to the image, but I just photocopied the photocopy and used that to retain the immediacy of that nice gritty look.

I KNOW THERE WERE SEVERAL OTHER INCARNATIONS OF THIS BOOK COVER. WERE THEY MORE VISUALLY EXCITING THAN APPROPRIATE?

I don't know that any of the others were any more visually exciting, but they just referenced different aspects of the book's content. One had a really patriotic feel, one expressed the continuing struggle for freedom, and another had a very editorial feel. In the end, the pulp fiction idea applied to this collection of personal historical accounts of dramatic events was the most relevant.

• • •

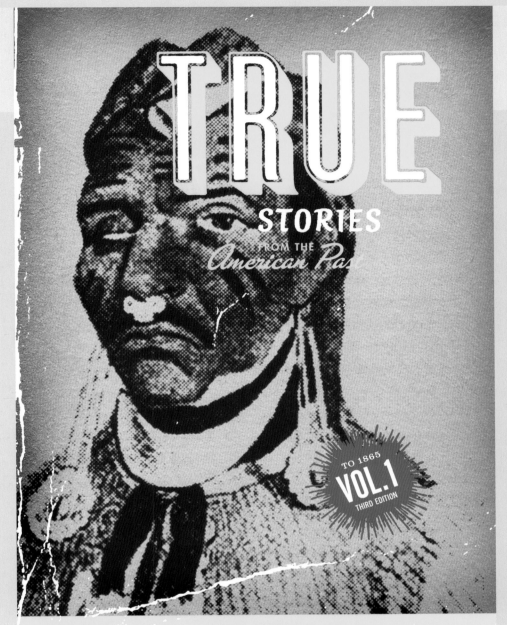

TRUE STORIES FROM THE American Past

TO 1865
VOL.1
THIRD EDITION

Stories by:

EDITED BY : ALTINA WALLER & WILLIAM GRAEBNER

NANCY SHOEMAKER•KAREN KUPPERMAN•BERNARD BAILYN•KENNETH LOCKRIDGE•T.J. DAVIS
PATRICIA TRACY•MICHAEL BELLESILES•GREG NOBLES•DAVID EDMUNDS•ALTINA WALLER
PETER WAY•MELTON MCCLARIN•EVERARD H. SMITH•VICTORIA BYNUM•STEPHEN NISSENBAUM

DESIGNER: Eric Kass **STUDIO NAME:** Lodge Design Co. **CITY:** Indianapolis, Indiana **URL:** www.lodgedesign.com **YEAR:** 2002 **SIZE:** 6⅜" x 9¼" (16 x 24 cm) **SOFTWARE PROGRAMS:** Quark, Photoshop **TYPEFACES:** Alternate Gothic No. 1, Clarendon, Futura, Las Vegas (House Industries), Trade Gothic Bold Condensed **ILLUSTRATOR:** Library of Congress

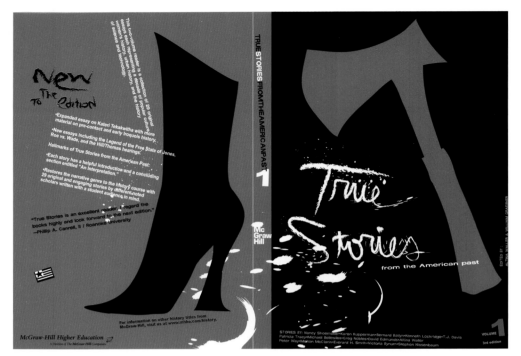

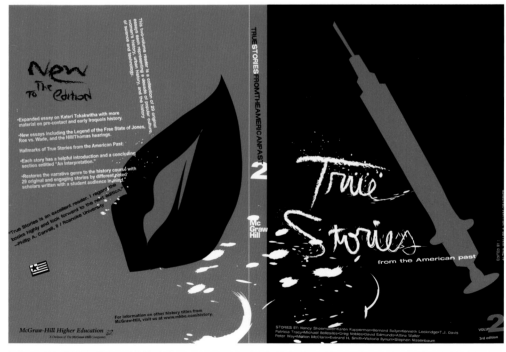

DESIGNER: Leigh White **STUDIO:** p11creative **CITY:** Santa Ana Heights, California **URLS:** www.p11.com, www.p11fun-haus.com **SOFTWARE PROGRAM:** Illustrator **TYPEFACES:** Handdrawn

MW: SO WHY DID YOU CHOOSE THIS PARTICULAR PIECE TO REDESIGN?

LW: I am the senior copywriter for p11creative and a published poet and spoken-word performer in my nonwork time, so it was a natural for me to want to design a book cover. Plus, I really liked the original design. The whole aged look was really cool. And it wasn't overdone.

YOUR REDESIGN CREATES A REALLY VIBRANT NEW LOOK FOR THE SERIES. WHAT WAS YOUR DESIGN CONCEPT?

Going against the predictable and patriotic red, white and blue, I went with a red, white and black palette to convey specific things: sensationalism, journalism and violence. I revamped this textbook to make it look more like a novel: an intriguing thriller, a tabloid, a suspense novel.

Much of the time, history can seem so blasé and clinical. My thoughts were to jump-start the reader into curiosity. The simplified cut silhouettes were used to generate high contrast. The entire layout is intentionally random and schizophrenic to reflect the spontaneous nature of a disorganized criminal mind and reinforce the intense caliber of these true stories.

WAS IT AN EASIER OR HARDER EXPERIENCE THAN YOU THOUGHT IT WOULD BE?

One of my hobbies is assemblage art, so I am constantly dismantling things to put them together in different ways, so dismantling someone else's design was pretty darn innate to me. Plus the taboo factor of it beckoned me. And not having any kind of relationship with the original designer didn't hurt either.

• • •

MW: WHY DID YOU CHOOSE THIS PIECE TO REDESIGN?

DR&GS: The title sparked some design ideas; it was less about the actual project's content and more about our initial feeling with the title.

SINCE IT WAS REALLY THE TITLE THAT ATTRACTED YOU, I'M CURIOUS TO KNOW WHAT YOU THOUGHT ABOUT THE ORIGINAL BOOK COVER.

We found the original effective but not really evocative. Also, it was a bit too focused on the Native American image.

WHAT WAS YOUR CONCEPT FOR THE COVER?

We knew we wanted something that used a period typeface but that also seemed tangible and handcrafted. Originally, we thought of cutting the letterforms out of mahogany wood veneer, but once we began testing concepts, the limitations of the material forced us in a different direction. The veneer was too brittle to cut in a complex fashion, so we decided to use it as our base material and screen printed the text and gun image onto it instead.

IT ALWAYS HELPS TO BE FLEXIBLE...HOW WAS THE OVERALL REDESIGN EXPERIENCE?

As with any project, we had hard patches as well as great strings of discovery and invention. At first, we didn't have any real concept or inspiration as to what we would do to begin, but in the end we were happy with the process as it developed. The challenges that we incurred throughout the process actually resulted in a great cooperative flow right at the cusp of our deadline that made for a fun experience that we didn't expect.

. . .

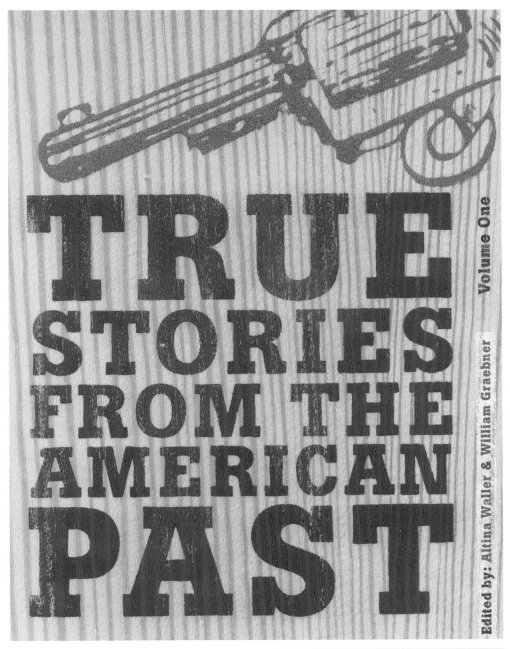

DESIGNERS: Davin Risk and Gayla Sanders **STUDIO:** Fluffco **CITY:** Toronto, Ontario, Canada **URL:** www.fluffco.com **SOFTWARE PROGRAMS:** Illustrator, Photoshop, Streamline **TYPEFACE:** Boton Bold (Adobe)

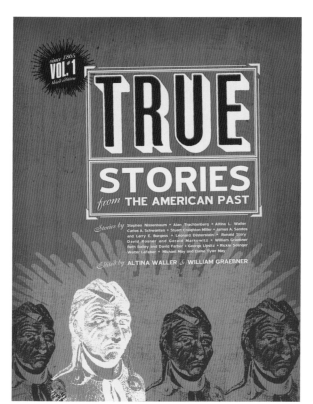

DESIGNER: Andrio Abero **STUDIO:** 33rpm **CITY:** Seattle, Washington **URL:** www.33rpmdesign.com **SOFTWARE PROGRAMS:** Photoshop, Illustrator **TYPEFACES:** Compacta, Boulevard, BlueHighway

MW: SO, WHAT LED YOU TO CHOOSE THIS PARTICULAR PIECE TO REDESIGN?

AA: I was drawn to the rough, authentic craftsmanship: the scratchy woodcut illustration, the imperfections of the typeface and just the general vintage look. The layout is also pretty clean and uncluttered.

SEEMS LIKE YOU THOUGHT THE ORIGINAL DESIGN WAS WELL DONE. WAS THERE ANY ASPECT OF IT YOU WANTED TO CHANGE?

I like the original design, but I just felt as though the colors weren't working together.

I SEE YOU CHANGED THOSE…WHAT WAS YOUR CONCEPT FOR THIS REDESIGN?

There wasn't much rethinking of the concept. I just felt the need to give it the same vintage look but with a bolder feel. I also wanted to bring the color scheme together to make it easier for the viewer's eye to travel.

WAS IT AN EASIER OR HARDER EXPERIENCE THAN YOU THOUGHT IT WOULD BE?

I think it was a little of both. It was hard taking something that was already well-designed and infusing my own style without losing the original concept and feel. But because the theme was already established, it was easy to just have fun and experiment by making it look different, but not radically different.

• • •

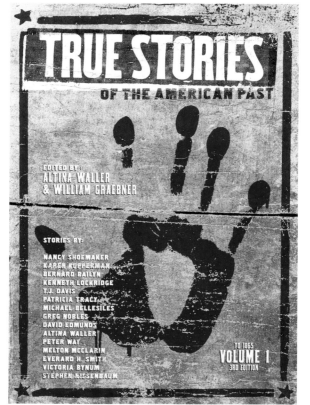

DESIGNER: Tim Gabor **CITY:** Seattle, Washington **URL:** www.timgabor.com **SOFTWARE PROGRAMS:** Photoshop, Quark **TYPEFACES:** Two hand-carved wood fonts created and digitized for me

MW: OUT OF ALL THE POSSIBLE PROJECTS, WHY DID YOU CHOOSE TO REDESIGN THIS BOOK COVER?

TG: I loved the subject, and it seemed like my personal aesthetic would fit well with the book's content. It seemed like a natural assignment for me, so I jumped in and had a blast.

DID YOU LIKE THE ORIGINAL DESIGN, OR DID YOU THINK IT COULD USE SOME HELP?

I try not to look at things like that—there are always multiple solutions. I usually approach a project from the standpoint of "That's cool…What would I do?"

SO, THAT'S COOL…WHAT DID YOU DO?

I wanted to use a singular image as a focal point. I thought the red handprint would be an attention-getter and would represent the victimization prevalent in all the cases. I used the wood type and the heavy textures to accentuate the historical aspect of the book.

• • •

MW: WHY DID YOU WANT TO WORK WITH THIS PARTICULAR PIECE?

MW: *True Stories* is just such a wide-open topic that it seemed like a fun one to explore.

WHAT WAS THE CONCEPT FOR THE REDESIGN?

From reading about the book, it just seemed as though it was filled with lurid tales of sex and violence from throughout history. I started imagining what it would have been like if tabloids had been around for centuries and all sorts of historical figures had to suffer the embarrassment of being slapped on the cover for everyone at the supermarket to see.

I was pretty aware that this was a really gimmicky solution, but for the project I thought it was still an effective solution. By using the visual language of tabloids, I think it could turn a lot of readers on to a book that they might have ignored otherwise.

HOW WAS THE REDESIGN EXPERIENCE THIS TIME AROUND?

This one was really fun. It just started out as a goofy exercise, and I kept coming back to it over the course of a few months to change the feature stories. At one time, I had managed to fill it up with about seven different boxed-out features. Even though that allowed more room for silliness, it really cluttered up the cover and diluted the impact of the design.

. . .

FEEDBACK FROM THE ORIGINAL DESIGNER:
ERIC KASS

WHAT'S YOUR INITIAL REACTION TO EACH REDESIGN?
p11creative: Murder
Fluffco: Wood
33rpm: Rust
Tim Gabor: Southwest
Plinko: Wigs

DO YOU HAVE A FAVORITE?
The tabloid design by Plinko is my favorite, because it's a new design that's still based on the editors' original concept for the content of the book. I think the design by p11creative still goes in the most unique direction, though.

WHICH ONE SURPRISES YOU THE MOST?
p11creative's piece feels very sexual and dangerous. I like that it doesn't have that old historical feel but instead focuses on the tension of the stories in the book. I think it's great that the whole book jacket was considered and not just the front cover.

OVERALL, WHAT DO YOU THINK OF ALL THE REDESIGNS?
The designers all took their own approach and expressed what they felt in the piece, which is good.

DESIGNER: Mark Wasserman **STUDIO:** Plinko **CITY:** San Francisco, California **URL:** www.plinko.com **SOFTWARE PROGRAMS:** Illustrator, Photoshop **TYPEFACES:** Future Bold Oblique, Champion (Hoefler)

CH
31

PRETTY GIRLS MAKE GRAVES CONCERT POSTER

MW: WHERE DID YOU DRAW YOUR INSPIRATION FROM FOR THIS DESIGN?

DS&JK: First and foremost, we wanted something that matched the name of the band, something that really captured the feeling of a lethal woman. We felt that the bleeding hand was an image that embodied the beauty and grace of a female but also showed the sinister side of the band's name as well.

"PRETTY GIRLS MAKE GRAVES" SEEMS SO RIPE FOR IMAGERY. DID YOU TRY ANY OTHER APPROACHES WITH THIS PIECE?

We usually sit down with four or five concepts each and figure out which one is going to work, what needs to be changed and what just doesn't make sense. With this poster, we both had "woman's hand" on our idea list. This was one of the few times that we both came to the table with the same idea, and it made it all the way through to the final piece.

WHAT WERE THE BIGGEST CHALLENGES IN CREATING THIS PIECE?

It seemed like satisfying ourselves was the hardest part of this design. We did page after page of sketches for the hand. For the final, I think we ended up doing a cut-paper illustration, scanning it and manipulating the shape in Illustrator. Looking at it now, it seems like such a simple shape, but it really took some labor to make it work.

...

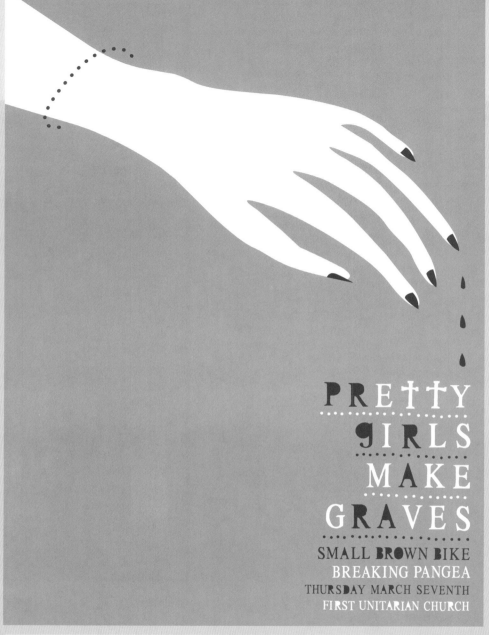

DESIGNERS: Dustin Summers and Jason Kernevich **STUDIO:** The Heads of State **CITY:** Philadelphia, Pennsylvania **URL:** www.theheadsofstate.com **YEAR:** 2002 **SIZE:** 17" x 23" (43 x 58 cm) **PRINTED BY:** BLT Screenprinting, Seattle, Washington **SOFTWARE PROGRAMS:** Illustrator, Photoshop **TYPEFACE:** State Serif (handmade)

MW: WHY DID YOU CHOOSE THIS PARTICULAR PIECE TO WORK WITH?

KR: I liked the title of the poster as well as the simple style of the piece. I also thought the original solution was the complete opposite to my design style, so it would be interesting to apply my techniques to create a complete contrast to the original.

HOW ABOUT A LITTLE INSIGHT INTO YOUR CONCEPT FOR THIS ONE?

My basic concept was to create an almost threatening piece of design, to make it dark and dirty without approaching it with the clichéd things you associate with death and graves.

YOUR WORK ALWAYS SEEMS TO HAVE THIS BLEND OF BEAUTY AND DIRT. WHAT'S YOUR GENERAL DESIGN PROCESS LIKE?

I usually visualize the finished piece in my mind. I try to think about how I can compose the piece and how I'd like people to read it. I usually have a main element that's either typographic, photographic or illustrative, and then I try to direct the reader's eye through the various elements of communication.

As for the beauty and dirt, I am a great believer in opposites complimenting each other. Thus, the use of dirty textures over clean beautiful imagery—the two balance each other out. Another reason for doing this is that I find a lot of computer-created graphic design very false and unnatural. I enjoy looking at things which have a much more spontaneous and organic feel—it helps give the design character and life.

. . .

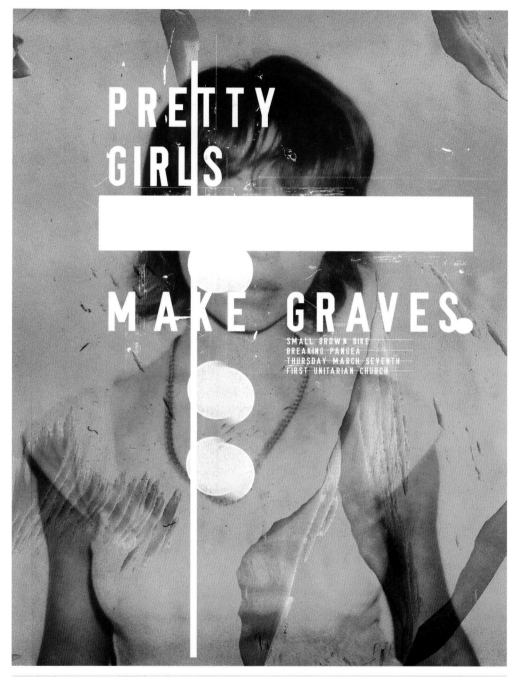

DESIGNER: Kerry Roper **STUDIO:** beautiful **CITY:** London, England **URL:** www.youarebeautiful.co.uk **SOFTWARE PROGRAMS:** Photoshop, Illustrator **TYPEFACE:** Tjsjecho

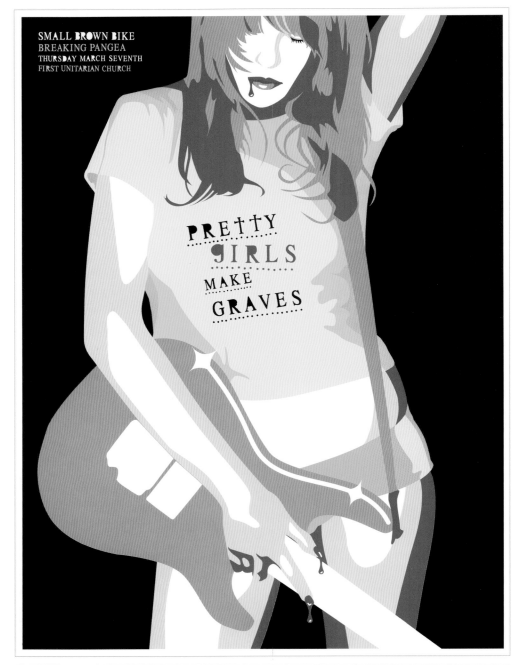

SMALL BROWN BIKE
BREAKING PANGEA
THURSDAY MARCH SEVENTH
FIRST UNITARIAN CHURCH

PRETTY
GIRLS
MAKE
GRAVES

MW: ANNA, YOU'RE A HERO…BACK FOR ANOTHER, EH? WHY'D YOU WANT TO HAVE A GO AT THIS ONE?

AA: I liked the concept of a lethal woman! I also thought that doing a poster for a girl-led band would be fun.

DID YOU LIKE THE ORIGINAL POSTER DESIGN?

Yup, I did. I thought it was effective. I really liked the typeface; it suited the title well and had a sort of gothic punk feel to it. I thought the style was a bit cartoony, but that's really just personal preference.

SO, HOW DID YOU APPROACH THIS PIECE?

I really liked the starting theme of the hand with the blood dripping from it. I thought I could take that idea a bit further. I wanted to introduce a musical element into it and a bit more sex appeal and lethalness. The end result was a stylized guitar girl with blood dripping from her hand and mouth. Finally, the type was used from the original design and placed on her T-shirt as a focal point.

WAS THIS ONE AN EASIER OR HARDER EXPERIENCE THAN YOU THOUGHT IT WOULD BE?

Probably easier because it just seemed to flow easily, and everything seemed to fit into place quite early in the process. I think it was because the original piece gave me a really strong visual in my mind of where I wanted to go to next.

• • •

DESIGNER: Anna Augul **CITY:** Melbourne, Australia **URLS:** www.quikanddirty.com, www.australianinfront.com.au, www.neverendingremix.com **SOFTWARE:** Illustrator

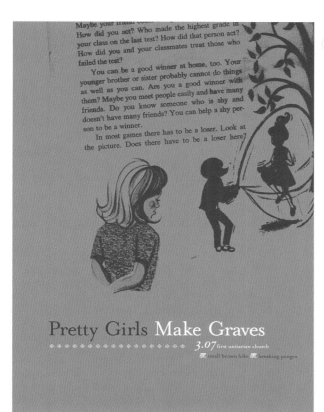

DESIGNER: Scott Sugiuchi CITY: Baltimore, Maryland URL: www.scottsugiuchi.com SOFTWARE PROGRAMS: Illustrator, Photoshop TYPEFACES: Mrs. Eaves (Émigré), Hoefler Text (Hoefler Type Foundry), Type Embellishments (Linotype)

MW: SO, WHY DID YOU CHOOSE THIS PARTICULAR PIECE TO REDESIGN?

SS: I just wanted to hang onto the coattails of those superstars, The Heads of State.

I GUESS YOU RECOGNIZED THE POSTER. DID YOU LIKE THE ORIGINAL DESIGN, OR WERE YOU ITCHING TO REDESIGN IT?

Nah, I loved the flavor of this poster, the simplicity of it. But designers can't help but think, "I would've done it this way…"

WHAT WAS YOUR CONCEPT FOR THIS REDESIGN?

I wanted to retain the palette as a shout-out to the original and then take the direction where I would've gone with it. I also wanted to contrast the aggressive nature of the band with some delicate type. As for the image—the main artwork kind of found me (old health books are beautiful). I was actually drawn to the sad little girl in the foreground, but when I applied the whole page with the original text (nothing's been altered), it took on a much more sinister tone with the words "Pretty Girls Make Graves" underneath.

SEEMS LIKE IT ALL CAME TOGETHER PRETTY QUICKLY.

It was pretty easy. I mean, c'mon, it's a music poster. How hard is that?

• • •

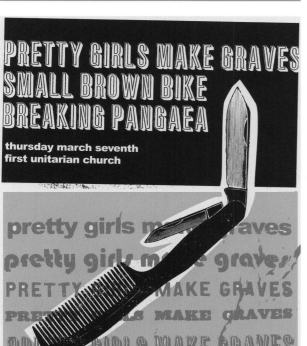

DESIGNER: Nick Pritchard STUDIO: metro/sea CITY: Los Angeles, California URL: www.metrosea.com SOFTWARE PROGRAMS: Photoshop, Illustrator TYPEFACES: Shadow Grotesque, Arial Black, Bauhaus 93, Fatslab

MW: SO, WHY DID YOU CHOOSE THIS PARTICULAR PIECE TO REDESIGN?

NP: I'm a fan of the bands Pretty Girls Make Graves and Small Brown Bike.

HOW'D YOU LIKE THE ORIGINAL DESIGN?

I thought the original design worked well, but I wanted to try to represent the dangerous woman without using the image of a woman.

LOOKS LIKE IT WORKED OUT WELL FOR YOU. WAS IT AN EASIER OR HARDER EXPERIENCE THAN YOU THOUGHT IT WOULD BE?

The biggest challenge was trying to find imagery that fit the "Pretty Girls Make Graves" name without using a picture of a girl. The idea came about very easily after looking through old catalogs and seeing the image of the knife and comb. When the two are combined, I think they make a powerful statement. And hey, the band's lead singer is a hairstylist during the day, so it all keeps coming together.

• • •

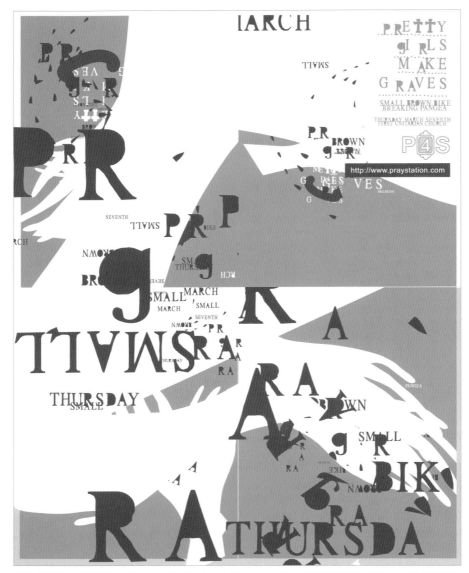

DESIGNER: Joshua Davis **STUDIO:** Joshua Davis Studios **CITY:** Port Washington, New York **URL:** www.joshua-davis.com **SOFTWARE PROGRAMS:** Illustrator, Flash

MW: WHAT ATTRACTED YOU TO THE ORIGINAL DESIGN?

JD: I chose Pretty Girls Make Graves because the programs I write tend to like certain structured elements more than others. I liked the variation in small and large shapes using only three colors. I also like the shape of the forms; it's a nice contrast from the organic form with broken type.

DID YOU LIKE WHAT THE DESIGNERS DID WITH THE ORIGINAL PIECE?

I did like it because it helped convey the message they needed it to— but I also like the abstraction of my redesign, even though it strays away from its intended message.

SO, WHAT WAS YOUR CONCEPT FOR THIS REDESIGN?

It's simple computer abstraction. Using a scripted program, my redesign took all of the original's elements and placed them within a system with rules and boundaries. I control only the boundaries of the program, not the output that the program draws. The idea is always living within the program, continually running the system. I'm just waiting to catch the composition which I deem interesting.

AS THE PROGRAM IS GENERATING DESIGNS, WHAT IS THE PROCESS LIKE?

It's not easy or hard, just time consuming. It takes a few days of running the program over and over again to get the final outputs. I must have generated a few hundred compositions to narrow it down to the final four, all pieced together, which you see here.

. . .

FEEDBACK FROM THE ORIGINAL DESIGN STUDIO:
THE HEADS OF STATE

WHAT'S YOUR INITIAL REACTION TO EACH REDESIGN?
beautiful: Menacing
Anna Augul: Vibrant
Scott Sugiuchi: Refined
metro/sea: Poignant
Joshua Davis Studios: Pulverized

DO YOU HAVE A FAVORITE?
It has to be metro/sea's. What an iconic image. This is the type of image we try to come up with every time we sit down at the drawing board: something that embodies either the name or feeling of the subject without being too literal.

WHICH OF THEM SURPRISES YOU THE MOST?
The version by beautiful really makes you look. It's not apparent what the subject is, and that's a good thing. You can look at this poster and get a million different feelings from it. This woman could be a killer, or she could be a victim. It's dependent on how the viewer perceives the piece.

OVERALL, WHAT DO YOU THINK OF THE REDESIGNS?
The difference in the five redesigns is amazing. Five clearly different styles, and five clearly different approaches to solving the problem.

MW: THIS PIECE CAUSED A LOT OF ATTENTION AMONG THE DESIGNERS IN THE BOOK. THE GENERAL COMMENT SEEMED TO BE "I LOVE IT! WHAT IS IT?" SO, ONCE AND FOR ALL, CAN YOU DESCRIBE WHAT WE'RE LOOKING AT?

JG: Wow, that's great. It's just a map. There's a green line pointing to a place I would like to visit before I die.

WHAT SPARKED THE IDEA FOR THIS PIECE?

I've been working with maps and topography data for the past couple years now. Using existing data, like city locations and bodies of water, I run various processes in Illustrator, often force quitting these processes or misusing filters from their intended purpose to produce results. The final works imply the original data but remain vague.

HOW DID YOU CREATE THE EFFECT OF THE TOPOGRAPHY? WAS IT ALL DONE BY HAND, OR ARE YOU USING ANY SORT OF SECRET MATHEMATICAL ALGORITHMS?

There's no secret algorithm. It's a mix of by-hand and my misuse of Illustrator. The 3-D extruded landmasses are done using a KPT plug-in for Illustrator 8 with a force-cancel of the filter halfway through and then going in by hand and removing parts.

. . .

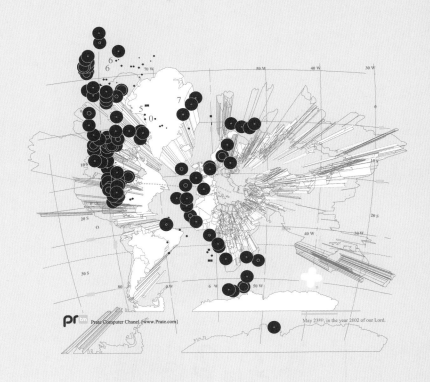

DESIGNER: Jemma Gura **STUDIO:** Prate™ Computer Channel **CITY:** Minneapolis, Minnesota **URLS:** www.prate.com, www.jemmagura.com **YEAR:** 2002 **SOFTWARE PROGRAM:** Adobe Illustrator **TYPEFACE:** Adobe Garamond

DESIGNER: Mike Lohr **STUDIO:** Semiliquid **CITY:** Los Angeles, California **URL:** www.semiliquid.net **SOFTWARE PROGRAM:** Adobe Illustrator

MW: SO, WHY DID YOU CHOOSE THIS PARTICULAR PIECE TO REDESIGN?

ML: I liked the original design, but since there didn't seem to be a specific audience or purpose to this piece, I thought it would be less restricting to redesign. I also thought it would be a challenge to reinterpret something with such a strong style.

WITH THAT IN MIND, WHAT WAS YOUR CONCEPT FOR THIS REDESIGN?

I approached the original as an abstract design. I wanted it to be more about nature and emotion than topography and commerce. I was inspired by the title.

DID IT END UP BEING AN EASIER OR HARDER EXPERIENCE THAN YOU HAD ORIGINALLY EXPECTED IT WOULD BE?

It was a harder experience than I thought. The lack of restriction was actually a little constricting. I think that it is difficult to redesign something that you like. That's why my piece was inspired by the feeling rather than the idea.

• • •

DESIGNER: David Linderman **STUDIO:** Fork Unstable Media **CITY:** Berlin, Germany **URLS:** www.fork.de, www.unstable-media.com **SOFTWARE PROGRAMS:** FreeHand, Adobe Photoshop **TYPEFACES:** Kit Stencil, Kit Human (both from Playpuppy.com)

MW: WHY DID YOU CHOOSE THIS PARTICULAR PIECE TO REDESIGN?

DL: I saw the Prate logo in the design and knew that Jemma Gura was probably behind it. I love her work and wanted to mix my own thoughts into it. When I found the "in the year of Our Lord" blurb, I knew it was divine intervention.

PERHAPS THERE WERE SOME OTHER FORCES AT PLAY...WHAT WAS YOUR REDESIGN CONCEPT?

Even though I loved the original artwork, it immediately inspired me to try and "quick-and-dirty" it up. It was very clean, and I'm not.

I remixed the piece during the months preceding the second gulf war. Considering my great dissatisfaction with American foreign policy over the last three years, I felt compelled to make some kind of statement, however abstract, about the volatility of the world at the moment and at the dangerous time we're living in.

I read way too many newspapers and watch too much "news." I'm angry about world events and at the callous nature in which the Bush administration has addressed foreign affairs. I felt it was an important and appropriate event to address, and, more importantly, I hope it documents the insecurity a lot of us had during the first few years of this new millennium.

• • •

MW: SO, WHY DID YOU CHOOSE THIS PARTICULAR PIECE TO REDESIGN?

AB: It's yummy. I thought it was a strong idea that was light, not overdesigned, and the colors are super tight. It was my first choice and, to tell you the truth, the only piece I really wanted to play with.

IT'S QUITE A CLEVER PIECE YOU'VE COME UP WITH. HOW'D YOU LIKE THE OVERALL EXPERIENCE?

It was a fun experience. I did the piece in couple of hours, which makes it nice and light and not overworked.

YOU REALLY DID PLAY AROUND WITH IT—YOU'VE LITERALLY CHANGED THE PERSPECTIVE ON THE ORIGINAL. WHAT WAS YOUR CONCEPT FOR THE REDESIGN?

I used the idea that the original piece was the cover of a broadcasting standards manual, and the piece I did was the layout from that manual.

YOUR DESIGN LOOKS SO OFFICIAL. DID YOU HAVE ANY PREVIOUS EXPERIENCE WORKING WITH BROADCASTING?

None at all.

REALLY? HOW ACCURATE IS THE TEXT IN THE BOTTOM LEFT-HAND CORNER? ARE YOU READY TO START BROADCASTING?

It's very accurate; we are ready to go. Tune in to the computer channel now.

. . .

DESIGNER: Ash Bolland **STUDIO:** Ÿmeric/Phojekt **CITY:** Sydney, Australia **URLS:** www.umeric.com, www.phojekt.com
SOFTWARE PROGRAMS: FreeHand, Photoshop, Cinema 4d **TYPEFACES:** Georgia, Bookman Old Style

DESIGNER: Andrew Taray **STUDIO:** ohioboy **CITY:** Brooklyn, New York **URL:** www.ohioboy.com **SOFTWARE PROGRAMS:** Photoshop, Illustrator **TYPEFACE:** Helvetica Neue 75 Bold

MW: WHAT MADE YOU CHOOSE THIS PIECE TO REDESIGN?

AT: I loved the original piece, and I wanted to take the words and thought process to a whole different level. The original was so tech-y and grid oriented. I'm usually hooked on the beautiful use of line drawings and diagrams, and I just thought this would be fun to focus on a different kind of approach. I wanted to take the words "Beautiful Land" and build a completely organic design. Also, I gave a shout-out to the blue collar workers.

YOU MANAGED TO GO ABOUT AS FAR AWAY FROM THE ORIGINAL AS POSSIBLE…WHAT WAS YOUR CONCEPT FOR THIS REDESIGN?

The original was built on the ports and I got this mega-industry feeling from the content. To me, the beautiful land is the truest land: the parts of the country that have yet to be given the All-American Concrete Makeover™. So, I thought along the lines of summer days, mowing the lawn, eating BLTs and working in the yard.

WAS IT AN EASIER OR HARDER EXPERIENCE THAN YOU THOUGHT IT WOULD BE?

It was a fun process for me to work in a collage style. I guess I would say it was easy to work with old textured images that I love but a little difficult to work with such a rough-edge cutout style. My first reaction is to try to clean everything up and make it too clean cut. I had a lot of fun though.

. . .

DESIGNER: Joshua Davis **STUDIO:** Joshua Davis Studios **CITY:** Port Washington, New York **URL:** www.joshua-davis.com **SOFTWARE PROGRAMS:** Illustrator, Flash

MW: SO, WHY DID YOU CHOOSE THIS PARTICULAR PIECE TO REDESIGN?

JD: I chose "Beautiful Land" because I have done several collaborations with Jemma in the past and our jamming together works well since we both employ tons of accidental and random processes in our work. I always love Jemma's work, and she loves the programs I write, which she sometimes uses to rip through postscript.

THIS REDESIGN LOOKS LIKE ANOTHER CASE OF JOSHUA DAVIS WIZARDRY. HOW DID THIS ONE COME ABOUT?

It's simple computer abstraction—my redesign piece took all of the original elements and placed them within a system of rules and boundaries. However, this redesign shows outputs and decisions that the computer did, not me. I had no control over the final output, only the boundaries in which the program draws.

IT'S ALMOST LIKE A PARALLEL WORLD OF ART DIRECTION, WHERE YOU CREATE THE GUIDELINES AND THE MACHINE DOES THE DIRTY WORK. HOW DID YOU LIKE THIS REDESIGN?

It wasn't really easy or hard, just time consuming. It takes a few days running the program over and over again to get the final outputs that I ended up using for the final layout. I must have generated a few hundred outputs to narrow it down to this final composition.

. . .

MW: SO, WHY DID YOU CHOOSE THIS PARTICULAR PIECE TO REDESIGN?

RM: I think it chose me. I'm not sure what the original design was for in the first place, but I liked it a lot. Also, I never intended to redesign it as much as to reinterpret the title, if that makes any sense…

WHAT WAS YOUR CONCEPT FOR THIS REDESIGN?

If in doubt, apply force.

IT'S KILLING ME THAT I CAN'T READ ALL OF THE TEXT. CAN YOU GIVE US A HINT?

The handwriting is a line from Husker Du's "Diane." I did part of the illustration after reading a proof copy of *Jarhead: A Marine's Chronicle of the Gulf War*, by Anthony Swofford. Factor in all the "Get your war on!" news coverage and I guess we're talking metaphors. But, y'know, it's effectively hidden and only apparent if you're familiar with the song…which is what I wanted.

I GET THE FEELING THERE'S A WHOLE STORY HERE THAT I DON'T UNDERSTAND. WHO ARE WE LOOKING AT, AND WHAT IS THE BEAUTIFUL LAND?

To me, the original design looked bulletridden, the kind of thing you get in sci-fi movies or video games when rounds enter metal or stone and leave a perfect, almost funnel-like concave depression. The image is just a generic comic book soldier. Comic book soldier in a comic book war. My brother, who left the parachute regiment a few years ago, was on numerous occasions in Pristina, about two seconds short of literally loosing his head. We were both addicted to the monthly Commando comic as kids. I could go on, but you get the idea.

• • •

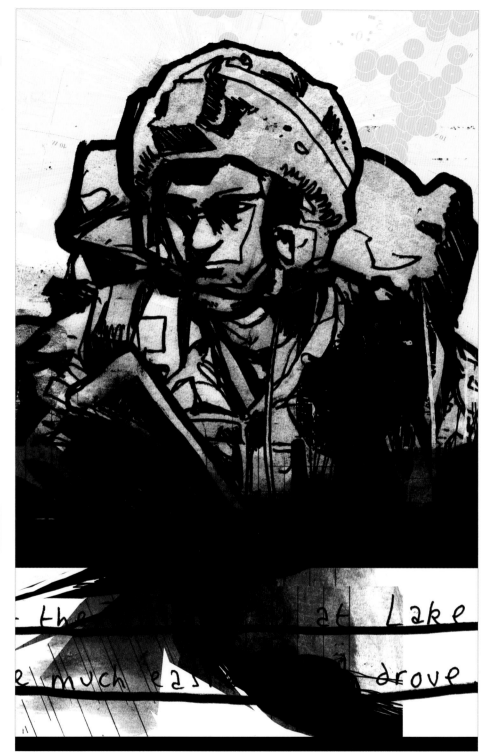

DESIGNER: Richard May **CITY:** London, England **URL:** www.richard-may.com, www.pixelsurgeon.com **SOFTWARE PROGRAMS:** Photoshop, marker pen

CH 33
HIP HOP
DON'T STOP
CD COVER

MW: WHAT WAS THE CONCEPT FOR THE DESIGN OF THE ALBUM COVER?

PC: Overall, it was to create a series of sleeves that took hip-hop back to its roots while looking up-to-date.

THIS WAS ONE IN A SERIES OF FOUR CDS. CAN YOU TALK MORE ABOUT THE DESIGN CONCEPTS?

I have always been a hip-hop fan. The first 12" single I bought was Afrika Bambaataa's "Planet Rock" way back in the mid 1980s. When I got into designing, I always thought a lot of hip-hop record sleeves were not up to scratch. When I got the opportunity to work on this set of releases, I wanted to take them back to basics: three-color sleeves and crunchy, with old school ideals that included shooting hoops, hanging with your crew, lowriders and fat trainers.

THE COLOR CHOICES REALLY STAND OUT—THEY'RE NOT TWO COLORS YOU LOOK AT AND INSTANTLY THINK, "RIGHT, CLASSIC HIP-HOP." HOW DID THEY COME ABOUT?

You hit the nail on the head. I used colors that look good together but are not normally associated with hip-hop.

THAT'S A PRETTY AMAZING CAR ON THE COVER. WHEN THEY DECIDE TO PRODUCE THEM, WHO WOULD BE THE FIRST ONE TO BUY IT?

I would like to see someone like Hugh Hefner and his ladies in it with De La Soul DJing on the decks whilst Q-Tip raps. How does that sound? Maybe we would need a bigger ride.

. . .

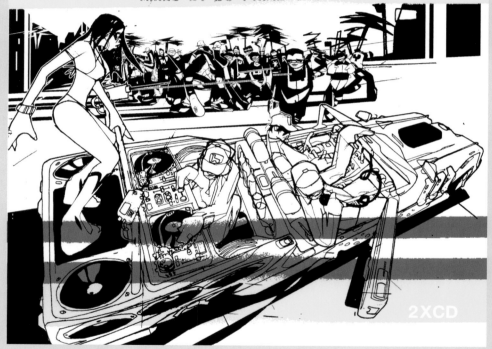

DESIGNER: Peter Chadwick **ILLUSTRATOR:** Will Barras **STUDIO:** Zip Design **CITY:** London, England **URL:** www.zipde-sign.co.uk **YEAR:** 1999 **SIZE:** 5" x 5" (13 x 13 cm) **SOFTWARE PROGRAMS:** Quark, FreeHand, Streamline, Photoshop **TYPEFACE:** Helvetica Neue

MW: SO, WHY DID YOU CHOOSE THIS PIECE TO REDESIGN?

MT: This would be something I would want to be hired for, had it been an actual jobby job.

WHAT DID YOU THINK OF THE ORIGINAL DESIGN?

I really love the illustrations and overall mood that is created from them. It's a sort of "funky-shake-your-ass-to-this" kind of feeling. But I felt that the type overpowered and fought the illustrations and could have been less prominent on the cover.

YOU'VE GOT THE CLASSIC OLD-SCHOOL SNEAKER FRONT AND CENTER. WHAT WAS YOUR CONCEPT FOR THIS REDESIGN?

Since the original was rather detailed and complex, I chose to go a more simple route. I wanted a single image that embodied old-school hip-hop, so what better than a shell-toe Adidas? Then to put the shoe into yet another hip-hop reference, I made it look like a wheat-pasted poster. Lastly, to further represent the elements of hip-hop from this time period, I used little icons of vinyl, a mic, a fat rope, a kangol, and again the shoes. Word.

HOW WAS THE OVERALL REDESIGN EXPERIENCE?

This was pretty challenging. Typically when I design a CD cover, there is direction coming from somewhere, but the existing cover kept creeping into my mind as sort of a counterdirection. It's not very often you get a project and someone says "do anything you want but this." So it threw me a little, but all in all I really enjoyed the experience.

• • •

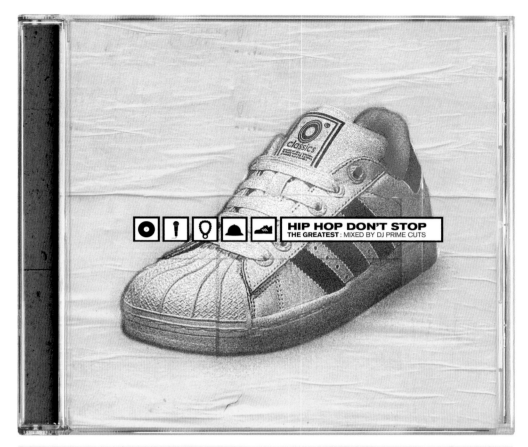

DESIGNER: Matt Taylor **STUDIO:** MattVarnish **CITY:** Los Angeles, California **SOFTWARE PROGRAMS:** Illustrator, Photoshop
TYPEFACES: Berthold Akzidenz Grotesque Bold Extended, Bold and Regular

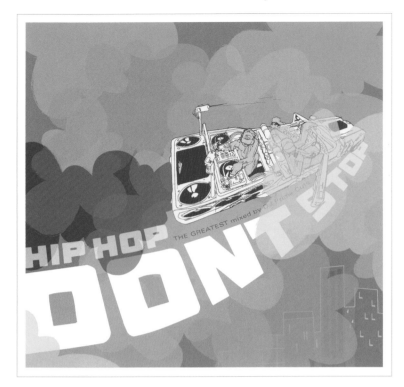

DESIGNER: Jeff Kleinsmith STUDIO: Patent Pending CITY: Seattle, Washington URL: www.patent-pendingindustries.com SOFTWARE PROGRAMS: Illustrator, FreeHand, Photoshop

MW: WHAT DID YOU THINK ABOUT THE ORIGINAL DESIGN?

JK: We liked it…we felt like it was great starting point. There were other pieces that we had wanted to work with because we thought we could improve upon them, but we chose this one because we liked the challenge of doing something different with an existing image.

WHAT WAS YOUR CONCEPT FOR THIS REDESIGN?

Rather than discard the preexisting art for the piece, we wanted to rework the current design into something new, creating a different mood or feel. The Hip Hop Don't Stop cover was cool to begin with and also held the potential for using the imagery in many ways, unique from the original. Obviously, we wanted to do something cool…We thought the main car image was great, but we wanted to cast it in a galactic environment. Instead of bumping down the road it would be flying into space.

WAS IT AN EASIER OR HARDER EXPERIENCE THAN YOU THOUGHT IT WOULD BE? WHY?

A little of both. It was easy because the groundwork had already been laid. We were given the images to use, and had the freedom to add and subtract as we pleased. However, because we already liked how the original looked, it was difficult to do something which deviated from it yet have the end result as cool as the original. We're not sure ours is an improvement, but hopefully it's different enough.

• • •

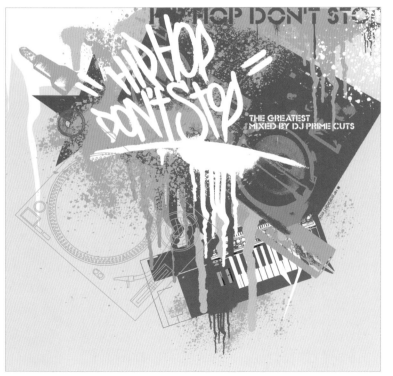

DESIGNER: AS1 STUDIO: InfiniTransformation CITY: New York, New York URL: www.infinitransformation.com SOFTWARE PROGRAMS: Photoshop, Illustrator

MW: WHAT WAS YOUR CONCEPT FOR THIS REDESIGN?

AS1: It's pure hip-hop.

WHAT DO YOU THINK ABOUT THE CURRENT STATE OF DESIGN IN HIP-HOP?

Some of the designs are interesting, and some are just commercial. I feel that we need to get away from the marketing aspects of artist photos and huge names, and get back to doing designs that are a bit more mysterious and not so obvious.

CLEARLY, YOUR CONCEPT WAS HIP-HOP. BUT OF COURSE, THERE ARE SO MANY LAYERS WITHIN THAT. WHEN YOU STARTED WORKING ON THE PIECE, WHAT ELEMENTS DID YOU KNOW YOU WANTED TO INCLUDE?

To symbolize the graffiti surrounding hip-hop, I included markers and spray can drips. For the aspect of DJ culture, I put in boom boxes and turntables. Also, I threw in some stars—which have been included in hip-hop artwork since the 1980s.

WAS IT AN EASIER OR HARDER EXPERIENCE THAN YOU THOUGHT IT WOULD BE?

The experience was exactly how I thought it would be: different.

• • •

dont´stop

MIXED BY DJ PRIME CUTS

HIP HOP 63

En 1998 el IDCT realzó de nuevo
el Festival en el teatro al aire libre La Media Torta,
llamándolo esta vez Rap al Parque.

DESIGNER: Paola Sarmiento Contreras **STUDIO:** copyright 0328 **CITY:** Bogotá, Colombia **SOFTWARE PROGRAM:** Photoshop **TYPEFACES:** Alba Super, Micrograma

FEEDBACK FROM THE ORIGINAL DESIGNER:
PETER CHADWICK

LOOKING AT THE REDESIGNS, WHAT'S YOUR INITIAL REACTION TO EACH ONE IN ONE WORD?
MattVarnish: Neat
Patent Pending: Flat
InfiniTransformation: Phat
Copyright 0328: Slick

WHICH ONE IS YOUR FAVORITE OF THE BUNCH?
I like InfiniTransformation's design for its vibrancy and roughness.

DO ANY OF THEM COME AS A SURPRISE TO YOU?
The piece by copyright 0328—it's different compared to how we approached the original sleeve. It has the look that could cross over from hip-hop magazines into style magazines.

OVERALL, WHAT DO YOU THINK OF ALL THE REDESIGNS?
Pretty good; some are better than others.

MW: WHAT DID YOU THINK OF THE HIP HOP DON'T STOP COVER?

PSC: Overall, I think it is an attractive CD cover. The only thing I didn't really like about the original design was the typeface used.

YOUR DESIGN SEEMS LIKE IT COULD BELONG EQUALLY TO THE FASHION WORLD, RATHER THAN PURELY HIP-HOP. WHAT WAS YOUR CONCEPT FOR THIS REDESIGN?

When I was working on this redesign, I wasn't really thinking about the music but instead about the people, their movements and the facial expressions that belong to the hip-hop scene. That was my starting point, and then I kept going all the way with it until I finally got the shapes and colors I was looking for.

WAS IT AN EASIER OR HARDER EXPERIENCE THAN YOU THOUGHT IT WOULD BE?

Whether it was easy or hard, I think it was definitely fun. When you start to work on the redesign, even if you try not to, you're going to be a little influenced by the previous design in some ways. It was a little confusing at the beginning, because I certainly didn't want my final result to be too similar to the original. After various sketches, I finally got something that I was comfortable with. From there, it became easier, even though it was much more time consuming because I did plenty of color variations. I liked many of them, and it's difficult to choose!

• • •

MEDICINE BAR
MENU

MW: GIVEN THAT IT'S CALLED THE "MEDICINE BAR," THE FIRST INSTINCT MIGHT TO BE TO INCLUDE SOME TYPE OF MEDICAL OR HEALTH CARE IMAGERY. DID YOU EVER EXPLORE THESE DIRECTIONS?

LB: It was considered, but I didn't want to react specifically to the name. Also, the place itself has more of a warm, worn feel; it's not really a clean, medical type of environment. As we definitely had to use the Muhammed Ali image, the design was pretty much dictated by that.

WHY WAS IT ESSENTIAL TO HAVE ALI AS PART OF THE DESIGN?

In the original Medicine Bar in Islington, they have a large painting of Ali as a young fighter. They wanted to use this image as their mascot, so we were originally given a photograph of this painting and asked to work with it. I used many processes to create something which was essentially the same image but then again appeared quite different. I wanted to make the piece resemble a screen printed poster or something more analog and handmade, even though almost every element of this job was created digitally.

THE HEADLINE TYPE IS REALLY DYNAMIC. HOW DID YOU CREATE THAT FONT?

Haircut Sir? was a font created just before undertaking this project. As it happens, it was perfect for the style I wanted to create for this campaign. Haircut Sir? originates from an old press-in-letter price board found in the attic of a hairdresser. The individual characters were scanned and then redrawn with deliberately random kerning and spacing for a more analog appearance.

WHAT WERE THE BIGGEST CHALLENGES IN CREATING THIS PIECE?

Getting the dirty, screen printed effect just right.

. . .

181 upper street, islington, london, n11rq
MONDAY TO THURSDAY 5P.M. UNTIL MIDNIGHT/FRIDAY & SATURDAY MIDDAY UNTIL 1A.M.
[see us at] www.liquid-life.com

FRIDAYS + SATURDAYS DJ/S IN ROTATION
del agua
big audio dynamite-sound system
ali b adam reagan
mo rock jon carter

EVERY SECOND THURSDAY
YARDBRUSH DJ/S
SPACEK DIESEL ROSS ALLEN
KIRK DEGIORGIO
THE NEXT MEN
PETE HOLDSWORTH [PRESSURE SOUNDS]

1ST FRIDAY OF EVERY MONTH
MIND YOUR HEAD
resident host JAMES PRENTICE
guests include:
EDDIE PILLAR
NORMAN JAY

MIND YOUR HEAD

LAST FRIDAY OF EVERY MONTH
SMILE - SOULFUL HOUSE/GARAGE/DISCO smile
zaki D [sensory productions]
mick kirkman
sean p richard sen [bronx dogs]

SUNDAYS 2-11
3-7 LIVE JAZZ ,JASON CAFFREY QUINTET

FREE ADMISSION. TELEPHONE. 0171 704 8056 [BAR] 0171 704 9536 [OFFICE]
PLEASE CALL THE OFFICE FOR PRIVATE BOOKINGS FAX. 0171 704 1070

MEDICINE BAR ™

FLUID

DESIGNER: Lee Basford **STUDIO:** Fluid **CITY:** Birmingham, England **URL:** www.fluidesign.co.uk **YEAR:** 2001
SOFTWARE PROGRAMS: Photoshop, Quark, Fontographer, Illustrator **TYPEFACES:** Haircut Sir (self-designed), Shablone (FontFont), Aachen

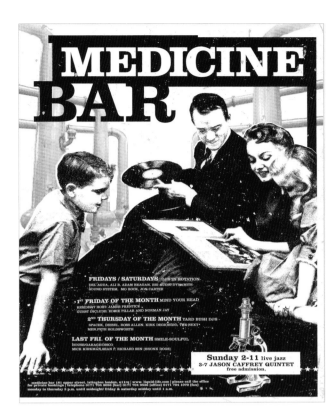

DESIGNER: JP Robinson **CITY:** Los Angeles, California **SOFTWARE PROGRAMS:** Quark XPress, Photoshop
TYPEFACE: Clarendon

MW: YOUR REDESIGN DOESN'T INCORPORATE ANY ELEMENTS OF THE ORIGINAL. WHAT DID YOU THINK ABOUT THE ORIGINAL MEDICINE BAR ADVERTISEMENT?

JPR: I liked parts of the original design. I just wanted to represent more of the music flavor of the club by using an interesting image.

YOUR DESIGN TAKES IT A BIT RETRO WITH THE HAPPY NUCLEAR FAMILY IMAGERY. WHAT'S YOUR FAVORITE SECRET SOURCE FOR FINDING IMAGERY?

I look through old 1950s and 1960s schoolbooks and magazines; thrift stores always have the best images.

HOW DID YOU GO ABOUT YOUR GENERAL DESIGN PROCESS? IS IT STRAIGHT TO THE MACHINE, OR DO YOU DO A LOT OF HAND SKETCHING BEFOREHAND?

I start the process with a sketch pad and a pen, drawing out what I see in my head. Then I look for some images that might work. I usually sketch and comp until I have five different ideas. I then critique them and pick a final design. The machine is the last step.

WHAT WAS THE MOST DIFFICULT PART FOR YOU?

Critiquing my own comps is the hardest part. I usually find different things about each design that I like. I usually end up combining the different successful parts of the designs to produce the one final design.

• • •

DESIGNER: Martijn van Egmond **STUDIO:** 1127 **CITY:** Rotterdam, The Netherlands **URL:** www.1127.com **SOFTWARE PROGRAMS:** Illustrator, Streamline, Photoshop, Acrobat **TYPEFACES:** Stencil BT, AG Book Stencil

MW: HOW DID YOU DECIDE ON THIS PIECE TO REDESIGN?

ME: I looked for pieces that I liked but didn't know anything about. I wanted to dig into the subject. This was a subject I didn't know about…and I still don't. But I love Ali.

HOW WAS THE ENTIRE EXPERIENCE?

It was very challenging to work on this piece. I'm definitely not experienced at designing in this way. I spent many hours on the design because I decided to re-create the image of Ali with spray paint and I used some background textures that I had to look for in the city.

DID YOU LIKE THE ORIGINAL DESIGN, OR DID YOU THINK IT NEEDED SOME HELP?

The original design has a nice layout and is good to look at as a piece of art, but it is a little too nonlinear in my opinion. I liked the overall image that was created, but I thought I could restructure the typography.

IT DEFINITELY WORKED FOR YOU. BY ARRANGING THE TYPE IN A MORE STRAIGHTFOR-WARD FASHION, YOU REALLY CHANGED THE LOOK OF THE PIECE. WHAT WAS YOUR OVERALL CONCEPT FOR THE REDESIGN?

To respect the original artist but don't hesitate to question his work. The outcome of this process would be something different but not "better," and hopefully a compliment.

• • •

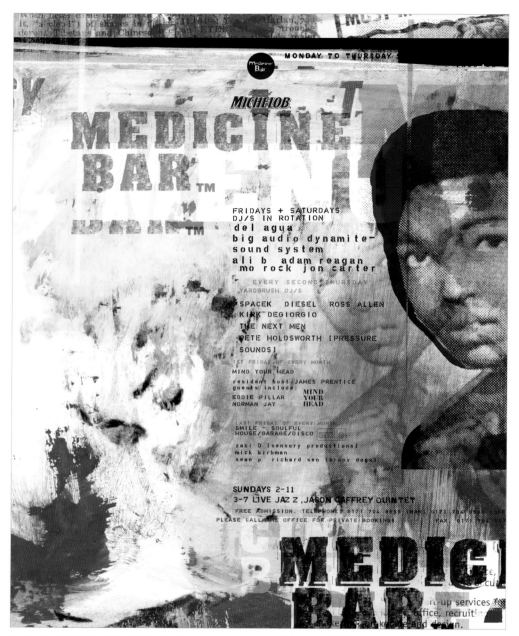

DESIGNER: Dung Hoang **STUDIO:** Furious Visual World **CITY:** Salt Lake City, Utah **URLS:** www.furyeffect.com, www.shaolin-fury.com **SOFTWARE PROGRAMS:** Photoshop, Illustrator, Quark **TYPEFACES:** Rosewood Fill (Linotype), House Script (House Industries)

MW: SO, WHY DID YOU CHOOSE THIS PARTICULAR PIECE TO REDESIGN?

DH: There were no particular reasons really. Perhaps it was the obscurity of the name "Medicine Bar" juxtaposed with the image of the boxer that appealed to me. The close resemblance of the piece to a Hatch Show poster certainly may have helped.

SOUNDS LIKE YOU LIKED THE OVERALL LOOK OF THE ORIGINAL MEDICINE BAR ADVERTISEMENT.

I like the original design and thought it was appropriately interesting. The design utilizes wood type, which created a nostalgic feel that I enjoyed. I didn't understand the relevance of the boxer. Perhaps the design is a reflection of the boxing tradition associated with this particular establishment, but I couldn't confirm that without actually contacting the client.

YOUR PIECE HAS A BRUSHED LOOK, ALMOST AS THOUGH IT WAS PAINTED. WHAT WAS YOUR CONCEPT FOR THIS REDESIGN?

None really. I simply reinterpreted the original design using my own visual language, which uses lots of layering of art to create a tonality that I thought may be more appropriate. One could say that I "updated" the look.

WAS IT AN EASIER OR HARDER EXPERIENCE THAN YOU THOUGHT IT WOULD BE?

Both. On the one hand, it was pure fun to redesign the art without any actual client limitations—such as the use of imagery, typography, dimensions or medium. Because of it, the results are limitless, thus making it quite hard for me to become satisfied with any one result. In the end I began to impose my own limitations upon it just so I could come to some acceptable results.

. . .

DESIGNER: Lars Hansson **STUDIO:** 24hr International **CITY:** Stockholm, Sweden **URL:** www.24hr.se **SOFTWARE PROGRAM:** Adobe Illustrator **TYPEFACES:** Foundry Sans (The Foundry), FF DIN (FontFont)

MW: WHY DID YOU CHOOSE THIS PIECE TO REDESIGN?

LH: I browsed through the titles and marked ones that gave me some kind of clever ideas.

DID YOU LIKE THE ORIGINAL DESIGN, OR JUST THE TITLE?

Honestly, the design got me a bit confused. I just couldn't figure out what kind of a place it was. My assumption is that most businesses that use names related to the medical industry do so because they're attracted to that kind of clean environment and design.

I LIKE THAT YOU WEREN'T AFRAID TO GO MINIMAL WITH YOUR REDESIGN. WHAT CONCEPT DID YOU HAVE IN MIND?

Since it is a remix project, I let my first association through and forgot all about what kind of place the Medicine Bar actually is. I didn't have any information about the bar, and the original piece didn't give me much help. I guess you could say that my concept is "modern jazz club with a touch of the medical industry look."

SO, WAS IT AN EASIER OR HARDER EXPERIENCE THAN YOU THOUGHT IT WOULD BE?

A bit harder, mostly because of the limited time I had to spare and the fact that I didn't know anything about the place. On the other hand, it was a relief to be able to be both the judge and the executioner.

. . .

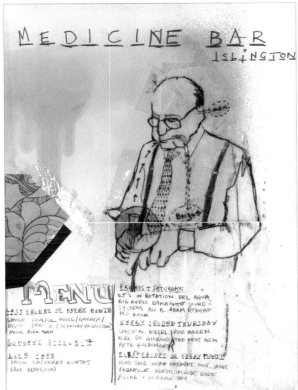

DESIGNER: Laura Quick **STUDIO:** Supergympie **CITY:** London, England **URL:** www.supergympie.com **SOFTWARE PROGRAM:** Photoshop

MW: WHY DID YOU CHOOSE THIS PIECE FOR A REDESIGN?

LQ: I wanted to try and tackle a brief for a trendy London bar in a different way and was pleased to see an advertisement for this kind of venue which avoided the often used cliché images of DJs spinning on the decks or semiclad women created in Illustrator.

YOU MOVED ABOUT AS FAR AWAY AS POSSIBLE FROM THAT CLICHÉ HERE. CAN YOU TALK ABOUT HOW YOUR DESIGN CAME ABOUT?

I wanted to take the idea of medicine and how people often refer to drinking as "having some medicine." This is quite an old-fashioned metaphor, so I took a photo of my great uncle Ted, an elderly man whose "medicine" was always a "tot" of sherry on a Sunday afternoon, and adapted it to fit the brief. It was also my way of moving as far as possible from the typical club imagery and making sure that the image didn't take itself too seriously. I also like drawing old people.

SOUNDS FUN—YOU EVEN GOT THE FAMILY INVOLVED. WHAT WAS IT LIKE?

It was quite hard, as I knew that the piece had to look quite trendy for the bar scene but had to have an image of an old man. I also wanted people to get the gist that the idea of alcohol being medicine is an old one and that old people on the sherry are quite funny, in my humble opinion.

. . .

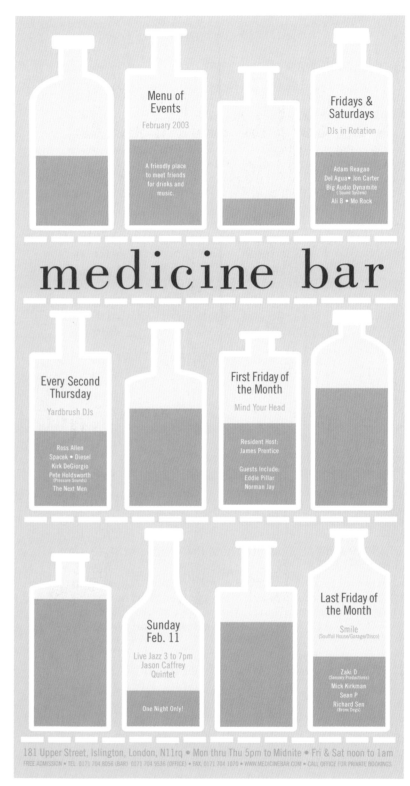

DESIGNER: Joe Newton **STUDIO:** Joe Newton Design **CITY:** Seattle, Washington **URL:** www.joseph-newton.com **SOFTWARE PROGRAM:** FreeHand **TYPEFACES:** Bodoni, Trade Gothic Condensed

MW: WHY DID YOU PICK THE MEDICINE BAR?

JN: The club's web site led me to believe it was a hangout for hip, upwardly mobile young Londoners and that the music was primarily electronic—drum and bass, etc. I didn't feel like the image of the boxer said anything about the mood of the club or the type of music. I chose this piece because I thought there were some functions that the poster intended to fulfill that weren't happening with the previous design.

WOULD YOU SAY THAT THE ORIGINAL DESIGN NEEDED SOME HELP?

I guess so. Although I liked the interesting textures the designer had achieved, I felt like the poster was cluttered and busy and that there was no order or hierarchy to the information. Because it was a calendar of events, I felt the events should be listed sequentially in a consistent point size and format so it was clear who was featured each night.

WHAT WAS YOUR CONCEPT FOR THE REDESIGN?

I thought the name "Medicine Bar" lent itself to nice medicinal and pharmacological imagery. The first thing that popped into my mind was a shelf full of old medicine bottles. I thought the blue had a pleasing quality that implied that your aches and pains would be soothed by their bartenders and the music.

HOW'D THE REDESIGN EXPERIENCE WORK OUT FOR YOU?

The process from concept to finish went smoothly. Honestly, because I didn't have to actually deal with anyone's taste opinions but my own, it made the job pretty easy. But I did try to honestly address the needs of a club calendar and not just make a pretty design.

. . .

FEEDBACK FROM THE ORIGINAL DESIGNER:
LEE BASFORD

WHAT'S YOUR INITIAL REACTION TO EACH REDESIGN?
JP Robinson: Dust
1127: Bleeding
Furious Visual World: Snake oil
24hr International: Hospital
Supergympie: Perfect
Joe Newton Design: Medicine

SIX DESIGNS TO CHOOSE FROM—WHAT'S YOUR FAVORITE?
Supergympie's. I love it, probably because the style is similar to some of my own work. It all looks very handmade with a nice tactile feel. The composition and comedy are just right. It's what a bar is all about: music and booze.

ANY OF THEM SURPRISE YOU?
Again, it's the piece by Supergympie, because I wouldn't have expected something so illustrative or even a design I would really like.

OVERALL, WHAT DO YOU THINK OF THE REDESIGNS?
I can't say I like them all, although I do like elements in most of the designs. It's so strange to see all these totally different perspectives based on the same content. I'd love to do it again.

CH 35 UMASS RESIDENCE HALL MANUAL

MW: WHAT WAS THE INSPIRATION FOR THE DESIGN?

CS: Mike Mills, Andy Warhol and Ed.

HOW WERE THE FIRST TWO INFLUENTIAL, AND WHO'S ED?

Mike Mills for his CD covers, particularly ones he did for Boss Hog and Air. Warhol for his off-registered silkscreen portraits. Ed is the nickname for Big Ed, the font we used.

HOW WAS THE CHOICE OF COLORS DECIDED UPON? THEY SEEM DECIDEDLY NONCOLLEGIATE. ARE THOSE COLORS USED BY THE SCHOOL, OR DID YOU HAVE ANOTHER IDEA IN MIND?

The colors were an extension of a palette we have used for this series of pieces over the last three years. At this point, it was literally trying to pick colors that looked decent but were different from other combos used on previous pieces.

WAS THE CLIENT VERY SPECIFIC ABOUT THE TYPE OF IMAGERY, OR DID YOU HAVE A LOT OF FREEDOM?

Since the housing itself was not very photogenic, the client required images of students on the cover. When we suggested using illustrations instead of photographs, the client agreed as long as the students were recognizable.

WHEN YOU SAY THAT THE STUDENTS HAD TO BE "RECOGNIZABLE," HOW SPECIFIC WAS THAT?

The client wanted them to be rendered accurately so that fellow students could recognize that one as so-and-so. That seemed like a silly request to us.

WHY ISN'T ANYONE STUDYING?

We were wondering the same thing.

WHAT WAS THE BIGGEST CHALLENGE FOR THIS PIECE?

The limited budget, in contrast with the level of scrutiny and hand-holding.

• • •

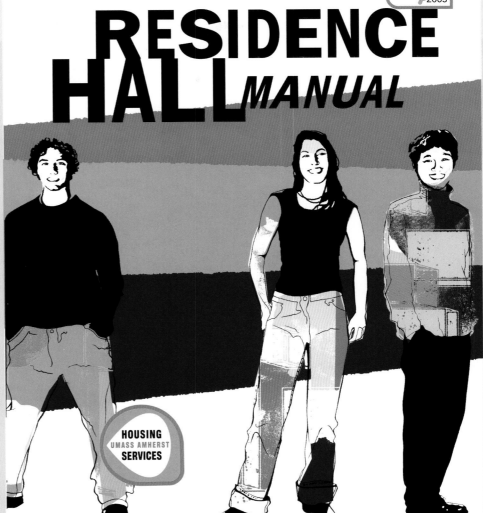

UNIVERSITY OF MASSACHUSETTS | Amherst

RESIDENCE HALL *MANUAL*

2002 2003

HOUSING
UMASS AMHERST
SERVICES

DESIGNER: Clifford Stoltze **STUDIO:** Stoltze Design **CITY:** Boston, Massachusetts **URL:** www.stoltze.com **YEAR:** 2002
SIZE: 7¾" x 11" (20 x 28 cm) **SOFTWARE PROGRAMS:** Quark, Illustrator, Photoshop **TYPEFACES:** Big Ed, Barbera, Avenir

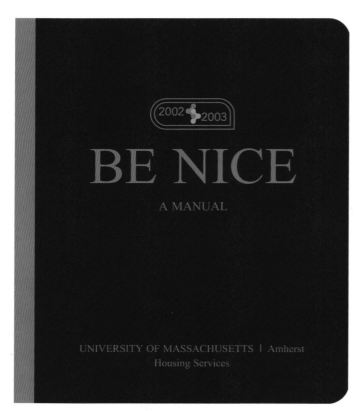

DESIGNER: Karl Ackermann **STUDIO:** Milky Elephant **CITY:** Brooklyn, New York **URLS:** www.milkyelephant.com, www.jurydoodie.com **SOFTWARE PROGRAM:** Flash **TYPEFACE:** David Transparent

MW: WHAT DID YOU THINK ABOUT THE ORIGINAL PIECE?

KA: I didn't really like it. I didn't understand the logic behind it. But I feel pretty out of touch with the tastes of the general public, so it's probably my own ignorance. I thought the logo and the date were pretty nice, so I decided to incorporate them into the redesign.

HOW DID YOU APPROACH THIS REDESIGN?

I was trying for something that could be taken seriously but have an element of fun as well. Books like *The Worst-Case Scenario Survival Handbook* and *Not For Tourists Guide to New York City* seem to strike this balance pretty well, so these became my model. I also looked at books like *U.S. Army Survival Manual* and *Oxford Foundation of Ethics*, which aren't flashy but are attractive simply because they seem important. The title was a little bit of self-effacing humor that I thought might win over the more cynical students. The structure of the book itself is at least as important as the cover design. Ideally, it'd be pocket sized, have a durable polyurethane cover, and contain sections useful for daily campus life such as maps, phone numbers for food and services, and a few "Two-Cinnabons-for-the-price-of-one" coupons.

GOOD THINKING. WHAT WAS THE REDESIGN EXPERIENCE LIKE FOR YOU?

Finding time to get started was harder than I anticipated, partially because I was busy and partially because I was apprehensive about designing for print, which I don't do too often…

• • •

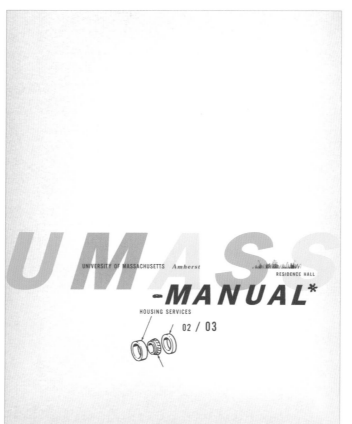

DESIGNER: Eric Kass **STUDIO:** Lodge Design Co./Funnel **CITY:** Indianapolis, Indiana **URLS:** www.lodgedesign.com, www.funnel.tv **SOFTWARE PROGRAM:** Quark XPress **TYPEFACES:** Alternate Gothic, Berthold Bodoni Medium Italic, Big Ed-Lazyboy

MW: WHY DID YOU CHOOSE THIS PARTICULAR PIECE TO REDESIGN?

EK: I saw an opportunity to do a much different take on this piece. The original solution felt a little decorative and seemed to have been strongly influenced by the client's requirements.

THERE ARE NOT ANY FRESH-FACED STUDENTS IN YOUR DESIGN. WHAT'S YOUR CONCEPT HERE?

I wanted to relate the idea of students living together with the components of a machine; individual pieces working in harmony to exist and serve a purpose.

YOUR USAGE OF THE GEARS AS METAPHOR IS JUST SPOT-ON. WAS THAT AN INSTANT CONNECTION FOR YOU, OR DID YOU GO THROUGH OTHER CONCEPTS AS WELL?

That is a theme that I have been exploring in my personal work and paintings. I have been interested in combining logical, mechanical items with elusive, spiritual and emotional concepts in order to reveal a connection. It's something that can help us understand ourselves and our relationships with others better.

DID YOU TRY TO PUT YOURSELF IN THE MIND OF A NEW STUDENT ENTERING COLLEGE?

I'm always in that mind-set. The more I learn, the less I feel I understand. I wish I had a manual to help me.

• • •

MW: WHAT DID YOU THINK ABOUT THE ORIGINAL DESIGN?

MW: Well, obviously I liked it, as I chose it to be included in the book. That said, I really empathize with the original designers because it does feel a bit sanitized.

My one concern was that it just didn't feel inviting to me. Coming into the collegiate environment is both scary and exciting, and I really wanted the cover to feel warmer, as though you were being welcomed into this new place.

WHAT'S THE REDESIGN CONCEPT HERE?

Even though it didn't start out this way, I suppose it's a bit of a parody of the sanitized dorm manual. At first, I just thought it would be funny if there was a very straight looking manual with stylized images of students passed out on each other. Welcome to college!

CARE TO EXPLAIN THE ETHNIC NAME TAGS?

The racial subject is always touchy, but here's what I was thinking: I was reminded of a story from a few years ago, where a university digitally inserted black faces into a sea of white people just to make the school look diverse for the school's promotional materials. I would argue that if you're digitally inserting people of color into a crowd shot, you've got bigger problems than what your brochure looks like.

To me, this piece had a little bit of that. It's like, OK, here's three people at our school. The fact that they're not interacting made it seem a bit unnatural, so since they all seemed a bit like racial tokens anyway, I figured I'd go ahead and label them to really announce the message, just in case anyone missed it. "Hey, everybody, we're diverse!"

That said, if I saw a collegiate brochure with no minorities represented, I would think that was absurd too. It's a tough call.

· · ·

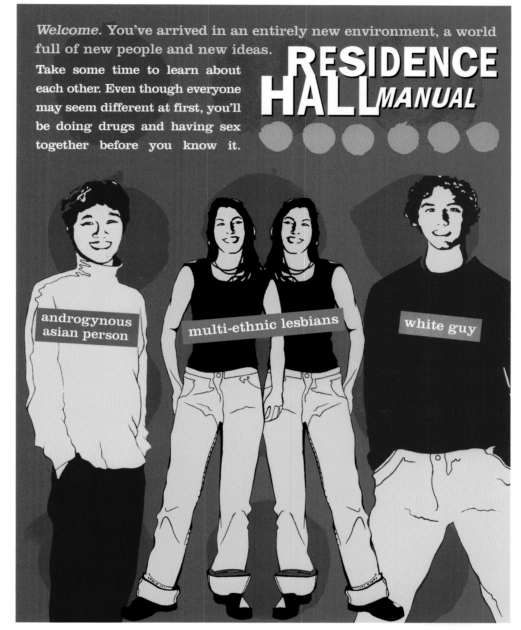

Welcome. You've arrived in an entirely new environment, a world full of new people and new ideas. Take some time to learn about each other. Even though everyone may seem different at first, you'll be doing drugs and having sex together before you know it.

RESIDENCE HALL MANUAL

androgynous asian person

multi-ethnic lesbians

white guy

DESIGNER: Mark Wasserman **STUDIO:** Plinko **CITY:** San Francisco, California **URL:** www.plinko.com **SOFTWARE PROGRAMS:** Illustrator, Photoshop **TYPEFACE:** Clarendon

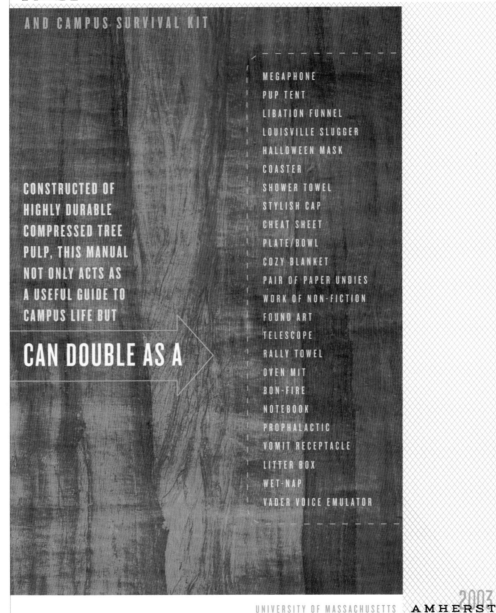

RESIDENCE HALL MANUAL

AND CAMPUS SURVIVAL KIT

CONSTRUCTED OF
HIGHLY DURABLE
COMPRESSED TREE
PULP, THIS MANUAL
NOT ONLY ACTS AS
A USEFUL GUIDE TO
CAMPUS LIFE BUT

CAN DOUBLE AS A

MEGAPHONE
PUP TENT
LIBATION FUNNEL
LOUISVILLE SLUGGER
HALLOWEEN MASK
COASTER
SHOWER TOWEL
STYLISH CAP
CHEAT SHEET
PLATE/BOWL
COZY BLANKET
PAIR OF PAPER UNDIES
WORK OF NON-FICTION
FOUND ART
TELESCOPE
RALLY TOWEL
OVEN MIT
BON-FIRE
NOTEBOOK
PROPHALACTIC
VOMIT RECEPTACLE
LITTER BOX
WET-NAP
VADER VOICE EMULATOR

UNIVERSITY OF MASSACHUSETTS ▷ AMHERST 2003

DESIGNERS: Dustin Summers and Jason Kernevich **STUDIO:** The Heads of State **CITY:** Philadelphia, Pennsylvania
URL: www.theheadsofstate.com **SOFTWARE PROGRAMS:** Illustrator, Photoshop **TYPEFACES:** Densmore, Knockout (Hoefler Type Foundry]

MW: I WOULDN'T EXACTLY PEG YOU FOR A COLLE-GIATE MANUAL. WHY DID YOU CHOOSE THIS PIECE TO WORK WITH?

DS&JK: It seemed like a challenge. Most of the pieces we work on professionally allow for a wider range of solutions due to their abstract nature. We really wanted a subject that would allow us to solve a specific problem.

HOW DID YOU FEEL ABOUT THE ORIGINAL DESIGN?

Knowing that the studio had to work under the watchful eye of a university, I think this was a great execution. It seems like the designer was able to bring life to a piece that could have been pretty run of the mill, while still satisfying what the university wanted out of it. There are hundreds of university manuals across the country, and I would say most are not as visually pleasing.

SO, WHAT WAS YOUR CONCEPT FOR THIS REDESIGN?

We wanted to do something that was utilitarian, something that could be put to good use in a college dorm. So, we decided to rattle off whatever uses we could think of for the manual itself: You could roll it up and use it as a beer funnel or just plop it down on the table as a coaster. Obviously some of the other ideas are far fetched, but we just went into this wanting to have some fun.

. . .

FEEDBACK FROM THE ORIGINAL DESIGNER:
CLIFFORD STOLTZE

LOOKING AT THE REDESIGNS, WHAT'S YOUR INITIAL REACTION TO EACH ONE IN ONE WORD?
Milky Elephant: Nice
Lodge Design Co.: Instructional
Plinko: P.I.
The Heads of State: Camp

DO YOU HAVE A FAVORITE?
Lodge Design—it's simple, but cool.

ANY OF THEM SURPRISE YOU?
Plinko. That was our initial concept.

REALLY?
No, we were kidding.

OVERALL, WHAT DO YOU THINK OF ALL THE REDESIGNS?
Flattering.

MUDHONEY
CD COVER

MW: HOW DID YOU COME UP WITH THE CONCEPT FOR THIS CD COVER?

JK&JL: The inspiration for this piece was naturally driven by the title of the record, *Since We've Become Translucent*, pretty literally.

SEEMS LIKE ANOTHER PRETTY RICH TOPIC. DID YOU TRY ANY OTHER APPROACHES WITH THIS PIECE?

No other approaches were attempted, really, except in the beginning Mudhoney wanted a live photo of themselves on the cover, and for this I was provided a slide from a recent show. It was pretty terrible quality. I abandoned that direction quickly.

WHAT WERE THE BIGGEST CHALLENGES IN CREATING THIS PIECE?

The art direction from the band was simply to make it "psychedelic." The problem, in my mind, was that this was like their ninth album and most of those nine were not psychedelic. Also, humor traditionally played a huge role in the cover art. Not to mention that many of those record covers were illustrated by Ed Fotheringham.

So, the major challenge was to play off the title, make it look psychedelic without resorting to the traditional trippy, hippy-dippy sense, and inject humor into it, while making sure that it fit within their body of work. It couldn't look as though it was an anomaly. You have to remember also that this was Mudhoney's triumphant return to Sub Pop Records, the label that originally signed them almost twelve years ago.

...

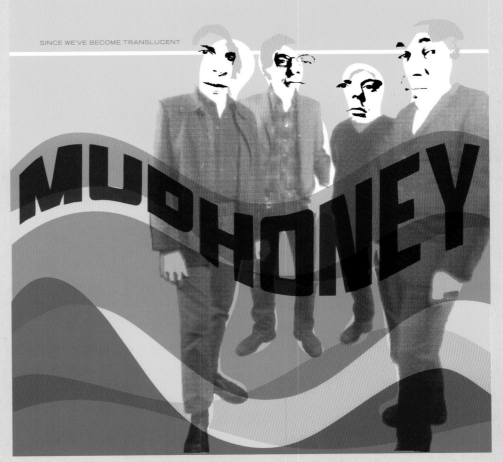

DESIGNERS: Jeff Kleinsmith and Jesse LeDoux **STUDIO:** Sub Pop Records **CITY:** Seattle, Washington **URL:** www.sub-pop.com **YEAR:** 2002 **SIZE:** Standard CD packaging **PHOTOGRAPHERS:** Lance Hammond (cover) and Emily Rieman (inside) **SOFTWARE PROGRAMS:** FreeHand, Illustrator, Photoshop **TYPEFACE:** Helvetica Neue, Enge Wotan (Dover—altered by designers)

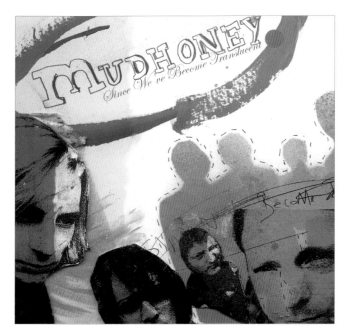

DESIGNERS: Laura Quick and Anna Magnowska **STUDIO:** Supergympie **CITY:** London, England **URL:** www.super-gympie.com **SOFTWARE PROGRAM:** Photoshop

MW: SO, WHY DID YOU CHOOSE THIS PARTICULAR PIECE TO REDESIGN?

LQ&AM: We'd both been really wanting to design a CD cover together, so when this project came up, it seemed like the perfect opportunity to do it. We also like working in squares, as odd as that may sound, so the format appealed as well.

HONESTLY, DID YOU LIKE THE ORIGINAL DESIGN?

We liked the concept of the design with the removable and interchangeable transparent squares inside the CD case, but we thought the colors—the bright yellows and greens—were unflattering to the design, and we weren't too keen on the "Mudhoney" text either, so really, we couldn't wait to get stuck into it.

WHAT WAS YOUR CONCEPT FOR THIS REDESIGN?

We wanted to use elements of the original design and base our images on the words *Since We've Become Translucent*, as this was quite inspiring. We took these elements as our starting points and then created images. We also wanted to use the faces of the band members as we thought they were "quirky" looking, so we tried to make the image reflect this. It was interesting using parts from the original but making them almost unrecognizable in the final image.

HOW'D YOU LIKE THE OVERALL PROCESS?

It was an enjoyable experience for both of us as we are used to working to fairly specific briefs. This one was a little more loose and open entirely to our own interpretation. Sometimes this freedom can be daunting, but in this case we both found it very liberating.

• • •

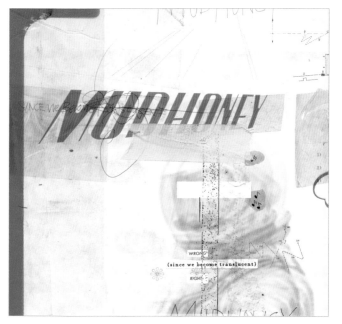

DESIGNER: Thomas Schostok **STUDIO:** {ths}design **CITY:** Essen, Germany **URLS:** www.ths.nu, www.cape-arcona.com **SOFTWARE PROGRAMS:** Photoshop, FreeHand **TYPEFACES:** Spy Royal (self-designed), Moscow Has a Plan (Cape-Arcona.com)

MW: WHY DID YOU CHOOSE THE MUDHONEY CD ARTWORK TO REDESIGN?

TS: I'm always interested in designing CD covers for bands. I knew Mudhoney and thought that it might be a good idea to redesign their cover, because I've always felt that their cover designs never quite fit their songs.

INTERESTING…IT'S LIKE THIS PROJECT WAS CALLING OUT FOR YOU. SO, DO YOU THINK THE ORIGINAL DESIGNERS HERE DID A GOOD JOB MATCHING THE VISUALS TO THE MUSIC?

I really liked the design, but for this album, again, it just didn't fit as a cover. The visual didn't harmonize with the audio, and I think that's the most important part if you design a CD cover for a band. Hear the sound, feel the music, and then go for it and make the cover.

SOUNDS LIKE YOU'VE GOT THIS PROCESS DOWN PRETTY WELL.

It's very important to get into the meaning of the music. You have to interpret the music and the CD's title since the band or the producer created that name. A designer's task is to integrate the title into the design. Everything must always work together.

SO, HOW WAS THE REDESIGN EXPERIENCE FOR YOU?

Generally, a designer has the chance to interpret what the musician wants to say. You can stay in contact with the artist and discuss the design with them all the time. To make a redesign without having any artist contact is much more complicated.

• • •

DESIGNER: Joe Kral **STUDIO:** Test Pilot Collective **CITY:** San Francisco, California **URL:** www.testpilotcollective.com **SOFTWARE PROGRAM:** Illustrator **TYPEFACE:** Helvetica Bold

MW: SO, HONESTLY, WHAT DID YOU THINK OF THE ORIGINAL DESIGN?

JK: I really liked the original, especially the colors and the flowing lines in the background of the design. I did think the faces were a little weird, so I deleted those.

WHAT'S YOUR CONCEPT FOR THE REDESIGN?

Since the name of this CD is *Since We Have Become Translucent*, I thought I'd try to make the colors and figures a little more translucent. The lines in the background reminded me of weather maps, so I added some additional lines.

YOU'RE SOMEONE WHO IS WELL KNOWN FOR HIS TYPE DESIGN. DO YOU TYPICALLY TRY OUT A WHOLE RANGE OF FONTS FOR A PIECE LIKE THIS?

I usually have a few fonts in mind from the beginning of the project. I'll try them out, and if they don't work I'll either start working on a new custom typeface or I'll fall back on the everlasting Helvetica Neue.

ALL YOUR OWN FONT CREATIONS AND YOU GO WITH HELVETICA?

Helvetica is the best! I felt that the type should stay somewhat neutral in this remix, so I just deleted some of the existing copy and then increased the point size to give it a different feel.

HOW DID YOU GO ABOUT ON YOUR GENERAL DESIGN PROCESS?

I usually run a lot of ideas through my head for about three weeks, and I also make lists of key words and little doodles to help me along with ideas for the final design. Then I bust it out on the day before it's due.

. . .

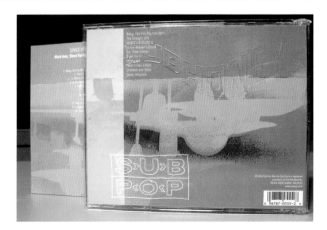

DESIGNER: Steve Carsella **STUDIO:** vibranium+co. **CITY:** Orlando, Florida
URL: www.vibranium.com **SOFTWARE PROGRAMS:** Photoshop, Illustrator
TYPEFACE: Solex (Émigré)

MW: ALRIGHT STEVE...BACK FOR MORE! WHY DID YOU WANT TO WORK WITH THE MUDHONEY CD DESIGN?

SC: It was to challenge myself. The work that comes out of Sub Pop Records is consistently stellar—you've really got to hand it to them.

HMM...IT'S A LITTLE HARD TO TELL IF YOU LIKED THE DESIGN OR NOT.

I loved it. It felt so handcrafted and unique. So many CDs are routine in their approach and their results. This one stands out in the crowd, in a way I hope more than just other designers appreciate.

WITH ALL THAT IN MIND, WHAT WAS YOUR CONCEPT FOR THE REDESIGN?

I wanted to try and play with the word "translucent," at least in its direct meaning. My first thought was it'd be great to do a completely clear jewel case that was etched. After poking around some record shops, I added some real-world limitations just to maintain the challenge. I quickly realized I'd never get away with a truly blank cover— so I added some images. I never fully abandoned the etched idea; I just tried to make it commercially feasible.

HOW'D THIS REDESIGN EXPERIENCE WORK OUT FOR YOU?

It was as hard as I thought it was going to be. I knew it'd be tough. The original is just such a solid solution. I struggled with this one.

• • •

FEEDBACK FROM THE ORIGINAL DESIGNERS:
JEFF KLEINSMITH & JESSE LEDOUX

WHAT'S YOUR INITIAL REACTION TO EACH REDESIGN?
Supergympie: Touch
{ths}design: Sick
Test Pilot Collective: Me
vibranium+co.: I'm

DO ANY OF THEM SURPRISE YOU?
The one by {ths}design is the most surprising simply because it veers the farthest away from what this band is all about. Most have a personal, collage-y, handmade feel to them, which we don't quite hear in the music.

OVERALL, WHAT DO YOU THINK OF ALL THE REDESIGNS?
A couple of the redesigns have a handmade folksy feel, while others look as if they should be filed into the ambient section of your local record store. These just don't seem to embrace the psychedelic freak-out of the music contained inside. Also, none of these really successfully play with the notion of translucency or transparency. and lack the humor that we feel is inherent in the band.

CH 37 ECOLOGICAL GUIDE TO PAPER POSTER

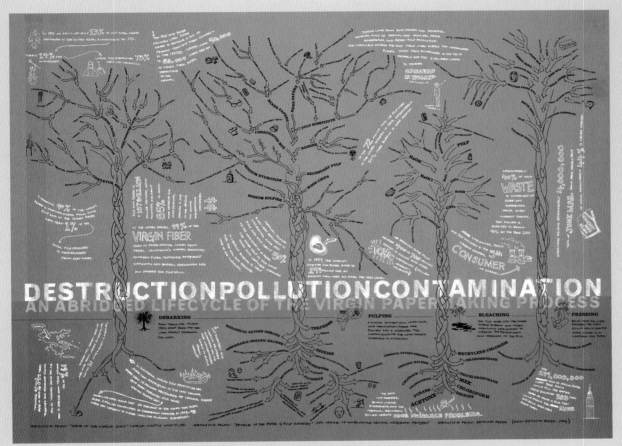

WHAT WAS THE INSPIRATION FOR THIS POSTER?

A few years ago, we heard J. Baldwin, a Buckminster Fuller pupil, give a lecture where he offered a comprehensive explanation of the materials and processes involved in making a standard number two pencil. A seemingly simple instrument was deconstructed to reveal an overwhelming amount of tools, shipping vehicles, containers and people.

The objective was to introduce the idea of comprehensive thinking. Ecological sustainability demands that we think comprehensively about all parts of a process as opposed to only the immediate. In doing so we begin to understand the full ramifications of our actions and hopefully tread a bit lighter on the earth. Inspired by this lecture, we wanted to comprehensively illustrate the papermaking process.

We knew that this illustration would be a process flow diagram taken to an almost a ridiculous level. The most

unexpected source—my grandmother's literal illustration of our family tree—inspired the diagram's final form. The references to trees for a poster about paper were all conscious efforts to underscore not only the extraordinary amount of materials that goes into the process, but also the many effects that this process has to your personal health.

WHAT WERE THE BIGGEST CHALLENGES IN CREATING THIS PIECE?

There were two big challenges: first, to find the message. As creators of our own content, narrowing all of the possible messages is always a feat. Second, the concern of outdoing yourself. The pressure of making something better than your last favorite piece is always a bit overwhelming at first. However, these expectations are what make us work harder.

• • •

DESIGNER: Patrick Castro **STUDIO:** Celery Design Collaborative **CITY:** Berkeley, California **URL:** www.celerydesign.com **YEAR:** 2001 **SIZE:** 18" x 24" (46 x 61 cm) **SOFTWARE PROGRAMS:** Adobe Photoshop, Adobe Illustrator **TYPEFACES:** Clarendon, Gothic 720

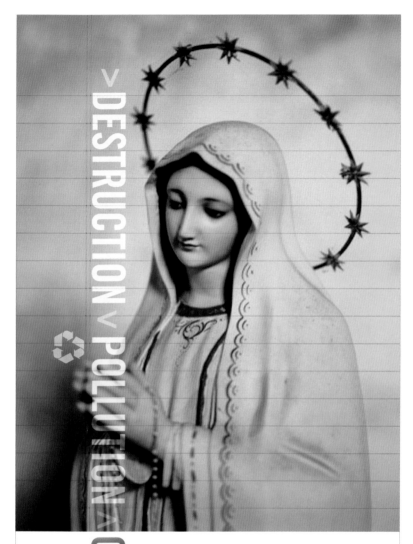

DESIGNERS: Russell Robinson II and VonDee **STUDIO:** God Created Design **CITY:** Los Angeles, California **URL:** www.godcreatedsight.com **PHOTOGRAPHER:** Olof Cardelus **SOFTWARE PROGRAMS:** Photoshop, Illustrator, Quark XPress **TYPEFACES:** TradeGothic Condensed and Bold Condensed (Adobe)

MW: WHY DID YOU CHOOSE THIS PARTICULAR PIECE TO REDESIGN?

RR: We chose this particular project because of the strong contrast of the words involved in the piece: "virgin," regarding the paper-making process, and the phrase "DestructionPollutionContamination," relating to the result of this process.

DID YOU LIKE THE ORIGINAL DESIGN, OR DID YOU THINK IT NEEDED A BIT OF REVISION?

We actually liked the design but felt it was too complicated of an effort. It didn't solve the problem of communicating the message clearly.

SO, WHAT WAS YOUR CONCEPT FOR THE REDESIGN?

We set out to show the contrast between the words "DestructionPollutionContamination" and virgin paper-making process. We thought that it was just ironic that the word "virgin" could be getting such a bad rap. So we thought that putting an image of the Virgin Mary against the words "DestructionPollutionContamination" was striking enough to garner attention from the viewer to read further.

WAS IT AN EASIER OR HARDER EXPERIENCE THAN YOU THOUGHT IT WOULD BE?

Initially, it seemed to be a daunting task, but after looking at the elements and brainstorming it further, the process was simple.

. . .

Destruction. Pollution. Contamination
AN ABRIDGED LIFECYCLE OF THE VIRGIN PAPERMAKING PROCESS

DEBARKING
A LARGE, SPINNING AND ROTATING DRUM THAT MAKES THE LOGS MOVE AROUND IS USED TO DEBARK THE TREES. AS THE LOGS RUB AGAINST EACH OTHER, THE BARK COMES OFF.

PULPING
WOOD CHIPS ARE "COOKED" IN A DIGESTER IN A SOLUTION OF SODIUM HYDROXIDE AND SODIUM SULFIDE CALLED WHITE LIQUOR.

BLEACHING
THE PULP GOES INTO THE MIXER WHERE BLEACH AND OTHER CHEMICALS ARE ADDED TO IMPROVE THE BRIGHTNESS AND STRENGTH OF THE PULP.

PRESSING
BELTS MOVE THE WEB BETWEEN THE PRESS ROLLS WHICH REMOVE MORE WATER AND COMPRESS THE PAPER.

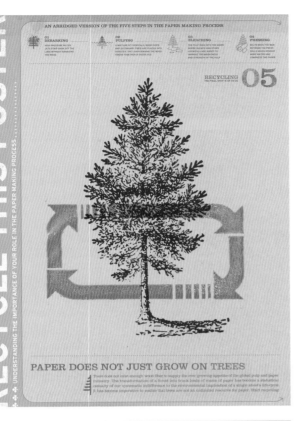

DESIGNER: John Patrick Turner **STUDIO:** Boy Burns Barn **CITY:** Cornwall, New York and New York, New York **URL:** www.boyburnsbarn.com **SOFTWARE PROGRAMS:** Illustrator, Photoshop **TYPEFACES:** Clarendon, Interstate, Helvetica Neue

MW: WHAT LED YOU TO YOU CHOOSE THIS PARTICULAR PIECE TO REDESIGN?

JPT: I thought it would be interesting to try and take one aspect of this very complex and detailed piece and turn that into an informative poster of its own. At the time I was also getting sick of seeing how much paper was being wasted at the different offices I was doing work for, so I was also drawn to the message of the piece.

DID YOU LIKE WHAT THE ORIGINAL DESIGNERS HAD DONE WITH THE CONCEPT?

I thought the original design was great, very intense. I just wanted to see if I could simplify it and make it more digestible for those of us with short attention spans.

WHAT WAS YOUR CONCEPT FOR THE REDESIGN?

The design of this poster is intended to both educate as well as set the example. The poster itself is telling the viewer to recycle it. The idea is that if one person can read this poster and be motivated enough to rip it down and recycle it, then chances are they'll spread the word to others—keeping the poster's message alive in a new way. The redesign also walks you through the papermaking process but, unlike the original design, includes a final step that includes the viewer's participation. That step is to recycle. The visual of the tree is a simple reminder that trees are not going to last if we keep burning through paper the way we do.

• • •

DESIGNER: Geneviève Gauckler **CITY:** Paris, France **URL:** www.g2works.com **SOFTWARE PROGRAMS:** Illustrator, Photoshop **TYPEFACE:** Helvetica Neue Roman

MW: WHAT ATTRACTED YOU TO THIS PARTICULAR PIECE TO REDESIGN?

GG: I chose it because it's related to ecology, the most important issue that humanity has to deal with.

HOW DID YOU LIKE THE ORIGINAL DESIGN?

I liked the idea of mixing type with the drawings of the trees, but I didn't like the colors and the general composition. I liked the abundance of information; you want to read everything. Unfortunately, I was too lazy to write down everything! So I only kept the main title.

YOUR DESIGN HAS NO RESEMBLANCE TO THE ORIGINAL…WHAT WAS YOUR CONCEPT?

I wanted to make something that looked thrashed, along with some dirty backgrounds. Also, I wanted to create characters that show the destruction of nature by human beings. The "rocket men" symbolize the high-tech civilization that we live in. The trees have been turned upside down because something has gone wrong between nature and us.

IT'S ALMOST LIKE A DISTRESS CALL. WAS IT AN EASIER OR HARDER EXPERIENCE THAN YOU IMAGINED IT WOULD BE?

There was nothing hard about doing an image like this. I got to choose the theme, and I was free to make anything I wanted.

• • •

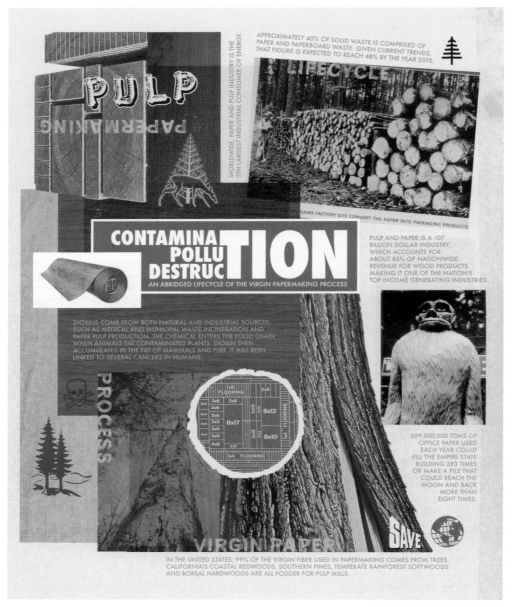

DESIGNER: Mike Levin STUDIO: Jetpack Design CITY: San Francisco, California URL: www.jetpack.com SOFTWARE
PROGRAMS: Photoshop, Illustrator TYPEFACES: Futura, Rustic

MW: SO, WHY DID YOU CHOOSE THIS PIECE TO REDESIGN?

ML: I was drawn to the complexity and detail of the piece and how the artist had used information from a lecture and represented all the ideas visually.

SEEMS LIKE EVERYONE LIKED ALL THE TINY DETAILS IN THE ORIGINAL DESIGN...WHAT WAS YOUR STRATEGY FOR CREATING AN EFFECTIVE REDESIGN?

I liked the original design, but saw a different interpretation—one that was a lot more simplified. The idea was to take this complex illustration and try to build a more graphic and iconic representation of it.

WAS THE REDESIGN PROCESS AN EASIER OR HARDER EXPERIENCE THAN YOU THOUGHT IT WOULD BE?

When I first started the redesign, it was hard because I really struggled with my original idea of trying to break down all the illustrated details into something that had some immediate and graphic impact.

In the end, I focused more on turning the themes of paper life cycles and the papermaking process into a collage, which I felt paralleled the idea of mixing and recycling imagery.

. . .

MW: ALRIGHT, LAST PIECE IN THE ENTIRE BOOK. WHAT'S GOING ON HERE?

MW: Throughout the process of compiling the book's artwork, I noticed how little white space was in most of the redesigns. I figured the reason was that there's an inherent competitive aspect to the book; people know their designs will ultimately be compared to the others. Using white space is often a risky proposition, and if someone in this context uses it poorly, it can look as though they were just being lazy.

I was talking with Henry H. Owings, a friend and contributor to this book, about the lack of white space in the redesigns. He noted that as much as he'd like to use white space in his self-published magazine, *Chunklet*, he really can't because it effectively costs him money. As the amount of white space increases, the number of pages it takes to convey all the content goes up, as do the printing costs and the amount of paper used. It was really a notion that I'd never thought of: for all this lovely sparseness that we like to see in books, magazines, etc., it means more paper is being used, and that ultimately has an effect on the environment.

The text is a parody of the old commercials for the ant-killing spray Raid: "Raid kills bugs dead."

LOOKS LIKE THIS DESIGN TOOK ABOUT FIVE MINUTES...

Yeah, I knew that's what people would think. Honestly, coming up with the actual design was pretty easy. The hard part was figuring out where it belonged on the page. If it wasn't for the deadline, I'd still be moving it around.

• • •

white space kills trees dead

DESIGNER: Mark Wasserman **STUDIO:** Plinko **CITY:** San Francisco, California
URL: www.plinko.com **SOFTWARE PROGRAMS:** Illustrator **TYPEFACE:** Cooper Black

FEEDBACK FROM THE ORIGINAL DESIGNER:
PATRICK CASTRO

WHAT'S YOUR INITIAL REACTION TO EACH REDESIGN?
God Created Design: Iconic
Boy Burns Barn: Direct
Genevieve Gauckler: Ominous
Jetpack Design: Exciting
Plinko: Thin

CAN YOU PICK OUT A FAVORITE?
As much as I like them all, Boy Burns Barn's stands out as the best combination of message and presentation.

WHICH ONE SURPRISES YOU THE MOST?
I was most surprised and confused by the piece by God Created. I had to think for a second before making the Virgin Mary-to-virgin paper connection. Using an icon like Mary so loaded with meaning for purposes other than religion is tricky. A strong metaphor will have many layers of interpretation, so with every viewing, the audience can peel back another layer and discover more. I would have liked to see a deeper connection between Mary and recycled paper.

OVERALL, WHAT DO YOU THINK OF ALL THE REDESIGNS?
Each solution touched on important facets of this issue and could easily be a beautiful object. If I looked at them in the context of the original, they are different designs rather than redesigns. Our fundamental goal was not only illustrating the papermaking process, but more importantly, the impact it has on our health and environment.

PERMISSIONS

CONTACT INFO FOR CONTRIBUTORS

1127 (P. 130, 171)
Lloydstraat 13G
3024 EA, Rotterdam
The Netherlands
www.1127.com

24HR INTERNATIONAL (P. 173)
Luntmakargatan 68 A
SE-113 25 Stockholm
Sweden
www.24hr.se

2ADVANCED STUDIOS (P. 53)
65 Enterprise
Aliso Viejo, CA 92656
www.2advanced.com

33RPM (P. 154)
4544 Latona NE
Seattle, WA 98105
www.33rpmdesign.com

ABIGAIL'S PARTY (P. 73)
www.davidweissberg.com

ACTION FIGURE (P. 121)
109 E. Tenth St.
Austin, TX 78701
www.actionfigure.com

AESTHETIC APPARATUS (P. 74)
27 N. Fourth St. #301
Minneapolis, MN 55401
www.aestheticapparatus.com

AMATEUR PROVOKATEUR (P. 133)
750 Chai Chee Rd.
#02-01/03. The Oasis
Technopark@Chai Chee
Singapore 469000
www.amateurprovokateur.com

AMES DESIGN (P. 25, 36)
1735 Westlake Ave. N. #401
Seattle, WA 98109
www.amesbros.com

AREA3 BARCELONA (P. 48)
Perez Galdos 7, 3a planta
08012 Barcelona, Spain
www.area3.net/barcelona

ARTHUR MOUNT ILLUSTRATION (P. 147)
www.arthurmount.com

ASTERIK STUDIO, INC. (P. 147)
3524 W. Government Way
Seattle, WA 98199
www.asterikstudio.com

ATOMIC (P. 86)
Calle 59 No. 6-39 of. 402
Bogota, Colombia, S.A.
santo90@yahoo.com

AUGUL, ANNA (P. 61, 112, 158)
Melbourne, Australia
www.quikanddirty.com

BEAUTIFUL (P. 75, 157)
www.youarebeautiful.co.uk

BEPOS|+|VE DESIGN (P. 16, 116)
90/94 Suwintavong Rd.
Nhongjok
Bangkok 10530, Thailand
www.bepositivedesign.com

BOOSTER SHOT CAFÉ (P. 60)
San Francisco, CA
www.boostershotcafe.com

BOY BURNS BARN (P. 185)
www.boyburnsbarn.com

BOZACK NATION (P. 12)
New York, NY
www.bozacknation.com

BRENT ROLLINS DESIGN EXPLOSION! (P. 17, 141)
516 W. 25th St. #305
New York, NY 10001
brentrollins@earthlink.net

BURKOM (P. 19)
www.burkom.com

BURNFIELD (P. 32)
Lundagatan 38a
117 27 Stockholm
Sweden
www.burnfield.com

CELERY DESIGN COLLABORATIVE (P. 183)
2315 B Prince St.
Berkeley, CA 94705
www.celerydesign.com

CHEUK, DEANNE (P. 147)
www.neomu.com

CHUNKLET GRAPHIC CONTROL (P. 107, 126)
P.O. Box 2814
Athens, GA 30612-0814
www.chunklet.com

COMMON SPACE DESIGN (P. 72)
137 Grand St. #402
New York, NY 10013
www.commonspace.fm

CONDUIT STUDIOS (P. 46, 124)
Cape Town, South Africa
www.conduit.co.za

COPYRIGHT_0328 (P. 169)
Cra 42bis No. 1b-88
Bogotá, Colombia
www.copyright_0328.com

CORREA, LUCHO (P. 32)
Carrera 2 # 70-92 casa 5
Bogotá, Colombia
luchocorrea@cable.net.co

CRANE, JORDAN (P. 98)
191 N. Union St.
Lambertville, NJ 08530
www.jordancrane.com

CRASHSHOP (P. 82)
2315 Western Ave., Suite 307
Seattle, WA 98121
www.crashshop.com

DEKA DESIGN (P. 102)
1133 Broadway, Suite 1011
New York, NY 10010
www.dekadesign.com

THE DESIGNCHAPEL (P. 18, 143)
www.designchapel.com

DIPHTHONG INTERACTIVE DESIGN (P. 105)
Blk 467 Hougang Ave. 8
#11-1514
Singapore 530467
www.diphthong.com

DZINENMOTION (P. 135)
Vancouver, BC, Canada
www.dzinenmotion.com

EBOY (P. 24)
Gerichtstr. 12-13
Aufgang 2
13347 Berlin, Germany
www.eboy.com

EGGERS, DAVE (P. 136)
826 Valencia
San Francisco, CA 94110
www.mcsweeneys.net

EELCO (P. 37)
Zweedsestraat 125a
3028 TS Rotterdam
The Netherlands
www.eelcovandenberg.com

ENGINE SYSTEM (P. 41)
www.enginesystem.com

EVAQ (P. 90)
31-37 33rd St. #3F
Astoria, NY 11106
www.evaq.com

EXTRA-OOMPH (P. 47)
750 Grand St. #4H
Brooklyn, New York 11211
www.extra-oomph.com

F6 DESIGN (P. 116)
www.f6.co.nz

FAT TRUCKERS UNION (P. 34)
www.fattruckersunion.com

FEEL GOOD ANYWAY (P. 123)
1017 SE 34th
Portland, OR 97214
www.feelgoodanyway.com

FLAT (P. 128)
391 Broadway, 3rd Fl.
New York, NY 10013
www.flat.com

FLUFFCO (P. 153)
www.fluffco.com

FLUID (P. 33, 58, 142, 170)
1/222 The Custard Factory
Gibb Street
Birmingham B9 4AA
England
www.fluidesign.co.uk

FORK UNSTABLE MEDIA (P. 111, 162)
Wolliner Strasse 18-19
10435 Berlin, Germany
www.fork.de

FORM (P. 71)
47 Tabernacle St.
London EC2A 4AA
United Kingdom
www.form.uk.com

FURIOUS VISUAL WORLD (P. 172)
www.shaolinfury.com

FUZEMINE (P. 15, 114)
2013 W. Race Ave.
Chicago, IL 60612
www.fuzemine.com

GABOR, TIM (P. 154)
www.TimGabor.com

GAUCKLER, GENEVIÈVE (P. 185)
17 avenue Trudaine
75009 Paris, France
www.g2works.com

GHAVA (P. 91)
184 Kent St., Suite 311
Brooklyn, NY 11211
info@ghava.com

GLORIOUSDAY (P. 100)
San Francisco, CA
www.gloriousday.com

GMUNK (P. 68)
1800 N. New Hampshire Ave. #131
Los Angeles, CA 90027
www.gmunk.com

GOD CREATED DESIGN (P. 184)
Los Angeles, CA
www.godcreatedsight.com

THE HEADS OF STATE (P. 156, 178)
1504 Naudain #2
Philadelphia, PA 19146
www.theheadsofstate.com

HELIOS DESIGN LABORATORIES (P. 54, 149)
489-491 Queen St. W.
Toronto, Canada
www.heliozilla.com

HOLMS, COREY (P. 97)
801 Carlson Dr.
Brea, CA 92821
www.coreyholms.com

HONEST (P. 66)
224 Centre St., 5th Floor
New York, NY 10013
www.stayhonest.com

HYDRO74 (P. 67, 79, 85)
7515 Northam Dr.
Dayton, OH 45459
www.hydro74.com

I AM ALWAYS HUNGRY (P. 13, 42, 45)
www.iamalwayshungry.com

ILO (P. 95)
San Francisco, CA
www.ilodesign.com

INFINITRANSFORMATION (P. 168)
www.infinitransformation.com

INSECT (P. 69, 144)
1-5 Clerkenwell Rd.
London EC1M 5PA
United Kingdom
www.insect.co.uk

IRIDIUM, A DESIGN AGENCY (P. 23, 59)
43 Eccles Street, 2nd Floor
Ottawa, Ontario
Canada K1R 6S3
www.iridium192.com

JETPACK DESIGN (P. 186)
234 Laussat St.
San Francisco, CA 94117
www.jetpack.com

JOE NEWTON DESIGN & ILLUSTRATION (P. 174)
www.josephnewton.com

JOSHUA DAVIS STUDIOS (P. 131, 160, 164)
130 Shore Rd. #202
Port Washington, NY 11050
www.joshuadavis.com
www.praystation.com

KARACTER (P. 132)
Cra.9C No.119-49 apto201
Bogotá, Colombia
juliopenau@hotmail.com

KINSEY VISUAL (P. 101)
P.O. Box 34426
Los Angeles, CA 90034
www.kinseyvisual.com
www.blkmrkt.com

KLEBER DESIGN (P. 92)
London, United Kingdom
www.kleber.net

KOLEGRAM (P. 63)
37 St-Joseph Boulevard
Hull, Québec J8Y 3V8
www.kolegram.com

KOZYNDAN (P. 66)
www.kozyndan.com

KRENING (P. 39, 146)
255 13th St. #4
Brooklyn, NY 11215
www.krening.com
www.kareningram.com

LA GRAPHICA (P. 35, 96)
2311 Fourth St. #310
Santa Monica, CA 90405
www.lagraphica.com

L-DOPA (P. 122)
1022 Cole St.
San Francisco, CA 94117
www.l-dopa.com

LEON, MICHAEL (P. 30)
3203 Glendale Blvd.
Los Angeles, CA 90039
www.commonwealthstacks.com

LODGE DESIGN CO. (P. 139, 151, 176)
9 Johnson Ave.
Indianapolis, IN 46219
www.lodgedesign.com

MACROSCOPIC (P. 56)
San Francisco, CA
www.macroscopic.com

MAGNETSTUDIO (P. 49)
www.magnetstudio.net
www.gangrule.com

MAMBO (P. 37)
114 Rue de France
94 300 Vincennes
France
www.mambo.vu

MARRS, TIM (P. 143)
33 B Waldegrave Rd.
Upper Norwood
London SE19 2AL
United Kingdom
www.timmarrs.co.uk

MARTHA RICH ILLUSTRATION (P. 14)
www.martharich.com

MATTVARNISH (P. 167)
3569 Vinton Ave. #110
Los Angeles, CA 90034
matt.taylor@attbi.com

MAY, RICHARD (P. 165)
www.richard-may.com

MEAT AND POTATOES, INC. (P. 106)
4216 Santa Monica Blvd.
Los Angeles, CA 90029
www.meatoes.com

MEOMI DESIGN (P. 81)
Vancouver, Canada
San Francisco, CA
www.meomi.com

METRO/SEA (P. 83, 159)
3748 Cayuga Lane
York, PA 17402
www.metrosea.com

MILKY ELEPHANT (P. 28, 120, 176)
44 Henry St., 4th Floor
Brooklyn, NY 11201
www.milkyelephant.com

MITCH (P. 137)
mitchy.bwoy@virgin.net

MR. JAGO (P. 51)
www.mrjago.com

MODERN DOG DESIGN CO. (P. 21, 94)
7903 Greenwood Ave. N.
Seattle, WA 98103
www.moderndog.com

NEWTASTY (P. 22)
Studio 315, The GreenHouse
Gibb Square
Birmingham B9 4AA
United Kingdom
www.newtasty.com

NONCONCEPTUAL (P. 70)
New York, NY
www.nonconceptual.com
www.monikernon.com

NON-FORMAT (P. 115)
EkhornForss Ltd.
2nd Floor E., Universal House
88-94 Wentworth Street
London E1 7SA
United Kingdom
www.ekhornforss.com

O'DONNELL DESIGN (P. 120, 138)
250 Park Ave. S., Suite 201
New York, NY 10003
www.odonnell-design.com

OFFICE NERD (P. 79)
www.officenerd.com

OHIOBOY (P. 164)
62 Cheever Place #2
Brooklyn, NY 11231
www.ohioboy.com

OLIVE (P. 38)
115 East 30th St.
New York, NY 10016
www.olivemedia.com

ONRUSHDESIGN (P. 64, 149)
Reykjavik, Iceland
www.onrushdesign.com

OPEN (P. 99)
180 Varick St., 8th Floor
New York, NY 10014-4606
www.notclosed.com

P11CREATIVE (P. 62, 118, 128, 152)
20331 Irvine Ave. #5
Santa Ana Heights, CA 92707
www.p11.com

PATENT PENDING (P. 168)
P.O. Box 61309
Seattle, WA 98141
www.patentpendingindustries.com

PHATPHOOL (P. 106)
197 Consort Rd.
London SE15 3RY
United Kingdom
philbedford@btinternet.com

PIGEONHOLE DESIGN (P. 52, 65, 127)
www.pigeonholedesign.com

PINKROOM (P. 129)
111A Church St.
Philadelphia, PA 19106
www.pinkroom.net

PLINKO (P. 44, 76, 104, 125, 155, 177, 187)
690 Fifth St., Suite #200
San Francisco, CA 94107
www.plinko.com

POWERFORWARD (P. 132)
16 E. 95th St. #4
New York, NY 10128
www.powerforward.com

PRATE COMPUTER CHANNEL™
(P. 161)
www.Prate.com

QUICKHONEY (P. 164)
www.quickhoney.com

RECONFIGURED (P. 117)
918 Natoma St.
San Francisco, CA 94103
www.reconfigured.com

RED DESIGN (P. 55)
11 Jew St.
Brighton
East Sussex BN1 1UT
United Kingdom
www.red-design.co.uk

REDBEAN (P. 108, 109)
www.redbean.com
www.missylis.com

RENASCENT (P. 89)
Paulus Potterstraat 22
5251 NK
Vlijmen
The Netherlands
www.renascent.nl
www.renascentfused.nl

JP ROBINSON (P. 171)
3745 Bagley Ave. #205
Los Angeles, CA 90034
jprobinson@attbi.com

SAGMEISTER INC. (P. 93)
222 W. 14th St., 15A
New York, NY 10011
SSagmeiste@aol.com

SCRIBBLE & TWEAK (P. 40)
www.scribbleandtweak.com

SELF (P. 84)
Keizersgracht 424
1016 CG Amsterdam
The Netherlands
www.self.nl

SEMILIQUID (P. 60, 162)
1326 Edgecliffe Dr. #6
Los Angeles, CA 90026
www.semiliquid.net

SENNEP (P. 110, 148)
London, United Kingdom
matt@sennep.com
hege@sennep.com

SHAWN WOLFE DESIGN (P. 42)
9411 17th Ave. NE
Seattle, WA 98115
www.shawnwolfe.com

SLEEPATWORK (P. 28)
www.sleepatwork.com

SNASEN (P. 57, 145)
Karenslyst allé 16 d
P.O. Box 54, Skøyen
N-0214 Oslo, Norway
www.snasen.com
www.rayon.no

SOAP DESIGN CO. (P. 26, 51)
2874 Rowena Ave.
Los Angeles, CA 90039
www.soapdesign.com

STAT.IND (P. 150)
Chicago/New York
www.staticopy.com

(((STEREOTYPE))) (P. 91)
341 Lafayette St. #765
New York, NY 10012
stereotype@bway.net

STOLTZE DESIGN (P. 27, 175)
49 Melcher Street, 4th Floor
Boston, MA 02210
www.stoltzedesign.com

STONE, EMMA (P. 29)
Elephantcloud
www.elephantcloud.com

SUBDISC (P. 18, 87)
Vancouver, Canada
play: www.subdisc.com
work: www.blastradius.com

SUBFREAKIE (P. 140)
1640 19th St. #B
Santa Monica, CA 90404
www.subfreakie.com

SUGIUCHI, SCOTT (P. 159)
www.vibranium.com

SUMPTER, RACHELL (P. 46)
527 Oleander Dr.
Los Angeles, CA 90042
www.rachellsumpter.com

SUPERGYMPIE (P. 76, 173, 180)
www.supergympie.com

SUPER NATURAL DESIGN (P. 20)
674 Arkansas St.
San Francisco, CA 94107
www.supernaturaldesign.com

SUPERBAD (P. 80)
Los Angeles, CA
www.superbad.com

SWEATERWEATHER (P. 113)
2636 W. Walton #3
Chicago, IL 60622
www.sweaterweather.org

SWEDEN (P. 50, 103)
Blekingegatan 46
SE-116 62
Stockholm, Sweden
www.swedengraphics.com

SYRUP HELSINKI (P. 31, 43)
Pursimiehenkatu 26 H
00150 Helsinki
Finland
www.syruphelsinki.com

ERKUT TERLIKSIZ (P. 134)
105 Walm Lane
Willesden Green
NW2 4QG London
United Kingdom
www.erkutterliksiz.com

TEST PILOT COLLECTIVE (P. 181)
182 Howard St. #340
San Francisco, CA 94105
www.testpilotcollective.com

THOMPSON, MICHELLE (P. 91)
michellethompson.studio@
btinternet.com

THREE (P. 107)
170 College Ave.
Athens, GA 30603
crb@chronictown.com

{THS}DESIGN (P. 180)
Rellinghauser Str. 107
45128 Essen, Germany
www.ths.nu

TOP DESIGN STUDIO (P. 41)
11108 Riverside Dr.
Los Angeles, CA 91602
www.topdesign.com

TRANSITLAB (P. 101)
182 Howard St. #742
San Francisco, CA 94105
www.transitlab.com

TWELVE:TEN (P. 78, 110)
4 Stoney St.
Lace Market
Nottingham NG1 1LG
United Kingdom
www.twelveten.com

TWOPIECE (P. 124)
New York, NY
www.twopiece.net

TYPO5 (P. 89)
Calle 43a #69d-51
Torre.5, Apt. 917
Bogotá, Colombia
www.typo5.com

UPSO (P. 96)
www.upso.org

THIRSTYPE.COM (P. 77)
www.thirstype.com
www.3st.com

VIBRANIUM+CO.
(P. 11, 52, 85, 182)
10006 Creekwater Blvd.
Orlando, FL 32825
www.vibranium.com

WEWORKFORTHEM (P. 88)
www.weworkforthem.com

WONDER WAGON (P. 119)
www.wonderwagon.com

JUSTIN WOOD (P. 13, 80)
218 Thorne St. Unit A
Highland Park, CA 90042
www.singlecell.to

ÝMERIC (P. 57, 163)
www.umeric.com

ZIP DESIGN (P. 23, 166)
Unit 2A Queens Studios
121 Salusbury Rd.
London NW6 6RG
United Kingdom
www.zipdesign.co.uk

• • •

MORE GREAT TITLES
FROM HOW DESIGN BOOKS!

Inside this pocket-sized powerhouse you'll discover thousands of ideas for graphic effects and type treatments—via hundreds of prompts designed to stimulate and expand your creative thinking. Use *Idea Index* to brainstorm ideas, explore different approaches to your work and stir up some creative genius when you need it most.

ISBN 1-58180-046-0, paperback w/vinyl cover, 312 pages, #31635-K

To identify trends, see innovative work, and fuel their own inspiration, graphic designers look to collections of great design work. *Colossal Design* offers more than 400 pieces of imaginative page design, all with captions that explain the thinking behind the concepts. The books includes brochures and posters, CD and music graphics, book covers and editorial designs, business collateral, and self-promotional pieces. As an added bonus, Colossal Design contains more than 100 quick tips from top designers on how to create marketable page design.

ISBN 1-58180-444-X, hardcover, 368 pages, #32692-K

Turn an impossible deadline into a realistic schedule. Identify problem areas before you start working. Master software and production techniques that save time and money. Produce good design on even the tightest budget. Pat Matson Knapp shows you how to do all this and more with *Designers in Handcuffs.* Use this book and you will beat project constraints and create head-turning designs every time.

ISBN 1-58180-331-1, paper over board, 192 pages, #32297-K

Nothing is more exciting than an unusual design challenge, but where do you begin if it's something you've never designed before? Relax. *Creative Solutions for Unusual Projects* has all the resources and design expertise you need to solve any design emergency. You'll find start-to-finish solutions for everything from funky brochures to out-of-the-ordinary packaging to larger-than-life projects.

ISBN 1-58180-120-3, paperback with flaps, 192 pages, #31816-K